RACES OF MANKIND

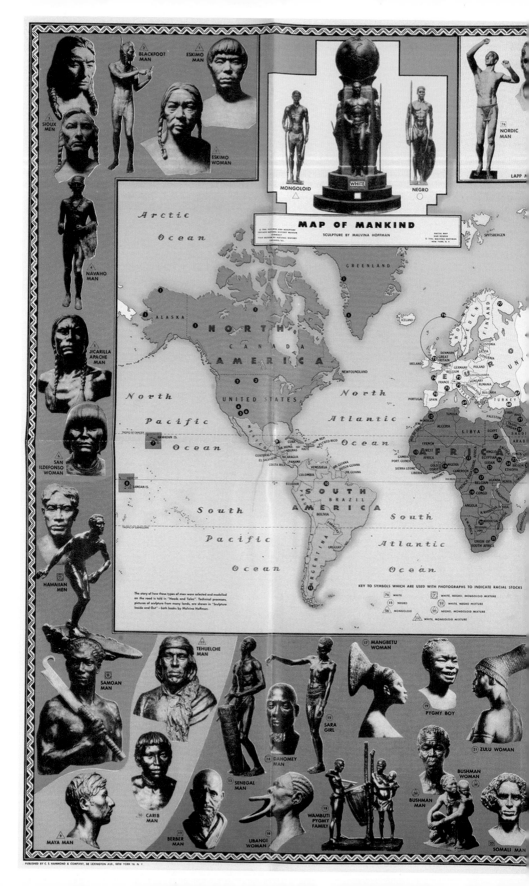

MAP OF MANKIND

SCULPTURE BY MALVINA HOFFMAN

MONGOLOID △ WHITE □ NEGRO ○

KEY TO SYMBOLS WHICH ARE USED WITH PHOTOGRAPHS TO INDICATE RACIAL STOCKS

76 WHITE 77 WHITE, NEGRO, MONGOLOID MIXTURE
15 NEGRO 23 WHITE, NEGRO MIXTURE
56 MONGOLOID 60 NEGRO, MONGOLOID MIXTURE
103 WHITE, MONGOLOID MIXTURE

The story of how these types of men were selected and modelled on the road is told in "Heads and Tales". Technical processes, pictures of sculpture from many lands, are shown in "Sculpture Inside and Out" — both books by Malvina Hoffman.

SIOUX MEN
BLACKFOOT MAN
ESKIMO MAN
ESKIMO WOMAN
NAVAHO MAN
JICARILLA APACHE MAN
SAN ILDEFONSO WOMAN
HAWAIIAN MEN
SAMOAN MAN
TEHUELCHE MAN
MAYA MAN
CARIB MAN
BERBER MAN
SENEGAL MAN
DAHOMEY MAN
UBANGI WOMAN
SARA GIRL
WAMBUTI PYGMY FAMILY
MANGBETU WOMAN
PYGMY BOY
ZULU WOMAN
BUSHMAN WOMAN
BUSHMAN MAN
SOMALI MAN
NORDIC MAN
LAPP

PUBLISHED BY C. S. HAMMOND & COMPANY, 88 LEXINGTON AVE., NEW YORK 16, N. Y.

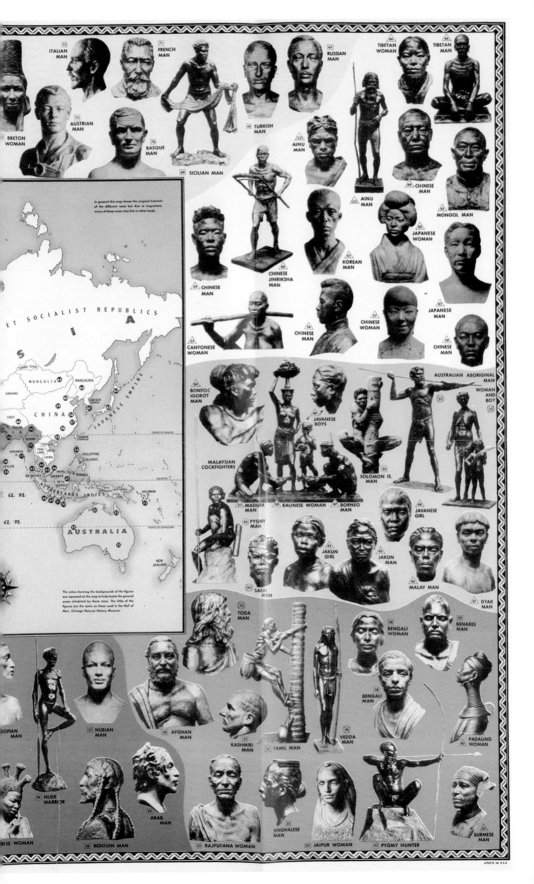

ITALIAN MAN

FRENCH MAN

RUSSIAN MAN

TIBETAN WOMAN

TIBETAN MAN

BRETON WOMAN

AUSTRIAN MAN

BASQUE MAN

SICILIAN MAN

TURKISH MAN

AINU MAN

AINU MAN

CHINESE MAN

MONGOL MAN

CHINESE JINRIKSHA MAN

KOREAN MAN

JAPANESE WOMAN

CHINESE MAN

CHINESE MAN

CHINESE WOMAN

JAPANESE MAN

CANTONESE WOMAN

CHINESE MAN

In general this map shows the original habitats of the different races but due to migrations, many of these races also live in other lands.

ET SOCIALIST REPUBLICS

SIA

MONGOLIA

MANCHURIA

CHINA

JAPANESE EMPIRE

TIBET

BURMA

FRENCH INDO CHINA

TAIWAN

CEYLON

PHILIPPINE ISLANDS

BORNEO

NETHERLANDS INDIES

SOLOMON

AUSTRALIA

NEW ZEALAND

The colors forming the backgrounds of the figures are repeated on the map to help locate the general areas inhabited by these races. The titles of the figures are the same as those used in the Hall of Man, Chicago Natural History Museum.

BONTOC IGOROT MAN

JAVANESE BOYS

AUSTRALIAN ABORIGINAL MAN, WOMAN AND BOY

MALAYSIAN COCKFIGHTERS

SOLOMON IS. MAN

MADURA MAN

BALINESE WOMAN

BORNEO MAN

JAVANESE GIRL

PYGMY MAN

JAKUN GIRL

JAKUN MAN

MALAY MAN

SAKAI MAN

DYAK MAN

TODA MAN

BENGALI WOMAN

BENARES MAN

IOPIAN MAN

NUBIAN MAN

AFGHAN MAN

KASHMIRI MAN

TAMIL MAN

VEDDA MAN

BENGALI MAN

PADAUNG WOMAN

NUER WARRIOR

ARAB MAN

SINGHALESE MAN

JAIPUR WOMAN

PYGMY HUNTER

BURMESE MAN

ESE WOMAN

BEDOUIN MAN

RAJPUTANA WOMAN

RACES OF MANKIND

THE SCULPTURES OF MALVINA HOFFMAN

MARIANNE KINKEL

University of Illinois Press

URBANA, CHICAGO, AND SPRINGFIELD

Please note: Members of Indigenous communities in Australia are advised that this book contains images of people who are deceased.

Publication of this book has been aided by a Wyeth Foundation for American Art Publication Grant of the College Art Association.

"Red Cross" from *The Collected Poems of Langston Hughes,* by Langston Hughes, edited by Arnold Rampersad with David Roessel, associate editor, copyright © 1994 by the Estate of Langston Hughes. Used by permission of Alfred A. Knopf, a division of Random House, Inc., and Harold Ober Associates Incorporated.

Frontispiece: Malvina Hoffman and the Field Museum, *Map of Mankind* (1946), printed by C. S. Hammond and Company. Malvina Hoffman papers, Research Library, The Getty Research Institute, Los Angeles (850042).

Library of Congress Cataloging-in-Publication Data
Kinkel, Marianne.
Races of mankind : sculptures of Malvina Hoffman / Marianne Kinkel.
p. cm.
Includes bibliographical references and index.
ISBN 978-0-252-03624-8 (cloth)
1. Hoffman, Malvina, 1887–1966 2. Hoffman, Malvina, 1887–1966—Ethnological collections. 3. Women sculptors—United States—Biography. 4. Race in art. 5. Ethnicity in art. 6. Field Museum of Natural History. Chauncey Keep Memorial Hall—Ethnological collections. 7. Century of Progress International Exposition (1933–1934 : Chicago, Ill.)—Ethnological collections.
I. Title.
NB237.H55K46 2011
730.92—dc22 2011012409

CONTENTS

Acknowledgments xi

Introduction 1

1. Initial Plans for a Physical Anthropology Display 21

2. Malvina Hoffman as Professional Artist 34

3. Producing the Sculptures and Building Consensus 48

4. The Hall of the Races of Mankind 82

5. Life beyond the Field Museum:
 Exhibiting Statuettes during the 1930s 124

6. Deploying the Races of Mankind
 Figures during the 1940s 144

 Conclusion: Retraction and Redeployment
 of the Sculptures in Chicago 183

Abbreviations 201

Notes 203

Bibliography 245

Index 263

ACKNOWLEDGMENTS

IN THE COURSE OF WRITING THIS BOOK, I received the generous assistance of many individuals. I wish to express my gratitude to the Malvina Hoffman Estate for granting permission to reproduce materials and photographic images from the sculptor's papers. Tamara Slobodkin and the late Lawrence Slobodkin kindly shared Louis Slobodkin's personal correspondence. Conversations with Larry Slobodkin gave me a broader understanding of the social milieu in which his father and Malvina Hoffman worked. Larry also provided invaluable lessons beyond the scope of this project, for which I am extremely grateful. At the Field Museum, I would like to thank Nina Cummings and Jerice Barrios, both of whom tenaciously searched for photographic materials. Ruth Andris, Michele Calhoun, Armand Esai, Wil Grewe-Mullins, and Ben Williams offered their help in locating archival materials at the Field Museum, and Alaka Wali kindly granted permission to include them and the images in this book. Mary Jo Arnoldi, David Hunt, and Stuart Speaker at the National Museum of Natural History sharpened my thinking concerning the politics surrounding anthropology exhibits and helped me to gain a greater understanding of the representational practices within physical anthropology. Jake Homiak, Daisy Njoku, and other staff members at the National Anthropological Archives offered much assistance. Kate Ralston at the Getty Research Institute graciously gave her time to locate images for this book. Craig Tenney, of Harold Ober Associates, Incorporated, offered timely guidance. Rose Tyson at the San Diego Museum of Man kindly permitted me to examine anthropological portraits and other materials from the Panama–California Exposition. Hélène Pinet at the musée Rodin in Paris offered suggestions on French sculptural practices and facilitated my research in Paris. Philippe Mennecier at the Musée de l'Homme kindly took me on a tour of the museum's anthropological collection. I am also grateful to Tina Craig, at the Royal College of Surgeons of England, who granted access to the

papers of Sir Arthur Keith. Ken Gonzales-Day generously offered a photograph from his *Profiled* series for the cover of this book. Lisa Schrenk kindly visited Malcolm X College and photographed the exhibit there.

Initial research was supported by a Smithsonian Predoctoral Fellowship; generous scholarships and grants from the Department of Art and Art History, the University of Texas at Austin; and a research travel grant from the Getty Research Institute. I am indebted to my dissertation committee—Desley Deacon, Michael Leja, Janice Leoshko, Richard Shiff, and Polly Turner Strong—for their thoughtful suggestions; my committee supervisor, Ann Reynolds gave much encouragement and guidance. Subsequent postdoctoral research was funded by a research travel grant from the Getty Research Institute and various grants from Washington State University. Portions of this book appear in my essay "Sculptures as Museum Models: Malvina Hoffman's Races of Mankind Display," in *Sculpture and the Museum,* edited by Christopher Marshall (Ashgate Publishing).

I wish to thank Joan Catapano at the University of Illinois Press for her guidance and support of this project and the anonymous readers who provided insightful suggestions for improving the manuscript. Many friends in Pullman kept me grounded while I wrote new chapters and revised the manuscript, especially Valerie Boydo, Ann Christenson, Maria DePrano, Michelle Forsyth, Kevin Haas, Nik Meisel, Io Palmer, Rich King, Garric Simonsen, John Streamas, Chris Watts, and Mary Woodall. I wish to thank my parents, Charles Kinkel and Diane Rhorer; my sisters, Jill and Natalie; my brother, Jeff; and members of my extended family: Kathy Kinkel, Donald Rhorer, Sharon Yount, Karen Rhorer, Kyle Rhorer, Lori Rhorer, Karen and Donald Butler, and Ruth and Loyd Shookman, whose encouragement and support were unwavering. Archy gave reassuring nudges while I wrote this book: *toujours gai archy toujours gai.* Most importantly, the devotion of my husband, Michael Yount, helped me carry this work to completion. To him I dedicate this book.

RACES OF MANKIND

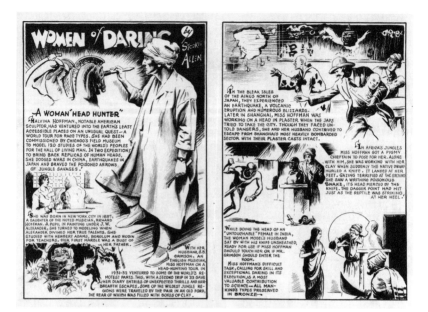

Figure 1. Stookie Allen, "Women of Daring: A Woman 'Head Hunter,'"
New York Daily Mirror (August 27, 1934). Malvina Hoffman papers,
Research Library, The Getty Research Institute, Los Angeles (850042).

INTRODUCTION

STOOKIE ALLEN'S CARTOON *A Woman "Head Hunter"* (figure 1) presents a powerful myth of the American sculptor Malvina Hoffman.[1] Loosely fashioned out of published photographs and newspaper stories on how the sculptor produced the Races of Mankind sculptures for the Field Museum of Natural History, the cartoon valorizes Hoffman through a quest narrative. In this narrative, ideas about race, gender, and representation are presented through the image of the artist as hunter, who, we are told, faced "untold dangers" and experienced "unexpected thrills and hair-breadth escapes" to capture her subjects in clay. This adventure cartoon invents a dramatic and easily recognizable image of the sculptor that circulated, with minor variations, in many newspaper accounts, science journals, school primers, and art reviews during the 1930s and 1940s. Whether or not the sculptor's audience naively accepted Hoffman as a "headhunter," the persona served several important rhetorical functions for the Races of Mankind sculptures. For instance, the myth of head hunting deflected attention away from the collaborative circumstances under which the sculptures were made. Instead of modeling in exotic places, Hoffman produced nearly all of the ninety-one Races of Mankind sculptures (figure 2) in her New York and Paris studios with a cadre of skilled workers. Although Hoffman's travels on behalf of the Field Museum were mostly confined to Asia, her search for human types was publicized as a worldwide tour. This travel narrative lent credibility to the sculptures, since contact with her subjects not only made Hoffman's work appear authentic, it also allowed her to claim that these full-length figures, portrait heads, and busts represent the essence of race.

The notion that Malvina Hoffman had the power to characterize a population by race circulated widely and even appeared in publications oriented to schoolchildren, such as *Twenty Modern Americans* (1942):

You may wonder why she went to all the bother. Why not simply make casts from living models or life masks, in the fashion which the waxen ladies we see in department-stores are made? The answer goes to the heart of

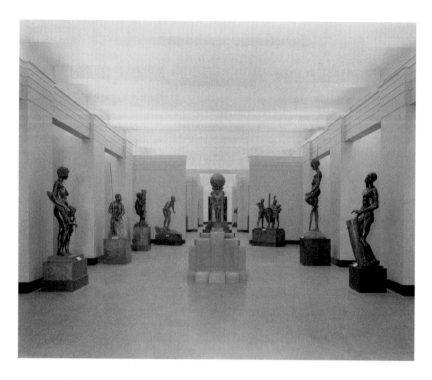

Figure 2. View of the Hall of the Races of Mankind, Field Museum (1933). © The Field Museum, CSA77747.

the artist's goal. A photograph or life mask shows how the subject looks. The good portrait or statue shows what he *is,* bringing to the surface his inner character or soul. Miss Hoffman went even further, in that each of her subjects is truly representative of his entire race. In her *one* Balinese, for example, you see *all* Balinese . . . That is why when you come to the end of an afternoon in the Hall of Man and leave the Afghan money lender, the Martinique dancing girl, the Cheyenne warrior, the Burmese beauty, and the family of little African pigmies, you will find it hard to realize you merely looked at them. You will feel that you have visited them.[2]

This passage identifies life casting as a mechanical means to produce resemblance, and clay modeling as a way for the sculptor to create a likeness that represents the inner essence of an individual. It explains that the sculptor's skill in selecting and representing characteristic traits enables her sculptures to be perceived simultaneously as individual portraits and as representatives of race. It also makes clear that the so-called "Martinique dancing girl" and

the "Afghan money lender" surpassed their primary roles as anatomical representations of race by telling ethnographic stories. Hoffman intended her sculptures to narrate other supposed signs of race through poses, gestures, and habitual actions associated with cultural activities and social occupations: "I watched the natives in their daily life, fishing, hunting, praying and preparing their food, or resting after a day's work. Then I chose the moment at which I felt each one represented something characteristic of his race and of no other."[3] What lent additional force to the sculptor's claim during the 1930s was the growing interest in pathognomy, which approached character in terms of mobile rather than stable features of the body. Studies of habitual behavior and facial expression in psychology, sociology, and cultural anthropology promoted ways of reading the body that challenged physiognomy, which focuses on fixed anatomical structures.[4] Artistic portrayals of character could mediate both practices.[5] At a moment when some anthropologists doubted the value of anthropometry, the measurement of human anatomy, to establish clearly defined racial divisions, Hoffman's Races of Mankind sculptures represented racial types artistically, and her rhetoric of character established the veracity of her sculptures in ways amenable to a wide variety of theoretical positions and fields closely allied to her project. Consequently, the artist's narrative concerning the sculptures has persisted for decades. As the catalogue for the traveling exhibition *American Masters: Sculptures from Brookgreen Gardens* (1998–1999) explains, "Hoffman tried to capture the moment at which each subject represented the individual characteristic of his race."[6]

Currently, the Field Museum presents a selection of the Races of Mankind as portraits of people from around the world. Much as the Field Museum would like visitors to consider these sculptures as fine art portraits, their history suggests that they were extremely efficient in articulating different racial discourses. From 1933 to 1969, the sculptures formed an anthropology display in the museum's Hall of the Races of Mankind (figure 2). Small-scale replicas of the Races of Mankind figures were exhibited in Paris and New York and then formed a traveling exhibition that crisscrossed the United States during the 1930s and 1940s. Photographic reproductions circulated widely when images of the sculptures appeared on C. S. Hammond's *Map of Mankind* (frontispiece), featured within world atlases, and served as plates in the *World Book Encyclopedia* from the late 1940s through the early 1970s. Because many public schools in the United States relied upon such educational materials during the postwar period, students who wanted to learn the "facts" on race would more than likely have encountered these images. Attending elementary school in southern California in 1969, I was introduced

to the sculptures through using Hammond atlases for classroom assignments. I remember being both fascinated and confused by the images. Despite the enormous role the sculptures played in representing race in American visual culture, they have been largely neglected in the history of American art, and this monograph is the first sustained study of their history.[7]

This book presents a history of the Races of Mankind sculptures in the form of a cultural biography, tracking the historical circulation of these objects to examine the accrual of social values. This biographical approach is informed by science studies, in particular the work of Susan Leigh Star and James Griesemer, who examine how participants from diverse social worlds, who possess varying forms of expertise and agendas, collaborate to inscribe objects with social meanings. Their concept of boundary objects helps to address how the Races of Mankind sculptures fulfilled multiple roles and satisfied informational demands across a range of cultural fields: boundary objects are "plastic enough to adapt to local needs and the constraints of the several parties employing them, yet robust enough to maintain a common identity across sites."[8] Considering the sculptures and their various manifestations in this way, this book examines how they participated in different racial paradigms by asserting fixed racial types and racial hierarchies in the 1930s, promoting the notion of a Brotherhood of Man in the 1940s, and engaging Afrocentric discourses in the early 1970s. Archival documents held at the Field Museum, and the artist's papers at the Getty Research Institute, provided a wealth of materials to study the collaborations involved in the production, display, and circulation of the figures. This book maintains a close engagement with this diverse range of materials in its endeavor to examine how the Races of Mankind sculptures engaged twentieth-century relations among art, anthropology, and visual culture. By examining key moments in the sculptures' career, we can understand more concretely how notions of race continue to be shaped and sustained.

The idea that a portrait can substitute for a person or represent a type has a long history in Western portraiture and in anthropological theories of race. Likeness not only assures a seemingly transparent relationship between a portrait and a subject, it supports claims that an internal essence and an abstract type can be inferred from external physical features. These deeply embedded ideas, as Allan Sekula notes, functioned not only in fine art "honorific" portraits, but also in the "repressive" archives of criminology, psychiatry, and anthropology, to construct notions of social deviancy and classifications of race.[9] Throughout the twentieth century, avant-garde artists attempted to dismantle notions of interiority and ways of reading the body

that operate within traditional portraiture.[10] Contemporary artists such as Glenn Ligon, Lorna Simpson, Carrie Mae Weems, and Fred Wilson engage portraiture to make apparent how historical practices of visualizing racial difference resonate in the present. For instance, Lorna Simpson's "anti-portraits" disrupt physiognomic habits and contradict familiar discourses of character. As Okwui Enwezor argues: "Simpson reworks the ethical paradigm of the documentary, critically questioning the maudlin sentimentality introduced in early photography of the face as a window into the soul of a subject. The face has been a cheap trick in photography, wherein shallow psychological and morality tales become conventions for reading deep character into nothing but a mask."[11] Glenn Ligon's *Self-Portrait Exaggerating My Black Features/Self-Portrait Exaggerating My White Features* (1998) encourages perceiving racial differences between two images.[12] Since the images are copies of the same photograph, viewers experience a sense of cognitive failure, which confounds the process of classifying an individual by race. Unfortunately, recent research on human genetic variation has renewed interest in the visual practices and notions of race that these artists subvert. In a 2005 *New York Times* opinion piece, the biologist Armand Marie Leroi claimed that current genetic studies confirm everyday racial assessments and the traditional categories of race.[13] In response, many scholars disputed these assertions and cautioned against efforts to reinject race into science.[14]

As the sociologists Michael Omi and Howard Winant theorize, race is a social fact that is continually renegotiated through social structures and representational practices that vary across cultural sites and at different moments in time.[15] Consequently, representations of race have changed frequently since the founding of the first anthropological societies in the mid-nineteenth century. Anthropologists devised many measurements, such as the cephalic index, to construct racial classifications, and they also relied upon visual representations to assess nonmetric variations. Taxonomists of race found that no single physical trait or feature, such as skin tone, eye color, or hair form, yielded a consistent way of demarcating races. Selecting a set of physical features to create a racial type also posed problems, because anatomical characteristics vary continuously and independently of one another, making typologies based on these traits "arbitrary and subjective."[16] Nevertheless, typological approaches to human biodiversity continued until opposition to racism and developments in population genetics during the mid-twentieth century caused many anthropologists to discredit race as a scientific concept. The career of the Races of Mankind sculptures uniquely illustrates how racial representations could acquire new meanings during this period of transition.

We will see in succeeding chapters how these sculptures' efficacy as artistic representations of race enabled them to fulfill competing roles of individual portrait and racial type, ethnographic figure and anatomical model.

THE GENRE OF ETHNOGRAPHIC SCULPTURE

The Field Museum's desire to include three-dimensional models in an anthropological display on race is not an anomaly in the history of anthropology, nor is Malvina Hoffman the first artist to undertake such a project for a natural history museum. Art historians have recently argued that Hoffman represents one of the last sculptors to participate in the genre of ethnographic sculpture, which functioned at the intersection of art and anthropology during the nineteenth century and played a crucial role in visualizing theories of race.[17] Exhibited primarily in natural history museums, ethnographic sculptures facilitated morphological assessment of the human body and physiognomic decipherment of facial features, visual practices involved in forming racial typologies and constructing racial hierarchies. As the 1994 exhibition *La sculpture ethnographique de la Vénus Hottentote à la Tehura de Gauguin* at the Musée d'Orsay has shown, many academically trained French sculptors like Louis-Ernest Barrias, Jean-Baptiste Carpeaux, Charles Cordier, and Louis Rochet carved or modeled ethnographic portraits and figures, not all of which were intended for natural history museums. American sculptors such as Paul Wayland Bartlett, Cyrus Dallin, James Earle Fraser, and Clark Mills also created ethnographic sculptures, and the artist Augustus Saint-Gaudens was quoted as saying that it was "the youthful sin of every American sculptor" to produce a statue of a Native American.[18] Notwithstanding the copious number of ethnographic sculptures, historical scholarship on race rarely considers this genre or the key role that such works played in visualizing racial types.

Ethnographic sculptures were often produced for anthropological study collections or museum exhibits for public instruction. These museum models included a range of three-dimensional objects: facial masks, portrait busts, and full-length figures, made through carving in stone, modeling in clay, or through a direct casting process. Although many artists and museum preparators combined these sculptural methods, aided by measurements, drawings, and photographs, to produce ethnographic sculpture for museums, the rhetoric surrounding material practices during the nineteenth and early twentieth centuries positioned clay modeling and direct casting as antagonistic processes. Clay modeling was long held to be a process of artistic imitation; an artist invents by interpreting nature and selecting, simplifying, or

emphasizing particular elements. Life casting, on the other hand, as Georges Didi-Huberman has recently shown, was considered to be a mechanical form of resemblance that does not need human intervention, and therefore the process negates the possibility of style and originality.[19] This distinction between invention and mechanical forms of imitation mirrored the better-known antagonisms surrounding painting and photography. What most concerned nineteenth-century sculptors and art critics about direct casting was that a cast replicates all the surface particulars. The certainty of physical contact and the material process generate a sense of authenticity, as the plaster of Paris mixed with water warms and hardens to make an impression, a process similar to natural forms of petrification. Some individuals found this process astounding; as one writer remarked, it produced "works of art from nature's workshop," but most critics claimed that the arresting capacity of casting could be equated with death itself.[20] This analogy was supported by the longstanding tradition of making death masks, a practice that flourished in the nineteenth century.

Understood in terms of natural or mechanical representation, plaster casts filled the requirements for objective documents of natural history during the late nineteenth century. As Lorraine Daston and Peter Galison have shown, forms of reproduction deemed "mechanical" increasingly shaped the notion of scientific objectivity.[21] Seemingly produced unaided by the human hand, the medium of plaster casting established claims of veracity dissociated from the sagacity of an artist and the possibility of subjective judgment. Museums used cast replicas as accurate and authentic substitutes for originals in order to build collections in anatomy, anthropology, botany, paleontology, and phrenology.[22] Naturalists even invented names such as "plastotype" to denote the kind of specimen a cast represented.[23] Understood as authentic substitutes, plaster casts aided the production of knowledge by allowing naturalists working in museums to construct, accumulate, and classify objects, a guiding principle in the formation of many nineteenth-century museums.

Many nineteenth-century artists and critics believed that direct casting was a means for producing facsimiles of nature, but as the French sculptor Jules Dalou claimed, "neither a cast from life nor a photograph will be art. Art only exists in as much as it is the interpretation of nature, whatever that may be. It is the spirit of nature that it is necessary to find, according to the needs of the subject and of the period. To force oneself to strictly reproduce nature is a great mistake."[24] Accusing a sculptor of casting from life was a serious charge, because it carried with it the suggestion that the artist had taken a shortcut to produce an illusion of realism. Works falsely alleged to

be casts, such as Auguste Rodin's *Age of Bronze* at the Salon of 1877, exposed the critics' assumptions that sculpture is based on artistic invention. Artists also claimed that casting produced forms devoid of a lifelike appearance, and Rodin himself criticized the practice: "a cast from life is the most exact copy that one can obtain, but it is without life, that is to say that it has neither movement nor eloquence, and it says very little."[25] Artists closely associated with the genre of ethnographic sculpture, whose work served as precedents for the Races of Mankind sculptures, responded similarly to the casting-versus-modeling debate. The best-known practitioner of ethnographic sculpture, the nineteenth-century French artist Charles Cordier, disparaged direct casting because the process "eliminates the physiognomy" of the model.[26] Cordier negotiated the terrain among art, anatomy, and anthropology by taking precise measurements, but more importantly he arrived at a racial type through his artistic imagination:

> I first examine and compare a great number of individuals, I study the form of their head, the traits of their visage, the expression of their physiognomy; I apply myself to seize the characters common to the race that I desire to represent, I appreciate them in their ensemble as well as in their details, I embrace for each one of them the range of individual variations, I come to conceive the ideal or rather, the type of each one of these characters, then grouping all those partial types, I constitute in my mind an ensemble type where I find reunited all the special beauty of that race which I study . . . After having thus conceived the ideal type of a race (I do not relate to reproduce it from my mere memories), I seek among the individuals that I have studied and compared those who present in the highest degree the reunion of the special beauties of his race, and that is the one that I choose to execute in an exact and characteristic sculpture.[27]

Elements of Malvina Hoffman's rhetoric of character are present here, for both artists claimed that accuracy rests upon traveling to distant lands, observing many people, and selecting a person whom they believe can serve as a representative type.

The British explorer-turned-sculptor Herbert Ward approached ethnographic sculpture in more symbolic terms.[28] Unlike Charles Cordier, Ward did not claim that his sculptures (figure 3) reflected accurate measurements. Instead, the authenticity and accuracy of his figures rested largely upon his personal biography of traveling and living in central Africa and upon his vast collection of art objects and zoological materials.[29] Ward did not conceive of his bronze sculptures as portraits; rather, he wanted to "make something

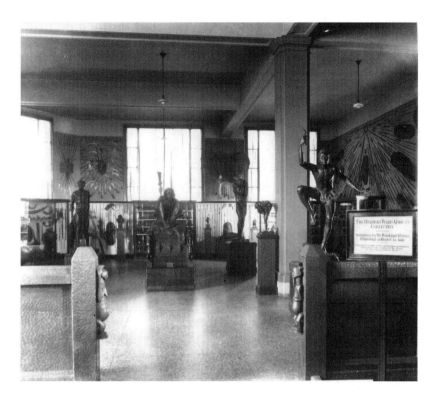

Figure 3. Installation view, Herbert Ward exhibit at the U.S. National Museum, Smithsonian Institution, *Defiance* (left), *Congo Chief* (center), *Distress* (right), and *Sorcerer* (far right). National Anthropological Archives, Smithsonian Institution (26914-G).

symbolical—not an absolute realistic thing like wax works in an anatomical museum—but to make something that demands two different requirements: the thing must have the spirit of Africa in its broad sense, and at the same time fill the requirements of the art of sculpture."[30] For Ward, each of his sculptures served as a symbolic type; for instance, he claimed that his *Congo Chief* (1908) represented "not one chief, but a hundred chiefs."[31] Regarding his sculptures as ethnographic pastiches, Mary Jo Arnoldi has recently shown how Ward used ethnographic objects and bodily ornamentation associated with one ethnic group to represent another in his delineation of a type.[32]

Instead of symbolic types, the well-known American sculptors Henry Hudson Kitson and Theodora Alice Kitson created two plaster figures (figure 4) to represent white racial types according to Dudley Sargent's anthropomet-

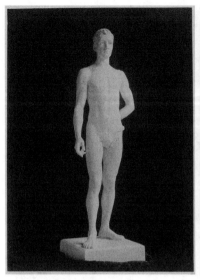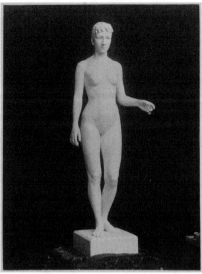

Figure 4. Henry Hudson Kitson and Theodora Alice Kitson, *Statues of Typical Americans, Male and Female,* for Dudley Sargent (1893), Peabody Museum. Courtesy of the Boston Public Library.

ric study of Ivy League college students. Sargent intended these composite figures, which were displayed in the anthropology hall at the 1893 Chicago World's Fair, to serve as a "base line by which to measure the physical advancement or deterioration of the race."[33] Eschewing the naturalism of their commissioned portraits and public monuments, as well as rejecting notions of the classical ideal, these sculptors modeled their figures based upon statistically averaged measurements and composite photographs. The influential art historian Charles Eliot Norton, of Harvard University, did not view these figures as meeting the requirements necessary for art; rather, he claimed that such figures would be better represented through two-dimensional diagrams than in sculpture.[34] The anthropologist Franz Boas similarly condemned the composite figures, but for a different reason: he believed that Sargent's use of averaged measurements created an oversimplified abstraction, because a statistical average is not typical of a race, nor does it reflect correlations of measurements of a population.[35]

Generalized sculptural types would have elicited skepticism from most American physical anthropologists, who would have found a large series of direct cast masks or busts a more accurate means to arrive at a racial type than a single composite figure. A temporary display (figure 5), mounted at the U.S. National Museum in May 1952, gives us an idea how these varying notions of types and sculptural debates continued to inform museum representations of race well into the twentieth century. Designed by the physical anthropologist T. Dale Stewart, this display was intended to explain the making of anthropological busts for museum exhibits. Two photographs of anthropology curator Frank Setzler removing a facial mold from a subject begin a V-shaped narrative sequence. Smaller models illustrating various production stages ascend to the finished portrait. This sequence begins with a cross-sectional view of a clay facial mask in a field mold, followed by a clay model with a head shape. The third stage presents modeled additions of ears and hair, and in the fourth stage "sculpted eyes" are added. The next model

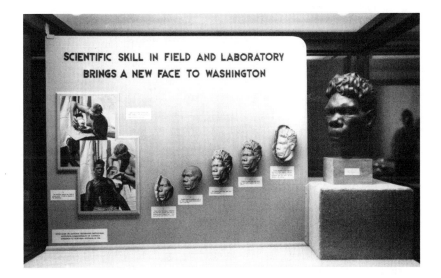

Figure 5. T. Dale Stewart, Temporary Display, Foyer, U.S. National Museum, Smithsonian Institution, May 1952. Notebook on Special Exhibits 1951–52, Department of Anthropology, USNM/NMNH, National Anthropological Archives, Smithsonian Institution.

shows a cross-sectional view of a plaster replica of the clay model inside the develop mold, and the series ends with the final portrait. The additions of a head, ears, hair, and eyes, as well as the final "bronzing" of the finished object, are conventions that fulfill requirements for artistic portraits, but the labels under each model disclaim any artistic license; we are told that the museum sculptor followed exact measurements and photographs taken in the field.[36] The large photographs and finished portrait dominate the display. Together, they function temporally as before and after, and spatially from out there in the field to here in the museum. This double reading, made possible by placing one indexical form of representation, photography, next to another, plaster casting, was intended to assure museum visitors of an authentic relationship between the museum model and an actual person.[37] It does so without making claims involving the internal character of its sitter or the divinatory powers of the museum artist. In fact, the identities of the subject and the museum modeler are effaced by the display's assertion of scientific objectivity and the conceptual leap from individual resemblance to physical type. However, if the rhetoric of character associated with conventional portraiture is suppressed in the display, so, too, is the purpose that anthropological portraits served at the museum. The notion of a "new face" does not explain historically how such portraits served as representations of race.

T. Dale Stewart's mentor and predecessor at the Smithsonian Institution, the prominent physical anthropologist Aleš Hrdlička, relied upon anthropological busts to construct a classification of races and to demonstrate his evolutionary theories in museum displays. Hrdlička believed that an extensive collection of facial masks and portrait busts, made through direct casting, was necessary for research, since details are "the essentials to all knowledge, and they are indispensable to anthropological comparisons."[38] His desire to accumulate a large series of "racial records," as he called them, conformed to his practice of amassing a horrifically large collection of human remains to secure a foundation for his racial studies. He claimed that it was only after describing and sorting such objects into a systematic series that conclusions could be drawn.[39]

Hrdlička's investment in individual portrait busts to represent race is best illustrated by the exhibit that he designed for the 1915 San Diego World's Fair, the Panama–California Exposition; he claimed that it was the most comprehensive physical anthropology display in the United States, one that rivaled those in Europe.[40] Mounted in the Science of Man building, the enormous exhibit consisted of five connected halls. The display corresponded to Hrdlička's aim to cast the field of physical anthropology as a purely objective science,

removed from the racial politics of the time. The display did not blatantly assert white superiority, even though much of Hrdlička's research was oriented to demonstrating his belief in white America's evolutionary progress.[41] In a letter, he confessed his reluctance to present his views in the display: "I must be very careful in this country where the racial question is quite acute; and I must defer to other wishes than my own. To show you how serious these questions are, especially with us who are employed by the government, I will tell you that we do not dare to undertake any investigation on the Negro, for the results would surely be taken advantage of by one part or the other and we should be blamed."[42] However, viewing Hrdlička's exhibit in relation to the various "villages" featuring live subjects within the midway zone, as well as the fair's overriding narrative of progress, many visitors and journalists responded to the physical anthropology display as if it established scientific proof of human evolution and the superiority of white America.[43]

In Room 1 (figure 6), Hrdlička represented evolutionary stages using plaster casts of rare fossil remains that he had purchased from European museums. Mounted on top of display cases were ten cast replicas of reconstructions of

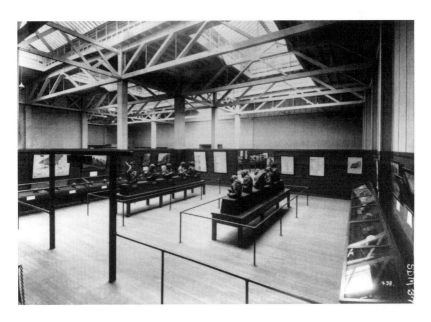

Figure 6. Room 1, "Phylogeny," Physical Anthropology Exhibit, Science of Man Building, Panama–California Exposition, San Diego (1915–16). © San Diego Museum of Man, photographs by Malcolm Farmer.

prehistoric man by the sculptor Louis Mascré, made under the supervision of Aimé Rutot, curator at the Royal Institute of Natural Sciences of Belgium. Mascré modeled the figures in a specific action and attitude, with tools and other objects to characterize each stage of human evolution, and many of the figures connoted emotional states, such as placidity, warlike aggression, or fear—as in the reconstruction of a Neanderthal woman with a baby.[44] Although Hrdlička exhibited these hypothetical reconstructions to demonstrate human evolution, he refrained from displaying such generalized representations in the succeeding rooms concerning his racial classification.

For Rooms 2 and 3, Hrdlička hired Frank Mička, an assistant sculptor to Gutzon Borglum, to make 106 facial masks, 90 portrait busts, and 20 waist-length plaster figures.[45] Hrdlička sent the sculptor and four other individuals on expeditions to different parts of the world to make life casts and to take photographs and measurements of a large number of people. Mička's sculptural procedure combined casting and modeling, similar to the techniques illustrated by T. Dale Stewart in figure 5. To make the facial casts suitable for display, Mička carved eyes out of white plaster casts and applied a bronzed finish to them. In each portrait bust, he went several steps further: he modeled a neck and head with hair, and for the female busts, he added bows or other hair ornaments. On each pedestal, the sculptor inscribed the name, tribe, or generation of the depicted subject to provide a hereditary framework. The waist-length figures required the most preparation; under Hrdlička's supervision, Mička assembled cast body parts and modeled torsos or arms as needed to create them. He also included objects or clothing and painted the figures in a variety of colors.

In Room 2 (figure 7), Hrdlička exhibited ninety painted portrait busts to illustrate the "principal races of this country, namely, the 'thoroughbred' white American (for at least three generations in this continent on each parental side), the Indian, and the full-blood American Negro."[46] Hrdlička arranged the portrait busts in three rows of glass cases and placed the white Americans series in the center, females on one side, males on the other. Each series began with a modeled figure of an infant, then progressed to portrait busts of children, adolescents, and adults, and ended with elderly individuals. Hrdlička intended this temporal progression to visualize how each of his proposed races followed its own line of development or life cycle. In an earlier study, he claimed that white children generally exhibited more diversity in physical characters than nonwhite children, which became more marked as they aged.[47] This claim supported his view that whites were undergoing progressive evolution while other races remained stagnant. As Hrdlička argued in

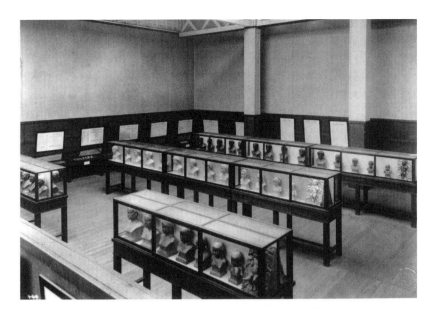

Figure 7. Room 2, "Ontogeny," Physical Anthropology Exhibit, Science of Man Building, Panama–California Exposition, San Diego (1915–16). © San Diego Museum of Man, photographs by Malcolm Farmer.

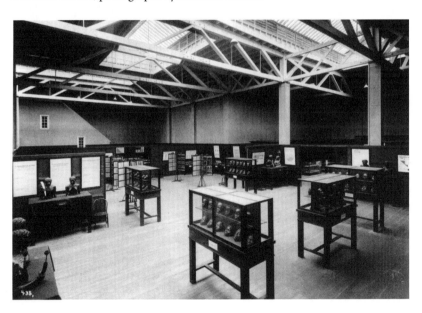

Figure 8. Room 3, "Man's Variation," Physical Anthropology Exhibit, Science of Man Building, Panama–California Exposition, San Diego (1915–16). © San Diego Museum of Man, photographs by Malcolm Farmer.

1915, "we see that the higher civilized white man has already in some respects outdistanced others, that he is rapidly diversifying, and that all about us those who cannot keep the accelerated pace are being eliminated by nature."[48] He believed that this process of evolution required segregation, and he stated three years later that "in the United States we are confronted on the one side with the grave problem of mixture of white and Negro, and on the other with that of white and Indian."[49]

In Room 3 (figure 8), Hrdlička grouped the 106 facial casts and 20 waist-length figures racially, based on skin tones of "white," "yellow-brown," and "black," as well as geographically. In the guidebook to the exhibit, Hrdlička used an organic metaphor to explain his racial taxonomy. The "main races," he explained, "may be defined as the main physical streams of humanity; the secondary races are the important tributaries of these streams; and the types are the main affluents of these tributaries."[50] The facial casts, waist-length busts, and graphic representations made this analogy concrete. The facial casts exhibited within glass vitrines served as a comparative series to discern tribal resemblances and individual variations in the human face. The waist-length painted plaster figures bordering Room 3 functioned as a representative series of the "ten subraces, five of the yellow-brown and five of the black stock," while charts and diagrams explaining classifications based on skin color, hair, nose shape, or head form represented the three racial stocks.[51] The conceptual system governing these various representations reveals how Hrdlička conceived of his anthropological research as moving from an extensive array of particular individuals, to a classification of groups, to characteristic types, then to subraces, and concluding with three racial stocks. The efficacy of Hrdlička's logic was that the typological system worked in reverse: one could move from generalized representations of race depicted on charts like *Racial Differences* (figure 9) to the individual portraits. By following these steps, even novice viewers could compare bodily forms and facial features and learn how to classify people by race.

REPRESENTING RACE AT THE FIELD MUSEUM

Aleš Hrdlička's exhibit inspired Berthold Laufer, who was appointed anthropology curator at the Field Museum in 1915, to propose installing a Hall of Physical Anthropology. Laufer wanted to ensure that the Field Museum achieved the status of a premier research institution.[52] At the time, most anthropological research was conducted in museums and universities on the East Coast, and Laufer sought to remedy deficiencies at the museum to

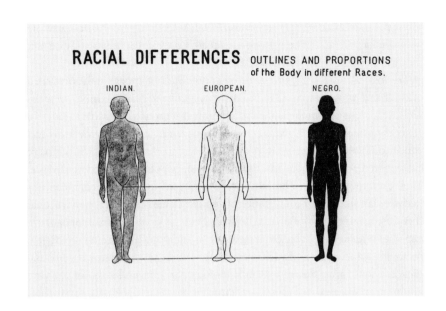

Figure 9. "Racial Differences," Room 3, Physical Anthropology Exhibit, Science of Man Building, Panama–California Exposition, San Diego (1915–16). © San Diego Museum of Man, photographs by Malcolm Farmer.

improve the status of his anthropological department in relation to those at other institutions. In 1916, he proposed mounting a comparative exhibit concerning the races of mankind, which would consist of skulls, skeletal materials, photographs, facial masks, and plaster figures.[53] In so doing, Laufer envisioned installing a physical anthropology exhibit not only like that at the new San Diego Museum of Man, where Hrdlička's display resided after the close of the Panama–California Exposition, but one that would conform to the study collections displayed at the American Museum of Natural History, the British Museum, and the Wistar Institute. Such displays were oriented to university students and researchers, but Laufer believed that his proposed exhibits would provide "valuable instruction and enjoyment" to the general public. The Field Museum's board of trustees rejected Laufer's request for funding, unmoved by his argument that "as a scientific institution, it is our duty to maintain such an exhibit."[54] Instead, they suggested that the department of anthropology continue collecting ethnological and archeological materials, and they requested that all work in physical anthropology be suspended until after the museum moved into its new building.[55] Six months after the Field Museum reopened at its new location in 1921, Laufer submitted

a new proposal based largely on his 1916 plan, and shortly thereafter he wrote to Hrdlička stating that he intended to create a physical anthropology exhibit following his method of display.[56]

The taxonomic display proposed by Laufer did not appeal to the president of the Field Museum, Stanley Field, who preferred other exhibition techniques, such as dioramas and ethnographic life groups, that would cater to general audiences. Their divergent views concerning exhibition methods and educational policies generated conflicts at the museum. These tensions were exacerbated by the lack of consensus among anthropologists concerning race. Their competing ideas of human variation ranged from nineteenth-century Lamarckian notions of inheritance of acquired characteristics, to hormonal theories of biological difference, to overtly racist explanations amenable to eugenics and German race hygiene ideas, to anthropogeographic theories of race, which focused on historical migrations and the environment. How the Field Museum administrators, anthropology curators, and sculptor Malvina Hoffman accommodated these conflicting perspectives during the production of the figures is a primary focus of the first part of this book.

Chapter 1 examines this debate over exhibition techniques and educational goals more fully. It shows how Berthold Laufer and Henry Field consulted prominent American and European anthropologists, anatomists, and ethnographers and considered an array of racial theories for the exhibit. Chapter 2 offers an account of Malvina Hoffman as a sculptor, but one that is limited to how she acquired a set of artistic and social strategies that provided her with the skills to wield influence in the production of the Races of Mankind sculptures and at later moments in the lives of the replicas. This chapter demonstrates how Hoffman successfully navigated the social worlds of wealthy patrons and the National Sculpture Society to gain prestige within the conservative cultural arena of American sculpture. It offers a discussion of the sculptor's rhetoric of character in relation to the genre of portraiture.

Chapter 3 examines how various individuals and modes of representation discussed in the preceding chapters converged during the production of the sculptures. The Field Museum's administrators, curators, advisors, and the sculptor and her studio workers negotiated aesthetic ideas and notions of authenticity and accuracy during the production process. Hoffman and her studio assistants adopted a mixture of sculptural techniques that included clay modeling, direct casting, photographic images, and measurements, which crossed conceptual boundaries between "artistic" and "mechanical" forms of representation. While Hoffman did not adhere to a single sculptural method to create the sculptures, she was determined to change the nature of the com-

mission; the sculptor mounted a series of experimental demonstrations that successfully convinced the Field Museum officials to accept the use of fine art conventions and to complete the figures in bronze and stone.

Chapter 4 analyzes how the Races of Mankind figures were exhibited at the Field Museum in 1933. Malvina Hoffman and a new set of collaborators adopted exhibition strategies, emerging in the 1930s, that reconceptualized museum displays in terms of a perceiving subject. The resulting exhibit hall encouraged multiple and ambiguous interpretations of the sculptures, and the guidebook to the display offered three competing explanations of race. Henry Field added the "special scientific" exhibit room to the exhibit hall in 1934 to limit this interpretive ambiguity. He intended the installation of charts, maps, photographs, skulls, and skeletons to anchor the sculptures to a biological explanation of race.

Chapter 5 considers how two exhibitions of small-scale replicas of the Races of Mankind sculptures, the *Les races humaines* exhibition at the Musée d'Ethnographie du Trocadéro in Paris and the *Races of Man* show at the Grand Central Galleries in New York, extended the lives of these figures. *Les races humaines* situated the sculptures within a form of anthropological knowledge closely linked to the Parisian artistic avant-garde, which challenged Western values and cultural hierarchies. The critical response to the exhibition helped these sculptures achieve the status of commodities and ensured the success of the Grand Central Galleries exhibition.

Chapter 6 shows how small-scale Races of Mankind statuettes were deployed at the beginning of World War II to promote a Brotherhood of Man discourse of race. It also considers a C. S. Hammond world map that featured photographic reproductions of the sculptures, the *Map of Mankind,* in relation to other visual representations that attempted to redefine American notions of race, specifically Ad Reinhardt's cartoons in the *Races of Mankind* pamphlet written by the cultural anthropologists Ruth Benedict and Gene Weltfish. The final section of this chapter examines how after the war, photographic images of the sculptures served as illustrations of race in standard educational materials, such as the *World Book Encyclopedia.*

The conclusion examines how criticism of typological approaches to human diversity and the emergence of a new politics of identity—aligned with Black Power movements in Chicago during the late 1960s and early 1970s—led the Field Museum to dismantle the exhibit hall and withdraw photographic reproductions of the sculptures from educational materials. This chapter investigates the politics involved in redeploying some of the sculptures to public display at the Field Museum and also at Malcolm X College, where

the sculptures functioned in an Afrocentric discourse. I examine other forms of engagement with the sculptures, specifically Fred Wilson's *OpEd* (1994) installation at the Museum of Contemporary Art in Chicago, in which the sculptures were brought into a new set of relations among cultural institutions, discourses of multiculturalism, and the racial politics of space in Chicago.

A final word about the titles of the sculptures: throughout this book, I use the titles of individual Races of Mankind sculptures that appeared in the 1934 guidebook to the exhibit hall at the Field Museum. While many of these titles are value-laden and offensive, my rationale for maintaining them is for clarity; many of the sculptures were renamed at various points in their career.

1. INITIAL PLANS FOR A PHYSICAL ANTHROPOLOGY DISPLAY

IN 1927, DAVID C. DAVIES, the director of the Field Museum, gave his approval to develop two new displays: the Hall of Prehistoric Man, which would reconstruct the morphology and culture of prehistoric humanity in Europe, and the Hall of Physical Anthropology, which would represent the "living races."[1] The chief anthropology curator, Berthold Laufer, wanted to tell the complete story of man in the manner of Aleš Hrdlička's physical anthropology display.[2] However, the anthropology curators and administrators at the museum had very different expectations of how to represent race in the physical anthropology exhibit. During the initial planning stages, Stanley Field, the president of the museum, pressed for a display that would attract and entertain general audiences.[3] Art was necessary, he argued, "to put life into it and to avoid old fashioned dry as dust scientific treatments of exhibits."[4] He reasoned that a physical anthropology exhibit installed on "purely scientific lines" would be a "failure so far as the interest to the public is concerned."[5] His views coincided with the perception of many American museum curators: osteological displays arranged in a taxonomic format are exhibits that least interest the general public, who lack the knowledge to appreciate them.[6]

The exhibition techniques that Stanley Field fostered as president of the museum were no doubt informed by his prior activities as vice president of Marshall Field and Company in Chicago.[7] At Marshall Field's State Street department store, the window dresser Arthur Fraser had achieved wide acclaim for developing artistically fashioned window displays in which papier-mâché mannequins were arranged in "animated attitudes" according to a central theme.[8] Stanley Field's demands for aesthetically informed displays were intended to fulfill the museum's educational policies, which increasingly be-

came oriented to the general public, especially schoolchildren. The museum's N. W. Harris Public School Extension program, established in 1911, circulated thousands of portable dioramas or musettes in Chicago schools. The extension director, Stephen Simms, believed that the program would enliven classroom studies and entice students to visit the museum. In an essay concerning the extension program, Simms was quoted as saying, "The whole emphasis in this collection is placed on giving a *complete* picture of the object shown, in place of the helter-skelter aggregation of facts which is so common in work of this sort. The exhibit on a local bird, for instance, will show its nest and eggs, its habits, its young, and a specimen of both sexes; and in the accompanying label attention will be called to each point and all necessary explanations will be clearly given."[9] The Field Museum's extension program used the habitat format widely in these traveling musettes, and many other natural history museums exhibited habitat groups to present dramatic, entertaining stories.[10] This effect required a high level of verisimilitude, which prompted museum preparators to develop new techniques to eliminate defects that called attention to the dioramas' artificiality.

Carl Akeley's early work at the Field Museum exemplifies what the administrators and curators considered to be a modern approach to museum display; the taxidermist's lifelike dioramas represented nature with scientific accuracy as well as "feeling and expression."[11] The *Summer* diorama (figure 1.1) from Akeley's *Four Seasons* group (1902) at the Field Museum represents much more than a physical description of white-tailed deer. It constructs a story of how these animals formed a typical family living in the Virginia woodlands. To engage the viewer's emotions and to characterize the mental traits of the animal, Akeley presented the figures in a dramatic moment; the family of deer is shown as if an unseen threatening presence has interrupted their grazing. The adult stag's direct gaze suggests that the viewers' presence is the cause of his alarm. Ears erect and muscles taut, the stag appears ready to charge or take flight at any moment. The adolescent stag's pose mimics the adult male's alert posture. The doe and spotted fawn in the background, however, do not share the appearance of impending movement; they are shown with relaxed muscles, as if they are not yet aware of the threat.

Reading detail by detail, figure by figure, the beholder becomes involved in a cumulative form of decipherment that imbues the deer with an emotional and mental life. In this interpretative process, viewers are offered different forms of identification to learn the lesson of survival. Such affective modes of decipherment are no doubt linked to other interpretative practices operating at the turn of the century. In his analysis of literary narratives concerning

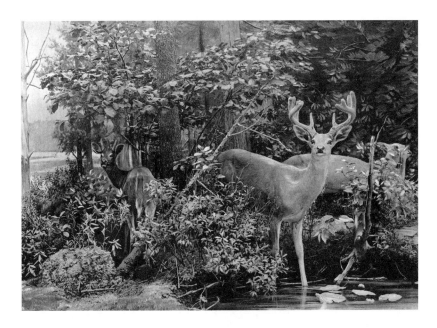

Figure 1.1. Carl Akeley, *Summer,* from the "Four Seasons" dioramas, Field Museum (1902). © The Field Museum, CSZ6210.

viewing art at the World's Columbian Exposition (1893), Michael Leja argues that many writers treated genre paintings and sculptures as "sentimental psychological dramas" that involved viewers in a process of assigning different emotional and psychological states to the depicted characters.[12] Leja suggests that melodramatic works, such as those by Thomas Hovenden and Johannes Gelert, served as "vehicles of sentimental education" that taught viewers how to negotiate the "psychological and emotional conflicts of modern life."[13] Like popular sentimental artworks, Akeley's habitat group encourages viewers to associate a set of fixed emotional traits with deer and to identify with the nuclear-family social structure, which many believed served as the foundation of American society. Such a lesson would be an effective means for socializing Chicago's large immigrant population, many of whom were unable to read and write in English. In this manner, habitat groups like Akeley's *Summer* diorama functioned as nonverbal, informal devices for acquiring a set of psychological and emotional structures deemed necessary for assimilation.

Ethnographic lay-figure groups exhibited in anthropology halls had much in common with habitat groups. William Henry Holmes, the originator of the family life group method of display, believed that they, too, ought "to tell a

story, to tell it at once, and in the most attractive manner."[14] Holmes presented lay figures as a typical family engaged in ordinary occupations to construct a fixed set of physical, mental, and emotional traits to characterize a culture.[15] He thought figures modeled from clay, made by skillful artists, had a much more vivid appearance than those produced through a direct casting process, because the latter "misrepresent the native countenance and disposition."[16] In his famous *Smith Sound Eskimo* diorama (figure 1.2) installed at the U.S. National Museum, Holmes intended to represent people living in Greenland as "exceptionally cheerful in disposition" despite their "struggle for existence."[17] Through reading familiar signs associated with humor, viewers encountered a socializing experience for adapting to a harsh environment; the family unity lesson of Akeley's diorama was reprised by Holmes's ethnographic life group.

Henry Field, assigned by Berthold Laufer to develop the physical anthropology exhibits, applied the life group format to the Hall of Prehistoric Man. Following the advice of the British anatomists Arthur Keith and Grafton Elliot

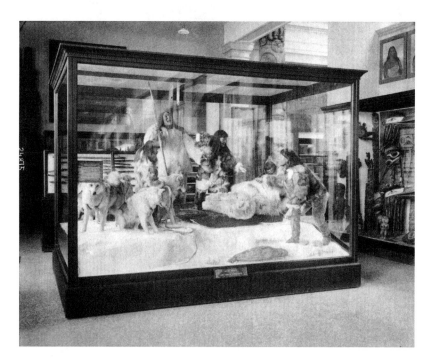

Figure 1.2. William Henry Holmes, *Smith Sound Eskimo,* U.S. National Museum, Smithsonian Institution. Smithsonian Institution Archives, image # 2002–10659 *Arctic Region Life Group.*

Smith and the French prehistorian Abbé Henri Breuil, Field had Frederick Blaschke, the modeler of the reconstructions, arrange these life-size figures in eight dioramas with murals painted by Charles Corwin (figure 1.3). Blaschke's reconstructions went far beyond Louis Mascré's busts (figure 6) in narrating the evolution of prehistoric man. Field used dramatic themes in the dioramas, such as a moonlit scene of Chellean hunters, a Neanderthal family, an Aurignacian artist kneeling before a cave painting, a Solutrean sculptor carving a horse, an Azilian boar hunt, a Neolithic priest worshiping the sun at Carnac, and a morning scene of fishermen on the shores of Lake Neuchâtel, Switzerland.[18] Flat cases filled with bones, casts, and archeological materials stood opposite these dioramas.[19] Field's dual exhibition method satisfied the museum administration's desire for entertaining exhibits while also providing rare specimens arranged in a systematic series for scientific study.

At the time, Henry Field was a novice in the field of physical anthropology. Hired in 1926 after completing his coursework at Oxford University, Field was the grandnephew of the museum's founder, Marshall Field I, and cousin to Marshall Field III and Stanley Field.[20] He had the family connections, the social rank, and the prestige of an Oxford education that should have conferred considerable stature at the Field Museum, but as Gabrielle Lyon has recently shown, this was not so.[21] In many ways, Henry Field failed to live up

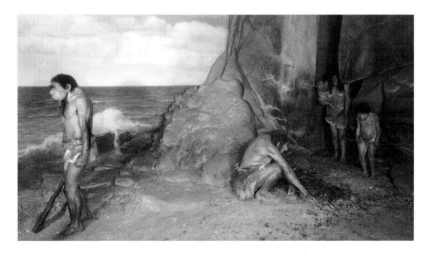

Figure 1.3. Frederick Blaschke, *Neanderthal Family at Devil's Tower Rock-Shelter, Gibraltar,* Hall of the Stone Age of the Old World, Field Museum (1932). © The Field Museum, CSA76895_Ac.

to the expectations of museum officials and members of his family. Stanley Field wanted his cousin to make substantial professional contributions and gave the novice opportunities to meet his high expectations. Berthold Laufer served as Field's mentor and took steps to establish his career. Laufer went so far as to suggest the topic of Field's doctoral thesis, the anthropology of Kish, to Franz Boas on his behalf.[22] However, Henry Field's anthropological training at Oxford did not introduce him to the methods employed by prominent American physical anthropologists.[23]

The chief anthropology curator, Berthold Laufer, likewise did not possess expertise in physical anthropology. A well-respected Jewish German intellectual and cultural anthropologist who specialized in China and Tibet, Laufer studied Eastern languages at the Seminary for Oriental Languages in Berlin, received his doctorate from Leipzig University in 1897, and immigrated to the United States a year later.[24] Prior to his arrival in Chicago, he lectured at Columbia University and participated in the Jesup Expedition to Siberia, under the direction of Franz Boas, for the American Museum of Natural History.[25] Laufer considered Boas to be the most important anthropologist in the United States and regularly consulted him on professional activities. Like Boas, Laufer wrote on a broad range of topics, from the history of fingerprinting to the uses of tobacco.[26] He also agreed with Boas that race is a biological concept, one that must be dissociated from social, cultural, and linguistic ideas.[27] Although Laufer viewed anthropology as a science of human understanding, he had difficulty shedding notions of progress and cultural epochs and did not question the idea of a fixed taxonomy of races.

When Henry Field turned his attention to developing ideas for the Hall of Physical Anthropology during the summer of 1929, Laufer did not provide him with a clear plan, so he traveled to the East Coast to study physical anthropology exhibits and to survey exhibition techniques employed at various museums. Field wrote to Dudley Buxton at Oxford, Alfred Haddon at Cambridge, and Arthur Keith at the Royal College of Surgeons, requesting their advice.[28] In December, he met with Franz Boas, Aleš Hrdlička, and Earnest Hooton to develop ideas for the proposed hall. These American and British anthropologists held differing positions that ranged from deep skepticism to a firm conviction toward the notion of race. Some of them used a statistical approach, others employed a method involving morphological assessment, while another group combined both methods. They also offered varying explanations for the causes of racial differentiation.[29] Because of their varying views on race, these anthropologists suggested different approaches to the exhibit.

Franz Boas, for example, recommended that Field consider the following issues for the exhibit:

Types and distribution
Method of describing types
Variability of racial strains and overlapping of types
Heredity—families, twins
Environment—trans[?] types, etc.
Functioning of various racial forms and its variability.[30]

This list, which Boas and Field probably discussed in greater detail during their meeting in December 1929, outlined Boas's major theoretical concerns. Although types and distribution appear first, Boas emphasized variability within a population and overlapping between groups in his studies of race.[31] Rather than constructing artificial types, Boas viewed race in terms of local populations made up of family and fraternal lines. For Boas, any study of racial inheritance should begin with an investigation of families: "It is much more feasible to obtain an impression of the general character of a population by examining a single family . . . and a few families would give us a good picture of the whole group."[32]

In his essay "Change in Bodily Form of Descendants of Immigrants" (1910), Boas argued that in a new environment, morphological differences between children and parents were observable after a short period of time. His statistical study showed that the head form, which most anthropologists accepted as stable, modified under new social and environmental conditions.[33] These results questioned the authority of the cephalic index as the key determiner for constructing racial types. In *Anthropology and Modern Life* (1928), Boas further undermined the notion of fixed types. He pointed out that anatomists and anthropologists began their studies from very different theoretical viewpoints. Anatomists, he claimed, concerned themselves with typical forms and disregarded particularities.[34] The assumed equivalence of type and average also troubled Boas, who had shown that variations within a statistical distribution could describe several different types.[35] On a more general level, he argued that subjective impressions from everyday experience informed notions of type.[36] For Boas, no single individual could stand in for an entire racial group: "Characteristic traits are found rarely combined in one and the same individual, although their frequency in the mass of the population induces us to imagine a typical individual in which all these traits appear combined."[37] By listing topics such as variability, heredity, and environmental conditions, Boas advised Field to think in terms of processes,

instead of constructing a fixed taxonomy of races.[38] Although Field sent him a diagram of the proposed exhibition space, Boas did not offer suggestions for how these processes could be presented in a museum display.

In contrast to Boas's theoretical recommendations, Aleš Hrdlička gave Henry Field practical advice. He approached the proposed exhibit from a taxonomic framework and outlined a four-race classification of White, Yellow-Brown, Australian, and African.[39] He proposed illustrating these races through a representative series of facial casts divided by sex, with six male and six female masks in each group. Hrdlička also suggested supplementing the facial casts with two freestanding trees supporting photographic transparencies and mounting large "wall pictures" designed by an artist.[40] Essentially, Hrdlička proposed mounting a display along the lines of his earlier physical anthropology exhibit, but much smaller in scope. A year later, Berthold Laufer sent Henry Field to San Diego to study Hrdlička's exhibit, to buy replicas of the facial casts, and to obtain copies of Hrdlička's various charts, which were later exhibited in the "special scientific" section of the Hall of the Races of Mankind.[41]

Berthold Laufer and Henry Field did not consult Boas or Hrdlička beyond the initial planning stages of the project.[42] Instead, Field looked to British anthropologists for guidance. He consulted with Dudley Buxton, his tutor at Oxford, and Arthur Keith, his advisor to the Field Museum's Hall of Prehistoric Man. Because of their professional positions and institutional affiliations, most American anthropologists respected Buxton and Keith and considered them established authorities on race.[43] However, the two held different views on the subject. Buxton employed a statistical method in his studies concerning environmental effects on race.[44] With Arthur Thomson, he developed a nasal index and argued that the shape of the nose had a high correlation with climatic conditions.[45] Coming from an anatomical background, Arthur Keith was less inclined to use statistical methods; indeed, he held that the eye was a better instrument for determining race. For example, in a 1935 review of a biometric study, Keith minimized the importance of anthropometric indices: "Dr. Kappers holds that the cephalic index—the relative width of the head—is a more reliable guide to race than are outward appearances. After a lifetime spent in the study of cranial characters and racial traits, I have come to an opposite conclusion—namely, that external traits are better guides to race and to degrees of racial affinity than are the relative diameters of the skull."[46]

Like Boas, Keith put little faith in the cephalic index, and in anthropometry in general, but for very different reasons. For Keith, diagnosing race from external traits was an unconscious ability:

Now if we are to build up a scientific system of knowledge concerning races—a system to which every worker can add his quota, then exact instrumental measurements must be made. But we should never forget that every man and woman born into this world is an anthropologist by nature—a student of the breeds of mankind. We need no technical aid to help us to identify negro, Chinaman, European, Bushman, etc., as they pass us in the street; a cast of the eye is sufficient to weigh a hundred and one diagnostic features. Explorers and travellers become wonderfully expert at identifying at sight members of tribes . . . We can never hope to make our technical methods yield us so delicate and so reliable results in racial identification as are reached by travellers dependent merely on their senses and judgment.[47]

This ability, the anatomist believed, served as an evolutionary mechanism because it helped to create a psychological barrier, or race antipathy, between groups and thus promoted segregation. Eugenicists like Charles Davenport and George Pitt-Rivers found Keith's ideas congenial to their own proposals for race betterment.[48] Berthold Laufer seemed unaware of Keith's views on evolution, even though they circulated widely in American and British newspapers. For instance, in a December 1931 letter to Franz Boas, Laufer recommended Keith as a potential speaker for a scientific congress to be held during the 1933 Century of Progress Exposition in Chicago.[49] Apparently Laufer did not know that, six months earlier, Boas had condemned Keith for his theory of a racial spirit and that national papers like the *New York Times* carried stories on Boas's criticism of Keith for several days.[50]

Although he was a well-known popularizer of race in print, Keith initially hesitated to give Henry Field advice on how to present the concept in a museum display. He cautioned Field that he had little exhibitionary experience beyond mounting research displays in the Hunterian Museum in London.[51] Nevertheless, Keith outlined a plan consisting of comparative exhibits, several of which followed displays at the Hunterian Museum concerning human evolution and growth. Keith suggested "representing all leading living racial types and their habitats"; mounting an "evolution series" composed of skeletons, skulls, hands, and feet; presenting a comparative display on age changes in "gorillas, chimpanzees and humans"; explaining "differences in simian and human"; illustrating "racial differences in skull and wax models of noses, chins, foreheads, cheeks, heels, thumbs and nails"; presenting methods of anthropology; and mounting a series on "dwarfs and giants to explain endocrine action."[52]

This latter series related specifically to Keith's endocrine theory of race formation, which worked in tandem with race antipathy. The anatomist

theorized that growth-regulating systems actively produced three primary races or stocks. For example, Keith claimed that the pituitary glands in the Caucasoid races functioned more actively than in other races, Negroid races held a more dominant adrenal gland, and Mongoloid races possessed a more active thyroid.[53] These various glands produce secretions (hormones) that Keith believed would determine the appearance of external characteristics like skin color and hair texture, as well as physical stature. Henry Field, who had previously conducted a study on hyperpituitarism[54] under Keith's guidance, purchased cast replicas of a comparative exhibit on abnormal growth from the Hunterian Museum for the special-exhibit area of the exhibit hall.[55]

Henry Field wanted especially to enlist Dudley Buxton, who had introduced him to anthropometric methods, as chief consultant for the project. Unlike Boas and Keith, who emphasized processes, Buxton saw the exhibit as visualizing a taxonomy of races. And unlike Hrdlička, Buxton suggested two ways for illustrating racial types when "direct casting is not possible."[56] In the first method, a museum modeler used measurements and photographs of one individual, while in the second, the preparator made a figure based on average measurements of a group and on photographs of one subject from a photographic series. In both scenarios, Buxton preferred using a photograph of a particular person because it "got at individuality"; however, he worried about the level of subjectivity of the modeler and warned Field to "make sure that the artist does not put too much of himself in it."[57]

Buxton advised Field to use Alfred Haddon's racial classification from *The Races of Man and Their Distribution* (1925) to develop an exhibit that avoided "technical terminology" as well as "controversial points."[58] Haddon employed a method that correlated phenotypical features, specifically the hair, skin, and nose, with geographical climates to build a history of race migrations.[59] However, he conceded that any such theory or racial classification was an artificial construct.[60] Thus Haddon held contradictory positions on race; as Elazar Barkan recently observed, Haddon questioned the epistemological basis of the concept while continuing to uphold racial hierarchies.[61]

Haddon's "anthropogeographic" approach to race differed from purely morphological or zoological classifications.[62] He believed that the geographic distribution of hair form, skin color, and nose shape fell along a north–south divide across the Eastern Hemisphere: "We find narrow-nosed, fair-skinned people with wavy hair north of the [Himalayan] mountain barrier, and those with very broad noses, dark skins, and woolly hair well to the south, while in intermediate areas are found intermediate physical characters."[63] From this spatial distribution, Haddon developed a theory of race formation according to

a hierarchy based on the Lamarckian law of Transformism, in which complex forms develop out of simpler ones.[64] This law served Haddon as a way to link a spatial distribution to a temporal framework and thus classify and evaluate different groups in terms of either progressive specialization or stagnation.

In *The Races of Man and Their Distribution,* Haddon spoke of a "Neanthropic Man," a common unspecialized stock, which he believed originated in western Asia. From this ancestral stock, he claimed, various groups migrated in a succession of waves into new habitats and climates. Haddon argued that groups migrating to southern equatorial regions, whose habitats offered limited conditions for evolutionary change, "retained their primitive characteristics." In contrast, groups living in northern temperate or arid zones, which provided favorable climates for specialization, continued to evolve. This process of race formation occurred in the distant past, and both groups, through sexual selection and isolation, had allegedly achieved a degree of stability. However, Haddon also asserted that "certain races are more static than others, and this may perhaps be granted for what are termed the lower races," and he cited Arthur Keith to suggest that the processes of adaptation and evolution were still at work.[65]

Henry Field's 1930 plan for the Hall of Physical Anthropology (figure 1.4), which he had worked out with Buxton and Haddon, reflected the latter's

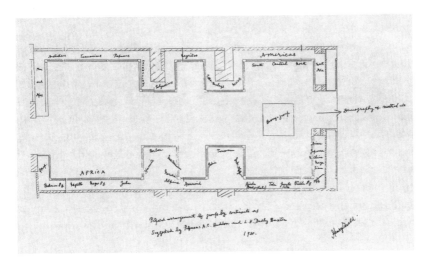

Figure 1.4. Henry Field, Plan for the Hall of the Races of Mankind approved by Dudley Buxton and A. C. Haddon (1930). Department of Anthropology, Field Museum.

Initial Plans for a Physical Anthropology Display 31

theory of different levels of specialization and roughly followed his north–south divide: the west section of the display would exhibit types inhabiting areas south of the Himalayas, while the east section would contain racial types north of the mountain range.[66] The sequence of figures in the exhibit hall began with a racial map and a comparative display, Man and Apes, at the entrance. Starting at the right side of the hall, the cases concerning African types would contain: Bushman male and female, Negrillo, Negro male and female, Zulu, Hamite, and Berber. This racial order began with what these anthropologists assumed were the earliest and most primitive inhabitants of Africa, the Bushman, and ended with the Hamite and Berber figures, both of which Haddon considered Euroafricans. These figures would then lead into the European section with Mediterranean, Nordic, and Alpine types. Next to the Alpine the marginal white groups of Armenoid, Bedouin, and Turcoman would lead to west Asian racial types composed of Indo-Afghan, Hindu, Toda, Jungle Tribe, Veddah, and Andaman groups, assumed to be the oldest inhabitants of Southeast Asia. Thus the figures would move away from those closest to European types toward groups that Haddon considered older and more stagnant. The Southeast and North Asian types of Siam, Naga, North China, and Japanese would also lead to another ancient though unrelated group, the Ainu.

On the opposite side of the hall, North Asian types would continue and progress to North, Central, and South American races. The Nesiots or Indonesians would then follow and lead to other Oceania groups, the Proto-Malays, Negritos, Polynesians, Melanesians, and Papuans. The exhibit would end with Tasmanians, a recently extinct race, and the Australians, whom Haddon as well as many other anthropologists believed were the most primitive group still alive. Their placement of the Australian types next to the Man and Ape osteological display suggested that Australians were more closely related to apes than were the other groups.[67] Their spatial plan also arranged the various types into three morphological divisions that roughly matched the proposed primary stocks of black, white, and yellow races. They placed Africans across from the Oceanic, Papuan, and Melanesian groups in the west section of the hall; European types and Polynesians, considered a mixed group, occupied the middle or intermediate zone; and the various Asian groups were arranged across from American types in the east end of the hall.

Berthold Laufer and Henry Field's lack of expertise in the field of physical anthropology significantly affected how they approached exhibiting the racial types that Field, Buxton, and Haddon had chosen. To reconcile Stanley Field's preference for lifelike habitat groups and dioramas with the taxonomic

method used by physical anthropologists, the curators obtained the cooperation and advice of many prominent anthropologists. Experts in America, Great Britain, China, France, Germany, and India offered their assistance and gave approval to individual figures and busts, and this network of alliances helped to build consensus for the display, as we will see in chapter 3.

2. MALVINA HOFFMAN
AS PROFESSIONAL ARTIST

WHEN MALVINA HOFFMAN ENTERED an agreement with the Field Museum on February 18, 1930, to produce the various facial masks, busts, and full-length figures for the physical anthropology display, she had large financial obligations. At age forty-five, the sculptor maintained two residences: a studio at 157 East Thirty-fifth Street, New York, and "Villa Asti" in the fifteenth arrondissement of Paris. Hoffman was married to British musician Samuel B. Grimson, who had been injured during World War I. Unable to continue his career as a concert violinist, Grimson worked sporadically restoring old musical instruments.[1] During their twelve-year marriage, Hoffman assumed the position of primary wage earner through her sculptural commissions (figure 2.1). Although Hoffman did not belong to the same economic stratum as the Field family, she possessed enormous cultural capital through her status as a professional sculptor and as a New York socialite. Indifferent to the intellectual credentials of the curators or the administrators' social status, Hoffman promoted her views with confidence. From her studio assistants to the president of the Field Museum, many commented upon her ability to establish a rapport with people of influence. Stanley Field was so impressed with the sculptor's skills in persuasion that he once remarked, "Miss Hoffman does get away with it."[2]

Hoffman's relationship with a primary consultant to the project, Sir Arthur Keith, illustrates how the sculptor won the support of influential people. Hoffman knew that she needed to gain Keith's confidence for the Field Museum officials to accept her work. To demonstrate her artistic abilities, she asked the aging anthropologist if she could model a portrait of him. Keith agreed and

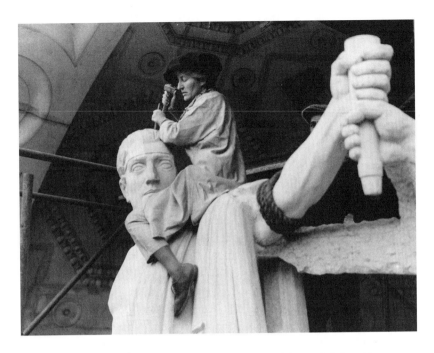

Figure 2.1. Malvina Hoffman astride the *Friendship of the English Speaking Peoples* sculptural group, carving the figure *England,* Bush House, London. Malvina Hoffman papers, Research Library, The Getty Research Institute, Los Angeles (850042). © Pacific and Atlantic Photos, Ltd./Corbis.

posed for the artist on three separate occasions. During these "séances," they formed a lasting friendship; Hoffman, Keith later recalled, "nearly swept me off my feet."[3] The portrait flattered Keith; it would later represent the *Nordic Type, Great Britain* (figure 3.5) in the Hall of the Races of Mankind, and the sculptor sent him a plaster replica of the bust to cement their friendship. She often gave gifts to gain favor, to fulfill obligations, or to smooth over difficulties. Hoffman's friendship with one of the most influential European race theorists helped her during critical moments of the commission. On more than one occasion, she successfully rebuffed criticism simply by mentioning Keith's support. How Malvina Hoffman acquired such skills, which enabled her to advance her interests during the Field Museum commission and to extend the life of the Races of Mankind sculptures for years afterward, is the subject of this chapter.

Malvina Hoffman acquired the social accoutrements necessary to enter the upper echelons of New York society early in her life. She attended the Chapin School for Girls for several years; then, at the age of thirteen, Hoffman enrolled in the Brearley School, one of the most respected finishing schools.[4] The sculptor's father, Richard Hoffman, was a well-known music teacher and concert pianist, and her mother, Fidelia M. Lamson, belonged to a well-established New York family. While not wealthy, her parents possessed great cultural and social resources. Hoffman grew up with intellectuals, musicians, and socialites frequently visiting her family home. As Joshua Taylor remarked, the Hoffmans were a "proper, well-connected, upper middle-class family—always with servants but worried about the rent—much given to the arts, particularly to music."[5] As a concert pianist and in his activities as a professional musician, Richard Hoffman shaped his daughter's attitude toward art and artists. In his essay "How to Stimulate Thought and Imagination in a Pupil," he urged young artists to appreciate the great masters' powers of interpretation, which lifted them above musicians possessing mere technical facility.[6]

Through her family connections, Hoffman established a broad social network to further her artistic studies. She was introduced to the sculptor Gutzon Borglum through a friend of her mother.[7] Borglum helped the novice with her first portrait and later gave Hoffman a letter of introduction to Auguste Rodin.[8] Mrs. Van Nest, the artist's godmother, bequeathed a small sum to Hoffman that enabled her to travel to Europe, accompanied by her mother, and to study art in Paris.[9] With this legacy and money Hoffman had earned from designing sheet-music covers, they lived in Europe from 1910 through 1911.[10] During this period, Hoffman befriended an array of artists, socialites, and literary figures, and she renewed relations with well-connected relatives. She was also exposed to different aesthetic theories, spiritualist notions, and feminist ideas that challenged her to think about her artistic values and how to achieve professional success.

In 1910, Hoffman saw an exhibition of Matisse's paintings and wrote in her daybook that she could not cope with his "violent chaos and ill-shaped nudes."[11] Upon viewing *The Green Line,* a portrait of Madame Matisse, Hoffman was horrified by the artist's disregard for resemblance, a fundamental precept for her rhetoric of character. His "cruel daubs of color and black inky lines," Hoffman wrote, "shocked beyond control." Her encounter with fauvism cemented her earlier appraisal of modernist work that she had seen at the Colonna Gallery in Rome and that also provoked a feeling of disgust.

Hoffman instead gravitated toward what she called the "old Greek boys" and the French sculptors Houdon, Rude, and Carpeaux, whose work she sketched at the Louvre.[12] She received her earliest commission from Mrs. Roger Bacon, wife of the American ambassador to France, to produce marble copies of Houdon's portraits of John Paul Jones, the Marquis de Lafayette, George Washington, and Benjamin Franklin displayed at the American Embassy in Paris.[13] Hoffman greatly admired the portraits of Houdon, and in her daybook she wrote, "If I cannot do busts as well as Houdon why do them at all?"[14]

Hoffman began working as a studio assistant for the sculptor Janet Scudder, whom she had met earlier at Mabel Dodge's home in Italy. She struck up a friendship with the American painter Ida Proper, who, like Scudder, helped Hoffman pursue her artistic training. Proper took her to the American Girls' Club, a philanthropic organization established in 1890 to assist women during their artistic studies in Paris.[15] Located in the chateau at 4 rue de Cherveuse, the organization provided moral guidance to the young women and discouraged them from entering the realm of "bohemianism."[16] Besides serving as an affordable residence for artists, the American Girls' Club held various social events and annual art exhibitions. Hoffman stated that she received a cold reception at the club when it was learned that she had only six months of experience drawing from plaster casts.[17] As a twenty-four-year-old, she was uncomfortable in the role of a "girl art student"; she saw herself as different from the other students, whom she considered to be unfriendly and to possess a superficial knowledge of art.[18] She enrolled at the Académie Colarossi, where she responded in a similar manner to the students, and in her daybook she stated that she could not work in such an environment.

Malvina Hoffman was much more comfortable with Ida Proper and Janet Scudder, who were recognized as artists. The latter provided Hoffman with a model of the successful woman sculptor; Scudder managed to straddle different social strata, from the New York elite to Left Bank bohemians. At her studio, Scudder held dinners, musical performances, and spiritualist séances.[19] She introduced Hoffman to a wide array of artists, writers, and musicians living around the rue Grand-Chaumière in Montparnasse, communities in which avant-garde activities prevailed. At Scudder's studio, Hoffman became acquainted with Mildred Aldrich, Eve Mudocci, Gertrude Stein, and Alice B. Toklas.[20]

Through Scudder, Hoffman also met sculptors Frederick MacMonnies, Emanuel Rosales, and Herbert Ward in 1911. Working in a naturalistic idiom, all of these artists reinforced Hoffman's orientation toward the work of Houdon and Carpeaux. She saw an exhibition of Ward's ethnographic

sculpture and believed that his "creatures of muscle and brawn" were well modeled but lacked spirit. Hoffman found Herbert Ward extremely cordial, and she followed his advice to study with his teacher Max Blandat, at his studio on rue Morney.[21] The Italian sculptor Emanuel Rosales also offered to take her as a student and claimed that her dancer figures reminded him of the work of Carpeaux. Through Rosales, Hoffman met the French sculptor Pierre-Marie Poisson, who gave her suggestions and advice. In her daybooks from this period, Hoffman expressed pleasure in these relationships and commented upon receiving a helping hand from "all the big people."[22]

Under their guidance, Hoffman negotiated her way between academic art and modernism and found instruction removed from the women's art organizations that she found alienating. In doing so, Hoffman chose a strategy of assimilation, seeking out artistic instruction from established male sculptors.[23] Such a strategy was one that Janet Scudder recommended in an essay that appeared in the New York Times. In "Janet Scudder Tells Why So Few Women Are Sculptors" (1912), the artist advised women art students to obtain apprenticeships with male sculptors like Frederick MacMonnies, whose tutelage she had never forgotten. The value of such apprenticeship, Scudder argued, was that it enabled women sculptors to take the profession seriously and to realize that sculpture was more than puttering in clay.[24] Women, she advised, also needed to avoid focusing on "dry as dust minutiae" or the current trendy fascination for originality.[25] She suggested working within tradition and saw no reason for women sculptors to forsake beauty; why not, she asked, develop old ideas? In her essay, Scudder outlined several other clichés about women sculptors; the most damaging was that by concentrating on minute particulars they did not attend to three-dimensional form. Laden with the nineteenth-century definitions of artistic imagination, Scudder argued that in order to create sculpture, women must move beyond copying trivial surface details. She recommended that women sculptors learn all aspects of the craft of sculpture and dismissed the charge that women were unable to perform the hard physical labor necessary to create sculpture. She thereby deflected the accusation leveled upon earlier women sculptors, that they relied upon studio assistants to produce their work.

Hoffman followed Scudder's advice and became a student of Auguste Rodin. She claimed that gaining access to the artist proved difficult; Hoffman presented Borglum's letter of introduction at Rodin's door, and his servants repeatedly turned her away. During her last attempt to meet the sculptor, she claimed to have a message from his patron Mrs. Simpson and was admitted.[26] Hoffman received valuable instruction from the aging artist. While in

Paris, she met with Rodin on a regular basis to receive his advice, and after her return to New York, she periodically sent photographs of her work for his review. There were secondary benefits to their relationship beyond "Hoffman as pupil, Rodin as master." Hoffman helped the sculptor to maintain his connections with American collectors, and she used this rather limited association to the fullest. On several occasions, she helped the sculptor to set up meetings with his American patrons. For example, in several letters to Rodin, she discussed appointments with the wealthy philanthropist and collector Mrs. E. H. Harriman.[27] Hoffman also asked Rodin to send her a signed price list of his work, which suggests that she wanted to act as an intermediary with his American collectors.[28] By serving as Rodin's unofficial agent, Hoffman would have strengthened her ties to wealthy collectors and elevated her status as an artist. Many American sculptors knew the value in claiming any association with Rodin, whose stature as sculptural genius was unrivaled at the time. A large portion of Hoffman's patrons shared the sculptor's devotion to genius and believed that they carried a moral and financial obligation to advance the careers of this elite group.[29] As a social reformer, Mrs. Harriman, who became Hoffman's principal supporter in New York, probably considered such gifted individuals in relation to eugenic programs that she sponsored. For eugenicists, members of "aristogenic families," like Rodin, were responsible for the advancement of white civilization.[30] Hoffman's reverence for artists like Ignacy Paderewski, Anna Pavlova, and Auguste Rodin never faltered.[31] The sculptor saw these individuals as "those who counted" and separated them from artists whom she considered "conventionalized plodders."[32] Hoffman worked extremely hard to fashion herself as one who counted and frequently wore her signature black velvet tam to attest to her status as a professional sculptor (figure 2.1).[33]

Introduced to modernism and suffragist ideas early in her career, Hoffman rejected both; she did not attempt to undermine the existing hierarchy of gender. Unlike Janet Scudder, Alice Morgan Wright, and Abastenia St. Leger Eberle, sculptors who engaged in suffragette activities, Hoffman never seemed to question existing power structures, despite benefiting from the cultural space these women helped to form. As the art historian Linda Nochlin aptly put it, "At no point, it would seem, did Hoffman ever wish to rock the boat. On the contrary, she was determined to climb aboard."[34] Hoffman's sole venture in working outside traditional structures was in December 1912, when she and Ida Proper, a member of the feminist group Heterodoxy, rented a first-floor room of an East Thirty-seventh Street brownstone to exhibit their work. One New York critic claimed that Hoffman and Proper had circum-

vented the gallery system through mounting the joint exhibition: "when you are a suffragette artist you do not depend upon the good graces of an agent or a gallery to get your wares before the public, but you strike right out for yourself."[35] However, Hoffman quickly learned that striking out on your own was not as profitable as working with prescribed steps of social advancement and by conforming to the image of a successful woman sculptor that was emerging in American art criticism.

In 1917, the influential artist and critic of sculpture Lorado Taft claimed that women sculptors had arrived in the second decade of the twentieth century: "woman's achievement in sculpture is no longer a novelty. Her artistic expression will henceforth be recognized as legitimate, sincere and valuable."[36] In his essay on women sculptors that appeared in *Good Housekeeping,* Gardner Teall claimed that the work of Janet Scudder, Anna Hyatt, Theodora Alice Kitson, and Gertrude Whitney rivaled the strongest sculpture produced by men.[37] According to Teall, a successful woman sculptor worked hard but did not neglect her children; was dedicated to serious work but did not sacrifice her social activities; was committed to her artistic vision but did not forget her philanthropic duties.[38] In his view, a successful woman sculptor fulfilled expectations of existing gender and class distinctions, while producing work that went beyond a mere hobby.

Hoffman took advantage of her membership in the social set of her wealthy patrons. The sculptor frequently entertained celebrities, socialites, and dignitaries at her New York and Paris residences. The sculptor Edward McCartan was exhausted by the different social worlds that Hoffman straddled. He explained in a letter that while he had enjoyed vacationing with her in Bar Harbor, he did not want to participate in her social activities: "you see I can never quite get rid of the idea that I belong in the studio and have to do with that side of your life more than with parties and holidays."[39] She also took part in philanthropic activities, work considered appropriate for upper-class white women like Mrs. Harriman, who formed the elite of New York society. The sculptor became involved in many charitable organizations, especially during World War I. She was active in the American Red Cross, the American Yugoslav Relief Society, and the Appui aux Artistes. In July 1919, for example, Hoffman went to the Balkans to investigate the distribution of food and medical supplies and reported her findings to Herbert Hoover, then secretary to the American Relief Administration, as well as to the American Red Cross and the U.S. State Department.[40] Before her war activities, Hoffman established the "Trouble Bureau," an informal organization that provided monetary assistance to artists. With her patrons Mrs. E. H. Harriman and

Mrs. Otto Kahn, she founded the Music League of America to arrange concert engagements for musicians. Through her various charitable activities, Hoffman acquired a reputation as a woman who had great sympathy for the less fortunate. The sculptor's humanitarian acts also helped Hoffman early in her career, for through them, she cemented relationships with influential collectors and established contacts for obtaining sculptural commissions.

Hoffman belonged to the National Sculpture Society, an organization that largely controlled access to commissions in New York and the means for professional advancement.[41] The society did not actively encourage its female members to participate in architectural sculpture or public monument commissions, both lucrative areas set aside for a small group of male sculptors. Instead, the organization sponsored exhibitions of garden sculpture and small-scale statuettes, sculpture associated with domestic sites of display, as promotional venues for female members.[42] Statuettes, in particular, were popular accessories for domestic interiors, as aesthetic and decorative objects that straddled the boundary between art and luxury goods. Held during the first two decades of the century, these exhibitions helped to legitimize sculpture as an activity suitable for upper-middle-class and wealthy women.

The society also established associate memberships for influential non-sculptors like architects, businessmen, critics, and lawyers.[43] These lay members were instrumental in establishing social and business connections to advance an individual's career.[44] The organization's different membership categories gave sculptors a recognizable position within the profession while encouraging them to form alliances. Hoffman was initially disillusioned; after attending her first meeting at the society in 1913, she wrote in her daybook that the members were too focused on securing jobs and becoming famous, which she found was in sharp contrast to the bohemia of Paris.[45] Despite her first impressions, she eventually became a full member of the society. As a member of this organization, Hoffman stood at the highest level within a hierarchical system. Full membership status served as a boundary that separated professional sculptors from their assistant modelers, carvers, plaster casters, and other studio workers.[46]

Once she had established her New York and Paris studios, Hoffman relied upon the strict division of labor governing the production of sculpture, a medium requiring the skills of many individuals. Like many prominent male sculptors, Hoffman employed assistant modelers, carvers, enlargers, and plaster casters at her studios. This arrangement emphasized the conceptual division between invention and translation; Hoffman conceived the initial clay model while her assistants merely executed it into final form. George

Gurney and Michele Bogart have demonstrated how a sculptor's authority rested upon maintaining this conceptual distinction.[47] Assistant sculptors working in the studio for artistic instruction usually labored within a gray area between work deemed imaginative and work deemed mechanical. Their involvement in the production of the artist's model could range from constructing a wooden armature, to building up a figure in clay, to completing the model in its entirety. As long as an artwork was produced under the supervision of a recognized sculptor, it fell under the authorship of the artist.

Many assistant modelers relied upon the goodwill and influence of their employers for nominations in competitions or for consideration in sculptural commissions.[48] The case of Hoffman's assistant sculptor Louis Slobodkin illustrates how much success depended upon such social connections. While working at her studio, Hoffman encouraged Slobodkin to apply for a Guggenheim fellowship, since she knew the Guggenheim family and "could go over the heads of Arthur Lee and the other small fry that have to do with the awards."[49] Nothing came of the proposition, but in 1935 Slobodkin obtained his first sculptural commission after Hoffman declined an invitation to compete for work at the Post Office Building in Washington and recommended him to the advisory committee.[50] Slobodkin understood the social dynamics involved in receiving architectural sculpture commissions, and in his later textbook, *Sculpture: Principles and Practice* (1949), he cautioned students that sculptors were usually chosen for such work "because in some distant way they were related to the architect, or because some Art Authority pulled some political strings."[51] To become an "art sculptor," Slobodkin advised, "devote yourself . . . to a book on etiquette and develop the social graces so you will be commissioned to carry on Architectural Sculpture. You can always hire a ghost."[52] To achieve success within this field of cultural production required much more than artistic skill or proficiency in a craft; it required knowledge of the social rules governing the hierarchical system and an ability to navigate them.[53]

FASHIONING AN ARTISTIC PERSONA

Around the same time that Malvina Hoffman began following the prescribed steps for professional advancement, she expanded her stylistic repertoire to correspond to the increasing diversification within American sculpture. In so doing, Hoffman achieved professional and popular success in the fields of architectural sculpture, estate garden statuary, small-scale statuettes, and commissioned portraits. As Linda Nochlin suggested, Hoffman was a "performer in the art of sculpture, slipping in and out of styles" to suit the needs

of the project.[54] As one of the few women sculptors to receive a large architectural sculpture commission in London (figure 2.1), Hoffman chose an archaic style for the heroic-sized male figures to match the severe classical facade of the Bush House.[55] Her youthful and exuberant fountain figures, done in the manner of Frederick MacMonnies and Janet Scudder, animated large estate gardens owned by affluent New York families like the Fricks and Warburgs. Hoffman tried not to overburden her wealthy friends with too much sculpture, but she did expect them "to represent her work when they built a new house or garden or museum."[56]

Hoffman achieved much of her professional success through the moderately priced dance statuettes that she sold to individual collectors and to art museums. Her *Russian Dancers,* inspired by Mikhail Mordkin and Anna Pavlova, won first prize at the 1911 salon of the Société Nationale des Beaux-Arts, and a heroic-sized version of her *Bacchanale Russe* was displayed in the Luxembourg Gardens.[57] Hoffman's portraits of socialites, celebrities, and dignitaries established her in the field of portraiture. For each portrait, the sculptor adopted a style that she believed best suited the sitter's individuality.[58]

In her bust of Mrs. Harriman (figure 2.2), for example, Hoffman used the restrained naturalism and conventions of "grande dame" portraits, which she associated with Houdon and Carpeaux.[59] In the marble bust, she depicted sagging flesh and wrinkles to create a likeness of her elderly subject but most strongly emphasized bone structure, such as the brow ridge and chin, to generate an effect of dignified maturity. Hoffman intended indicators of wealth and social status, such as the string of pearls and fur-lined cloak, to lend further specificity, representing Harriman as if she were dressed for an evening at the Metropolitan Opera.[60] Hoffman positioned the head with a slight turn to the left and depicted a system of drapery folds to anchor the bust. These drapery folds meet at an angle, echoing the turn of the head and adding movement to the otherwise static bust.

For Hoffman, changing her technique was necessary to create a likeness, but more importantly, it was essential to translate the character or soul of the individual. Her notion of character functioned as an effective rhetorical device to construct a coherent artistic persona without having to link it to a particular style. While Hoffman rarely practiced Rodin's expressive modeling technique, she closely followed his concept of character, which involved a criterion of truth and falsity, soul and nonsoul. This shift in criterion, from beauty to truth, enabled Rodin to articulate his aesthetic concerns and set them apart from those of academic sculptors: "In fact, in art, only that which has *character* is beautiful. *Character* is the essential truth of any natural object,

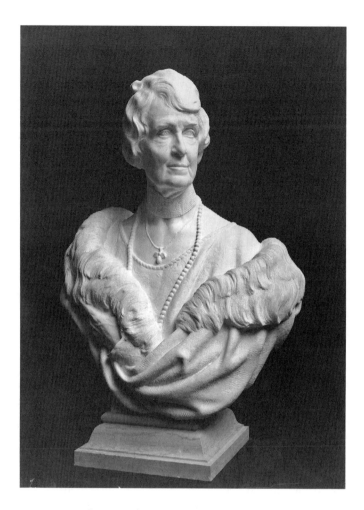

Figure 2.2. Malvina Hoffman, detail of photograph, portrait
of Mrs. E. H. Harriman. Peter A. Juley & Son Collection,
Smithsonian American Art Museum (J0035234).

whether ugly or beautiful; it is even what one might call a *double truth*, for it
is the inner truth translated by the outer truth; it is the soul, the feelings, the
ideas, expressed by the features of the face, by the gestures and actions of a
human being, by the tones of a sky, by the lines of a horizon."[61] By posing the
problem of art as the divination of character, the sculptor equated an artist to
a physiognomist, an individual whom he believed could "easily distinguish
between a cajoling air and one of real kindness."[62] Rodin assumed this role

in his discussion of his portraits, reading head shape and facial features in terms of race, class, and occupation.[63]

Unlike Rodin, Hoffman did not explicitly connect her practice to physiognomy, but she did claim that a sincere artist divines the essence of things. She claimed that when she made a portrait of an individual, there was a "sacred pact" between her and the sitter; they did not speak, since there was a "state of radio emanation" between them.[64] She consistently used the term *séance* for such encounters. While the word in French means a meeting or session, like a sitting, it also carried telepathic connotations for the sculptor. Hoffman maintained that throughout her career she received premonitions and visions, a skill she believed Janet Scudder shared.[65] In her autobiography, *Yesterday is Tomorrow* (1965), Hoffman stated that she based several of her early portraits on sudden, unexpected visions. For example, she alleged that her posthumous portrait of John Keats followed an appearance of the poet in a room where he died.[66] The sculptor believed that some unknown power, her daemon, directed her to draw his portrait and concluded that her profile sketch was much more accurate than existing facial casts of the poet.[67] Hoffman relayed other such anecdotes in her autobiography.[68] However, in her earlier writings, she presented her psychic abilities in slightly different terms. Hoffman explained her skills in divination through a vocabulary associated with telegraphy and theories of wireless communication, a strategy that Linda Henderson has recently shown was prevalent among artists during the first part of the twentieth century.[69] Hoffman's descriptions of "radio emanations" and "vibrations that direct our thoughts," published in her widely read account of the Field Museum commission *Heads and Tales* (1936), confirm the sculptor's effort to situate her sculptural practice in a rhetoric that described psychic phenomena through technological processes.[70]

The sculptor frequently employed various imprint metaphors to describe her divination of character: "My mind became sensitized like a photographic plate, and to keep the impressions vivid and apart demanded endless concentration at a high pitch."[71] Equating her mind to a photosensitive surface was linked to allegations that photography recorded unseen phenomena. For example, Hippolyte Baraduc's 1911 edition of *L'âme humaine, ses mouvements, ses lumières et l'iconographie de l'invisible fluidique* also claimed that "plaques sensibles," or photographic plates, possessed the power to register inner vibrations of a subject.[72] Linda Henderson has also noted that the imprint process of plaster casting carried similar occult associations. The criminal anthropologist Cesare Lombroso, for example, believed that a set of facial casts, or "transcendental plastiques" as he called them, were evidence of

supernatural apparitions.[73] Grounded in Aristotelian conceptions of generation and memory, truth claims were established by imprints ranging from the supernatural, as in the case of "plaques sensibles" and "transcendental plastiques," to the natural, as in impressions of light and fossils, and to the mechanical, as in anthropometric photographs and facial casts.[74]

By explaining character through imprint metaphors, Hoffman engaged a gendered discourse in which the active forming agent was conceived as male and the passive material, female:

> Each race left its mark upon my consciousness with a vivid impression. I have tried both by the gestures and poise of the various statues, as well as by the characterization in the facial modelling, to give a convincing and lifelike impression. I watched the natives in their daily life, fishing, hunting, praying, and preparing their food, or resting after a day's work. Then I chose the moment at which I felt each one represented something *characteristic of his race, and of no other*. To register accurately just these subtle gestures and poses, I had to efface my own personality completely and let the image flow through me directly from the model to the clay, without impediment of any subjective mood, or conscious art mannerism on my part.[75] [Her emphasis]

In this description of her artistic process, Hoffman claimed that she had eliminated a sense of her own self and avoided making any marks that carried with them associations of a personal style. Instead of echoing Janet's Scudder's argument for overcoming deficiencies associated with a feminine sensibility, Hoffman framed her artistic ability as reconciling the feminine passivity associated with imprint processes with a masculine ability to select an individual deemed most typical.

Hoffman's rhetoric resonated with the dominant discourse of character operating within the genre of traditional portraiture. In a 1925 essay published in *International Studio,* Walter Agard argued that there were three kinds of sculptural portraits: those produced for likeness, those that serve as character studies, and those created as works of art. For the first, Agard linked likeness to plaster casting and photography, which recorded every last wrinkle and surface detail but failed to convey character. Recognizing the public demand for accurate likeness, Agard maintained that such portraits were an inevitable form of portraiture. Character studies, on the other hand, did not reproduce all surface particulars of a subject. According to Agard, Jean Antoine Houdon, the master of character portraits, eliminated that which was deemed inessential, suppressed the commonplace, and focused upon the essential lines and

masses. In modern portraiture, sculptors like Jacob Epstein and Jo Davidson were capable of producing a portrait "which reveals alike the sitter's character and the artist's penetration."[76] While some critics called Epstein the leader of a psychological school of portraiture, the sculptor did not subscribe to Agard's view that a clear boundary existed between character studies and portraits that functioned as works of art.[77] Agard had claimed that modern portraits produced by Bourdelle, Maillol, and Meštrović exhibited greater aesthetic concerns and functioned less as character studies than as artworks that delighted the senses and satisfied the mind. Photographers worked with similar categories of portraiture, as expressed in a 1922 *Photographic Journal* essay: map-like portraits that depict every surface detail, imaginative portraits that represent an individual's character, and those in which the photographer expressed too much of his or her own personality and thereby violated the honesty of the medium.[78] To produce a good portrait, one commentator argued, a photographer needed to possess "keen observation, intimate sympathy and the ability to read character."[79] Edward Weston explained portrait photography in similar terms, and some photographers even claimed to possess the ability to photograph the soul. For instance, the photographer Walter Best asserted that he "always endeavored to 'submerge' myself within my sitter, in order to get this sitter's 'wisdom,' or personality so that I could reproduce it in my pictures."[80] Although many acknowledged that the genre of portraiture held little appeal for artists, other than to make ends meet, many photographers and sculptors deployed the rhetoric of character to support their activities within the field. As we will see in the following chapters, Malvina Hoffman fulfilled the Field Museum commission not through divinatory powers but through a collaborative process. Her sculptural approach involved reconciling portraiture conventions with the accuracy requirements associated with anthropometric photographs, plaster casts, and measurements, while also engaging fine art compositional techniques and ethnographic narratives that she hoped would enliven the figures.

3. PRODUCING THE SCULPTURES AND BUILDING CONSENSUS

MALVINA HOFFMAN FIRST MET Stanley Field in December 1929 at a dinner party held at the home of Charles and Ginevra King. Sitting next to the museum president, the sculptor took the opportunity to solicit him for work.[1] Field rebuffed her by quickly changing the subject but then asked Henry Field to visit Hoffman's studio to see if her work would be suitable for the Races of Mankind project.[2] During the next couple of weeks, Henry Field met with the sculptor and his cousin, Marshall Field III. Marshall Field wanted to give the commission to Malvina Hoffman, whom he had met through his wife, Evelyn I. (Marshall) Field, the sculptor's second cousin. Henry Field remained vague on what role Hoffman might play in the project; he had intended to give the Races of Mankind project to Frederick Blaschke, the modeler of the museum's prehistoric man reconstructions.[3] Fitted with glass eyes and real hair, Blaschke's full-length reconstructions (figure 1.3) epitomized the kind of figures that Henry Field and Berthold Laufer envisioned for the physical anthropology display.[4] However, Field was dissuaded by personality conflicts with the modeler, and he began considering Hoffman as well as other artists for the job.[5] Hoffman wrote to him, requesting that Field send an outline of his plans and offering her own ideas on the display. She suggested modeling portraits to represent individuals from "each country of the world" and making heroic-sized heads for races and life-size figures for the "branches of races."[6] Such figures, she argued, could be placed against painted background landscapes or modern settings like "the whites of 1930." Henry Field responded evasively, stating he would need more time before he could develop concrete plans for the exhibit.

Anxious to give the commission to his friend, Marshall Field went to Chicago in January 1930 and met with the president of the museum and the anthropology curators. Marshall Field envisioned Hoffman modeling figures and casting them into bronze. However, during their meeting, Laufer and Henry Field convinced him that bronze sculptures were inappropriate for a physical anthropology display. Bronze, they argued, would not adequately represent skin color; scientific accuracy required figures in a material that could be painted in different colors and that could allow for the application of hair. Shortly after this meeting, Henry Field sent Hoffman a list calling for 30 full-length figures, 30 busts, and 150 facial masks. On February 16, 1930, the museum officials invited Hoffman to the museum to look over Blaschke's figures. She agreed to produce figures in a material like the one used for the reconstructions but asked Henry Field to obtain the formula secretly from the modeler.[7] Perhaps as a compromise, Laufer suggested that a central group symbolizing the unity of mankind could be completed in bronze.

Stanley Field rejected Hoffman's initial estimate of $375,000 for the project. To reduce costs, Laufer and Field eliminated a number of racial types, and Hoffman lowered her estimate to $109,000. On the following day, February 18, 1930, Hoffman signed the contract for 20 full-length figures, 27 busts, and 100 facial masks in "durable colored materials with real hair" for a minimum of $109,000 and a maximum of $125,000.[8] The board of trustees approved the use of the Chauncey Keep $50,000 bequest for the exhibit hall, and Marshall Field III agreed to cover the remaining balance. Before signing the contract, Hoffman arranged with Mrs. Charles Schweppe, daughter of the former president of Marshall Field and Company, to cover the cost of the *Unity of Mankind* bronze sculptural group. Hoffman's skill in obtaining outside financial support must have impressed the museum officials, who verbally agreed that the bronze sculpture would hold a prominent position in the exhibit hall, while the figures, busts, and masks would be exhibited within five glass wall cases.[9]

The contract specified the conditions by which Hoffman would complete the figures. For example, a clause in the contract required Hoffman to submit a preliminary sketch for the *Unity of Mankind* group to the officials at the museum. The contract also stipulated that the anthropology department would provide the sculptor with measurements and photographs for life-size figures. This arrangement conformed to Dudley Buxton's recommended practice of modeling figures from photographs of one individual and using average measurements of a group.[10] However, the contract made no provision

for how Hoffman would produce the 100 facial masks, which suggests that the officials believed that direct casting did not require their supervision.[11] The museum also gave Henry Field $15,000 for traveling expenses and for the purchase of materials, such as casts, photographs, books, and charts. These materials would form a separate "technical" display concerning the subjects of pathology, physiology, demography, and racial problems in the United States.[12] By separating the exhibit hall into two sections, the museum administrators and curators envisioned a dual arrangement format like that used in the Hall of Prehistoric Man.

REDEFINING THE PROJECT THROUGH REPRESENTATIONAL PRACTICES

In March 1930, Hoffman met anthropologists Clark Wissler and Harry Shapiro at the American Museum of Natural History so that she and her assistant, Karl Gruppe, could begin work on the facial masks.[13] In her daybook, Hoffman notes that she borrowed a "poorly colored cast of an Indian head, (elderly)" from the museum.[14] This entry supports visual evidence that the artist made recasts or surmoulages of anthropological busts. Her *Sioux Indian Male* (figure 3.1), in particular, does not have the appearance of being worked up in clay. The facial features seem to hover on the surface and do not give the sense that they correspond with an underlying structure. Comparing this bust to one by the preparator Caspar Mayer (figure 3.2), similarities between the two become obvious; it appears that Hoffman simply shifted the position of the head downward and altered the eyes so that they appeared opened.[15]

On April 11, 1930, Hoffman presented her *Sioux Indian Male* and other heads as "experiments" to Stanley Field. No doubt, the president visually compared Hoffman's experiments to the Mayer anthropological busts, because Field found them "correct in every detail, without the slightest artistic liberty taken," and believed that all Hoffman had done was to "pose the head so that it has life and is not dead."[16] To convince Stanley Field further that she should employ a method that combined modeling and casting, she took him to the American Museum of Natural History to examine its facial cast collection. At the museum, Hoffman demonstrated how casting produced distortions and how these deformations affected not only the appearance of a mask, but also measurements taken from it.

Hoffman's experiments also served to counter the opinions of the physical anthropologist Earnest Hooton, whom Stanley Field met at Harvard before visiting the sculptor in New York. Hooton took Field to examine the facial cast

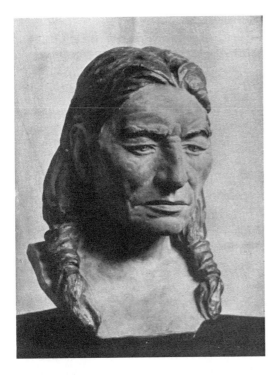

Figure 3.1. Malvina Hoffman, *Sioux Indian Male.*

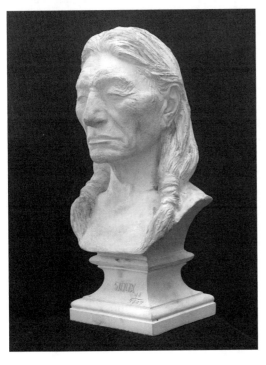

Figure 3.2. Caspar Mayer, *Number 151: Sioux,* American Museum of Natural History, New York. Image #: 13166, Photo by: American Museum of Natural History, American Museum of Natural History Library.

collection at the Peabody Museum and explained to the president that "casting from life" was the "only faithful" and "scientifically correct" technique available for producing anthropological busts.[17] The physical anthropologist shared Aleš Hrdlička's views that plaster casting ensured a level of authenticity necessary to produce "accurate racial records." Weighing Hooton's argument for the scientific necessity of direct casting against Hoffman's mixed technique, Stanley Field chose the latter. He believed that if the sculptor could produce masks that maintained the accuracy of casts but did not exhibit visual defects, then the Field Museum would be the only museum to have an "absolutely good collection of masks."[18] He informed the anthropology curators of his decision and stated that if they "insisted on having casts then buy them for the study collection."[19] For the president, the educational and entertainment value of the exhibit was more important than its research value.

Several problems arose concerning the *Unity of Mankind* sculptural group (figures 3.3 and 6.13). The contract stipulated that the central group would symbolize the "unity of mankind" by three life-size figures representing "the Mongol, Negro, and Caucasian" underneath a transparent globe.[20] This broad description led to confusion. Hoffman would have thought of well-known sculptures of personification figures representing the world, such as Carpeaux's famous *Quatre parties du monde* (1872). Eschewing the established tradition of using female figures to represent continents, Hoffman depicted male figures. And unlike Carpeaux's freestanding figures placed beneath the globe, Hoffman's initial sketch was in relief; the three male figures were placed within architectural niches of a column supporting a globe. Hoffman modeled the figure representing the white race in a toga and with a book. The figure representing the black race wore a headdress and skirt and held a spear. The third figure, representing the yellow race, wore a simple tunic and carried an ax. In her clay sketch, the relief was shallow, offering little spatial recession, and the clothing obscured the anatomical forms of the figures.

In a different clay sketch, Hoffman gave a much more three-dimensional appearance to the work by eliminating the niches and placing the figures around a central column (figure 3.4). She also changed some of the attributes of the white male. The figure now held a rectangular form and grasped an equilateral triangle with a mallet at its side. Such objects placed beneath a globe would have resonated with the spiritualist ideas of her friend Édouard Schuré, who believed that geometric shapes reflected harmonic relations in all natural forms. Schuré's *Les grands initiés* (1889), which he had earlier advised Hoffman to read, promoted Pythagorean theories of geometric proportions and the idea of universal and harmonious relations. The white male figure holding an

equilateral triangle would have suggested spiritualist ideas of sacred geometry and divine measurement. The incised lamp on the nearby panel would have reinforced the association of divine knowledge with the white race.

Field Museum anthropologists, however, did not entertain such theosophical ideas. Their initial reaction to Hoffman's preliminary sketch was to focus

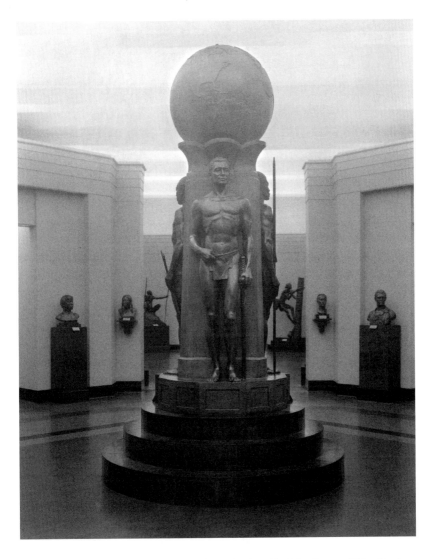

Figure 3.3. Malvina Hoffman, *Unity of Mankind,* Hall of the Races of Mankind, Field Museum. © The Field Museum, MH89.

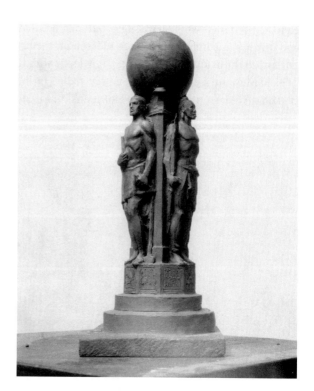

Figure 3.4. Malvina Hoffman, clay sketch for *Unity of Mankind*. Malvina Hoffman papers, Research Library, The Getty Research Institute, Los Angeles (850042).

immediately upon the anatomical aspects of the figures and how such body forms could demonstrate racial differences. After examining a photographic reproduction of a clay sketch, Henry Field recommended modeling the figures in the round rather than in relief so that viewers could study proportions and compare muscles.[21] In Henry Field's view, the figurative group would serve as an object for morphological study and thereby fulfill a scientific purpose. Berthold Laufer, too, believed that Hoffman needed to make significant changes. For example, he suggested raising the globe because he believed it detracted from the figures.[22] Laufer also wanted Hoffman to eliminate narrative elements; the book that the white figure held, the anthropologist argued, had to go. Laufer sent Hoffman a drawing of his own to guide her. Upon receiving his sketch and comments, Hoffman found his criticism severe. She believed that Laufer wanted to eliminate too many elements of design, and she claimed that from a "sculptural point of view" his sketch could not be carried out.[23]

Hoffman countered Laufer's criticism by claiming that Mrs. Schweppe "was delighted with it," as if an endorsement from the donor would change his opinion. She then brought Stanley Field into the dilemma. Stating that he always

refrained from interfering in the "scientific end of the work," the president reminded the anthropologists that he preferred lifelike and engaging displays. Stanley Field believed that Laufer was wrong in both his concept of the group and its purpose. The president found Hoffman's sketch a "very beautiful thing" and stated that the purpose of the group was to "attract people into the hall and to help give the hall life."[24] In addition, Field disagreed with Laufer's objection to adding objects to the figures, especially the book held by the white figure and the spear held by the black figure. He conceded that "trimming up" the figures might obscure physical characteristics and make morphological comparison difficult. But if such accessories did not conceal any part of the body, the president argued, "what harm would be done by including objects that would add life, avoid monotony, and make the whole attractive?"[25]

Laufer crafted a careful response to Director Simms, after he consulted with the art historian John Shapley and the anthropologist Edward Sapir, both at the University of Chicago. First, he claimed that Hoffman misunderstood the purpose of the figurative group; it was not intended to be ornamental or a work of art. Since the group would represent the three principal races arranged in a circle or triangle, they would "symbolize racial unity or man as a homogenous species."[26] He stated that he would never display a "pure work of art" in an exhibition hall. While Laufer wanted to increase the scientific value of the group, he also wanted it to be "artistic and full of life." For Laufer, having the figures hold objects did not accomplish these goals. On the contrary, he listed well-known Greek and Roman nude statues and stated that John Shapley believed that held objects did not serve an artistic principle.

Laufer went further, claiming that including objects could not be justified from a scientific viewpoint. Choosing an object or emblem appropriate for each race was impossible, for it involved fixing each figure to a particular place and time. He recognized that emblems would elicit such associations and add narratives beyond the symbolic statement of unity. For Laufer, selecting an object would mean reducing diversity to one particular group; for example, he explained that a white figure representing a European would exclude other white groups. The chosen object would also imply a phase of cultural development, which in itself Laufer did not oppose, but which would entail making a decision about which cultural stage should be represented. He suggested following Edward Sapir's advice that no suitable emblem could be found, and therefore the figures should hold no objects. However, Laufer offered the compromise that it would be permissible to "arm the white man with a sword and the yellowman with a bow" if the "negro is to hold a spear."[27] Laufer's solution lessened Hoffman's rather overt statement of cultural hierarchies.

However, the sculptor complied with Laufer's request, and on April 30, 1930, she included his proposed weapons (figure 3.3).[28]

Like the shift from facial casts to modified masks, this compromise had an enormous impact on the commission. Berthold Laufer realized that Stanley Field supported Hoffman's view on "trimming up" the full-length figures with ethnographic objects. He knew that by including these narrative additions, the figures would function more as ethnographic lay figures than as anatomical models. Laufer also knew that confusing the boundaries between ethnography and physical anthropology could generate new problems for him. However, Hoffman attempted to prevent further criticism by consulting anthropologists when selecting objects for the figures and by using casting to make the various accessories. Through casting ethnographic objects, Hoffman stated in a report to the Field Museum, she would produce "exact reproductions" of the originals and thus ensure their authenticity.[29]

Since Stanley Field's visit to Hoffman's studio raised such significant issues concerning how the figures would be executed, the president suggested that Berthold Laufer and Henry Field visit her New York studio to hash things out. However, before their departure on May 15, 1930, the president wrote to the sculptor, stating that he and the curators had already reached an agreement and that he felt certain there would be no more difficulties. Both Laufer and Henry Field agreed with Stanley Field's view of the defects inherent in plaster casting. In addition, the president believed that they would accept modeled hair instead of real hair. Three or four of the figures, he conceded, would still require actual hair "when hair is the principal characteristic, and should be shown."[30] Thus two of the most pressing reasons for making plaster figures had been eliminated. Stanley Field also informed the sculptor that they had agreed to change the name of the exhibit from the Hall of Physical Anthropology to the Hall of the Races of Mankind. For the president, this new title would indicate that the museum was "getting away from the old fashioned dry as dust scientific treatments" of the exhibits, but for the anthropology curators the new title distanced the exhibit from the scientific claims of physical anthropology.[31] Nevertheless, at Hoffman's studio they approved the work she had already completed. Henry Field stated that Laufer was radiant and enthusiastic about Hoffman doing the work. Perhaps to reward Henry Field for accepting the various changes in the contract, Hoffman gave him a mask of Pavlova.[32] Hoffman had dinner prepared for the group at her studio, and later that night, the sculptor and Henry Field went to the theater with Marshall Field.

Hoffman solicited the support of Sir Arthur Keith in a similar manner. On a foggy morning in October 1930, Hoffman held her first "séance" with

Keith in the attic of the Royal College of Surgeons in London. Despite the makeshift conditions, Hoffman needed to produce a convincing portrait of Keith to win his support (figure 3.5). A Mr. Priestly attended their séance and took photographs of the anatomist. The following day, a preparator from the Victoria and Albert Museum made a cast of Keith's face. In her daybook, the sculptor noted that the anatomist was "wonderful" during the casting process and that he apologized for having to breathe.[33] Hoffman then carried the facial

Figure 3.5. Malvina Hoffman, *Nordic Type, Great Britain,* Hall of the Races of Mankind, Field Museum. © The Field Museum, MH22.

mask and photographs to her Paris studio. A few weeks later, she took the cast to a commercial shop to have a piece mold and squeeze made.[34] From these materials, Hoffman and her assistants worked up a clay model. In January 1931, the sculptor returned to London with her assistant Louis Slobodkin. For several mornings, they continued to work on the portrait at the Royal College of Surgeons, and Slobodkin later claimed that he modeled a substantial portion of the head.[35] Back in Paris, Hoffman sent a photograph of the portrait to Keith for his review. The following month, she removed the shoulders from the plaster model and followed Keith's recommendation to "color it lightish." An American physical anthropologist on a National Research Council fellowship at the Royal College of Surgeons, Wilton Krogman, relayed the anatomist's instructions.[36] Hoffman sent a photograph of the work to Keith, who enthusiastically approved it.[37]

As we can see from this sequence of events, the artificial boundaries between artistic invention and mechanical processes were constantly crossed. Despite Hoffman's claims of a spiritual encounter between the artist and her subject, from the start she employed photography and plaster casting, and at every step in the process, these modes of representation intervened. One could argue that these facial casts and photographs served as visual guides between sittings. In traditional accounts of sculpture, if these representational processes are considered, they are discussed separately from the making process; a sculptor *consults* these "aides-mémoires" but does not work *with* them.[38] However, to admit that casts and photographs are an integral part of the production is to grant a level of agency to representational processes that are coded with values related to mechanical reproduction. For example, a facial mold allows for the production of multiple replicas or clay "squeezes," while retaining a standard of likeness.[39] Neither Hoffman nor Keith believed that using casts diminished the artistic value of his portrait in any way. On the contrary, they each noted the procedure in their daybooks, as if they regarded it a routine technique necessary to secure a high level of authenticity and accuracy for the project.

Photography played another significant mediating role in the production process; Hoffman sent photographs of her clay model to the anthropologists in Chicago as well as to the anatomist in London, and thus each image served as a vehicle for evaluation at different locations. The photograph of the portrait especially pleased Henry Field, who claimed it was a "splendid likeness" of Keith.[40] However, the anthropology curators' enthusiasm clouded their judgment on how the bust would function as a representative of race within the exhibit. Hoffman initially told Berthold Laufer that the portrait represented

an Anglo-Saxon.[41] The anthropologists accepted this racial designation and affixed *Anglo-Saxon* to the work when it went on display in the exhibit hall. Hoffman later discovered that Keith was born in Edinburgh, Scotland. Assuming that Keith's place of birth determined his racial identity, she asked the anthropologists to change the label to read *Celt*.[42] This reclassifying created a problem for the anthropology department. For Laufer, both *Anglo-Saxon* and *Celt* referred to "ethnic or linguistic groups" and therefore did not "mean anything from the standpoint of physical anthropology."[43] To clarify the matter, Laufer asked Keith to provide his racial designation and stated he would "abide by the master's verdict."[44] Keith responded that he was Nordic since "the highlanders of Scotland are more akin to Scandinavians physically than to any other people."[45] Laufer then changed the label to *Nordic Type, Great Britain*. While Hoffman's production method involving casts and photographs alleviated the anthropologist's concerns for accuracy and authenticity, the notion of race depended upon arbitrary and shifting categories, even when those categories applied to one of the chief promoters of race.

To ensure anthropological accuracy, the original contract specified that the Field Museum would provide the artist with reference materials. However, in many cases Laufer and Field could not find the required measurements and photographs and failed to give adequate guidance for making the figures. Growing frustrated, Hoffman wrote a memo to the museum in which she reminded the anthropologists that it was the museum's responsibility to provide her with such materials and restated her photographic needs: "Please continue head hunting in albums for good pictures of *types* and when they are photographed by your photographer have him get the exact *face lengths* and heights from Dr. Laufer and enlarge the *best* ones to these proportions as a *guide* for me to *make* the head. Make sharp *glossy prints* not *matte*."[46]

In many cases, the sculptor and her assistants used life-size enlargements of photographs for the initial designs. Like her working procedure involving casts, Hoffman's use of photographs contradicted the artist's claims of invention. Many of these photographs had been previously reproduced, collected, and circulated in different cultural arenas and therefore had already achieved the status of authentic racial portraits. For example, Hoffman based her *Ethiopian Male* bust on photographs which were reproduced in a 1905 text on race by the German anthropologist Felix von Luschan.[47] Hoffman also borrowed photographs from the Eugenics Record Office to produce the *Maya Male*. These photographs also circulated in a well-known anthropological text.[48] Hoffman found other photographs from published racial studies as well as from anthropological archives at the Field Museum, the British Museum,

and other institutions. Many of these photographs had already gone through a selection process by anthropologists recognized as experts on race. Their reproduction in racialist studies or their collection in museum archives gave these photographic images the authoritative status of characteristic types. In addition, Hoffman selected images from commercial photographic service bureaus like Ewing Galloway. Thus some of the figures related to images already circulating within mass culture. Indeed, many of these photographs already possessed values and histories or social lives that added different meanings to the figures.

Through archival materials, it is possible to track how Hoffman's figures gained veracity through the former lives of specific photographs. For example, George Specht's photograph of Nobosodru (figure 3.6), taken during the 1924 Citroën Central Africa Expedition, served as the basis for Hoffman's *Mangbetu Woman* (figure 3.7) and for several other cultural objects. The leader of the expedition, Georges-Marie Haardt, reproduced the photograph in his book *La croisière noire,* published in 1925. The image served as the design for a poster printed to advertise the film, *La croisière noire.*[49] Artists commissioned by the Musée Grevin in Paris used the photograph to model a lay

Figure 3.6. George Specht, "Nobosodrou, Femme Mangbetou," from the Georges-Marie Haardt Citroën Expedition to Central Africa (ca. 1924). Malvina Hoffman papers, Research Library, The Getty Research Institute, Los Angeles (850042).

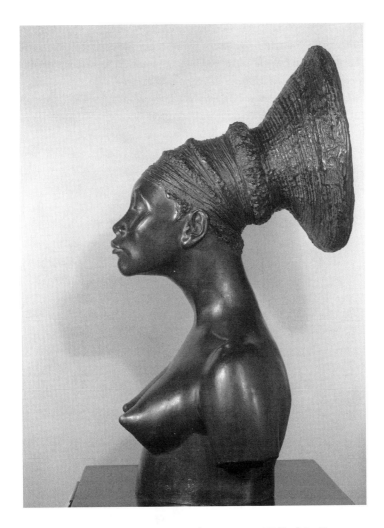

Figure 3.7. Malvina Hoffman, *Mangbetu Woman,* Hall of the Races of Mankind, Field Museum. © The Field Museum, MH14A.

figure for a diorama, which was displayed at the Pavillon de Marsan exhibition in 1926.[50] The Swiss artist Auguste Heng produced a plaster head using the photograph, which was also on display at the Pavillon de Marsan. Emile Adolphe Monier based an edition of terra-cotta heads on the photograph and sold them as souvenirs at the 1931 Exposition Coloniale.[51] In the United States, the ceramic artist Victor Schreckengost produced a plaster bust entitled *Jeddu* (1931) from the image, and Aaron Douglas loosely based a drawing on

Producing the Sculptures and Building Consensus 61

the photograph, which circulated on the cover of the May 1927 *Opportunity* magazine.[52] Hoffman, too, made a drawing of her *Mangbetu Woman* with two other busts, which may have served later as a design for the artist's mural at Helena Rubinstein's New York beauty salon.[53]

The sculpture *Negro Dancing Girl, Sara Tribe*, later called *Daboa* (figure 3.8), illustrates how much the sculptor relied upon photographic images for her

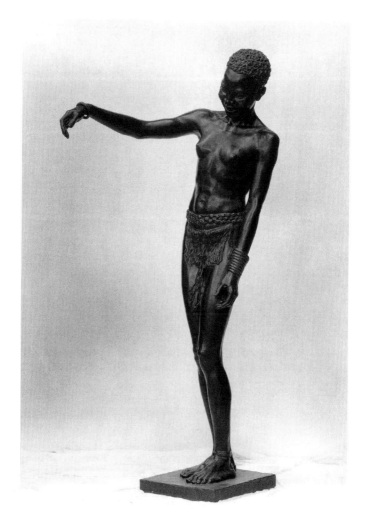

Figure 3.8. Malvina Hoffman, *Negro Dancing Girl, Sara Tribe* [*Daboa*], Hall of the Races of Mankind, Field Museum. © The Field Museum, MH2.

initial designs. Taken during the Expédition Citroën (1924), the photograph (figure 3.9) represents two women in conversation on a tennis court.[54] Hoffman had the photograph of the standing woman enlarged to life size. In her clay model, she sought to replicate the illusion of movement produced in the photograph. The sculptor copied gestures, such as the extended arm, to suggest the momentary transition between bodily positions, but she characterized them in terms of dance. The tilt of the woman's head is also reproduced in the figure as part of a dance movement. Although the original photograph has nothing to do with dance, Hoffman, like many other Anglo-American artists, made the assumption that dance and rhythmic movement defined the racial temperament of Africa, and therefore she aimed to reproduce it.

Hoffman believed that photographs assisted her in determining character. Aware of Francis Galton's system of composite photographs, in which portraits of different people were superimposed to reveal an underlying archetype, the sculptor dismissed such techniques. She insisted that a racial type could be arrived at only through visually assessing an individual, and she advocated using

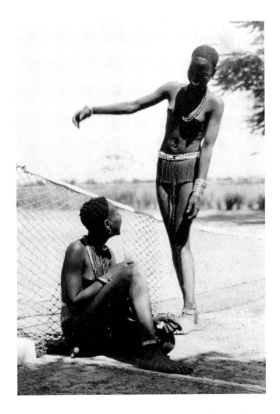

Figure 3.9. Photograph of two women on a tennis court, from the Georges-Marie Haardt Citroën Expedition to Central Africa (ca. 1924). Malvina Hoffman papers, Research Library, The Getty Research Institute, Los Angeles (850042).

a different form of composite photography to reveal elements of character that a subject attempted to hide.[55] She used a photographic portrait to make two new mirror images composed of the left side of the face with its reflection and the right side of the face with its reflection. These symmetrical images, when placed next to the original photograph, putatively allowed Hoffman to compare the subject's personalities and accentuated her process of finding striking characteristics and lines. Asymmetrical aspects of the face also became visually apparent. She took great stock in this procedure, believing that psychoanalysts should adopt it as a means to "dissect their patients painlessly" without their knowledge, and she demonstrated it as a photographic experiment to Alexis Carrel and Arthur Keith.[56] This form of composite photography, however, was not the sculptor's invention; Hoffman probably became acquainted with this procedure, which was used in psychological studies of facial expression, through accounts of it in popular newspapers.

Hoffman's reliance on photographs did not always prevent mishaps. The *Aztec Male,* based on an image reproduced in Frederick Starr's 1902 photographic series *The Physical Character of the Indians of Southern Mexico,* failed to meet the approval of the Field Museum anthropologists. In January 1931, Hoffman finished a male head, whose asymmetrical facial forms she believed would indicate a "brigand," and both Arthur Keith and Wilton Krogman approved it.[57] Hoffman sent a photograph to the Field Museum anthropologists for their final approval but received a letter from Stanley Field rejecting it. The president stated that a member of the museum staff, Eric Thompson, thought the photograph had been misidentified because Aztecs "all have very high domed skulls."[58] Wilton Krogman attempted to establish the racial identification of the photographed subject by tracing the provenance of the image. Krogman found the photograph at the British Museum archives, where it was labeled "Aztec Female from the State of Puebla in Mexico."[59] He wrote to Stanley Field stating, "I go on record as of the opinion that the bust faithfully depicts a female Aztec type."[60] Despite Krogman's racial determination, the Field Museum anthropologists decided not to exhibit this work, but they did accept the plaster head into the collection.

Besides Krogman, Hoffman received the advice of other anthropologists at museums like the American Museum of Natural History in New York and the Musée d'Ethnographie du Trocadéro in Paris. These specialists helped the sculptor to select subjects or photographs and approved works when she completed them. Their involvement lessened Field and Laufer's control over the production of the works, but both anthropologists were willing to

rely upon the advice of outside experts if it meant that the status of figures as authentic representations of racial types would be increased.

The *Australian* (figure 3.10) is an example of the level of involvement of such advisors in producing the figures. Berthold Laufer responded negatively to Hoffman's preliminary sketch because he thought the figure had an idealized face and a "body like a Caucasian."[61] Arthur Keith also criticized the figure. He

Figure 3.10. Malvina Hoffman, *Australian,* Hall of the Races of Mankind, Field Museum. © The Field Museum, MH87.

objected to the "heaviness of the legs" and suggested recarving the shape of the head.[62] Dr. Malcolm from the Wellcome Museum and Adolph Schultz from Johns Hopkins Medical School examined the clay model and recommended that Hoffman reduce the width of the feet and further separate the toes on the plaster figure.[63] This latter advice relating to the foot increased the primitiveness of the figure, as many anthropologists considered the "prehensile" big toe to be a sign of grasping power associated with the feet of primates. Hoffman also sought the advice of Marcel Mauss at the Sorbonne, who examined photographs of the figure.[64] The pose of the figure, reminiscent of classical sculpture, also required adjustment. Hoffman believed the pose served as an accurate illustration of hunting with a boomerang and spear. Reviewing the figure from a photograph, the anthropologist Alfred Radcliffe-Brown questioned the gesture and suggested Hoffman make slight changes.[65] Hoffman responded that Arthur Keith, L. W. G. Malcolm, Adolph Schultz, and anthropologists in Paris had already approved of the figure and that she had cast it into bronze.[66] In 1934, the museum curators removed the boomerang and spear after they received a letter claiming that it was sacrilegious to use a boomerang in such a manner.[67]

A photograph of the painted plaster figure (figure 3.11) suggests how the works would have appeared if they had been produced under the terms of the original contract. The light-colored, curving lines on the figure contrast sharply with the dark-colored body. The lines also flatten the three-dimensional appearance of forms and pull attention away from incised surface details, like the scars on the chest. In contrast, the body forms of the bronze figure read more as three-dimensional shapes that work in relation to the pose. Hoffman no doubt wanted such jarring visual effects of the plaster figures to change the opinion of Field Museum officials. In September 1930, she met with Stanley Field and presented him with some new experiments. She showed the president painted plaster figures and those cast in bronze, like her small-scale *Daboa*, in order to change the contract to bronze figures. She suggested producing a series of twenty-three bronze full-length figures and twenty-seven bronze busts.[68] On October 27, 1930, the museum officials and the sculptor signed a supplemental contract that authorized a set of full-length figures cast in bronze and called for full heads instead of facial masks.[69] Hoffman was so pleased by these changes that she rewarded the president with a statuette of *Daboa*.[70] Stanley Field and Berthold Laufer did not consult Henry Field in making their decision; instead, they sent the physical anthropologist a cable on November 12, 1930, notifying him of the change.[71] Seven months later, Stanley Field visited Hoffman's studio in Paris, where he compared an-

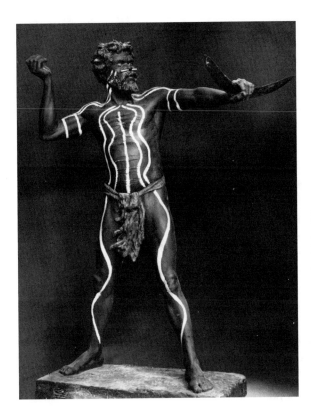

Figure 3.11.
Malvina Hoffman.
Painted Plaster
Model, *Australian*
(captioned "War
Paint on Plaster").
Malvina Hoffman
papers, Research
Library, The Getty
Research Institute,
Los Angeles
(850042).

other set of painted portraits with those cast in bronze and agreed to have
the remaining busts and heads cast in bronze.[72] However, before the president
made the final decision, he contacted Arthur Keith, who was "delighted and
enthusiastic" about changing all the figures to bronze.[73] To dispel any linger-
ing concerns about representing skin tones, Hoffman agreed to hand-color
a series of photographic transparencies to denote skin color in the special-
exhibit area of the display. She alluded to variation in skin tones by applying
different patinas onto the bronzes. Successful in transforming the commission
to fine art materials, Hoffman even persuaded the museum officials to accept
a few stone portraits to lend greater variety to the exhibit hall. Marshall Field
III had initially proposed using white marble to represent the white races in
figures such as the full-length *Nordic Type;* however, none was used. Instead,
the link between material and skin tone was made through three yellow-pink
limestone portraits and a black marble head placed in the Asian and African
sections of the exhibit. Carved in a simplified manner (figure 3.17), these stone

portraits offered stylistic contrasts to the highly detailed, modeled sculptures. This contrast between stone and bronze sculptures was emphasized later when the Field Museum prominently exhibited three out of the four stone portraits within shadow boxes in the Hall of the Races of Mankind.

HOFFMAN'S EXPEDITION TO ASIA

In February 1931, Stanley and Henry Field began discussing Hoffman's expedition to Asia. The sculptor had suggested a process of taking photographs and measurements, making casts, and modeling heads of selected individuals. From these materials, Hoffman would then complete the full-length figures at her studio. The president agreed that her idea was sound, but it brought up the issue of "whether, when the world is all done, it would still have the same authenticity as if the modelling was done from the actual being."[74] The president articulated his preference for such a direct relation with subjects after he learned that Hoffman had not used live models at the 1931 Exposition Coloniale as expected.[75] For the expedition, Henry Field suggested taking films of Hoffman modeling during the trip so that the museum would have "conclusive proof" of the authenticity of her work as well as a "valuable permanent pictorial record."[76] Despite their concerns for authenticity, Stanley Field and Henry Field knew that Hoffman had already used photographs and casts to complete many of the figures.

The museum administrators and curators understood that, for most physical anthropologists, the accuracy of the figures rested upon the judgment of the person who selected subjects to be represented. Dr. Malcolm suggested that Wilton Krogman accompany the sculptor on the trip to do the selecting. However, Krogman had arrangements to work with Wingate Todd at Western Reserve University in Ohio and therefore was unavailable.[77] They consulted Arthur Keith, who claimed that there was not a physical anthropologist in the world who could fulfill the requirements of such an expedition. If he had to choose between Hoffman and a "cold blooded" anthropologist selecting individuals, Keith claimed, he would "back Hoffman's judgment" because she had "the eye of the artist as well as a flair for seeing or rendering the outward racial characters of every man and woman she works on."[78] In addition, the anatomist explained to Stanley Field, he did not believe that obtaining anthropometric measurements was really necessary, as the "world is full of them."[79]

Henry Field wrote to Earnest Hooton requesting his advice. Hooton responded that an anthropologist was needed for the expedition, because it would enormously enhance the scientific value of the project. He proposed

that an anthropologist precede the sculptor to various areas, measure 100 individuals, collect data, and select people for her to model.[80] Such anthropometric work, Hooton told Henry Field, would "prove to be the most worthwhile part of the project."[81] He explained further that two physical anthropologists, Harry Shapiro and Alfred Tozzer, shared his view that without an anthropologist selecting types, the exhibit would have little scientific value.[82] An anthropologist at Harvard University, Roland Dixon, expressed similar concerns one year later in a letter to Hooton: "I shall fear that the result will be far from satisfying from a racial point of view if the selection is left to any artist. Were a really serious attempt made, with a physical anthropologist to select the models, one could make out a fairly detailed program of where to go for certain types. As it is, the labor involved in making such a program is not worth it."[83] Hooton recommended sending one of his own students and suggested that the museum offer the student a stipend. However, the museum adopted Keith's solution: Hoffman would go on the trip without a physical anthropologist. Keith agreed to prepare her way by writing to anthropologists and acquaintances in countries Hoffman planned to visit.

Hoffman's expedition to Asia lasted over seven months, from October 2, 1931, through May 10, 1932, with visits to cities in Hawaii, Japan, China, Bali, Java, the Malay Peninsula, India, and Ceylon. Samuel Grimson served as the expedition photographer and took various films, and Jean de Marco acted as Hoffman's sculpture assistant and plaster caster. Gretchen Green, secretary to the project, traveled in advance of the group to make contacts with various museum curators and government officials. Green later met up with the sculptor in China, and there she helped Grimson to complete anthropometric forms that Berthold Laufer required for each subject. At each stop on their itinerary, the group received assistance from local anthropologists and museum curators, but in some locations, Hoffman encountered resistance. For example, she ran into many tourists and fellow "globetrotters" in Manila but was unable to find people willing to serve as anthropological subjects.[84] Stanley Field received a letter from the Office of the Governor General of the Philippine Islands that explained that many "civilized Philippine people" did not want "tourists or cheap travel log artists to represent the entire islands as being inhabited by naked savages."[85] Davidson Black, known for his research on "Peking Man," acquired models for Hoffman and set up a temporary studio for her at the Peking Union Medical College. The paleoanthropologist viewed Hoffman's project as an amusing diversion: "It is indeed a whimsical and pleasant thought that such a responsibility should fall upon my shoulders or should one say neck?"[86] Despite suffering from sinus headaches, with her left

arm in a sling due to a severe bacterial infection, Hoffman managed to model some heads in Beijing. Hoffman also maintained a hectic social calendar. She lunched with Mr. Engert from the U.S. Embassy, attended a dinner at Mrs. Calhoun's estate, and served as Hu Shih's guest of honor at a reception held at the Returned Students' Club.

Throughout the rest of her trip, Hoffman continued to combine social activities with "field" work. On the Dollar Liner ship to Hong Kong, she watched a Maurice Chevalier movie, and during her stay in Bali, she attended a performance of court dancers with the film director John Ford. Concerning her visit to Rangoon, Hoffman wrote, "A most delightful afternoon spent on the country estate of a wealthy Chinese racing stable owner. Our host had permitted us to use his garden as setting for moving pictures of Burmese court dancing troupe . . . then tea was formally served in the drawing room, and to top off the afternoon, champagne was brought in a great bowl filled with squares of ice, a frigidaire having been added recently to this luxurious household."[87] With a demanding social schedule and recurring bouts of sinusitis, Hoffman modeled only a small number of heads during the expedition. In fact, her studio assistant Louis Slobodkin wrote to his wife that Hoffman returned from her travels with only "a mask . . . three poor heads and a horrible sketch of a Chinaman."[88] While Slobodkin no doubt understated the number of works for rhetorical effect, Hoffman's expedition was largely one of taking measurements, casts, photographs, and films. In some of Grimson's films, subjects turned 360 degrees in front of the camera so that multiple views of the subject's head could be studied later in stills. In the case of the Balinese dancer Ni Polog (figure 3.12), Hoffman and Grimson took anthropometric measurements, casts, and photographs for the *Woman, Bali* portrait head, and for the *Group of Cockfighters* female figure, the sculptor had her subject pose holding a stack of straw hats, in place of a fruit bowl, raised above her head. Similarly, in Hawaii Hoffman modeled a head of Sargent Kahanamoku, brother of the former Olympic swimmer and movie star Duke Kahanamoku, and partially completed an anthropometric form for her *Surf Rider* (figure 3.13). Harry Shapiro, who had assisted Hoffman earlier at the American Museum of Natural History, was in Hawaii at the time and offered some suggestions to the sculptor. Hoffman changed the eyes of the portrait, and then Shapiro gave his approval.[89] Although Hoffman claimed that she did not pose her model, as to do so would mean losing the essence of his "racial individuality," Kahanamoku simulated surfing by posing in four different positions on a surfboard, one end propped up on a rock, on Waikiki Beach, and Grimson took photographs. Returning to her Paris studio, Hoff-

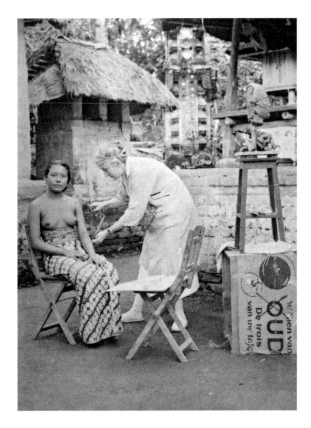

Figure 3.12. Malvina Hoffman measuring model (Ni Polog) and with clay "squeeze" on stand for *Woman, Bali* portrait and the female figure in the *Group of Cockfighters,* Bali (January 30, 1932). Malvina Hoffman papers, Research Library, The Getty Research Institute, Los Angeles (850042).

man traced a photograph of the "balance and steering" pose she had selected and wrote down (in English and Italian) various measurements to guide her studio assistants to create the full-length figure (figure 3.14). Hoffman followed this method throughout her expedition: she took photographs, casts, and measurements of her subjects conforming to anthropometric practices; she posed her subjects for her compositions; and she secured the approval of a local authority.

PRODUCING THE SCULPTURES IN NEW YORK AND PARIS

During the period of 1930 through 1932, Hoffman employed two to four assistant modelers in her studio to complete the Field Museum commission (figure 3.15).[90] These sculptors were much more involved in the production of

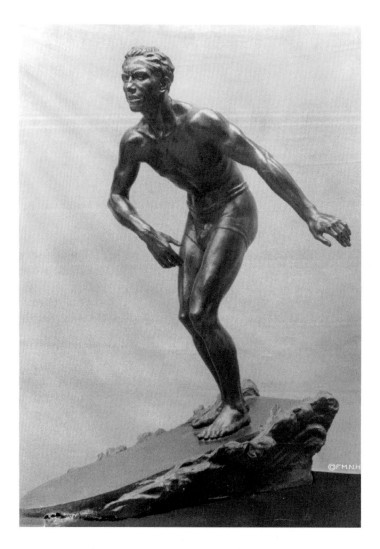

Figure 3.13. Malvina Hoffman, *Hawaiian Surf-Rider, Polynesia,* Hall of the Races of Mankind, Field Museum. © The Field Museum, MH71.

the figures than her plaster caster, Jean de Marco, and Gozo Kawamura, who made enlargements of clay models in her New York studio. These workers fall into the category of less-privileged sculptors that was mentioned in the previous chapter; understood as working in a sculptor's studio for artistic instruction, they were considered skilled artisans but not artists. Hoffman's studio assistants also included artists who had already achieved professional suc-

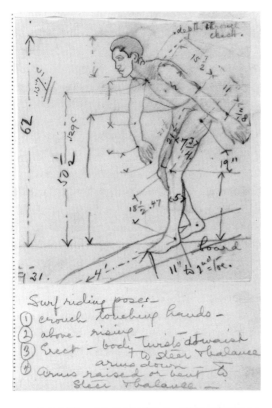

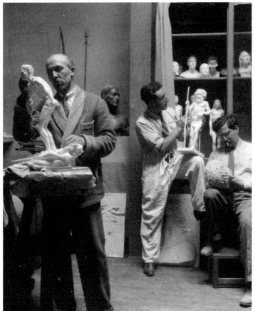

Figure 3.14. Malvina Hoffman, sketch for *Hawaiian Surf-Rider, Polynesia.* Malvina Hoffman papers, Research Library, The Getty Research Institute, Los Angeles (850042).

Figure 3.15. Assistants at Malvina Hoffman's studio in Paris. *left to right:* Rosso Rossi, Jean de Marco, and Louis Slobodkin. Malvina Hoffman papers, Research Library, The Getty Research Institute, Los Angeles (850042).

cess from competitions and had received commissions on their own. Duane Champlain, Karl Gruppe, and Louis Slobodkin, who worked in Hoffman's New York studio, fell into this category of sculptors. Champlain and Gruppe were members of the National Sculpture Society and won competitions and exhibited works at the Panama–Pacific International Exposition (1915) in San Francisco. Both had worked as studio assistants to established sculptors like A. A. Weinman and Karl Bitter.[91] Owing to the economic depression, Hoffman had her choice among highly qualified sculptors to hire as assistants. Yet she presented them as her students to Stanley Field. When the president expressed surprise upon finding Slobodkin at work in her Paris studio and asked why he was there, Hoffman replied that he was there for his "artistic education." The phrasing is significant; not only did it seem to satisfy Field, it elevated her status as an artist whom others sought out for instruction. The phrase also concealed the fact that Hoffman had a contract with Slobodkin for completing sculptures for the Field Museum project; she paid Slobodkin $42 a week and bore the cost of his travel to and from Paris. At the time that Slobodkin was working for her, the French government was expelling illegal foreign workers. Slobodkin believed that if the police knew he was working on a salaried basis, and not for his artistic education, he would be deported and Hoffman fined.[92] Hoffman employed other well-known sculptors in her Paris studio: Maurice Saulo, Rosso Rossi, and Georges Chauvel and Guerin.[93] Trained by Jules-Félix Coutan and at the École des Beaux-Arts, Maurice Saulo exhibited at the Salon d'Automne frequently after 1919 and received a Premier Second Grand Prix de Rome in 1927.[94] Georges Chauvel made models for ceramics and received critical attention from art critics, like André Salomon and Pierre Ladoue, for his ability to create the sense of movement in sculpture. Like Hoffman's studio assistants in New York, many of these sculptors had received awards and commissions on their own.

Hoffman's daybooks indicate their level of involvement in the production of the figures. For example, Hoffman noted in her daybook that on April 24, 1930, Louis Slobodkin worked on the "Indian full length" from a model, Chief Longlance, and that Reid [?] spent all day on the "white full length" figure at her New York studio.[95] For the same day, the sculptor listed her own activities as "coloring bacchanale panel," a sculptural relief unrelated to the commission. On April 25, 1930, Hoffman noted that she worked on the "Indian full length," a figure that Karl Gruppe had also helped to create, while Duane Champlain worked on the "field group."[96] At her Paris studio, Hoffman employed Saulo and Guerin during the summer of 1930. In her daybooks, she noted that Saulo

worked on "chinaman six hours" from a model and started the "bushman archer" for the *Bushman Family, Kalahari Desert* group with "Sahr" posing.

After her expedition to Asia, Hoffman had Louis Slobodkin return to her Paris studio for three months to complete six full-length figures and an unspecified number of heads and busts. Slobodkin believed that the hectic production schedule led to "cheap work." He remarked that he spent only five days on a life-size figure and that an "honest piece of work" required at least five days just to mass in the figure.[97] He also claimed that Hoffman used his sketches for some of the figures and that in the case of the *Ainu*, he completed it from a sketch he had made before Hoffman went to Japan: "She showed me some movies they had taken on their trips—flickery uncertain photographs of the Ainus in the native land. Ran them off at teatime after two days work was done. Now that the figure I'd modeled from the smaller sketch I'd made before she went to Asia, is finished, it is rather silly to show me the film. For my part and as far as the figure is concerned she might just as well have gone to Coney Island."[98]

After working for Hoffman for nearly two years, Slobodkin did not hold her artistic practice in high regard:

> The fifth figure of the series she began herself. I've finished number four and have commenced number six in the time that she has been puttering on that figure—and is going to [*sic*] badly and is in such an impossible state now I don't know what to do with it when she gives it to me—which I believe she will in a few days—Perhaps since it's the first time I've seen her begin work—always someone else constructs some semblance of the true form and she niggles and putters the surface—she feels self-conscious— You see, the time an artist shows himself as he really is, is in his primary indications—then you see his (or hers if they exist as "shes") innermost guts—then you see his (or hers) artistic bowels are clean fresh and clear— the surface work is acquired tricks and superficialities . . . [99]

Slobodkin's low opinion of Hoffman rested upon an argument leveled against many beaux-arts sculptors of being "surface modelers." Informed by modernist ideas of originality, Slobodkin believed that an artist should work up the sculpture in its entirety and not rely upon assistants to build up the "true" form. Claiming that Hoffman merely puttered the surface also questioned the creativity of women and evoked the nineteenth-century stereotype of women sculptors, who, it was claimed, relied upon male assistants to produce their work. However much Slobodkin abhorred Hoffman's sculptural practices, he

nonetheless believed that the Races of Mankind sculptures were a significant improvement over the ethnographic facial casts and plaster figures he had seen on display at the Trocadéro.

BECOMING MUSEUM OBJECTS FOR DISPLAY

After spending over $150,000 and investing over three and a half years of work in the project, the anthropologists at the Field Museum did not have a clear idea of what racial types Hoffman had produced for the hall. Hoffman's failure to complete anthropometric forms on her subjects created a situation in which the chief anthropology curator was still trying to identify certain figures almost a year after the exhibit opened. Although Berthold Laufer originally claimed that it was Hoffman's job to produce the figures and the anthropologist's job to assign their racial designations, in May of 1934, he was unable to classify some of the works based on their appearance.[100] The anthropologist attempted to sort the works by the sculptor's incomplete list of geographic locations. Having spent several days trying to identify works based on Hoffman's tribal and geographic names, Laufer claimed, "It is a miracle that the list is now as intelligent as it is ... almost all her names and identifications from India were wrong."[101] Laufer explained his difficulties to the director of the museum: "to cite one example, she has a label 'Kashmiri, Gwalior, Kashmir.' There is no place Gwalior in Kashmir; Gwalior is in north central India, which of course has nothing to do with Kashmir."[102]

Hoffman also submitted portraits as substitutes for types called for in the original contract. For example, she completed a portrait that she believed represented a Berber, since she could not locate materials to produce the required Bedouin. Laufer originally did not want to accept the work, because a Berber could not be substituted for a Bedouin.[103] He further explained, "It would have been much wiser and more businesslike on the part of Miss Hoffman first to have reported the fact that she could not get a Bedouin and to have asked for instruction, instead of going ahead with a subject not contained on the final list."[104] However, Laufer agreed to accept the work on the condition that he would substitute it for a head that the museum had reluctantly accepted earlier, called the *Elephant Hunter.* Laufer objected to this work because he believed that Hoffman made the head before she entered the contract with the museum, and therefore he could never be certain about the "tribe to which he belongs."[105] Stanley Field was not concerned about such anthropological matters, and instead he was persuaded by the sculptor's argument that she

had made substantial revisions to the original to make the work suitable for the museum's collection.

The sculptor's *Armenian Jew* (figure 3.16) created a dilemma for Laufer and the museum administrators. Laufer and Henry Field had initially planned to include an "Armenoid," but they were unable to decide whether to display it within the Asian or European section of the exhibit. Later on, they chose not to include it at all. When Hoffman presented them with a portrait that she believed represented a typical Armenian Jew, which the prehistorian Abbé Henri Breuil had approved, Stanley Field reminded the sculptor that the final list of figures included neither an Armenian nor a Jew. Laufer feared that the Armenian and Jewish communities in Chicago would criticize the museum for displaying the portrait: "An Armenian Jew should not be placed on exhibition as he is hardly representative of all Jews and Armenian Jews might protest and insist on adding other Jewish types."[106] He also could not

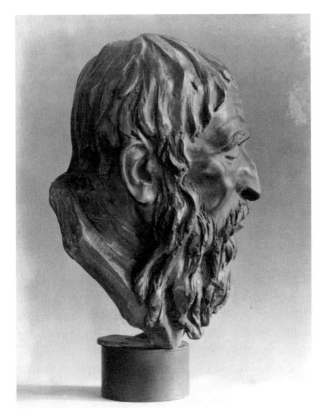

Figure 3.16. Malvina Hoffman, *Armenian Jew,* Hall of the Races of Mankind, Field Museum. Malvina Hoffman papers, Research Library, The Getty Research Institute, Los Angeles (850042).

understand how the bronze head had suddenly "metamorphosed into a genuine Armenian." Seeking a compromise, Stanley Field suggested using this term, but only if the portrait represented a typical Armenian. Responding to Laufer's criticism, Hoffman was purported to have replied, "Even if you call him just an 'Armenian,' even if you call him a Presbyterian, his face still proves his family's name is 'Shylock.'"[107] Her remark must have personally offended the anthropologist, but the museum administrators overruled his objections, and in February 1934, the head went on display. Shortly thereafter, Laufer placed a label under the work stating "Armenian Jew, native of Armenia." His gesture of renaming the work baffled Director Simms, since he believed that everyone agreed to omit "Jew" from the label. Perhaps, because the museum administrators had frequently disregarded his objections, Laufer wanted the museum to receive outside criticism. However, the portrait had a rather short life in the exhibition hall, where it remained on display no later than 1937.

Shortly after the Hall of the Races of Mankind opened, another incident occurred that realized Laufer's fear that some of Hoffman's sculptures might be found offensive. This incident, which involved the portrait entitled *Chinese Woman, Type of Scholar, Southern China* (figure 3.17), is a rare example in which one of Hoffman's models, or rather the husband of one of her subjects, responded to the prospect of serving as a representation of a racial type within an anthropology exhibit. A photographic image of the portrait was reproduced in an essay written by Arthur Keith for the May 20, 1933, edition of the *Illustrated London News* (figure 4.13). With its international circulation, the newspaper reached Wu Lien-Teh, a Cambridge-trained medical doctor associated with the National Quarantine Service in Shanghai. Dr. Wu was married to the author Wu Shu-ch'iung, who posed for photographs for the bust in December 1931. Dr. Wu was enraged to find a portrait of his wife in Keith's essay. On June 21, 1933, he wrote to the Field Museum condemning Hoffman for failing to obtain Mrs. Wu's approval of the finished sculpture and for its appearance in the *Illustrated London News*. Dr. Wu wanted the museum officials to curb "Miss Hoffman's unscrupulousness and stupidity," since he blamed the sculptor for having the "impertinence to place a distinguished and cultured Chinese lady among savages and Negroes" in the British newspaper.[108] The caption to the photograph, which read "a representative of the yellow or Mongolian race of mankind: a woman of Northern China," also offended Dr. Wu. He stated that Mrs. Wu was not a "northerner," but from an "ancient family in Foochow."[109] If, he claimed, Hoffman had wanted a "true mongol type," she could have found "many pure mongol women resident in Peiping." The term *Mongol* would have carried derogatory meanings

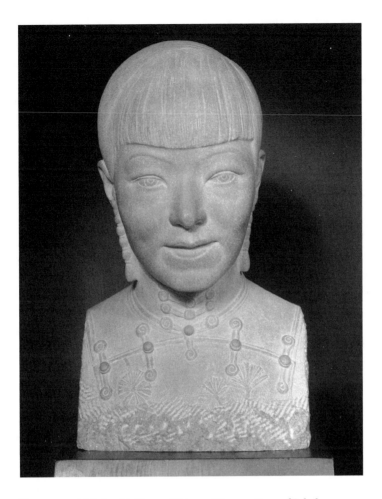

Figure 3.17. Malvina Hoffman, *Chinese Woman, Type of Scholar, Southern China,* Hall of the Races of Mankind, Field Museum. © The Field Museum, MH50.

for Dr. Wu. At the time, hostile relations existed among the different ethnic factions aligned with the Chinese Republic, Japan, and Russia, which were further exacerbated by the Japanese invasion of Manchuria in 1931 and its transformation into Manchukuo.[110]

Dr. Wu's letter generated a flurry of correspondence among Hoffman, Grimson, Laufer, and the president of the Field Museum. Stanley Field asked the sculptor for details concerning the portrait in order to respond to Dr. Wu's accusations. Hoffman admitted that she had used all her charm to persuade

Mrs. Wu to sit for her and that Samuel Grimson had taken a series of photographs and measures of her in the presence of Gretchen Green.[111] Hoffman claimed that Mrs. Wu was happy to have posed for her and that she had even given the sculptor a gift of an embroidered tunic, which the sculptor copied in the stone bust. Dr. Wu believed, however, that Hoffman failed to fulfill her promise in obtaining Mrs. Wu's approval of the final portrait.[112] In his letter to Stanley Field, Samuel Grimson claimed that Mrs. Wu had approved the work in Beijing and that he had given her photographs that he had taken of her.[113] In a March 27, 1933, letter to Malvina Hoffman, Mrs. Wu requested photographs of the completed portrait, which indicates that, in fact, she had approved only Grimson's photographs.[114] That Hoffman did not share Mrs. Wu's letter with the Field Museum officials, which would have shown that they were on amicable terms, suggests that the sculptor did not want them to know that she had not fulfilled her promise to Mrs. Wu. Defending Hoffman's honor, Grimson urged Stanley Field not to allow Laufer to give a "soft" response; he demanded that the anthropologist take Dr. Wu to task for his insults to his wife, which would not be made to "ladies of distinction in this country."[115]

In his diplomatic response to Dr. Wu, Berthold Laufer reminded Wu Lien-Teh of their friendship of many years and stated that he, too, thought the *Illustrated London News* had committed an "unfortunate blunder."[116] Laufer stressed the aesthetic value of the stone portrait, stating that it could not be judged by the newspaper's "poor reproduction" and that it was a "splendid piece of artistic sculpture, very lovely and admired by everyone."[117] He then explained that in the Hall of the Races of Mankind, the portrait of Mrs. Wu was displayed in a place of honor, in a "moon gate" shadow box placed at "a respectable distance" between the portraits of the philosopher Dr. Hu Shih and the well-respected geologist Weng Wen-hao, "not in the proximity of any savages."[118] Laufer stated that a museum display dealing with physical, and not cultural, aspects of man required equal representation of all races, regardless of their belonging "to savages or highly civilized nations."[119] He noted that the portrait of the "famous British anthropologist, Sir Arthur Keith" served as a type of Anglo-Saxon in the museum display.

Laufer blamed the *Illustrated London News* for the "clumsy captions," even though Arthur Keith had written them.[120] He pointed out that the Field Museum exhibited the bust under the title "Chinese woman, type of scholar, Southern China" and stated that while he avoided using the word *Mongol*, the term was entrenched within anthropology and was used to define a biological group.[121] Laufer explained that when anthropologists "say that the Chinese belong to the Mongol race, we do not mean any offence, but simply

state a scientific fact." Laufer then offered the following analogy: as the term *Caucasian* defined the most typical physical features of the white race, so, too, the word *Mongol* denoted the most typical peoples of northern, central, and eastern Asia. In both cases, one group of people, the mountain tribes of Caucasus or the Mongols of Mongolia, were chosen to serve as the most representative of the whole.

Laufer included a photograph of Mrs. Wu's portrait along with the guide-book to the hall in his letter to demonstrate that the "museum's motives were pure." He attempted to show that Hoffman also had pure intentions; he argued that the reason the sculptor had not fulfilled her promise to Mrs. Wu was that the sculptor was forced to leave Shanghai prematurely when Japanese soldiers attempted to invade the city. Along with this diplomatic letter, Field Museum officials relied upon Hu Shih, who had recently seen his own portrait and that of Mrs. Wu during his tour of the museum display, to persuade Dr. Wu of the merits of the work. Berthold Laufer made an agreement with Dr. Wu to restrict reproductions of the portrait.[122] Due to the incident, the museum officials also decided to restrict reproduction of the portraits of Mrs. Kamala Chatterji, Dr. Hu Shih, Sir Arthur Keith, and Mons. Eugène Rudier to avoid receiving adverse criticism of the sculptures in the future. However, Hoffman did not always comply with this prohibition, for she later reproduced images of all four of these works on the *Map of Mankind* (1946), despite the Field Museum officials reminding her of this early incident with Mrs. Wu.[123]

The incident concerning the portrait of Mrs. Wu must have exacerbated growing tensions between Berthold Laufer and Malvina Hoffman. In May 1933, he objected to Hoffman's clay sketch representing a Chinese male with a long braid. The anthropologist believed that Chinese would resent Hoffman's portrayal, since no one in China adhered to this hairstyle. The process of approving the sculptures had deteriorated to the point where Berthold Laufer urged Stanley Field to explain to the sculptor that it was "necessary to strictly conform to the needs of the department as already agreed to."[124] However, the anthropology curators continued to accept substitutions as late as September 1933.[125] Despite the increasing difficulties involved in producing and approving the sculptures, seventy-four of them were ready for display when the Hall of the Races of Mankind opened on June 6, 1933.

4. THE HALL OF THE RACES OF MANKIND

AT FIRST GLANCE, THE PLAN FOR THE Hall of the Races of Mankind (figure 4.1) appears to conform to the rules of classical museum architecture; two symmetrical galleries flank a central octagonal room. The west entrance to the hall oriented visitors toward this central room, leading to a second gallery containing a "special exhibit" area. However, photographs of this exhibit hall indicate that it departed from the tradition of classical architecture. Views from the primary entrance show bronze figures placed in front of stark piers situated between a series of rectangular alcoves (figure 4.2). An Art Deco cornice connected these austere elements and served to keep the eye from wandering upward and noticing that the seemingly solid piers and walls were actually partitions.

Camouflaging the Field Museum's Greek architectural vocabulary, these partitions formed an architectural screen to create a human-scale environment. Each alcove contained a small group of heads and busts mounted at eye level on pedestals, and some of the alcoves featured shadow boxes that pierced the architectural screen (figure 4.3). The central octagonal room reversed this arrangement; busts and heads rested against broad piers (figure 4.4), while full-length figures inhabited niches surrounding the *Unity of Mankind* sculptural group. The full-length figures rested upon wooden pedestals stained with translucent shades of walnut and other tones, and large benches were similarly stained to reveal the pattern of the grain. The linoleum flooring simulating wood and the partition walls painted in a "pale golden beige color" complemented these wooden materials. New methods in artificial lighting emphasized the sculptural qualities of the portraits, busts, and full-length figures: concealed indirect ceiling fixtures created highlights

GENERAL PLAN OF HALL 3

Figure 4.1. Plan, Hall of the Races of Mankind, Field Museum. Henry Field, *The Races of Mankind: An Introduction to Chauncey Keep Memorial Hall* (1933).

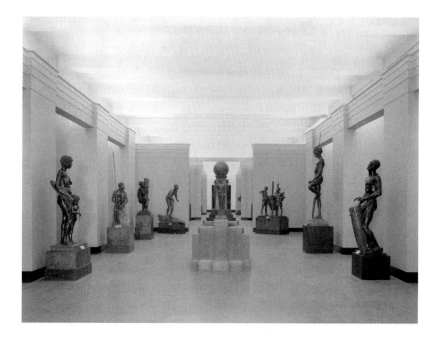

Figure 4.2. View of the Hall of the Races of Mankind, Field Museum (1933). © The Field Museum, CSA77747.

and shadows on the sculptures, a hidden cove lighting system equipped with metal reflectors illuminated each alcove, and an unseen backlighting system in three shadow boxes encircled the sculptures in a soft halo of light, which emphasized the contour of each stone bust (figure 4.3).[1]

Such an exhibition format, wood materials, and unusual lighting effects do not conform to installation practices employed in most art museums at the

Figure 4.3. View of Alcove, East Gallery. Hall of the Races of Mankind, Field Museum. © The Field Museum, CSA77748.

Figure 4.4. View of Central Room. Hall of the Races of Mankind, Field Museum. Malvina Hoffman papers, Research Library, The Getty Research Institute, Los Angeles (850042).

time. For example, the June 1932 issue of *Architectural Forum* featured Paul Cret and Jacques Gréber's 1929 plan for the Rodin Museum in Philadelphia as a model for deploying architectural forms to house a collection of works by a single sculptor (figure 4.5). This Renaissance-inspired setting epitomizes a classical "palatial" method of display, where natural light emanates from a central skylight to illuminate sculptures installed along peripheral walls. Few works inhabit the center of the space, since direct overhead light produces extreme highlights and casts dark shadows.[2] In such a heroic-scale setting, artworks conform to the monumental architectural space and natural lighting.

Figure 4.5. Paul Cret and Jacques Greber, architects, Rodin Museum, Philadelphia (1929). Courtesy of the Philadelphia Museum of Art.

In choosing to disguise the palatial architecture of the Field Museum, Malvina Hoffman and her collaborators combined a mixture of installation techniques that derived from an entirely different set of functional and aesthetic concerns. For instance, the practice of wrapping an architectural screen around the sculptures stems in part from European installation practices developed around the turn of the century. The so-called German cabinet, or small exhibition room, reverses the relationship between objects and architectural space.[3] In contrast to the monumental scale of the Field Museum or that of the Rodin Museum, the cabinet format exhibits objects within a human-scale environment. During the first three decades of the twentieth century, a growing number of curators and architects were critical of the palatial model and expressed concern over how display techniques elicited cognitive and perceptual responses from visitors. For instance, Franz Boas claimed that while the monumental scale of large halls created "architectural impressiveness," these museum spaces decreased the viewer's ability to concentrate on the objects on display.[4] The cultural critic Lewis Mumford also weighed in on the subject of museum displays in his 1918 essay "The Marriage of Museums." He urged fine art and natural history museums to rethink their methods of display in terms of an "active education," so they could move beyond the distracting effects of "princely loot" in art museums and the "hunter's cache" in natural history museums. From this vantage point, Mumford argued, curators would find a "communion of purpose" among museums and realize that "knowing and feeling are not warring 'faculties' of the mind, but diverse attitudes which men assume at appropriate times in their endeavor to have commerce with the things that lie about them."[5]

Mumford urged natural history museums to hire fine artists to design displays, since they possess a "synthetic vision," which could reconcile cognition with emotion and resolve perceptual problems frequently encountered in display methods such as the diorama.[6] In his assessment, the diorama exhibition format generated conflicting spatial effects; the highly detailed cast lay figures contrasted with the generalized painted backgrounds. Such spatial discrepancies also troubled Adolf Hildebrand, who earlier advocated reconciling near and far vision in sculpture through the medium of relief. Hildebrand claimed that panoramas presented confusing spatial effects that brought forth "an unpleasant feeling, a sort of dizziness, instead of the satisfaction which attends a unitary spatial impression."[7] Franz Boas also looked to visual experiences within panoramas, but unlike Hildebrand, he believed that darkened interiors and focused lighting systems of panoramas successfully resolved conflicting effects between two- and three-dimensional elements.

Yet Boas concluded that such panoramic effects could not successfully be recreated within natural history museums.[8] Lewis Mumford distinguished such unsettling perceptual effects that involved seeing exhibits within museums from a distance: "A plethora of discrete objects, especially when they are the same or similar objects, prevents one from seeing a single object: when the eye is overwhelmed with a horde of creditors crying for attention, it despairs of meeting any demand at all and goes bankrupt."[9] Benjamin Ives Gilman had earlier described this visual sensation as a "new form of mental exhaustion" and coined the term "museum fatigue" to describe it.[10] For many curators, the causes of this "institutional ailment" were the scale of the buildings, glare produced by skylights, and displaying too many objects in one place.[11] Considered in relation to Hildebrand's theories of perception, such synoptic exhibits fatigued viewers because the latter applied visual habits associated with near vision (i.e., a rapid succession of eye movements) to a distant view.[12] Although Mumford may not have been aware of Hildebrand's theories of vision, or Boas's critique of museum displays, he, too, considered contrasting perceptual effects and called for a "synthetic vision" to resolve them within museum displays.

In his essay "Museum Showmanship" (1932), the American stage designer Lee Simonson advised architects to rethink museum architectural spaces to solve the perceptual problems underlying museum fatigue. Instead of the palatial model, Simonson recommended focusing visitors' attention: "every wall space should be broken up wherever possible with angled planes, alcoves or projection screens so that no more than one picture or one vase is seen at one time."[13] For Simonson, tactile values of an exhibition space took precedence over the taxonomic logic of a synoptic display or the mimetic values of the diorama format, since they enhance viewers' perceptual and emotional responses.[14] Earlier, he had attempted to solve similar spatial effects in the theater, specifically those produced by live actors in front of large two-dimensional painted backdrops. Instead of applying illusionistic pictorial devices to stage design, Simonson followed the ideas of the Swiss theorist Adolphe Appia, who advocated using sculptural conventions to achieve visual unity in the theater. In his stage sets, Simonson used the human figure as the basic unit for proportions for the set, a practice that Appia recommended in his theory of stagecraft.[15] Simonson's installation strategies were also informed by the science of psychology, which he believed "established the primacy of our sense of touch and made all other senses extensions and verifications of it."[16] His readings of Bernard Berenson influenced his ideas concerning tactile qualities of space.[17] In *The Stage Is Set* (1932), Simonson included the follow-

ing quotation by the art historian to explain how tactile sensations produced immediate physiological effects in viewers: "With every change of space we suffer on the instant a change in our circulation and our breathing—a change which we become aware of as a feeling of heightened or lowered vitality."[18]

Simonson's installation practices should be considered in relation to those of Alfred Barr at the Museum of Modern Art. As Mary Anne Staniszewski notes in her study of his display techniques, Barr treated works of art not as "decorative elements within an overpowering architecture" but encased them within an "aesthetic shell."[19] She argues that the director placed objects on or slightly below eye level, in front of walls covered in beige monk's cloth, in order to increase the viewer's level of perceptual engagement. Staniszewski attributes Barr's innovations in installation design to his acquaintance with exhibition methods developed in Germany, such as those used at the Folkwang Museum in Essen and the renovated exhibition halls at the Hannover Landesmuseum.[20] Such experiments in museology not only suggest wide dissatisfaction with established installation practices, they reflect a shift in aesthetic and ideological concerns that reconceptualized museum displays in terms of a perceiving subject. Although many museum curators shared this viewpoint, they employed different exhibition strategies to engage museum visitors perceptually. The installation solutions developed by Barr and Simonson no longer required visitors to disengage from their physical surroundings; each element of the display worked toward situating viewers optically and haptically within an exhibition space.

What compelled the Field Museum of Natural History to install a display on race that engaged these emerging museological techniques? Certainly, the anthropology curators did not advocate an exhibition design that called for such a radical departure from traditional physical anthropology displays, such as those mounted by Aleš Hrdlička. Invested in the diorama exhibition format, Stanley Field was initially disinclined to adopt a format that deviated from those employed at the museum. However, he planned to standardize displays through a "modernization" program, which no doubt made him open to new installation techniques.[21] Malvina Hoffman did not have the theoretical acumen to design such an exhibit, but she did understand how much an "artistic impression" of a work depended upon the context in which it was seen.[22] The sculptor also knew that by collaborating with others, she could come up with a suitable installation format. No doubt confident that others would assist Hoffman, the president of the museum signed the October 27, 1930, supplemental agreement that authorized her to develop the installation design.[23]

Like Alfred Barr, Malvina Hoffman looked to European methods of display. The sculptor studied different installation techniques employed in German ethnographic museums; the Africa and Oceania rooms at the Volkerkunde Museum in Berlin especially impressed her.[24] Reinstalled in 1926, these exhibition spaces displayed objects within human-scale architectural units, and thus they relate to the cabinet idea.[25] Hoffman also studied the architectural forms, materials, and display formats within the Netherlands East Indies Building at the 1931 Exposition Coloniale in Paris. Combining Art Deco elements with a variety of Indonesian architectural forms, this building served as an example of the kind of environment that Hoffman envisioned for the Hall of the Races of Mankind.[26] She took Stanley Field and Marshall Field to the building, and they "agreed that the soft background of natural wood and severe plain lines for cases, benches, stands, etc., would be the best scheme to follow in the Hall of Man."[27] Their approval of such a scheme reversed the museum's earlier plan calling for a series of glass wall cases (figure 4.6).[28]

On November 10, 1930, Hoffman consulted Henry W. Kent, secretary of the Metropolitan Museum of Art, and Lee Simonson to develop her installation ideas for the display.[29] Simonson no doubt encouraged the sculptor to use

Figure 4.6.
Malvina Hoffman,
drawing, letter to
Director Simms,
Field Museum
(March 13, 1930).

The Hall of the Races of Mankind 89

tactile materials and to adopt an alcove format. She later hired a designer to build a small-scale model of one section of the hall so they could work out problems of scale and proportion.[30] The sculptor also met with representatives from the Curtis Lighting Company to develop a system of indirect lighting. As in the production of the sculptures, Hoffman relied heavily upon the involvement of others. Although her collaborators had little experience in designing physical anthropology displays, these curators, exhibit designers, and lighting professionals knew a great deal about new museological techniques designed to elicit spectators' aesthetic, physiological, and psychological responses.[31]

REPRESENTING CHARACTER AND PRODUCING AMBIGUITY

The spatial configuration of the exhibit set up a coherent system of correspondences that mediated the physical and conceptual distance between the museum visitor and the sculptures. With the two large galleries divided into a series of alcoves, visitors moved from large environments with full-length figures into smaller spatial units containing heads and busts. Writing in 1940, the geographer Elizabeth Eiselen lauded the Field Museum for this exhibit format: "Simplicity, one phase of artistic presentation, may find its expression in so arranging the display that the spectator is never confronted with large masses of material. The room containing the Races of Mankind exhibit at the Field Museum is so designed that attention at any one time centers on one life-size figure or on a group of three busts."[32] This arrangement corresponded to a conceptual order in which the full-length figures functioned as racial types, while the heads and busts represented racial variations.[33] Visible from either gallery, the heroic-sized *Unity of Mankind* sculptural group presented the three primary racial divisions to complete the taxonomic hierarchy.

The exhibit hall also presented viewers with formal and narrative structures to construct notions of race using a variety of interpretative stances, especially those revolving around notions of character. For example, the display fostered the physiognomic practice of inferring a racial essence or character from external features. On the other hand, many of the sculptural groups presented ethnographic stories that asserted the notion of a cultural personality or national character. At the time the exhibit opened, character served to link difference and similarity, general and particular, external and internal, as well as type and individual within taxonomies of race, typologies of culture, and constructions of individual identity.[34] Hoffman employed three compositional techniques to elicit such interpretations: organization of

sculptural elements through geometrical forms, such as a triangle; picturesque narratives in which figures are represented in an activity or "caught action" poses suggesting different temporal moments; and stereotyped or truncated compositions in which figures and objects are fragmented and require viewers to fill in the missing elements.

In a distant view of the west gallery (figure 4.2), the beige partitions provided a uniform background for reading the silhouettes of individual sculptures to compare bodily stature and contours, and for perceiving how figurative groups form compositional wholes. For example, the *Group of Cockfighters* (figure 4.7) is an assemblage of figures arranged in a triangular format.[35] The female figure,

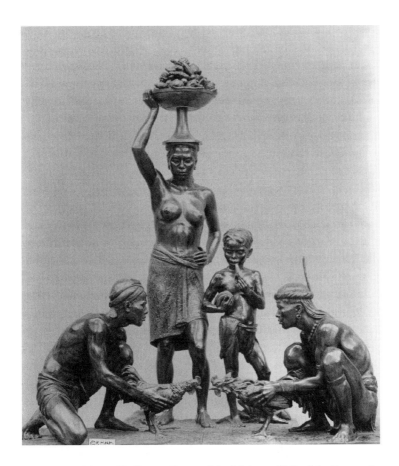

Figure 4.7 Malvina Hoffman, *Group of Cockfighters,* Hall of the Races of Mankind, Field Museum. © The Field Museum, MH88.

representing a woman from Bali, functions as a central vertical element, while the bowl of fruit serves as the apex to a base formed by two crouching male figures. From this distanced perspective, the pictorial format organizes the figures into a silhouette, where the impression of the whole obscures surface details. At closer range, viewers of the *Group of Cockfighters* could discern how various forms relate to the compositional whole. The gestures and poses of the figures suggest a balance between tense and relaxed forms. The female figure shown in contrapposto gracefully balances a bowl of fruit on her head; the figure of the small boy assumes a similar pose while eating a banana and glancing downward. The angular forms of the two squatting male figures counter the standing figures' relaxed poses, smooth surfaces, and placid expressions. Two roosters face each other and replicate the male figures' alert and confrontational stance. Other doubling effects, like the triangular group of fruit that reasserts the group's pyramidal composition, encourage viewers to shift their attention from large to small forms and to perceive formal analogies.

Despite Henry Field's claim that the work represents a composite of Malayan racial types, these figures form a story that characterizes the physical and cultural similarities of all Malayans.[36] The Malayan's mode of living is represented not as a struggle for existence, the theme of the *Bushman Family, Kalahari Desert* group (figure 4.8), but one in which food is plentiful and easily acquired and where daily activities consist of cultural events like cockfighting. The pyramidal format and balanced forms suggest that harmony or equilibrium is the defining physical and cultural characteristic of the racial group. Indeed, Malvina Hoffman intended visitors to reach such a conclusion, since she advanced the notion of an inheritable racial character in which bodily form, gesture, and pose reflect fixed mental and emotional qualities of a group.

Sculptures like the *Group of Cockfighters* could also function within anthropological discourses that did not assign a racial essence to a group. Proponents of the emerging field of culture and personality studies in American anthropology, such as Jane Belo and Ruth Benedict, viewed bodily poses and habitual gestures as evidence of an integrated cultural whole or national character. In her essay "The Balinese Temper" (1935), Jane Belo claimed that an "equilibrated, delicately adjusted, and essentially unstrained behavior" characterizes Balinese, and she found their culture highly desirable: "For the Balinese life is divided into two phases quite opposed to those of the modern city dweller in our world; the Balinese works in relaxation, and in his pleasure finds intense stimulation, whereas our city dweller works under a strain of intense stimulation, and for his pleasure seeks relaxation."[37] Instead of pur-

suing the notion of an innate racial character, Ruth Benedict attempted to define typical cultural patterns determined by social and historical processes.[38] Biological or evolutionary concepts did not inform her view of cultures as "aesthetically pleasing wholes."[39] As anthropologist Edward Sapir remarked in a lecture, "to speak of a whole culture as having a personality configuration is, of course, a pleasing image, but I am afraid that it belongs more to the order of aesthetic or poetic constructs than of scientific ones."[40] And in fashioning abstractions from observed particulars, Benedict and Belo encountered epistemological dilemmas that plagued taxonomists of race. Sapir cautioned his students that despite the general consensus that culture is not inherited, many anthropologists did not "always know whether to ascribe certain aspects of behavior to culture or biology."[41] Sapir also noted the conceptual difficulty in attributing a trait to a specific individual or to a larger group.[42] The overall uncertainty surrounding biological and cultural traits, combined with an emerging aestheticized notion of culture in American anthropology, increased the productivity of the sculptures. Oscillating between cultural and racial types, the figures supported multiple interpretations that could function within very different kinds of typological constructs.

Instead of the equilateral triangle used in the *Group of Cockfighters*, the *Bushman Family, Kalahari Desert* group (figure 4.8) is recognizable in a distant view as a right triangle with one long side. While the relaxed pose of the seated female figure with a baby balances the tense, awkward pose of the standing male figure to establish this triangle, the composition also constructs a picturesque narrative. The positions of the heads are directed toward the male figure's mid-action gesture of releasing an arrow from a taut bow. Ethnographic objects—the ostrich eggs for collecting water, and the bow and arrow for hunting—assert the anthropological idea that the most fundamental social grouping is a family unit of hunters and gatherers.[43] Indeed, a 1936 *Field Museum News* essay on this sculptural group claimed that it represents a hunting culture comparable to the Stone Age culture of early Europe.[44]

These familiar formal and narrative structures mediate the visual effects of surface details.[45] The perceptual disturbance that art historian Linda Nochlin aptly describes as an "appalling concentration on surface detail" involves difficult shifts between near and far vision to adjust to different orders of representation within each figure. Emphasized for their anthropological value as racial traits, isolated surface features demand equal attention and thus require viewers to move through different spatial registers.[46] For example, the deep creases on the male figure's stomach and the folds around knee joints offer a level of visual complexity distinct from the body forms and the simple

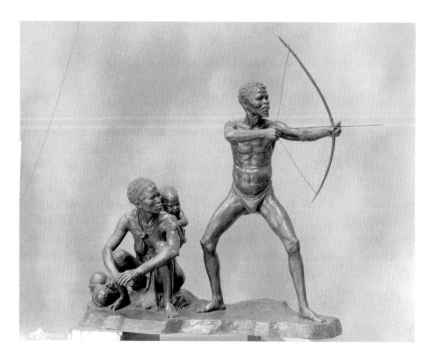

Figure 4.8 Malvina Hoffman, *Bushman Family, Kalahari Desert,* Hall of the Races of Mankind, Field Museum. © The Field Museum, MH1.

triangular format. The visual tensions between surface details and general design relate to the different modes of representation used to produce the figures. Archival documents support visual evidence that Hoffman used various body casts to produce the figures for this group.[47] These cast elements not only clash with the geometric format, they confuse the temporality of the whole by functioning as visual traces of prior moments of action. However, the compositional device hides one of the most defining racial features that anthropologists assigned to this group. The sculptor placed the female figure in a seated position and added the figure of a child to minimize the appearance of steatopygia. Hoffman later claimed that she did not want to model a figure that resembled the "monsterpiece of female ugliness," the infamous *Hottentot Venus* cast figure held in the collection at the Muséum National de l'Histoire Naturelle in Paris.[48]

Several of the full-length figures reflect a compositional strategy that differs significantly from those discussed above. Instead of reproducing a recognizable geometrical shape or a caught-action format, some of the figures evoke

a sense of compositional incompleteness in a distanced perception. For example, the shafts that end abruptly in the *Chinese Jinriksha Coolie* (figure 4.9) encourage viewers to imagine another compositional element, a rickshaw or carriage, to complete the silhouette.[49] In filling in missing elements, viewers would recall previously encountered images and actively decipher the story to create a compositional whole. This narrative strategy and literal fragmentation relates to Walter Lippmann's definition of *stereotype* as articulated in his highly influential text *Public Opinion* (1922). There, Lippmann did not

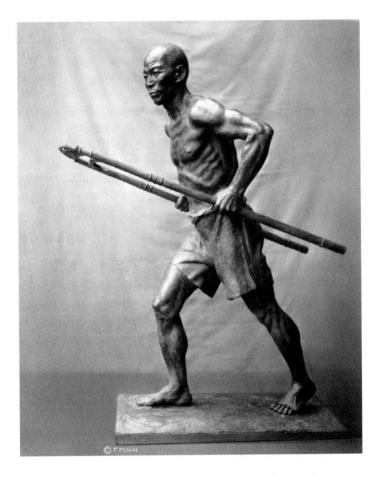

Figure 4.9 Malvina Hoffman, *Chinese Jinriksha Coolie, North Chinese Type,* Hall of the Races of Mankind, Field Museum. © The Field Museum, MH53A.

consider *stereotype* solely as a pejorative term; instead, he claimed it formed an economy of attention that was necessary to navigate chaotic aspects of modern life.[50] Lippmann defined the perception of a stereotype as an activity involving a "shortcut" process where viewers recall associations or traits through knowledge of preexisting images.[51] The figure's flexed deltoids and triceps, as well as the hands clenched around the poles, suggest hauling a heavy load. No doubt, Hoffman intended spectators to respond to this figure through imagining the bodily sensation of expending great physical force. As such, the work relates to the notion of stereotype forms described by the German sculptor Adolf Hildebrand, in which viewers empathetically respond to the representation of movement.[52] Moreover, the display of extreme muscular activity and the high level of surface detail of the hands and feet would provide physical anthropologists the opportunity for studying the structure and function of these body forms, which many considered fundamental to understanding differences between humans and other primates. For those physical anthropologists interested in the effects of the environment on race, the representation of hands and feet in action would suggest how habitual movements could modify body forms and how these adaptations hypothetically became fixed racial traits. The use of hands and feet served as evidence of different mentalities behind environmental adaptations and thus performed a crucial role in linking mind, body, and habitat in appraisals of race. Berthold Laufer recognized the research value of these body forms when he claimed that the figures "permit the study of the physical functions which are more important for evaluation of a race than bodily measurements."[53]

Placed in a niche within the central octagonal room, the *Nordic Type* (figure 4.10) is the only sculpture in the display shown fully nude and without ethnographic objects. Posed in contrapposto, the *Nordic Type* relates to the classical ideal in sculpture of balancing oppositional forces, such as tensed and relaxed muscles, stasis and movement. With the right arm above the head and the bent left arm, the pose of the *Nordic Type* recalls Rodin's *Age of Bronze*. While visually referencing the fine art tradition of the male nude, the figure also evokes the Hippocratic notion of health as harmonious equilibrium. The sense of horizontal, forward movement in the lower half of the figure, counterbalanced by the strong vertical pull of the upper half, generates an effect of balance between contrasting movements. This illusion of movement is achieved without recourse to Rodin's subtle modulations among forms; Hoffman instead chose a more tightly controlled depiction of muscular interaction and form. Posed to imply the culmination of a movement in a future moment, the raised arms suggest striving beyond the physical realm.

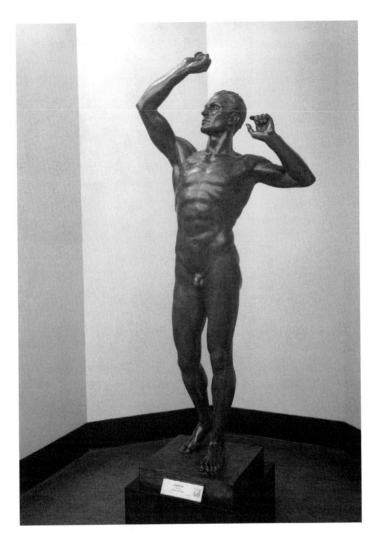

Figure 4.10. Malvina Hoffman, *Nordic Type*, Hall of the Races of Mankind, Field Museum. © The Field Museum, MH25B.

Based on an earlier version of this work (figure 4.11), Hoffman made changes to create this aspirational effect.[54] In her initial study, the ankles are more massive and the torso muscles are much more taut and compact. The combined effect generated by this initial model is one in which the legs, torso, and arms function as separate elements rather than as an organic whole. In the bronze sculpture, the lower pair of muscles of the torso is less prominent

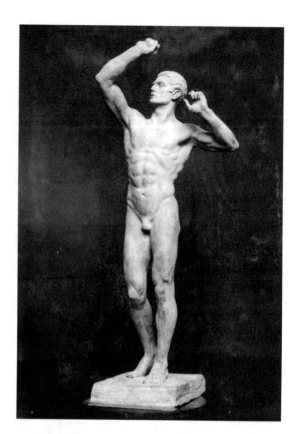

Figure 4.11. Malvina Hoffman, plaster sketch for *Nordic Type*. Malvina Hoffman papers, Research Library, The Getty Research Institute, Los Angeles (850042).

and the side muscles are diminished in size to enhance the effect of ascending movement. Hoffman also reworked the head and face. In the earlier model, the facial features conform more to a generalized ideal than in the finished figure, which shows particularizing elements such as the hollow depression in the cheeks. She also changed the position of the mouth from opened to closed, to express the idea of tight-lipped determination.

In its suggestion of striving beyond the physical realm, the *Nordic Type* evokes a sense of temporality associated with the *Age of Bronze*. As the French art critic Paul Gsell claimed in his widely read interview with Rodin, it reflected the transition from "somnolence" to "vigor" so as to convey the "first victory of reason over the brutishness of the prehistoric ages."[55] However, rather than transcending a moment in the distant past, the *Nordic Type* suggests transcending the present through self-mastery and control. The figure's

upward-stretching arms, the slight upward tilt of the head, and the arched eyebrows increase the illusion of physical power restrained by great cerebral effort. These forms and gestures invite viewers to infer internal causes such as intellectual mastery and rational control from external effects.[56] Such a presentation of the Nordic body would support the views of American eugenicists like Henry Fairfield Osborn and German race biologists like Hans Günther and Fritz Lenz. For example, in 1927 Lenz claimed that such bodily gestures reflect the Nordics' "aristocratic power of self-restraint."[57]

Although the full-length figures engage different notions of type, few evoke the sense of portraiture. The various compositional formats focused viewers' attention upon the poses and bodily gestures of the sculptures rather than on specific facial features. In contrast, the heads and busts offer a much subtler range of expressions and tend to vary between notions of type and portrait. The increased sense of individuation of the heads and busts encouraged different forms of engagement. Each alcove presented four or five heads and busts at eye level and in a position facing the larger galleries, which enabled visitors to see individual heads from either front or side views (figure 4.3). The soft beige color of the walls provided a uniform background to take in the contours or silhouettes of heads.[58] Such unobstructed views facilitated interpretative modes linked to different physiognomic traditions.

In a distanced perception, the profile view offered up the head for reading proportional relations between anatomical landmarks such as the nose, chin, and forehead, known as the facial angle. Viewers familiar with anthropometric photographs or the facial angle of Petrus Camper could analyze the head in relation to an imaginary grid made up of vertical and horizontal lines, with the ear serving as a fixed reference point. Maria Montessori, in her book *Pedagogical Anthropology* (1913), had encouraged her readers to superimpose such a grid when encountering a person or sculpture: "When an artist wishes to judge of the harmony of proportions in a drawing, a painting, or a statue, he often reconstructs with his eye a geometrical design that no longer exists in the finished work, but that must have served in its construction. In short, there exist certain secret guiding lines and points which the eye of the observer must learn to recognize, to trace and to judge. This is the way that we should proceed in studying the facial profile."[59] Montessori argued that observers would become skilled in recognizing degrees of prognathism by developing a "habit of tracing these imaginary lines," which she believed was better than a system of measurement.[60] In the guidebook to the Hall of the Races of Mankind, Henry Field also encouraged viewers to visualize a

similar system of imaginary lines: "In profile the face may project markedly forward from the line of the forehead, as among the Negroes (prognathism), in contrast to the normal projection among European peoples."[61]

From a frontal view, visitors could apprehend the shape of the head, nose, chin, and eye forms that the guidebook explained were essential racial traits. Frontal viewing also facilitated the decipherment of the countenance or expression formed by the depiction of facial muscles. Viewers could read these forms as isolated features and compare them to other facial features of a particular head, then try to assess the character of the portrait. As Arthur Keith argued earlier, scientific facts supported the common practice of reading facial muscles, "the servants of the brain," to infer the mental capacity of a subject: "Facial muscles of primates keep pace in their evolution with the brain; as the convolutions increase in number and capacity, the muscles of the face become smaller and more finely differentiated. The study of anatomy therefore supports the experience of our every-day life that much can be learned of mental character and capacity from the muscles of the face."[62] For those who did not subscribe to Keith's evolutionary ideas concerning the correlation of facial muscles and mental capacity, Hoffman's portraits were amenable to the renewed interest in pathognomy, the expression of emotion. American psychologists such as Carney Landis, who studied facial expressions, discredited the physiognomic tradition of deciphering facial features and the structure of the head: "physiognomists failed to achieve their hope of a permanent science, that is, they tried to correlate character with static features. We really judge character and emotions chiefly by the features in motion, by the play of expression, by the changing highlights and shadows brought about by the various muscular contractions and not, ordinarily, by any static pose." [63] Similarly, Rex Knight in "Character and the Face" (1932) discounted physiognomic studies that linked mental disposition to external physical features. The British psychologist found value in studying habitual expressions, and he claimed that the human face not only expresses transitory states of feeling, it shows signs of habitual emotions.[64]

The head entitled *Bengali Woman* (figure 4.12) presents an expression of spiritual contemplation. Hoffman achieved this effect of meditation by presenting the upper eyelids in a state between opened and closed.[65] The depiction of how the "upper valley of the lips fits into the little valley which surrounds the nostrils," as Hoffman later explained, also helped to convey expression, and in the case of the *Bengali Woman* it suggests an inhalation of breath.[66] Viewing this portrait in relation to the other sculptures in the South Asia alcove (figure 4.3), visitors could compare different facial expressions;

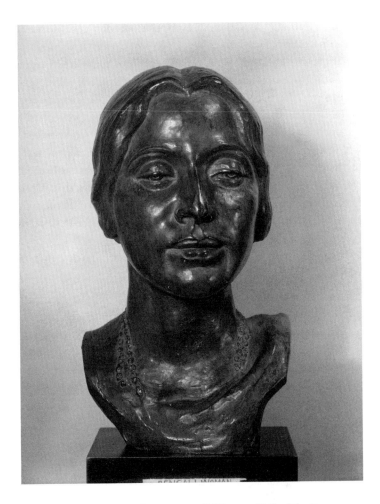

Figure 4.12. Malvina Hoffman, *Bengali Woman,* Hall of the Races of Mankind, Field Museum. © The Field Museum, MH39.

notice how three of the other portraits also exhibit downcast or slightly closed eyes and share the same expression of meditation. Indeed, Hoffman's commentary on the *Brahmin Benares* head, placed next to the *Bengali Woman,* confirms that inward spiritualness is the defining character of Indian racial types: "eyes are lowered, but not shut, he sees not, hears not, he speaks not[;] his world is evoked by his mind and he has found peace and contentment for his spirit."[67] The figure at the entrance of the alcove, *Kashmiri in Attitude of Meditation,* which Hoffman believed represented an Aryan type, furthers

this characterization.[68] A triangular composition, the figure is shown in a yoga pose on a base of lotus leaves with downcast eyes, as if deeply absorbed in meditation. In addition, the mandala-shaped opening of the shadow box containing the stone portrait *Jaipur Woman* furthers the idea of Indian spirituality. However, the male bust entitled *Bengali, India* does not present these signs of meditation. Instead, the bust exhibits a different expression in which eyes are open, as if glancing to the right. Hoffman later explained that she intended this expression to suggest how "too much Occidental reading" could disturb the "rhythm" of Eastern philosophy.[69] Taken together, the five portraits suggest different states of mental awareness and levels of spiritual development. From the standpoint of the sculptor, these works would offer viewers ways to reconnect with cosmic forces and thus overcome the destructive and accelerated pace of modernity.[70]

During a radio broadcast that aired on June 7, 1933, the day after the exhibit hall officially opened, Malvina Hoffman articulated a framework for performing such interpretative activities, in which white Americans would vicariously learn moral, spiritual, and racial lessons:

> We are all influenced by climate and surroundings and these affect the character of a race. We should not judge a person unless we know under what conditions he lives; from every one the others may learn much . . . May this effort result in bringing us into a simpler and more direct understanding of each other. We need to realize and practice more today than ever before the fine art of human intercourse, of mutual respect and honesty. Sailing the seven seas and studying the endless varieties of primitive people I found rare qualities in all of them. They have learned to draw their strength from the elements and natural forces that surround them. If only we can detect these qualities and by our own sincerity create mutual confidence there would be a strong formation laid for building up the Brotherhood of Man and restoring equilibrium to a distracted and unbelieving world.[71]

Informing Hoffman's view that Western society was spiritually bankrupt were the ideas of her friend Édouard Schuré and his popular theosophical text *Les grands initiés: Esquisse de l'histoire secrète des religions* (1889), which claimed that a new spiritual equilibrium could be reached through a reconciliation between western and eastern religions.[72] The aesthetic and ideological discourses of Bretonism, Orientalism, and Primitivism also asserted that the distracted urban subject could regain his or her spiritual equilibrium through an encounter with what the art historian Romy Golan calls "Concrete Man."[73] Constituted by spatial and temporal distance from the modern white subject,

she argues that this Concrete Man was believed to maintain direct contact with elemental life forces and to lead a simpler and more spiritual life.[74]

The *Unity of Mankind* (figure 4.4) served as a symbolic representation of the "Mongol, Negro, and Caucasian" racial stocks in the exhibit. The anthropologists intended each figure to embody the "highest physical qualities" of each race, and thus they viewed these figures as ideal or abstract types that functioned outside the temporality of the heads, busts, and full-length figures. When Arthur Keith claimed that this sculptural group represented the "central crux of modern anthropology," that "out of unity has come diversity," he located these heroic-scaled works in a temporal moment preceding the other works.[75] These figures metaphorically functioned as archetypes from which the other works emanate. The spatial arrangement of sculptures in the central room supported this metaphor, since the other sculptures in the room surrounded the *Unity of Mankind* group. The radiating bands of linoleum tiles served as an additional linking device between the central group and the figures, heads, and busts resting upon wood pedestals.

How individuals viewed "diversity out of unity" during the 1930s depended upon whether they emphasized similarity or difference in their racial ordering of the world. For example, the globe above the figures functioned to unify them and to represent the six continents of human habitation. However, different-colored patinas divided these geographic areas into three racial zones. The arrow, spear, and sword held in the figures' hands were read as weapons for protecting the earth or as instruments for protecting racial boundaries marked on the globe.[76] Hoffman explained these items in terms of the latter, claiming that they told the story of how "each race has defended its own boundaries."[77] Such an interpretation supported Arthur Keith's theory of race differentiation, in which racial prejudice functioned as an evolutionary mechanism for maintaining difference: "Race-feeling lies latent in men and women as long as they move among their own kind, but when they move outside the frontiers of their tribe or country deep instinctive feelings of race-prejudice are awakened and under certain circumstances may become inflamed and uncontrollable. I regard race-feeling as part of the evolutionary machinery which safeguards the purity of a race."[78]

Keith believed this instinctive mechanism currently manifested itself in the form of nationalism and war. He claimed that war served as "nature's pruning hook" and worked for humanity's benefit, although it undermined the altruistic efforts of the League of Nations.[79] Patriotism and nationalism, Keith argued, worked as an isolating mechanism, and without isolation, "evolution is powerless to work out new types."[80] He offered segregation in the United

States as an example of isolation at work, where white and black races "remain apart, each developing the qualities that nature has bestowed on them as a heritage from the evolutionary past."[81] Newspapers carried numerous stories on Keith's theory of race prejudice as an evolutionary mechanism and covered the criticism that it generated. Some opponents explicitly linked Keith's views to Nazism and fascism, while others chose to emphasize only one of Keith's terms, *altruism,* by arguing that sympathy, cooperation, and understanding were the necessary ingredients to forming a new society.[82] Keith's chief critic, Franz Boas, challenged him to prove that race antipathy is more instinctive than other, culturally created types of prejudice: "equally strong antipathies between denominational groups, or between social strata . . . are social phenomena."[83]

Wingate Todd, Wilton Krogman's colleague at Western Reserve University, believed that the research of Melville Herskovits lent support to Keith's views that instincts were involved in race building.[84] Like Keith, Herskovits saw the formation of human types as an ongoing process in which social selection was just as important a factor as natural selection. He also believed that segregation in the United States supported this process: "the American Negro is establishing a more or less definite physical type" due to "strong pressure, on the Negro side as on the white, against mixture with the other racial group."[85] However, Herskovits credited social norms and prejudices, and not an innate racial instinct, for contributing to the processes of evolution, and he reached the conclusion that "social processes lie deeply in the unconscious, and there is hence no rhyme nor reason to what will be selected by social caprice as desirable."[86] William O. Brown also argued that race consciousness is arbitrary. As the sociologist explained, "among the race conscious their race is reacted to as a social object. It becomes a fiction, a mental stereotype."[87] Brown recognized stereotype as an ideological construct "meaning all things to all men. Its utility grows out of this very inconsistency."[88] The *Unity of Mankind* figural group did indeed stand at the "crux of modern anthropology," engaging not only how people appear, but how people understand one another. The productive power of the sculptures, and the exhibit as a whole, rested upon straddling conflicting views of race and conceptualizations of the world.

TEXTUAL GUIDANCE

When the Field Museum inaugurated the Hall of the Races of Mankind on June 6, 1933, it opened without fanfare. Although a private tea was held to mark the occasion, Stanley Field adhered to the museum's tradition of simply

opening new exhibits to the public without elaborate ceremonies. However, the museum's publicity campaign for the exhibit hall had begun months earlier. In February 1933, Director Stephen Simms and Malvina Hoffman worked with the *Chicago Daily News* and the *New York Times* to publicize the sculptures. They collaborated with the newspaper staff in selecting photographic reproductions of the sculptures for their rotogravure sections, and they invited Arthur Keith to write an essay on the sculptures for the *New York Times*. Simms and Hoffman coordinated the release of publicity materials for the weekend of May 21, 1933, to advertise the opening of the exhibit hall, with the intent of attracting people who were planning to travel to Chicago to visit the Century of Progress Exposition. The opening also coincided with the annual conference of the American Association for the Advancement of Science. Serving as the chairman of the local committee, Henry Field made arrangements for the Section H anthropology sessions to be held at the Field Museum and organized a tour of the Hall of the Races of Mankind and the Hall of Prehistoric Man for conference attendees.[89]

Anthropologists and the general public alike encountered an incomplete display during the summer of 1933.[90] Didactic materials such as explanatory charts, maps, casts, and photographs that Henry Field intended to exhibit had not yet been installed in the "special scientific" section of the display. The sculptural series was also incomplete; Hoffman needed to produce figures representing North and South American types to fulfill her contract. Because these absent figures created spatial gaps in the central room, the museum curators placed works representing Asian types in the American and European areas of the exhibit, which defied the original plan. Sculptures displayed in the African section deviated from the racial scheme that anthropologists Alfred Haddon and Dudley Buxton had approved three years earlier. Their 1930 plan called for arranging the figures in a sequence to demonstrate racial mixtures and gradations in Africa starting with the *Bushman Family* figural group (figure 4.8), representing the "most primitive racial stock," and ending with sculptural busts representing Hamites or Euroafricans, the most culturally developed.[91] Formerly listed between the *Bushman* and *Negro* sculptures on a subsequent plan, the *Pygmy Group, Ituri Forest*, which Field believed represented one of the "oldest racial stocks in Africa," now appeared against the partition separating the African and European sections of the hall.[92] The Oceania section of the hall reflected similar changes from the 1930 plan. Instead of appearing at the end of the sequence of figures near the proposed "man and ape" display, the full-length figures *Australian Aboriginal* (figure 3.10) and *Australian Aboriginal Woman* were exhibited against piers sepa-

rating alcoves containing the Jakun busts and Javanese heads. The museum curators also decided to eliminate the "man and ape" display and to place the multifigure *Group of Cockfighters* representing Malayan types closest to the entrance, ending the sequence of figures.

Another change that significantly lessened the racial logic of the display was its location in the Field Museum. Instead of placing the exhibit next to the Hall of Prehistoric Man in the basement, as they had planned in 1930, Field Museum officials decided to install the display on the main floor of the museum.[93] This change in location removed the Races of Mankind sculptures from a phylogenic context and disrupted their original idea of telling the complete "story of man." As Stanley Field explained in a letter to Malvina Hoffman, "We have all concluded that we have been working on the wrong theory when we have said that a proper scientific sequence demanded that the Hall of the Races of the World must be next to the Hall of Prehistoric Man and that there is no reason why these two halls should not be separated."[94]

Due to the lack of didactic materials, the incompleteness of the display, and the exhibit's dislocation from a phylogenic past, museum visitors were offered little guidance to make conceptual distinctions within the exhibit hall. The *Races of Mankind* guidebook (1933) provided an overall plan of the display to help visitors orient themselves within the space (figure 4.1). The guidebook listed the sculptures in their order of appearance, starting from the right side of the main entrance. The curators intended visitors to move through the exhibit along a circuitous route, metaphorically traveling across Africa, Europe, Asia, America, and Oceania. The architectural plan of the exhibit hall and the geographical ordering of the figures achieved a level of coherence through the motif of a travel itinerary. However, the three essays following this diagram in the guidebook offered conflicting ways to understand the exhibit as a demonstration of race. Berthold Laufer explained that the display promoted human sympathy. Arthur Keith claimed that the display fostered an instinctive ability of diagnosing race. Henry Field presented the display in terms of an objective account of "human biology" or "man as an animal species," based on standardized anthropometric measurements and indices. These guidebook essays demonstrate how Hoffman's figures successfully mediated different theories of race.

Although Berthold Laufer initially resisted "trimming up" the figures with ethnographic accessories, because he believed that such elements shifted the display away from biology and toward ethnography, he relied upon the various narrative effects of the sculptures to promote human sympathy: "If the visitors to the hall will receive the impression that race prejudice is merely

the outcome of ignorance and will leave it with their sympathy for mankind deepened and strengthened and with their interest in the study of mankind stimulated and intensified, our efforts will not have been futile and will have fulfilled their purpose."[95] For Laufer, the exhibit served as a way to transform racial attitudes; he intended visitors to readjust their perceptions of themselves and of others through viewing the sculptures. Such a conciliatory stance, he argued, was fundamental to anthropology, the "science of human understanding." Laufer envisioned his visitors as white Americans; he used the possessive pronoun "our" throughout his essay to include readers in his condemnation of white domination: "with the advance of our civilization and the white man's expansion all over the globe many primitive tribes are now doomed to extinction and are gradually dying out."[96] Laufer also claimed, "It is chiefly social and legal restriction and segregation" in America that "keeps their [African American] race consciousness alive."[97] From his perspective, responsibility for these actions morally required white Americans to change their attitudes. However, in assigning blame, the anthropologist gave the white American viewer the power to change, a power he denied to the "primitive tribes." Eventually, Laufer claimed, "many a vanishing race will continue to live only in the statues and busts displayed in this hall."[98]

Laufer cautioned his readers that anthropology was a young discipline and that there was little agreement as to its "methods, conclusions, and results." Racial classifications in particular required special caution, since no reliable method had been developed that went beyond everyday assessments based on skin color.[99] Laufer disassociated hereditary traits from those relating to culture or social heritage and argued further that the concept of race needed to be considered separate from language, culture, and nationality, since "much harm has been done by the general confusion of the terms."[100] He also claimed that there is "no such thing as an Aryan race, nor are blond hair, fair skin, and blue eyes characteristic of Indo-Europeans."[101] Appearing six months after Hitler became chancellor, Laufer's refutation was an attempt to undermine Nazi theories of racial superiority. The anthropologist's claim that the behavior of a nation was determined not by its biological origin, but by its cultural tradition, significantly contrasted with Nazi racial theories and with those of Arthur Keith. However, Laufer did not argue that races were equal, nor did he claim that races were mutable.[102]

Aware of the increasing criticism of German race hygiene ideas and the controversies surrounding his own theories, Arthur Keith refrained from explicitly stating them in his guidebook entry. Instead, the anatomist indirectly presented his theory of race evolution by contrasting different mu-

seum methods of exhibiting race. He claimed that by mounting a sculpture exhibit, the Field Museum departed from physical anthropology exhibits containing skulls, facial casts, photographs, and charts, which were oriented to professional students of anthropology and were "likely to repel rather than to attract visitors to the study of mankind."[103] The value of the Hall of the Races of Mankind, Keith suggested, was that it catered to general audiences, who unconsciously made racial assessments every day. Keith claimed that everyone practiced a form of physiognomic perception and did so from birth. This form of anthropological knowledge, the anatomist argued, only increased through time; year after year, "we have continued, quite unconsciously, to add to our gallery of mental portraiture."[104] For Keith, scientific measurement could never rival the "accuracy and completeness of the rule of thumb method practised by the man in the street."[105] His faith in this skill led him to state that "the eye, at a single glance, picks out the racial features more certainly than could a band of trained anthropologists, who depend on measurements" to make their racial assessments.[106]

Keith also claimed that some individuals possess a greater capacity to discern race than others. A true artist, like Malvina Hoffman, he argued, secured a racial likeness because her "mirror of imagination caught from her sitters and held only the essential traits of race."[107] By advancing the idea that Hoffman intuitively selected essential characteristics, Keith used Neoplatonic ideas to support his notion of race, in which gifted individuals recognized an essential type. He had earlier called such gifted individuals "artist anthropologists," who "can clothe dry bones with living flesh, give expression to eyes and mouth, suggest mentality and with a few simple lines give a more vivid realization of national types than is possible for a professional anthropologist, whose portraits are but lists of measurements."[108] According to his earlier publications, this instinct, which functioned as an evolutionary mechanism, was related to race and gender: Nordics had a strong instinct for race prejudice, and women possessed a greater capacity for it than men.[109] Because Hoffman possessed the ability to detect race and to demonstrate it in concrete form, Keith argued, the exhibit provided viewers with "priceless registers of anthropological fact" that were "scientific documents as well as works of art."[110]

Arthur Keith explicitly linked the Races of Mankind sculptures to his theory of race evolution in "Races of the World: A Gallery in Bronze," which appeared in the *New York Times Magazine* two weeks before the exhibit hall opened.[111] Keith theorized that the human family comprised four races, and not three as proposed in the guidebook, and he argued that various peoples visibly exhibited different stages of racial evolution, during which recog-

nizable racial traits became more common and more distinctively marked. According to Keith, the Races of Mankind sculptures served as evidence of this ongoing process, but some "orthodox anthropologists are shaking their professional heads" over the exhibit hall, since science had been sacrificed for art. Keith originally wrote "orthodox anthropologists in a huddle," but this phrase alarmed the editors of the newspaper and prompted them to contact the Field Museum to see if it could be changed. In a letter to Berthold Laufer, Keith explained that he had included the phrase because he believed that Aleš Hrdlička "would be inclined to curse [the museum's] scheme" and that he wanted to "get one in, in advance," to deflect criticism.[112] Keith understood his power as an established authority on race; if Hrdlička or other anthropologists wanted to criticize the sculptures, they would have to denounce the anatomist's theory of racial evolution.

On his own initiative, Keith wrote "Art Wedded to Anthropology" for the May 20, 1933, edition of the *Illustrated London News*, which presented visual exercises for readers to apply their physiognomic skills to photographic reproductions of the sculptures (figure 4.13).[113] Compare the image of the *Australian Woman* with that of the portrait entitled *Kalahari Bush Woman*,

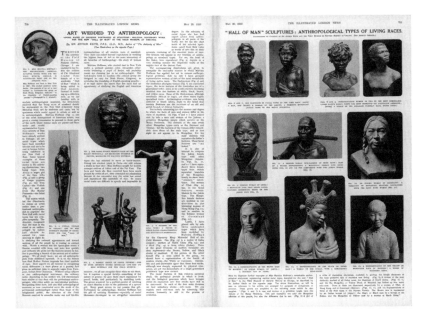

Figure 4.13. Arthur Keith, "Art Wedded to Anthropology," *Illustrated London News* (May 20, 1933). Illustrated London News/Mary Evans Picture Library.

the anatomist suggested, and see how the former illustrates generalized racial features, while the latter reveals many specialized traits.[114] He then instructed his readers to consider the photographic image of Malvina Hoffman, whom he claimed was an example of the "white or Caucasian" race, and compare it to the reproductions of the works captioned *Jaipur Woman, Sudanese Woman,* and *Chinese Woman* (the portrait of Mrs. Wu). By incorporating an image of Hoffman into his lesson on racial portraiture, Keith linked the sculptor, physically and conceptually, to his idea that a racial instinct functioned as an evolutionary mechanism.

In his contribution to the museum's guidebook to the display, Henry Field avoided Keith's theory of racial evolution; instead, he relied heavily upon the writings of Alfred Haddon and other British anthropologists. Field unequivocally presented classifications of race, despite Laufer's statement that they were unreliable. While he acknowledged that physical anthropologists devised different racial schemes, Field claimed that standardized measurements facilitated comparative analysis.[115] He identified three well-known craniological indices as fundamental to such comparisons: the cephalic index, the length-to-breadth ratio of the head; the gnathic index, the angle of the projection of the face; and the nasal index, the length-to-breadth ratio of the nose.[116] Field also identified nonmeasurable traits, specifically hair shape and skin color, as the basis for the three primary classifications of race (Caucasian, Mongolian, and Negroid) and added stature, eyes, nose, ears, and lips as other physical features critical to its determination.

Shortly after the guidebook's publication, Henry Field sent complimentary copies to various advisors to the project and to other well-known anthropologists. No one seemed disturbed by how Field, Keith, and Laufer presented conflicting ways to understand the Races of Mankind sculptures. The former assistant to Malvina Hoffman, Wilton Krogman, congratulated Field for "compressing salient facts on race into a few clearly written pages" and stated that "the paper will certainly achieve its purpose of acquainting the public with race and race problems."[117] The French philosopher and anthropologist Lucien Levy-Bruhl hoped that the booklet would be "widely read" and receive the "success it deserves."[118] Melville Herskovits also praised Henry Field for the guidebook, stating that he would use it and the exhibit hall when teaching his Races of Man course at Northwestern University.[119] Reviews of the booklet published in the *American Anthropologist* and in *Eugenical News* confirm that the museum's strategy of providing different frameworks for the Hall of the Races of Mankind helped to ensure the acceptance of the sculptures as representations of race within diverse anthropological communities.[120]

Six months after the exhibit hall opened, Henry Field set out to reduce the ambiguity of the Races of Mankind sculptures by anchoring them to his understanding of physical anthropology. On January 2, 1934, Henry Field completed revisions to his plans for the "special scientific" section of the exhibit hall, which called for filling wall cases with charts, photographs, x-rays, specimens, and maps to articulate subjects that he considered crucial to racial studies: physical characteristics of race; demography; uses of hands and feet; racial relationships; artificial deformations of the body; brains, growth changes, and physical anomalies; and a comparison of the skeletal structure of primates.[121] These topics reflected three general concerns that Field considered crucial to race biology: comparative analysis of physical traits constituting race, human evolution, and cultural modifications of the body. Field chose these topics for display after surveying various museum exhibits. As noted earlier, he had toured Hrdlička's physical anthropology exhibits in the San Diego Museum of Man and hired an artist to copy many of those exhibits' charts in 1930. He visited the American Museum of Natural History's physical anthropology exhibits and studied types of cases, labels, and objects on display. In July 1933, Field studied Wingate Todd and Wilton Krogman's display on variation in human growth, which focused on brain development, in the Hall of Social Science at the Century of Progress Exposition. One month later, Field returned to the American Museum of Natural History and took detailed notes on William K. Gregory's evolutionary displays.

Henry Field wanted to include the subject of eugenics within his special exhibit section of the hall. Guided by Harry H. Laughlin, the superintendent of the Eugenics Record Office, Field toured the exhibits at the Third International Eugenics Congress, held at the American Museum of Natural History, in 1932. Field compiled a detailed list of the exhibits and charts and concluded that "there are many suggestions for exhibit material in Hall 3 [the Hall of the Races of Mankind] which would be of educational value and interest to the general public."[122] In his January 8, 1933, plan, Field listed "Heredity and Eugenics" as including the following topics: race mixture in Hawaii; the inheritance of musical talent; color design; color blindness; alcoholism; and the heredity of the "Hapsburg lip."[123] He also proposed a separate demography case, which would present vital statistics of population growth, race problems in the United States, immigration, and anti-miscegenation laws. In another case, Field intended to mount charts that dealt with crime

statistics, the sterilization of criminals, and the Bertillon fingerprint system. He also wanted to display eugenic pedigree charts representing "defectives," the "genius class," and a "normal family."

Harry Laughlin believed that, in contrast to displaying charts, Henry Field's Hall of Prehistoric Man dioramas offered an innovative way to present eugenics to the general public. An article in the July–August 1933 issue of *Eugenical News*, "Eugenics as a Museum Subject," claimed that Henry Field intended to mount a new exhibit hall that would utilize the diorama method of display to demonstrate that eugenics was "the science by means of which man can in substantial degree, direct his own future of evolution."[124] In December 1933, Harry Laughlin privately urged the physical anthropologist to follow through with his plans for installing the new exhibit hall at the Field Museum.[125] However, Henry Field backed away from the idea: "The time will come very soon when eugenics will be given its proper place and I can assure you that I should like to see some work done along those lines in this museum. It seems out of the question to do anything really constructive at the moment, but I am very much interested in the subject, and shall make every effort to inaugurate the work when ever possible."[126]

Despite Henry Field's enthusiasm for eugenics, he omitted the Heredity and Eugenics display and Crime display from his January 2, 1934, plan. His description of the technical section within the 1934 edition of the guidebook confirms that the physical anthropologist no longer intended to link the Hall of the Races of Mankind explicitly to eugenics. What impelled Field to remove the eugenic displays is not entirely clear. Wingate Todd had earlier suggested that Henry Field mount displays that lessened the importance of race in demography; as he explained, "the orthodox concept of demography with its restrictions to so-called racial types appeals to me very little."[127] Instead of following the advice of Laughlin or Todd, Henry Field chose to recapitulate physical anthropology methods concerning racial classification, cultural modification of the body, and human evolution. He adopted an exhibition strategy that cobbled together well-known concepts and images that deferred to established authorities on race.

In many of these displays, Field mounted charts and illustrations featured in anthropology texts commonly used in college-level courses. In so doing, he attempted to bring the exhibit hall in line with Berthold Laufer's position that the museum displays in the Anthropology Department were equivalent to university courses.[128] Although Henry Field did not state that he developed the technical section of the exhibit hall for university students, the various displays required viewers to possess anthropological expertise. His schematic charts

and maps summarizing racial traits and their geographic distribution, as well as his explanatory labels of various nineteenth-century craniological indices, would have required viewers to have prior knowledge of these anthropological concepts. A letter by a Chicago resident, written over thirty years later, confirms that these technical exhibits were not intended to educate the general public. The Chicagoan asked the museum director to explain the relationship between the Races of Mankind sculptures and the technical displays, since it was not readily apparent. He stated that after viewing the technical section of the hall, he could not understand how anthropologists used physical traits in their racial classifications.[129] On the other hand, anthropologists would have noticed that Field did not acknowledge scholarly disputes concerning the methods of physical anthropology, such as the reliability of the cephalic index, and would have recognized other inconsistencies in his choice of materials, which in some cases offered competing theories of race and evolution. To put it simply, Henry Field began to install displays in January 1934 that both Stanley Field and Arthur Keith considered "dry as dust," that were less oriented to the general public or researchers than to college-level anthropology students.

In the *Physical Characteristics of Mankind* wall case (figure 4.14), Field arranged hair samples, charts, and maps in a tabular format to present physical

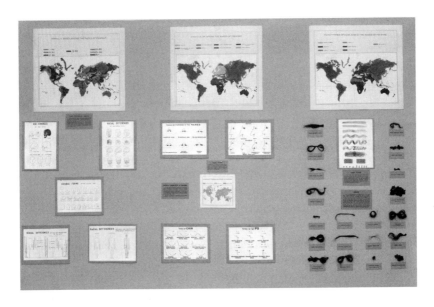

Figure 4.14. Henry Field, *Physical Characteristics of Mankind* display, Hall of the Races of Mankind, Field Museum. © The Field Museum, A78412.

traits that anthropologists used to construct racial classifications. A label credited the drawings to Aleš Hrdlička, who had exhibited them earlier at the Panama–California Exposition. These charts used Hrdlička's terms, such as "Yellow Brown Race" and "Colored," which were not part of the vocabulary used in the guidebook or in the exhibit hall.[130] Field arranged the display case by placing world maps summarizing the distribution of the cephalic index, skin color, and hair types at the top of three columns. This layout followed a display technique recommended earlier by former Field Museum geology curator Oliver Farrington, who recommended placing large labels, like "headlines in a newspaper column," within display cases to "show at a glance the character of the contents" and to engage familiar habits of reading.[131] The right column of the display, which presents hair as a racial marker, follows this strategy: the large map denoting geographic distribution of hair types is placed at the top of the column, below which appear examples of hair form and texture illustrated on a chart copied from Rudolf Martin's well-known *Lehrbuch der Anthropologie*. Four rows of hair swatches were placed near this chart, suggesting that Field intended viewers to situate hair types within geographic locations.

The legibility associated with a tabular format loses coherence in the other two columns. At the top of the left column, a world map represents the distribution of the cephalic index, but most of the drawings in this column are unrelated to this index. The top row of the middle chart, "Racial Differences of the Skull," does label three skulls with terms associated with the cephalic index, which played an important role in classifying races.[132] However, the second row of the chart, representing back views of three skulls, is related not to the cephalic index, but to the vertical index, the ratio of the height and length of the head. The third row of the chart, depicting three skulls in profile, illustrates the gnathic index, commonly known as the facial angle. The bottom row's three frontal views of the skull simultaneously present three different indices: the facial length, the orbital index, and the nasal index. The chart does not identify these indices, nor does it explain that craniologists failed to demonstrate how indices distinguished fixed types within distinct geographical areas. As Alfred Kroeber later acknowledged, "There is, for instance, no typical head form for the Caucasian race. There are narrow-headed, medium-headed, and broad-headed Caucasians."[133] Moreover, Field presented methods of analyzing the skull that involved observational, and not metric, techniques in another chart. While craniology encompassed both craniometric and cranioscopic methods, "orthodox" anthropologists, as Arthur Keith claimed relentlessly, preferred the former method, since many

of them considered measurement to be the most objective means to study racial differences. Although Field credited Giuseppe Sergi on the chart, he did not explain what these rows of skulls were intended to represent, or that the Italian anthropologist's system of classification of skull types reasserted observation over measurement. Sergi's theory of craniological shapes, based on geometric figures such as the ellipse and the pentagon, challenged the status of craniometry. Field offered no explanation for how these charts represented metric and observational techniques, nor did he indicate that they constituted conflicting approaches in craniology.

The center column likewise contains inconsistencies. The skin-color-distribution map at the top is unrelated to the drawings that appear underneath it, two diagrams of noses and a small distribution map that correlated nose shape with climate. At the bottom of the center column, Field included two drawings that represent profile and frontal views of chins and lips, features unrelated to the nasal index and uncorrelated with climate. What are the connections among variations of skin tone and nose, lip, and chin? The display does not offer an answer, nor does it explain how anthropologists used these physical traits to distinguish racial types.

Henry Field's guidebook essay indicated how these traits might be combined to form a type. In his description of races, Field frequently employed terms that suggest how aesthetic distinctions played important roles within physical anthropology. For example, he used the terms *aristocratic* and *coarse* to classify Japanese people into two different types.[134] According to Field, the aristocratic type possessed "fine features" and was "tall and slender, with an elongated face, a prominent, narrow, arched nose, eyes either straight or oblique, and the epicanthic fold rarely absent."[135] In contrast, the coarse type, made up of immigrants from Southeast Asia, was "short and stocky, with a broad face, short, concave nose with rounded nostrils, an oblique eye, usually an epicanthic fold and a darker complexion than the other group."[136] To justify his claim that the *Jakun* and *Jakun Woman* busts represented a primitive group from the Malay Peninsula, Field suggested that visitors physiognomically compare these works to a head displayed in an adjacent alcove: "In marked contrast to these primitive types, there is a pure type of Malay (No. 61) whose features express a high grade of intelligence compared with the Jakun."[137]

Field relied upon the ideas of British anthropologist Charles Seligman to make similar assertions concerning other heads and busts in the African section exhibiting "fine, delicate features."[138] Seligman's widely known "Hamiticization" theory claimed that ancient migratory invasions created different levels of cultural and racial development in Africa.[139] According to his book

Races of Africa (1930): "The history of Africa south of the Sahara is no more than the story of the permeation through the ages, in different degrees and at various times, of the Negro and Bushman aborigines by Hamitic blood and culture. The Hamites were, in fact, the great civilizing force of black Africa."[140] In his comparison of "Hamites" with "True Negroes" and "African Pygmies," Field stated that Hamites were further removed from the latter two groups because they exhibited "refinement of facial features." Hamites, he argued, "belong to the Caucasian branch of mankind," a type that possesses a "long head, an oval elongated face with no forward protrusion, thin lips, pointed chin, and a prominent, well-shaped, narrow nose."[141] When confronted with the bust *Mangbetu Woman* (figure 3.7), which defied his three-race classification, Field claimed that it showed "primarily a true Negro type; but the light brown skin of the aristocratic class suggests some Hamitic mixture."[142] These assessments illustrate the partiality of typologies of race. By combining seemingly value-neutral descriptions of individual traits, racialists assembled types that were value-laden and hierarchical.

Henry Field illustrated a racial hierarchy using a more familiar pedagogical device, the phylogenic tree, in his *Races of Mankind* display (figure 4.15). The tree diagram had appeared in many scientific explanations of evolution after the German biologist Ernst Haeckel introduced it in the mid-nineteenth century.[143] This diagram was featured prominently within displays intended

Figure 4.15. Henry Field, *Races of Mankind* after Viktor Lebzelter, Hall of the Races of Mankind, Field Museum. © The Field Museum, A78413.

for general audiences at the Century of Progress Exposition; in the Hall of Science, the tree diagram served as a way to weave disparate objects and images into a narrative of evolutionary progress. Diagrammatic trees and pedigree charts such as those displayed at the 1932 Third International Eugenics Congress had also served as the primary means for eugenicists to explain their racial project of better breeding.

In the Field Museum display, the tree diagram represented evolutionary development through a profusion of branches stemming from nine trunks sharing a single horizontal root, labeled *Pygmy Stock*. Small labels incorporating Alfred Haddon's terminology identify different racial types and racial stocks, but Field credited the Austrian anthropologist Viktor Lebzelter and his exhibit at the Museum of Anthropology in Vienna for the design of the display. The branches and trunks convey the idea of different evolutionary stages. Those trunks closest to the root, resembling a slight shoot, hold only one or two photographs and thus suggest evolutionary dead ends (in Haddon's terms, lower, stagnated racial groups.) Those branches extending the full length of the display would have indicated specializations or higher races, which Haddon earlier claimed had "blossomed into several varieties" because of their plasticity.[144] To suggest how the workings of evolution depended upon climatic conditions, three colored bands were added to represent different geographic zones. Europe and Asia, which Haddon had argued provided the most favorable conditions for adaptations, contained many branches and photographs.

Unlike William K. Gregory's "Man among the Primates" wall chart, exhibited at the American Museum of Natural History and within the Hall of Science at the Century of Progress Exposition, the primary trunk was not envisioned as white, culminating with a classical athlete; rather, the thickest trunk served to denote the Mongoloid stock.[145] If plasticity served as the criterion for a hierarchical ranking, as suggested by the thickest trunk, then the racial types classified within the Mongoloid stock would hold the highest rank. However, such a hierarchy was undermined by the placement of the photograph labeled *Nordic* above all the other photographs. This photograph, along with those labeled *Mediterranean, Hamite,* and *Arab,* emanate from the trunk labeled *Euroafrican stock,* while the photograph marked *Alpine* is presented as part of the *Euroasiatic stock.* Such phylogenic relationships differ from the classification of races that Henry Field offered in the guidebook to the hall, where he placed the Nordic, Mediterranean, and Alpine into a single category based on geographic location in Europe. Field offered no reason for how these racial relationships deviated from Haddon's proposed anthropogeographic theory, but this layout suggested that some internal biological

mechanism was the driving force of racial variation and hierarchicalization. Novice viewers would have found it difficult to reconcile such conflicting claims and reach conclusions beyond the premise of an Asiatic origin of humanity, represented by the main trunk.

This exhibit contained thirty-seven photographs from anthropological textbooks as well as from archives held at American and European natural history museums. These frontal views follow the standard of anthropometric photography. An alert viewer would recognize that Field included photographs taken by Samuel Grimson that Hoffman and studio assistants had used to produce the Ainu, Lapp, and Carib sculptures. Photographs, or rather photographic transparencies, constituted another display. Henry Field intended these transparencies, which Malvina Hoffman had hand colored, to supplement the Races of Mankind sculptures, since they would serve as demonstrations of the "true skin colors of the human races."[146] These transparencies, however, do not conform to standards for anthropometric photographs as in the previous display; they feature clothed individuals engaged in various activities and function more as ethnographic photographs.

The *Use of Hands and Feet* exhibit (figure 4.16) featured casts that Malvina Hoffman and Jean de Marco made during their expedition to Asia. Henry Field

Figure 4.16. Henry Field, *Use of Hands and Feet* display, Hall of the Races of Mankind, Field Museum. © The Field Museum, A78448.

added casts purchased from other museums to present the casts in a three-race schema. Replicas of Rudolf Pöch's well-known collection of anthropological casts were labeled "Kalahari Bushman" and "Hottentot," and duplicates from the Josef Weninger cast collection served to represent European types. Henry Field thus intended viewers to make racial distinctions among these body parts, which were shown engaged in various cultural activities, such as sewing, hunting, and writing. Field arranged the casts of feet at the bottom of the case and suspended various casts of hands from the back wall. The cast hands holding chopsticks and a bowl in the lower middle section of the case were a particularly unusual presentation. Hoffman arranged these casts above a tilted mirror so that simultaneous views from different positions were possible.

Other groupings of casts and photographs encouraged viewers to make different kinds of perceptual shifts. In the upper left corner of the case, for example, four photographs of dancers were interspersed with three cast hands posed in different mudra positions. This arrangement encouraged viewers to connect the casts to the photographic images. Differences in scale between the photographic vignettes and cast hands created a perceptual conflict that could be lessened by enlisting visual habits associated with viewing motion pictures. Film narrative techniques such as shifting from isolated details or close-ups to larger scenes frequently required viewers to make transitions between disparate spatial registers. A film sequence of dancers mounted on the left wall might have encouraged viewers to perform a similar form of engagement. While visually compelling, this display did not explicitly state how habitual movements of the hands and feet were related to race or to the inheritance of racial characteristics. One could read these casts in light of earlier Lamarckian theories of inheritance, or in relation to evolutionary theories of the human foot and hand in regard to other primates, or perhaps in terms of cultural practices and social habits.

A Chicago surgeon, Emil Hauser, provided clues to how hands and feet could be understood to express racial traits in an anatomical treatise on the human foot. Hauser argued that the foot became specialized in various races because of different functional demands. To prove his point, he surprisingly used photographs of five Races of Mankind sculptures as anatomical illustrations. Racial differences of the human foot, he claimed, had been "nicely brought out" by Malvina Hoffman: the Hawaiian foot exhibited a paddle-like shape, well adapted for swimming; the broad, coarse foot of the Chinese coolie spoke to its power and endurance; the foot of *Daboa* indicated excellent muscle control; while the tree climber exhibited a highly developed prehensile character, with its great toe abducted, that showed remarkable

adaptation.[147] By implication, Hawaiians had a special aptitude for swimming or Chinese for pulling rickshaws, stereotypes that we would find ridiculous. Such specializations, Hauser argued, were not visible in the *Nordic Type*'s "normal" foot, which was useful for a variety of functions, including stability and propulsive force for an erect body. Hauser thus advanced the theory that greater plasticity was a sign of racial superiority, because specialization limited the possibility of future evolution.

Henry Field mounted another exhibit concerning cultural practices, but those relating to cranial deformation and to scarification and tattooing of the body. In this display, he reproduced images of historical as well as current practices of bodily adornment within different cultures. Field claimed that the custom of tattooing was frequently practiced in white-skinned peoples, while the practice of scarification was commonly found among darker-skinned peoples.[148] Again, the physical anthropologist did not provide an explicit reason for how such practices related to race biology. For students acquainted with criminal anthropology, the link between an activity such as tattooing and race would have been readily apparent. In *Criminal Man* (1887), the founding text within the field, Cesare Lombroso read such bodily adornments as physical signs of the criminality of savages.[149] For viewers without such knowledge, the display would have evoked associations with exhibitions of human oddities in anatomical displays and in popular dime museums. Malvina Hoffman recognized that this display verged upon the grotesque, for she strongly opposed Henry Field's decision to move two of the Races of Mankind sculptures near it. She wrote to the president of the museum, claiming that Henry Field had put these sculptures within the "realm of aberrations."[150] Field believed that the two works, *Padaung Woman* and *Ubangi Woman,* had greater educational value as examples of such cultural practices than as racial types. In their new location, the *Padaung Woman* represented the practice of stretching the neck by wearing metal rings and the *Ubangi Woman* depicted the enlargement of lips through inserting wooden lip studs.[151] Berthold Laufer probably approved of this move, since he had earlier objected to exhibiting the *Padaung Woman* bust, which he believed could not serve as a typical Burmese because it represented a very small group, the Karen.

Trepanning and cultural modifications of the skull were illustrated in another wall case (figure 4.17). Field arranged plaster casts and skulls in a columnar format to represent prehistoric surgical operations on the skull alongside two other exhibits concerning human evolution. These evolutionary exhibits were made up of diagrams of skulls and endocranial casts, three-dimensional forms molded from the interiors of skulls. Henry Field intended these objects

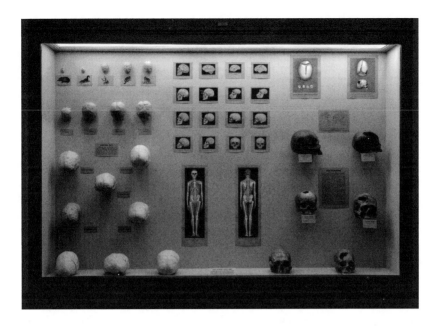

Figure 4.17. Henry Field, *Cranial Deformation and Evolution* display, Hall of the Races of Mankind, Field Museum. © The Field Museum, A78449.

to demonstrate the relative sizes of brains of humans (divided by race) and other mammals. Thus he mounted a type of exhibit that illustrated what was historically the primary goal of most craniological studies: a ranking of "intellectual values of the various races" based on anatomical comparisons between human brains and those of other primates.[152] Although Field explained in the 1937 edition of the guidebook that the exhibit demonstrated the relative sizes of the brain and that size should not be understood as evidence of intellectual ability, the collection of casts and drawings of mammals formed a progressive series, beginning with the hedgehog and ending with modern races, that would have prompted novice viewers to conclude that size and morphological differences demonstrated a hierarchy of mental capacities. The endocranial casts labeled *Negro, East Africa* and *Negro, West Africa* in the center of the column marked the boundary between simian and human. Beneath these casts, Field placed casts marked *Australian Aboriginal* and *Maori, New Zealand,* which were followed by three casts identified ambiguously as "modern races" resting upon the floor of the display case. Henry Field claimed in his 1934 guidebook essay that this exhibit illustrated differences between brains of primitive and modern races, but he did not offer a rationale for this assertion.[153]

The selection of endocranial casts, which included tenrec, tupaia, lemur, macaque, gorilla, chimpanzee, orangutan, and gibbon, promoted the well-known theory that development of the brain, rather than erect posture as Arthur Keith had proposed, was crucial to human evolution.[154] The chief proponent of this evolutionary theory, the British anatomist and anthropologist Grafton Elliot Smith, had served as one of Henry Field's advisors to the Hall of Prehistoric Man. In his theory, Elliot Smith argued that the development of stereoscopic vision and the reduction of the olfactory part of the brain elevated primates over other mammals.[155] Coinciding with the development of stereoscopic vision, Elliot Smith theorized, the increased size of the neopallium, the associative area of the brain regulating various senses, was a key factor in the ascent of humans over other primates.[156] This theory was presented in the central column of the display case, where Field copied sixteen drawings of the brain and skull from Edward P. Stibbe's textbook *An Introduction to Physical Anthropology* (1930). Elliot Smith had advised Stibbe on this anthropological volume, which Alfred Kroeber characterized as a "sound and useful little textbook, or more exactly, what in England they call a cram book for degree examinations."[157] Henry Field replicated Stibbe's comparative arrangement of diagrams in the display: the first row presented drawings of human and gorilla brains, while the second row illustrated the skulls of a human, chimpanzee, and ape.[158] The third and fourth rows deviated slightly in their arrangement because Henry Field attempted to reconcile Stibbe's six-race classification with the three-race classification asserted by the Races of Mankind sculptures. The third row differentiated European racial types from the Mongoloid racial type through four profile views of skulls labeled *Nordic Type, Mediterranean Type, Alpine Type,* and *Mongolian Type.* Here, the *Alpine Type,* which anthropologists believed to extend into Central Asia, is situated on the ambiguous boundary between the European and Mongoloid races. As Malvina Hoffman remarked, "the number of experts consulted on the subject of what constituted a pure Alpine type resulted in confusion and contradictions all along the line. Each anthropologist seemed to have his own pet idea about the elusive Alpine."[159] The last horizontal row, consisting of two profile views of skulls marked *Australian Aboriginal* and *Negroid Type,* followed by two frontal views marked *Alpine Type* and *Mongolian Type,* again indicated the general anthropological concern for defining the limits of whiteness that the Alpine supposedly represented.

Two osteological exhibits that physically bracketed the displays discussed above demanded less from viewers; they did not contain omissions and inconsistencies that required making complex conceptual and perceptual leaps.

The viewer simply needed to note the similarities and differences among the skeletons to learn the lesson of progressive evolution. In the first exhibit, a skeleton on the left labeled *Adult White Male* served as the norm from which to consider four other skeletons, two of which were marked *Mongoloid*, one *Negroid*, and one *Aboriginal Australian*.[160] This sequence suggested a four-race classification, which would conflict with the *Unity of Mankind* sculptural group and with the three-race system presented in the hall. The other osteological display also contained five skeletons, arranged to illustrate the evolution of erect posture. In this wall case, Field placed a skeleton labeled *European Male* at the left to provide the norm from which to compare four other primate skeletons, identified as *Gorilla, Chimpanzee, Orangutan,* and *Gibbon.*

In July 1934, Henry Field installed a display in the Hall of Prehistoric Man that would "graphically demonstrate relationships between Primates, Prehistoric Hominids, and the present Races of Man," to articulate theoretical connections between the two exhibit halls.[161] Organizing the wall case with a phylogenic tree, Field believed that the comparative display of skulls illustrated the common ancestry as well as parallel evolution of apes and humans. In this display, Field presented skulls of the "four principal racial types . . . the Australian, the Negro, the Mongolian, and the White" and expected visitors to notice the similarities and differences between the head structures of simians and humans.[162] His shift to a four-race classification from the three-race classification reflected his inability to stabilize the arbitrariness of racial taxonomies. Novice viewers would have found the Field Museum's simultaneous presentation of two racial classifications bewildering indeed. As in the "special scientific" display cases, Henry Field amassed authoritative anthropological concepts and methods in this exhibit, but he failed to provide an interpretative framework for viewers to understand them.

One can see that Henry Field's installation strategy of selecting diagrams and charts from published anthropological sources and combining them with objects situated the Races of Mankind sculptures in relation to established anthropological methods, racial classifications, and evolutionary theories. Field relied upon the research and authority of recognized anthropologists, but he did not connect the sculptures to one particular racial theory. Seasoned anthropologists might have quarreled with the research Field selected for the display, but for college-level students, the exhibit would have served as a means to recall material encountered in anthropology textbooks. Ultimately, the ambiguity of Malvina Hoffman's sculptures was not resolved by these special displays, because they contained contradictions that denied their intended purpose of conveying scientific certainty of race.

5. LIFE BEYOND THE FIELD MUSEUM: EXHIBITING STATUETTES DURING THE 1930S

ONE MIGHT CONSIDER THE LIFE of the sculptures beginning at Hoffman's studio and ending at a final destination, the Hall of the Races of Mankind. However, such a view does not attend to the career of replicas of the Races of Mankind sculptures. By tracking the social life of these reproductions, we can trace the accrual of new values and functions of these pedagogical objects and their transformation into collectible fine art objects. Small-scale statuettes formed a blockbuster show that traveled to American art galleries, natural history museums, and universities until the early 1940s. These replicas entered diverse museums such as the American Museum of Natural History, the Brooklyn Museum, the Buffalo Museum of Science, and the Metropolitan Museum of Art. Art galleries sold Races of Mankind statuettes as decorative objets d'art that made their way into private collections and domestic settings. This circulation of small-scale replicas served to increase the critical assessment of the sculptures at the Field Museum; indeed, most reviews of the sculptures were based on seeing the statuettes and not the full-scale figures displayed within the Hall of the Races of Mankind. In this chapter, I discuss two exhibitions that served as entry points into different cultural arenas: the *Les races humaines* exhibition at the Musée d'Ethnographie du Trocadéro in Paris in November 1933, and the *Races of Man* show at the Grand Central Galleries in New York from January to March 1934. Hoffman's Trocadéro show situated the sculptures within a form of anthropological knowledge closely linked to the Parisian artistic avant-garde, which challenged Western values and cultural hierarchies. This exhibition not only validated the small-scale

statuettes through this anthropological discourse, it also strengthened their status as works of art and assisted their entrance into the New York art market. Hoffman's subsequent highly successful exhibition at Grand Central Galleries was a manufactured event in which an array of publicity techniques was deployed to help transform replicas of the Races of Mankind sculptures into commodities. As we will see, Grand Central Art Galleries was recognized as one of the first institutions in United States to apply "the principles of big business to the marketing of American art."[1]

The initial contract between Malvina Hoffman and the Field Museum, dated February 18, 1930, greatly circumscribed the sculptor's rights to reproduce the Races of Mankind figures: the Field Museum held copyright to all of the sculptures. This contract limited the replication of the sculptures to one set of small-scale statuettes for Hoffman's personal collection; no further duplication was permitted beyond her "private" set.[2] Given Hoffman's awareness of copyright laws, it is remarkable that she initially agreed to such a restrictive clause, especially since she derived substantial income from selling moderately priced statuettes throughout her career. However, the October 27, 1930, supplementary agreement between Hoffman and the Field Museum officials granted Hoffman the right to replicate the Races of Mankind figures as small-scale reductions and to sell them to her clients, with all accrued profits going to the sculptor. Their revised contract stipulated that the Field Museum could also sell duplicates, with profits divided equally between the institution and the artist. The contract established retail prices for the reductions: each full-length figure would be sold at $800 and each portrait or bust at $350.[3] Institutions would receive a slight discount, and the Field Museum had an option of purchasing additional statuettes at $500 for each full-length figure and $300 for each bust or portrait.[4] Although the contract did not specify how many statuettes would be made, an article in *Art Digest* claimed that each work was limited to an edition of twelve.[5] They also agreed that these small-scale replicas would be marked "Copyright Malvina Hoffman–Field Museum, Chicago" to reflect the sculptor's new replication rights and to maintain those of the museum.

Although Stanley Field agreed to extend rights to Malvina Hoffman for statuettes, he wanted to restrict sales of life-size replicas to other museums to preserve the uniqueness of the display at the Field Museum. The supplementary contract contained no provisions for replicating the figures, busts, and portraits in life size, which suggests that such replication was done on a case-by-case basis at the Field Museum. The president of the museum also expressed misgivings about exhibiting small-scale replicas at other museums.

However, his awareness that such replicas could serve as publicity for the Field Museum seemed to override his concerns.[6] In 1932, Stanley Field followed Berthold Laufer's recommendation that the museum refer potential orders to Malvina Hoffman, as it would help the museum save on labor and expense.[7] In so doing, the museum officials gave Malvina Hoffman the opportunity to extend the lives of the replicas.

THE TROCADÉRO EXHIBITION

Five months after the Hall of the Races of Mankind opened, the Musée d'Ethnographie du Trocadéro held *Les races humaines,* the first exhibition of small-scale statuettes (figure 5.1). Hoffman valued the exhibit at the Trocadéro, for it meant that the ethnographers and anthropologists associated with the museum, Marcel Griaule, Georges-Henri Rivière, and Paul Rivet, were providing a "seal of approval on my racial types."[8] These three colleagues had earlier allied themselves with the Parisian artistic avant-garde, most notably as contributors to the journal *Documents.* Paul Rivet practiced a form of anthropological knowledge called "ethnologie" that encapsulated the subjects of

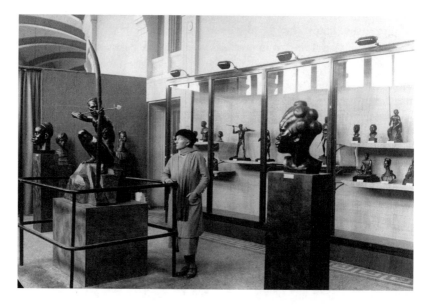

Figure 5.1. Malvina Hoffman, *Les races humaines,* Musée d'Ethnographie du Trocadéro de Paris (November 1933). Malvina Hoffman papers, Research Library, The Getty Research Institute, Los Angeles (850042).

physical anthropology, linguistics, and ethnography and that maintained the concept of race but greatly circumscribed its explanatory power. James Clifford recently used the term *ethnographic humanism* to describe this antiracist form of French anthropology.[9] Stressing the commonality of humanity and calling for the appreciation of cultural diversity, this ethnographic humanism countered the anthropology promoted at the École d'Anthropologie by Georges Montandon and Georges Papillault, both of whom adhered to the notion of a racial hierarchy and subscribed to evolutionary theories of fixed stages of development.[10] The director of the museum, Paul Rivet, who co-founded an antifascist organization only three months after Hoffman's exhibition, had promoted this revised form of French anthropology since the 1920s.[11]

Initially trained as a physician, Paul Rivet accepted the notion of racial types but questioned existing anthropometric techniques, specifically those relating to the facial angle. In his early anthropological research, Rivet published a series of articles devoted to prognathism, which he argued was more useful in the study of race than the cephalic index.[12] Although Rivet claimed it was illegitimate to construct racial hierarchies, he devised a new technique for measuring prognathism.[13] By 1930, Rivet had become much less confident in anthropometric methods and placed greater value on morphological observation. For Rivet, anthropometry played a supportive role to visual assessment: "This metric method is unable to translate faithfully characteristics that, seizing the eye, have greatly impressed travelers. After having lived for a certain time among a population, a good observer easily distinguishes local types . . . Measurements taken on natives only in an imperfect manner translate the very sure impressions that the eye has recorded."[14]

Around the time of Hoffman's exhibition at the Trocadéro, Paul Rivet taught a general physical anthropology course.[15] Student notes from this course offer insight on Rivet's views of physical anthropology and its methods. These notes, along with an analysis of his museological approach, also help to explain why Rivet invited Malvina Hoffman to exhibit small-scale replicas of the Races of Mankind figures at the museum. The sculptures' ambiguous mixture of physical and ethnographic elements would have been amenable to how Rivet practiced *ethnologie*, shifting attention among somatic, ethnographic, and linguistic concerns in order to study a culture in its ensemble.

In his lectures, Rivet maintained a three-race classification but claimed that anthropologists knew too little about the laws of biology or inheritance to explain racial differences. Following the views of Joseph Deniker, Rivet advised using a classification based on morphological characteristics including skin color, hair shape and color, stature, eye shape, and the form of the head, nose,

and face.[16] He acknowledged that many considered anthropometric methods "bankrupt" but argued with some reservations that these methods were still valuable as a means for bringing various physical characteristics together for analysis.[17] He based his reservations on several issues. First, Rivet argued that an ensemble of indices did not attend to morphological form.[18] Like Arthur Keith, he downplayed the value of anthropometry: "measurement only imperfectly translates differences that the eye of a traveler can distinguish quickly."[19] Rivet dismissed the notion of a numeric or statistical average or "type moyen" and claimed that the more frequent types within a population were much more interesting to study.[20] Like Franz Boas, Rivet argued that there were greater differences among individuals within a population than between racial groups. And like Alfred Haddon, Rivet believed that extensive migrations had created racial mixtures within human populations, making it extremely difficult to reconstruct pure racial lines outside of rare isolated populations.

Rivet recommended to his students what he called "ethnic anthropology," which studied an ensemble of racial characteristics of a given population or focused upon one morphological characteristic, like the nose, across different racial groups.[21] He cautioned that a single physical trait could not serve as the sole determining factor to define a race. His students used worksheets with drawings of facial forms, like those of the lips, ears, and nose. Probably copied from Paul Topinard's anthropology textbook, some of these drawings are similar to those exhibited in the *Physical Characteristics of Mankind* display at the Field Museum. Students would learn how to diagnose these forms by observing the drawings on one side of the page and then drawing copies of them on the other. These exercises suggest another reason why Rivet "greatly admired" the sculptures: they provided a way to learn how to perform a morphological analysis.

Indeed, Rivet believed that Hoffman's figures were "so important and of a striking exactitude," which suggests that he found the replicas worthy "documents" suitable for display in the renovated halls at the Musée d'Ethnographie.[22] At the time of Hoffman's *Les races humaines* exhibition, Paul Rivet and assistant director Georges-Henri Rivière were attempting to bring order to the "museum of bric-brac" that avant-garde artists earlier found so compelling. René Daumal, a founding member of the literary group Le Grand Jeu, claimed that the time in which one could make "sensational excavations and discoveries in this place of chaos and dust" was over; under these anthropologists the museum was becoming a "grand luxury store."[23] Despite his lament, Daumal viewed their renovations as a way for the institution to become the "richest and most complete living European museum."[24]

Beginning in 1928, Rivet and Rivière reorganized the museum according to a plan encompassing four interrelated concerns: scientific, educational, artistic, and colonial.[25] They experimented with museographic techniques in which they displayed objects for their aesthetic value and rarity, as in the case of the Salle du Trésor (1932), or for their status as the most characteristic or representative specimens to construct a cultural ensemble, as in the case of the Salle d'Afrique Blanche (1933). Jean Jamin argues that their conceptualization of an "ethnographic object" was indebted to the ideas of sociologist Marcel Mauss, in which an object was considered "evidence" or a "piece of conviction" that revealed the social and material processes of a given culture.[26] Jamin convincingly shows that Paul Rivet maintained a naturalist orientation in his collection of objects and in his adoption of the concept of series.[27] In 1930, Georges-Henri Rivière explained that the aim of renovating the public exhibits was to display didactically what he considered the most representative material objects of a given culture.[28] The museum curator arranged such representative specimens according to a geographic area, then by tribe, and then by media or material categories, in glass cases with a neutral scheme.[29] Rivet and Rivière displayed only the most representative objects in public exhibit halls and placed duplicates as well as objects forming a series into study collections accessible to qualified researchers.[30] Paul Rivet, two years later, summed up their museological practices in his proposal for the Musée de l'Homme: "The goal will be to give the visitor clear and precise ideas, to bring out for him the essential facts without burdening him with overabundant documentation. The most typical anthropological or ethnological specimens will be chosen, and great care will be taken to avoid presenting so many that they would exhaust and disperse the attention of the spectator."[31] Like the American museum curators who were using new exhibition techniques to avoid museum fatigue and sustain visitors' attention, they sought to develop exhibition formats to enhance viewers' visual and psychological responses. Georges-Henri Rivière's recent survey of museological techniques at various American and European museums informed the Trocadéro's strategies of display.[32]

Hoffman's *Les races humaines* opened on the same day as two other exhibitions. Taken together, these exhibitions demonstrated Rivet and Rivière's experiments in using replicas or facsimiles as the primary objects of display. Calques, or tracings, of north African rock engravings in Leo Frobenius's temporary show *Art préhistorique de l'Afrique du Nord* allowed representations of remote originals to be studied comparatively.[33] Likewise, dioramas of prehistoric African art in the museum's permanent display, the *Salle de préhistoire exotique*, presented facsimiles of south African rock paintings copied from

well-known books on the subject. In this respect, these exhibitions seemed to trouble the museum's orientation toward displaying material objects as witnesses to a culture. The exhibitions also eschewed the strategy of collage, which was deployed earlier in the journal *Documents,* where photographic illustrations functioned to subvert Western cultural hierarchies and to disrupt habits of viewing. Instead, Rivet and Rivière exploited replicas to encourage visitors to make comparisons based on resemblance between objects deemed characteristic or typical.[34] Publicity for these exhibitions asserted the accuracy of the replicas and encouraged visitors to view them as if they had unmediated access to the originals.

Paul Rivet was convinced that an exhibition of Hoffman's statuettes at the Trocadéro would attract the French public and serve as "excellent propaganda" for the Field Museum, which had taken recourse to her "great talent."[35] The exhibition came about through Malvina Hoffman's earlier association with the staff at the museum. According to her daybooks, the sculptor began studying with Paul Rivet in June 1930.[36] During the production of the sculptures, Malvina Hoffman and Louis Slobodkin made frequent visits to the museum to consult photographs, casts, and ethnographic sculptures in its collection. She also received advice from Marcel Griaule, Harper Kelley, Eric Lutten, and Georges-Henri Rivière and sought their approval of finished works during an October 1932 meeting, which was followed by "tea and films" at her studio.[37] As in her relations with Arthur Keith and Stanley Field, the sculptor mixed professional collaboration with personal friendship; many of these ethnographers spent "musical evenings" at Villa Asti with Hoffman and her husband. Their level of camaraderie is apparent in their correspondence and frequent use of nicknames for each other. In a letter to the sculptor, Georges-Henri Rivière called the artist "the esthetic animator of mankind, our rational and sweet Malvina," and referred to himself as a "rubber lover."[38] Hoffman affectionately called Marcel Griaule "Pierrot." Hoffman worked with these French ethnographers on their own projects. She promoted Georges-Henri Rivière's proposed "museum of primitive and popular art" to her American patrons in an attempt to secure funding for the project.[39] The sculptor and Marcel Griaule, whom she portrayed in a bust entitled *The Aviator,* collaborated on a bas-relief representing a Dogon funerary dance, derived from photographs and movie stills from the Mission Dakar-Djibouti; it was completed in 1937 but never cast in bronze.

Operating in a budget deficit, the museum had little money or staff to install Hoffman's *Les races humaines* exhibition. Georges-Henri Rivière became ill and was unable to offer much assistance. Harper Kelley, Eric Lester, and

Marcel Griaule stepped in to help the sculptor, but Hoffman herself basically organized the three-week exhibition. She recruited her studio assistants to install the sculptures within the recently renovated semicircular exhibition gallery on the first floor of the museum.[40] They placed small-scale replicas within glass wall cases according to geographic location and mounted eight full-size painted plasters, such as the *Andaman Islander,* on pedestals (figure 5.1).[41] Hoffman exhibited sculptures unrelated to the Races of Mankind project: two earlier heroic-size heads, *Senegalese Warrior* and *Martinique Woman,* and a portrait of a Sikh prince, *Yuvuraj of Patiala.* The sculptor also included some of her dance figures and mounted a series of plaster cast hands of a Javanese dancer in the display.

The problem of entitling the works, encountered at the Field Museum, resurfaced at the Trocadéro. While it is unknown whether Paul Rivet or other members of the museum staff helped to prepare the labels, a typed list of figures with penciled corrections is held in the archives at the Musée de l'Homme. The label "Nordic Type" was crossed out and substituted by "American Type," only to be supplemented with the query, "of Scandinavian ancestry?" The portrait of Rudier was originally listed as "French Man," then marked "Mediterranean," which was then replaced with "Parisian Type." The *Unity of Mankind* figural group, originally titled "Group Symbolizing the Unity of Races of Mankind," was crossed out and replaced with "elements of white race, black race, and yellow race."

According to May Birkhead, Paris correspondent of the *Chicago Tribune,* the opening was a "brilliant and distinguished affair,"[42] an indication that the event lived up to the museum's chic status among fashionable circles of Parisian society. Members of the French and American social elite attended Hoffman's exhibition, along with what the sculptor called "rubans rouges," government officials.[43] The minister of national education, Monsieur de Monzie, officiated and congratulated the museum and the sculptor on the "instructive exhibition that was unique in the annals of sculpture and racial delineation."[44] Following the opening festivities, which began strangely with a sudden failure of the new electrical system, throwing the crowd of five hundred guests into complete darkness, Alma Spreckles held a reception for the artist at the Ritz.[45] Hoffman claimed that more than five thousand visitors saw her works over the course of the exhibition. Rivière confirmed that her show broke entrance records, and Griaule stated that after the exhibition had closed, attendance at the museum dropped.[46]

For most critics, the documentary requirements of the Field Museum commission, like those associated with exact tracings and facsimiles, were

a hindrance to Malvina Hoffman's artistic process. In several reviews of the Races of Mankind statuettes, the term "documentary" was used negatively to suggest that Hoffman's sculptural practice was limited to an extreme level of verisimilitude. Some claimed that she ran the risk of producing works that satisfied the exactitude necessary for a documentary object but were devoid of aesthetic qualities. Other reviewers argued that Hoffman satisfied both the aesthetic and documentary requirements. Definitions of these concepts were inconsistent in the French reviews, but most authors, regardless of orientation, considered them as opposing terms. The overriding issue for these reviewers was how to reconcile veristic values of a documentary object with the plastic form of an aesthetic object; portraiture rarely entered the assessments.

In his review for *Le Rempart,* René Daumal faulted Malvina Hoffman for excessively following the documentary requirements of the project and argued that photographs could have served as better documents. He considered the sculptures "scrupulous copies accurate to a millimeter of human types" and dismissed them by equating them to "mediocre bronzes that decorate vestibules."[47] Nevertheless, Daumal believed that in the field of ethnography, the sculptures might have some use. In his essay for *La Nouvelle Revue Française,* Daumal again criticized Hoffman for "measuring with compass millimeter by millimeter" her subjects and stated that as the "ancients did not construct their canon for nothing, neither should Hoffman." He then claimed that her sculptural method was as exact as moulage [direct casting] but resulted in works lacking in expression and life.[48] In dismissing the sculptures as lifeless casts, Daumal was deploying a common rhetorical strategy to delimit the boundary between artistic imitation and mechanical reproduction, which haunted the genre of ethnographic sculpture and which Hoffman had used to separate her works from those by museum preparators. Another critic also took recourse to this rhetoric to disparage the Races of Mankind statuettes as "soulless moulages that do not exhibit life."[49] Raymond Lécuyer, in *Le Figaro,* a conservative and widely read international newspaper, believed that the overall collection gave an "oppressive impression of monotone coolness."[50] While the statuettes would satisfy the curiosity of certain savants, Lécuyer argued, a Parisian with no pretense of being an anthropologist would run from the exhibit and study racial differences on the rue de la Paix.

In contrast to these negative assessments of the statuettes, Hoffman received support from the elderly art critic Louis Vauxcelles. Known for coining the terms *fauvism* and *cubism* in his earlier art reviews, Vauxcelles championed French regionalism in the late 1920s and early 1930s and was hostile to foreign artists working in Paris.[51] The art critic, however, did not display such a

sentiment toward Hoffman, whom he noted was a former student of Rodin. In his two reviews of the Races of Mankind sculptures, Vauxcelles expressed his admiration of the artist for undertaking a formidable project that had not been previously entrusted to an artist. In his November 1932 essay, Vauxcelles asked his readers to consider the magnitude of the Field Museum commission: the sculptor had to reconcile literal truth, to meet the documentary needs of the project, with plastic truth, while not sinking beneath the weight of the task.[52] Imagine the difficulty in deciphering character from sitters, he asked his readers, when communicating with them only through gesture and by exchanging glances. Each work, he claimed, represented a different type, attitude, and action. The collection of bronzes, Vauxcelles claimed, exhibited "intense life," which was the first goal of any artist. He offered Hoffman's depiction of action in the *Hawaiian Surf-Rider* as an example of her ability to capture the "vital rhythm" of her subjects. Vauxcelles suspected that some critics would fault Hoffman because she did not follow classical ideas of "the language of harmonious balanced volumes."[53] Instead, Hoffman achieved her effect of intense life through well-calculated planes that distributed a play of light and shadows. Hoffman, he concluded, was an artist of the first rank, who possessed an intelligent and sensitive talent.

In his later review, "La vie artistique: Mme. Malvina Hoffmann [*sic*] au musée d'ethnographie," Vauxcelles reiterated his previous views: Hoffman, he argued, was an artist who had a talent in observation, understanding, and expressive intensity.[54] She excelled in interpreting the habits and spirit (*l'âme*) of all the living races of the globe. The sculptor, he claimed, endured great hardship to fulfill the commission; she "confronted the tropical heat, the polar cold, traveling to five continents, Pacific Islands, the sands of the Sahara in order to penetrate the soul of inhospitable tribes."[55] Peppering his narrative with such picturesque elements, Vauxcelles built an image of Malvina Hoffman as "exploratrice." Vauxcelles's final verdict, and one frequently cited by American critics, was that in "accepting an almost superhuman task, conferred to her by Professor Berthold Laufer of Chicago, she risked a heavy stake; she has triumphed. One doesn't know which to admire most, the dauntlessness of the explorer or the forceful talent of the artist."[56] Huguette Godin, in her review entitled "Mouvement féministe: Malvina Hoffman sculpteur ethnographe," agreed with Vauxcelles but added that while the sculptor would receive such compliments in France, many would secretly regret that she "did not stay home to be a good spouse, spin yarn, and darn socks."[57]

Malvina Hoffman recognized that she had pulled off a publicity coup with a two-page spread in *L'Illustration*, a conservative newspaper with a large mid-

dle-class readership.[58] The review featured five photographic reproductions of the sculptures and an essay by Jean Gallotti, who described the sculptures in terms of exoticism and picturesqueness, a rhetoric he had used earlier in reviews of exhibits at the 1931 Exposition Coloniale. He alerted his readers that small-scale reproductions of the Races of Mankind sculptures were exhibited in the Musée d'Ethnographie and not, as one would expect, in the other end of the Trocadéro in the Musée de Sculpture Comparée. Gallotti claimed that the Races of Mankind sculptures fit within a strange genre of art, which could only be known by the term "ethnographic sculpture."[59] He argued that the status of Hoffman, as a well-known sculptor and as a former student of Rodin, should reassure the public of the credibility of this genre. Gallotti argued that this collection of exotic figures would satisfy the interests of individuals who studied race, because Hoffman had executed the sculptures with scientific exactitude and reproduced every trait of her subjects. The critic claimed that she had exhibited greater freedom of interpretation in her *Senegalese Warrior* and *Martinique Woman,* but he apparently did not know that these works were unrelated to the Field Museum project. Gallotti found primitive and picturesque qualities in various works; *Daboa* was a masterpiece with its graceful, undulating forms suggesting a nonchalant dance and representing "a synthesis of the seductions of the black world."[60] Hoffman's *Sakai Warrior* called up primeval visions for the critic, who believed that it represented "perhaps the most primitive of all men" who had no other means of habitation than trees and lived in the most virginal of forests. Gallotti expressed surprise in finding representations of Parisian types and an "American of Nordic Origin" in the exhibit that displayed "specimens of humanity that were all but animals, and on the point of disappearance."[61]

The success of the *Les races humaines* exhibition gave new values to the sculptural reproductions and helped to establish their career as a traveling show in the United States. Paul Rivet's endorsement of the statuettes linked them to racial studies that rejected evolutionary and hierarchical frameworks and offered a form of validation distinct from Arthur Keith and the physical anthropologists who had advised Henry Field earlier. The enormous coverage in European and American newspapers presented the exhibition as a topical, newsworthy event; American journalists frequently stated that Malvina Hoffman was the first American sculptor to have held an exhibition at the Parisian museum, which had drawn large crowds. This claim carried enormous cultural cachet for the sculptor and for the reception of the reproductions in the United States. The reviews by art critics such as Gallotti and Vauxcelles testified to the reproductions' status as art objects. This validation by French

cultural authorities was deployed in publicity materials in order to ensure a positive reception of the replicas in America. The exhibition also served as the moment in which reproductions became available for purchase. Sales of the statuettes at the opening reception temporarily turned the museum into a commercial enterprise and lent support to René Daumal's view that the Musée d'Ethnographie had become a grand luxury store. Malvina Hoffman summed up the situation in a letter to Georges-Henri Rivière, who missed the reception because he was convalescing in the countryside: "You should have been at the 'troca' today . . . to see all the rich fur coated elite flirting with my bronze children, cases had to be unlocked, checks drawn, billets de'mille counted, and a thriving trade done! Large strange ladies bought Daboa and Shilluk and Pekun types and one even paid me $5.00 for a book I had in my arm called 'Malvina' what think you this for a pauvre petite etrangere—it was more than amusing in fact quite theatrical . . ."[62]

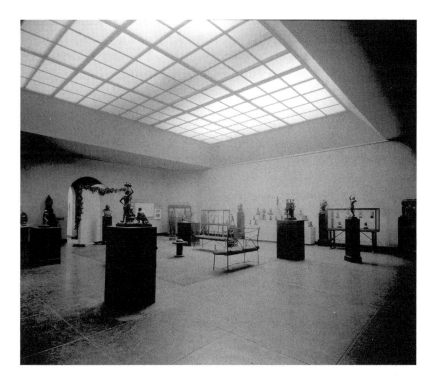

Figure 5.2. Detail, *The Races of Man,* Grand Central Galleries, New York (1934). Peter A. Juley & Son Collection, Smithsonian American Art Museum (J0035304).

On a visit to the Century of Progress Exposition in the fall of 1933, the director of Grand Central Galleries in New York, Erwin S. Barrie, stopped by the Field Museum to see the new Hall of the Races of Mankind. The exhibit hall so impressed Barrie—he stated that it formed the "finest one man exhibition" in sculpture he had seen—that he wrote to Malvina Hoffman and proposed an exhibition of replicas at Grand Central Galleries.[63] Realizing the market potential of statuettes, Barrie offered the show at no cost to the sculptor; Grand Central Galleries would cover the expense of installing the exhibition, printing a catalogue, mailing invitations, and mounting an extensive publicity campaign. Hoffman agreed and also accepted Barrie's terms on sales, in which the art gallery would receive a 25 percent commission except for sales that she initiated before the show.[64]

Founded by Walter L. Clark in 1923 as a nonprofit enterprise, Grand Central Galleries was a joint venture between artists and wealthy patrons intended to broaden the market for American art. The galleries were initially funded by a hundred lay members, who gave $600 each year, and a hundred artists, who each donated an artwork annually.[65] The two groups' financial commitment gave the galleries a working capital of $60,000 to cover operating costs and marketing expenses.[66] Headed by John Singer Sargent and Daniel Chester French, the group of prominent American artists included Malvina Hoffman, as well as Herbert Adams, Edwin Blashfield, Cecilia Beaux, Harriet Frishmuth, Carl Jennewein, Frederick MacMonnies, Edward McCartan, Janet Scudder, John Sloan, Lorado Taft, and Bessie Vonnoh, who made up the artists committee.[67] The founding lay members included eight art museum administrators, such as Robert de Forest of the Metropolitan Museum of Art, Charles Hutchinson of the Art Institute of Chicago, and Charles Glover of the Corcoran Gallery in Washington, as well as prominent collectors from Boston, Chicago, New York, and Philadelphia.[68] Some of these lay members, Mrs. E. H. Harriman, Irving Bush, Otto Kahn, and Paul Warburg, were also Malvina Hoffman's early patrons.

Walter L. Clark hired Erwin S. Barrie, the former director of the art gallery at the Carson Pirie Scott department store in Chicago, to apply modern business practices to the sale of American art.[69] Barrie developed a massive system of advertising, mounted exhibitions in which every artwork had the same price regardless of its value, and set up a series of traveling exhibitions to increase visibility and to promote sales across the United States.[70] Some critics saw the Grand Central Galleries as an alternative to the traditional

patronage system and as a means for institutionalizing artists' commercial relations with the general public.[71] With a total of fifteen thousand square feet of floor space, which was divided into twenty small gallery spaces, Erwin Barrie claimed that no other sales gallery in the world was conducted on a "scale of equal magnitude."[72] The venture proved to be extremely successful; Grand Central Art Galleries boasted sales over $5 million in its first decade.[73] Clark hoped that the gallery would sell over $1 million annually, explaining, "art is a proved commodity and is each day becoming a necessity in the life of the nation."[74]

Located on the sixth floor in the Grand Central Terminal, the art galleries were situated within a new kind of architectural space. Architectural historian Anthony Raynsford persuasively shows how Grand Central Terminal merged the monumental scale, aesthetics, and rationalism of Beaux-Arts architecture with a modern spatial plan designed for circulating masses of people with efficiency and speed.[75] Considering the station as a circulating machine, Raynsford argues that Grand Central Terminal formed a utopian kind of social space of modernity, a city within a city.[76] In this "terminal city," the circulation of passengers was regulated and aestheticized into formal patterns, and beauty salons, barbershops, elegant restaurants, and retail stores served as sites of spectacle and consumption.[77] One journalist claimed that "the location of the galleries in a railway station is psychologically correct; there is nothing like travel to stimulate the gland of expenditure."[78]

Although newspaper accounts of Grand Central Galleries stated that the goal of the venture was to increase the visibility of unknown American artists and to give them an entrée into the exclusive art gallery system, the founding members consisted primarily of well-established painters and sculptors, and many were members and associates of the National Academy of Design.[79] The galleries were also intended to represent the diversity of styles and approaches within contemporary American art, yet nearly all the founding members were associated with academic naturalism and traditional art-making practices.[80] For the art critic Henry McBride, Grand Central Galleries had given a new lease on life to these academic artists, whose work held little interest for "clever art dealers" and the New York intelligentsia.[81] McBride lauded Grand Central Galleries' application of new business principles to the selling of art, especially the concept of traveling exhibitions that delivered art shows to cities such as Aurora, Illinois, and Atlanta, Georgia, and claimed: "Business, Big Business had come to their aid."[82] Art critics agreed with McBride's assessment that the taste for traditional art prevailed at Grand Central Galleries, and one writer in *Time* magazine called the establishment "one of the

strongest citadels of conservatism."[83] Hoffman had previously mounted an exhibition of her sculptures, featuring her *Senegalese Warrior,* the *Martinique Woman,* and the *Elephant Hunter* in February 1928.[84] However, in the early 1930s, Erwin Barrie began to vary the kind of art exhibitions shown at Grand Central Galleries. In partnership with the Downtown Gallery, the galleries held *33 Moderns,* exhibiting 132 paintings by artists such as Stuart Davis, Walt Kuhn, Yasuo Kuniyoshi, and Marguerite Zorach, and sculptures by Duncan Ferguson, Robert Laurent, and William Zorach.[85] In collaboration with the wealthy art patron Amelia Elizabeth White, the painter John Sloan organized the *Exposition of Indian Tribal Arts* (1931), in an attempt to elevate Native American arts simultaneously from the realms of ethnology and tourist art.[86]

For her *Races of Man* exhibition, Malvina Hoffman installed the statuettes in a geographic arrangement. Some of the sculptures were placed on free-standing pedestals, while others were displayed in glass cases (figure 5.2). As in the Trocadéro exhibition, early works such as the heroic-sized *Senegalese Warrior* and *Martinique Woman* were displayed with dance figures, sculptures unrelated to the Field Museum commission. The exhibition space, the Sargent Room, in Grand Central Galleries conformed to the palatial model, with its monumental scale and central skylight. Hoffman arranged the statuettes around the periphery of the room and placed settees beneath the large skylight. Henry McBride, writing for the *New York City Sun,* claimed this art-gallery setting increased the appreciation of the figures as aesthetic objects: "[at the Field Museum,] anthropological interest, rather than more purely aesthetic considerations, naturally dominates the large collection of sculptures that Malvina Hoffman is showing here."[87]

Erwin Barrie mounted an extensive marketing campaign for the *Races of Man* exhibition; photographic reproductions of various works graced the covers of *Art Digest, Art News,* and the College Art Association's publication, *Parnassus,* during January and February 1934.[88] The publicity department of the art gallery also took out full-page advertisements in February issues of *Art News* and *Art Digest,* the latter featuring a photographic image of *Daboa* and citing the French critic Louis Vauxcelles. Each of these journals, except *Parnassus,* also contained a review within the same issue. A small-scale replica of the *Hawaiian Surf-Rider* was featured in a window display at the Fifth Avenue location of Brentano's Book Stores to advertise the show and to sell copies of Arsène Alexandre's monograph on the sculptor, *Malvina Hoffman* (1930).[89] At the gallery, Hoffman arranged to sell copies of the Field Museum's guidebook to the exhibit hall, as well as postcards featuring images of individual works. An English translation of Alexandre's book was also available at the show.

The opening reception, held on January 30, 1934, served as a benefit for the Emergency Fund for Needy American Artists. Fashioning the opening reception as a charitable event and enlisting members of the social and wealthy elite to serve as its patrons formed an effective marketing strategy to build prestige for the exhibition. However, some individuals refused to have their names put to work despite the philanthropic cause; the drama critic Alexander Woollcott claimed that his refusal was a "feeble protest against all this rubbishy business of serving as patron."[90] Patrons who agreed to sponsor the exhibition included foreign diplomats, local and state politicians, representatives of the Chicago business elite, members of well-established New York families, socialites, sculptors, architects, and Hoffman's personal friends and early patrons. Uday Shankar and members of his dance company, Mary Pickford, and Amelia Earhart had also seen the show during the course of the exhibition.[91] *Art News* noted that more than ten thousand people visited the exhibition and claimed that many who had attended seldom went to art exhibitions. Erwin Barrie boasted that, with the exception of an earlier John Singer Sargent exhibition, Hoffman's *Races of Man* was the most successful show ever held at the art gallery and extended it until March 3, 1934. Hoffman sold, or obtained commitments to purchase, over half of the exhibition, forty-five statuettes in all.[92]

The New York chapter of the Society of Women Geographers attended the exhibition and held a tea in honor of the sculptor on February 3, 1934. Hoffman took students from the International Student House on a tour of the exhibition and briefly talked to them.[93] A group of high school students visited the show on February 11, 1934, and they, too, met the sculptor. Students wrote short reports that provide insight into how the general public responded to the sculptures. One student stated that the works gave her a "great understanding of peoples' characteristics and culture," while another thought that Hoffman's explanation of how she achieved her "photographic effect" of movement in the sculptures was a "very valuable secret."[94] The comments of a sixteen-year-old girl reveal how the works confirmed her preexisting perceptions of race: "the head of a Hindu woman who is one of the most high-bred looking women I have ever seen. I think that Miss Hoffman fell down a little on the white race which I, for one, thought rather uninteresting, but in all I thought the exhibition was a splendid example of what may be done with a set of firmly laid boundaries like 'the races of man.' I think it was pleasure to learn of the world through such a delightful medium."[95]

How did New York critics evaluate the *Races of Man* exhibition? To address this question, let us return to Lewis Mumford's essay "The Marriage of

Museums" (1918), discussed in the last chapter. In his essay, Mumford urged natural history museums to hire academically trained artists to work on museum displays, since they possessed a synthetic vision, which he believed would reconcile feeling and knowing. Not only did these artists share with scientists an objective logic, Mumford claimed, they used a naturalistic technique that could "accommodate itself to values extraneous to those demanded by an absolute esthetic response."[96] Consider the possibilities for sculptors, he asked, if they were to model figures for ethnographic life groups and to represent racial types.[97] Such modeled figures would supersede lay figures naively made by museum preparators and replace ethnic casts: "once let the scientific impulse get hold of the sculptor (who is an anatomist by current practise anyway) and a new horizon of possibility will open up for both science and art."[98] With the exception of Mumford, none of the art critics who reviewed the exhibition referred to his essay, but the art critic Royal Cortissoz and Edward Alden Jewell grappled with how the Races of Mankind statuettes mediated this "new horizon of possibility." Unlike the French reviewers, who concerned themselves with defining a documentary object, these critics did not question the aesthetic value of the reproductions; they structured their analysis around issues of individual portraits, racial types, and works of art.

The conservative art critic Royal Cortissoz, whose views appealed to the middle-class readership of the widely circulating newspaper the *New York Herald Tribune,* traveled to Chicago to see the Hall of the Races of Mankind at the Field Museum. In his November 1933 review, the self-labeled traditionalist claimed that the sculptures were an "artistic tour de force."[99] He explained further that artistic studies of racial types formed a genre within sculpture. Cortissoz paraphrased Augustus Saint-Gaudens, stating that a "statue of an Indian was the youthful sin of every American sculptor," and offered Jean-Baptiste Carpeaux's *Les quatre parties du monde* at the Observatoire in Paris as a precedent for Hoffman's sculpture.[100] The art critic argued that the Races of Mankind sculptures should not be considered mere derivatives of Rodin, because they lacked his sensuous modeling and subtle modulation between forms. Instead, Cortissoz suggested that Hoffman might have had "contact with the classical tradition," because she modeled strongly defined contours and infused the works with a classical sense of compositional unity.[101] The Races of Mankind sculptures reflected an artistic vision, he argued, that avoided theatricality, picturesqueness, and superficial tricks, which might have tempted any artist undertaking such a project. But what Cortissoz believed made the works an artistic tour de force was how Hoffman modeled "living, vitalized portraits" that expressed racial nuances and were "persuasive interpretations that only

an artist can fashion."[102] Cortissoz considered the sculptures antithetical to what he called manikins and ethnographic life groups, the latter of which he claimed hypothetically recreated "the primitive members of the human family" but possessed a "veil of unreality" about them.[103]

In his review of the *Races of Man* exhibition at Grand Central Galleries, Cortissoz claimed the sculptures' validity as "studies of character" had not been lost during their transformation into small-scale statuettes.[104] On the contrary, he argued, they might even have gained a "delicate charm." For Cortissoz, the inclusion of earlier works in the exhibition brought into focus Hoffman's steady development as an artist. These early works, as well as Arsène Alexandre's monograph on the sculptor, provided the critic with the means to assert that the Races of Mankind sculptures were the inevitable result of Hoffman's long artistic career, beginning with her initial studies with the painter John Alexander, extending to her sculptural training under Auguste Rodin, to becoming a professional sculptor who had received architectural commissions. He claimed that while Hoffman was proficient in architectural sculpture, her highest achievement was in the realm of portraiture. He praised the sculptor for infusing vitality in her series of portraits through her vivid rendering of facial features and her ability to make the "turn of the head significant." For Cortissoz, Hoffman's sculptures successfully represented portraits, racial types, and works of art. The *Hamite Abyssinia,* he explained, not only reflected nature itself and suggested the "natural aristocracy of Africa," it represented nature "transmuted by artistic unity."

In his review for the *New York Times,* Edward Alden Jewell claimed that Malvina Hoffman's exhibition at Grand Central Galleries was part of an emerging "sculpture renaissance." Developments in the plastic arts and their support by art galleries and museums, Jewell claimed, suggested a significant rebirth of sculpture in the United States.[105] To prove his point, Jewell reproduced Hoffman's *Batwa Boy* next to a portrait by Dorothea Schwarcz Greenbaum, and below Paul Manship's fountain figure *Prometheus,* installed at Rockefeller Center. Serving as a vertical element, a photograph of the full-length *Ainu Male* balanced an image of John Flanagan's *Mother and Child.* With this arrangement of images, Jewell placed Hoffman's Races of Mankind figures alongside experiments in direct carving, architectural sculpture, and contemporary portraiture. Paraphrasing Louis Vauxcelles, Jewell claimed that Hoffman had "ably accomplished what probably represents the most formidable task ever attempted by a woman sculptor."[106] Hoffman, he explained, wisely kept to realism to produce what he called "anthropological sculpture." Like Cortissoz, he argued that Hoffman went beyond merely reproducing a

subject's likeness; a series of individual portraits could not meet the requirements of the Field Museum. In each portrait, Jewell claimed, Hoffman had created a "composite" that was infused with symbolic meaning and a sense of "racial summation."[107] He suggested that Hoffman's racial portraits, based on observation of individual subjects, mediated the horizon of possibility between art and science.

Edward Alden Jewell had earlier considered the notion of a "composite" in an article entitled "The Masterpiece and the Modeled Chart," which appeared in the *New York Times*.[108] Jewell reproduced a male figure by Jane Davenport Harris, daughter of eugenicist Charles B. Davenport, entitled *The Average American,* between two photographs of Greek and Egyptian sculptures and asked, "What is a work of art and what is a work of science?" In his answer, the critic claimed that all three were impersonal composites but that each followed a different notion of a generalized type. Davenport's figure, exhibited in the Department of Eugenics at the American Museum of Natural History, was an example of a statistical composite, compiled from measurements of more than one thousand World War I soldiers.[109] While the figure was an authentic scientific composite, Jewell argued, it was a "perfectly lifeless" modeled chart; a shop window manikin exhibited a greater sense of personality. In contrast, the Greek and Egyptian male figures were examples of an impersonal, aesthetic composite, a type based on an ideal synthesis. The art critic offered a fourth kind of generalized composite, which he called a "hypothetical average citizen" that he claimed was formed mentally through encountering individuals in everyday life.

Jewell countered these generalized composites with modern artistic approaches to representing nature, which, he explained, vacillated between the poles of "photographic fidelity to a subject and sheer abstraction."[110] While noting that there were innumerable modes of representation between the realms of realism and abstraction, he concluded that John Ruskin had offered a way to negotiate this increasing diversity: "there is only one way of seeing things, and that is seeing the whole of them."[111] Jewell's reference to a familiar essay, "The Unity of Art," by the nineteenth-century British art critic would have signaled to his readers that the problem of this kind of composite revolved around perception. According to Ruskin, an artist perceives the whole of a human figure, uniting external and internal qualities. Art by great artists such as Titian or Tintoretto produced with this "whole" form of perception, Ruskin claimed, gratified viewers equipped with narrower ways of seeing, shaped by specialized taste.[112] As he explained further, "a sensualist will find

sensuality in Titian; the thinker will find thought; the saint, sanctity; the colourist, colour; the anatomist, form."[113]

From Jewell's perspective, this whole way of perceiving nature led to naturalistic composites that were in contrast to purely aesthetic or scientific ones. In his essay on the *Races of Man* exhibition, Jewell doubted whether any mode other than naturalism could have satisfactorily furnished the Field Museum with authentic records without taking recourse to the medium of direct casting. And when the American art critic claimed that Hoffman produced composites infused with symbolic meaning, he meant that she produced portraits that catered to multiple audiences with specialized tastes. In doing so, Jewell seemed aware of how the sculptures functioned as boundary objects. He agreed with Lewis Mumford that "more and more do our natural history museums appear to be turning to art" for just this kind of artistic vision and added that the "Field Museum has certainly found its plastic historian" in Malvina Hoffman. However, Lewis Mumford reached the opposite conclusion, namely that the Races of Mankind figures did not fulfill his earlier expectations for mediating the horizon between art and science. In his review for *The New Yorker*, Mumford explained with dissatisfaction,

> The difficulties of doing this work are obvious. What a museum of natural history properly wants is realism of the first order, and such realism is hard to associate with plastic form of the first order, although the task was not beyond Rodin when he did the "Age of Bronze" nor was it, perhaps, beyond Brancusi [*sic*] when he did his anatomical man with the skin removed. Perhaps the mistake in this commission was in having a single artist do the entire work. One feels that if there were more knowledge of the racial type and life, there might be more depth and feeling in the work itself. Indeed, could Michelangelo himself do justice to all these types and render them all with sufficient subtlety? The answer is No. The example of the Field Museum should be emulated by those who are willing to go more slowly and choose their artists more patiently. A hundred years would not be too long in which to get such a work properly finished.[114]

Despite Mumford's disappointment, the fact that the figures were able to traverse the territory from Rivet and Rivière's anthropological aims to Clark and Barrie's business endeavors shows how successful the statuettes were in accruing new values and functions beyond their display at the Field Museum.

6. DEPLOYING THE RACES OF MANKIND FIGURES DURING THE 1940S

WHILE MOST CRITICS IN THE 1930S viewed the Races of Mankind sculptures as a novel combination of art and science, Malvina Hoffman's deployment of small-scale replicas and photographic reproductions at the beginning of World War II engaged a very different social and political climate, where such an interpretation no longer held much currency. Similarly, the other major thread running through many art reviews of the sculptures during the 1930s, the notion that Hoffman could divine innate racial differences, was also at odds with an emerging discourse on race that stressed similarity over difference. Many antiracist texts, like Ruth Benedict and Gene Weltfish's *Races of Mankind* (1943), explained human differences in terms of culture and not biology. Physical variations, they claimed, are merely superficial.[1] While such publications maintained previous taxonomies of races, many argued that all races were biologically and mentally equal. The idea of a Brotherhood of Man, which played a minor discursive role in the early 1930s, gained a much greater currency at the beginning of World War II.

For many of these writers, promoting a Brotherhood of Man was crucial to creating a better democracy.[2] This concept served to combat what Gunnar Myrdal later described as the "American dilemma": the failure of white America to recognize the contradiction between its ideals of individual equality on the one hand, and racial intolerance on the other.[3] As historians Matthew Frye Jacobson and Michael Denning recently observed, racial politics in America were extremely volatile in the late 1930s and early 1940s. Responding to the threat of a massive demonstration in Washington, D.C., President Roosevelt

signed Executive Order 8802 on June 25, 1941, to prohibit racial discrimination in the defense industries. New organizations like the American Civil Liberties Union's Committee Against Racial Discrimination and the Congress of Racial Equality (CORE) were founded in 1942. The Council Against Racial Intolerance held Victory through Unity conferences across the country and intensified its educational efforts. African American newspapers launched the Double Victory campaign, arguing for "Victory against Fascism Abroad and Victory against Racism at Home."[4] During the summer of 1943, race riots occurred in Harlem and Detroit.[5] Many individuals, including Ruth Benedict, Pearl Buck, and Wendell Willkie, pointed out that contradictions between American ideals of democracy and its practices of racial discrimination were apparent to other nations, as well. Hitler, Benedict claimed, used the racial politics in America to mobilize other countries and to propagate the notion of Aryan superiority. Like the production front or inflation front, the anthropologist argued, Americans must combat the race front.[6]

During the 1940s, Malvina Hoffman's small-scale replicas and photographic reproductions of the Races of Mankind sculptures engaged these ideas concerning the race front. To promote the sculptures, Hoffman shifted from her rhetoric of character, which emphasized racial differences, to the notion of a Brotherhood of Man. New social configurations emerged that enabled reproductions of the Races of Mankind figures to circulate widely, promote brotherhood, and engage a new world picture for the postwar era, while increasing their role as normative representations of race.

THE *MEN OF THE WORLD* EXHIBITION

Shortly after the Battle of Midway, in the middle of June 1942, Malvina Hoffman and the Coordinating Council of French Relief Societies opened the *Men of the World* benefit exhibition, which featured a number of Races of Mankind statuettes (figure 6.1). Proceeds from admission fees and 25 percent of all sales went toward food packages for French prisoners of war, civilian internees, French children, and kits for American soldiers sent through the International Red Cross.[7] Held at the Whitelaw Reid Mansion at 451 Madison Avenue in New York, the exhibition was an overwhelming success.[8] The show ran for more than four months and was open seven days a week to accommodate the large number of visitors.

Although existing photographs of the exhibit do not clearly indicate how the statuettes were displayed, an anonymous reviewer in *Art Digest* observed that they were placed in an "appropriate landscape setting."[9] The arrangement

Figure 6.1. View, *Men of the World* exhibition. Merchant Marine Day, Whitelaw Reid Mansion, New York (June 1942). Malvina Hoffman papers, Research Library, The Getty Research Institute, Los Angeles (850042).

of the figures prompted the critic to claim that the various types were juxtaposed dramatically: "Viceroy stands near untouchable, pigmie near giant, savage near soldier."[10] Such a description suggests that the exhibit stressed differences rather than similarities. The *Men of the World* exhibit also included earlier portraits by Hoffman, a six-foot figure of Saint Francis, and a heroic-size head of Christ. The religious sculptures helped to situate the Races of Mankind statuettes within the Christian ideal of a Brotherhood of Man. To connect the figures further to this discourse, Hoffman placed this caption beneath the head of Christ: "Have ye forgotten, all ye who pass by, that all men are equal in my sight?" As if it emanated directly from Christ, Hoffman offered divine authority to sanction the claim of equality. The sculptor's *St. Francis of Assisi* supported the idea of Christian brotherhood, since the Catholic Church had recently proclaimed the saint the patron of Catholic

Action.[11] For the Catholic Interracial Council, an organization established to combat racism within the Church's American parishes, Catholic Action and the doctrine of "Mystical Body of Christ" served as the foundation for advancing the idea of universal brotherhood.[12]

A large "Victory" photomural hung at the entrance to the exhibition (figure 6.2), which also carried a caption.[13] Here, Hoffman quoted the seventeenth-century poet John Donne: "No man is an island, entire of itself, every man is a piece of the continent, a part of the main. If a clod be washed away by the sea, Europe is the less, as well as if a promontory were. Any man's death diminishes me, because I am involved in mankind." To claim her sculptures' relevance to the war, Hoffman argued that they would show that "this war must establish equality among the races."[14] The Coordinating Council of French Relief Societies held a similar position, since it also believed that the exhibit visualized "the necessity of unity in all races."[15] Statements such as these, released through the council's Public Relations Bureau, helped to construct this new interpretative frame. An editorial in the June 20, 1942, issue of the *New York Times* adopted

Figure 6.2. Malvina Hoffman et al., "Victory" photomural, *Men of the World* exhibition, Whitelaw Reid Mansion, New York (1942). Malvina Hoffman papers, Research Library, The Getty Research Institute, Los Angeles (850042).

this frame by stating, "There are bigger art exhibitions than this in the city, but there is none that conveys with such subtle force the meaning of this war of many peoples or that expresses so concretely John Donne's eloquent recognition of mankind's unity."[16] Radio stations broadcasted similar stories and a wide range of publications—from the art periodicals *Art News* and *Art Digest,* to newspapers such as the *New York Herald Tribune* and the Hebrew publication *Forward,* to the Office of War Information's *L'Victoire*—praised the show for its contribution to the war effort.[17]

However, this rhetoric of brotherhood did not displace the show's assertions of racial types. Indeed, the exhibit was untouched by recent challenges to the race concept, such as those by Ashley Montagu, because other elements constructed a fixed taxonomy of races. One of the most emphatic statements of race was Hoffman's "Men of the World" design on the two-toned exhibition brochure (figure 6.3). Presenting a series of profiles, this image recalled earlier

Figure 6.3. Malvina Hoffman, *Men of the World* exhibition brochure, IBM School, Endicott, New York. Malvina Hoffman papers, Research Library, The Getty Research Institute, Los Angeles (850042).

drawings of facial angles.[18] Beginning from the left, the tilting profiles show varying degrees of prognathism, or the extreme projection of the lower jaw.

Another photomural, entitled "Who Is News Today?" with the subtitle "Mural of Mankind and Racial Map" (figure 6.4), implied that race is determined by geography. In an early press release, the council claimed that this mural demonstrated "how geographic location of peoples influences their character and governs their pursuits."[19] Such a statement fits within environmental theories of race, like Alfred Haddon's anthropogeographic explanation that gained wide acceptance during the 1930s. The 10-by-12-foot photomural featured a world map bordered by photographs. Working collaboratively with Louise Branch, Dix Duryea, Gordon Hurd, Erica Anderson, Florence Conrad, and Robert Haas, Hoffman assembled images selected from the *Asia* magazine, from the Field Museum, and from individual photographers such as Margaret Bourke-White, Adolf Fassbender, and her former husband Sam Grimson.

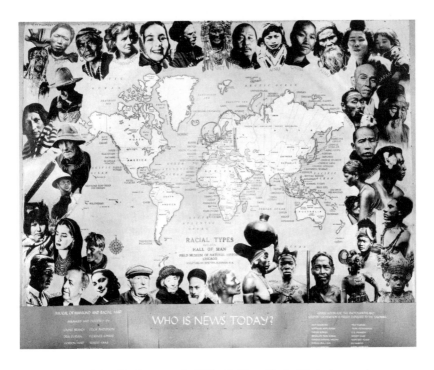

Figure 6.4. Malvina Hoffman et al., "Who Is News Today?" photomural, *Men of the World* exhibition, Whitelaw Reid Mansion, New York (1942). Malvina Hoffman papers, Research Library, The Getty Research Institute, Los Angeles (850042).

Several of these images were reprints of photographs Hoffman used to produce the figures. Red dots and captions on the map indicated where each national group lived, and movement arrows identified areas discussed in the daily news concerning the war. She hoped that through this mural, the public's interest would be "kept alive not only in the daily arena of war news, but instructing them as to what the people look like in the actual battle zone."[20]

In a less direct fashion, the "Who Is News Today?" photomural presented a system of visual links that constructed a Nordic ancestry for the hypothesized American viewer. The photographs of white males captioned "New England" and "USA" contradict the primary interpretive system of the mural, because unlike the labels for the adjacent photographs, they were not reproduced on the map.[21] To connect these images to a geographic space, the viewer needed to make a conceptual leap involving another disconnected element.[22] The large red circle hovering over sections of Britain, Sweden, Norway, and Denmark assisted the viewer in linking these photographs to northern Europe and to an assumed Nordic ancestry. Written in large type and placed between North America and Europe on the map, the caption "Nordic" assured viewers that they had made the correct reading.

By constructing America as Nordic, the mural not only upheld previous distinctions between white races, it also implied that earlier immigration policies, like the Johnson Act of 1924, had successfully maintained what Alain Locke called a "citadel of Nordicism." This Nordic lineage and its historical placement at the top of racial hierarchies eroded the exhibit's claim of racial equality. Although the religious framework of the exhibit stressed the idea of a universal brotherhood, elements such as these indicate that earlier notions of racial hierarchies were not displaced. Indeed, tensions between the idea of a spiritual unity and the notion of fixed physical differences were left unresolved.

However, the social apparatus surrounding the *Men of the World* exhibit involved more people in linking the sculptures to the rhetoric of brotherhood. Working with the council, the sculptor enlisted the support of many wealthy philanthropists, prominent educators, artists, and religious figures. These individuals agreed to serve as patrons of the show and allowed the council to use their names in publicity materials.[23] Celebrities also endorsed the exhibit through their presence at a private viewing. These guests of honor included the film actors Madeleine Carroll and Constance Collier, the stage performer and monologist Ruth Draper, the writer André Maurois, and the president of the International Business Machines (IBM) Corporation, Thomas J. Watson.[24]

The council's alliances with other organizations connected the exhibit to a much wider social field. The Chinese Women's Relief, the National Urban

League Guild, the Seamen's Church Institute (associated with the Merchant Marines), the YWCA, the American Friends of Yugoslavia, France Forever, the Paderewski Testimonial Fund, and the American Red Cross all held special fund-raising events in conjunction with the show.[25] These organizations pursued a wide array of concerns, from ending discriminatory practices against African Americans, to promoting war-related activities of the Merchant Marines and the American Red Cross, to increasing the awareness of the plight of people living in occupied areas within China, France, and Yugoslavia. Sponsoring the exhibit helped these unrelated organizations to link their particular interests not only to the abstract theme of universal brotherhood but also to the sculptures themselves. Conversely, coming from multiple and even conflicting standpoints, these organizations helped to ensure the figures' status as embodiments of a Brotherhood of Man. The benefit show was a succession of unstable alliances between Hoffman, the council, and various organizations. Various groups adjusted their interests in an attempt to parallel the tactics employed by the sculptor and the Coordinating Council of French Relief Societies. In doing so, they added new meanings to the idea of racial equality, broadening the sculptor's charge of universal brotherhood.

On September 8, 1942, the Chinese Women's Relief Association sponsored the show. At the time of this fund-raising event, the U.S. military's invasion of Guadalcanal, which had begun one month earlier, held the nation's attention. However, many Americans knew little about the Solomon Islands and other South Asian countries. Newspapers published maps and human-interest stories in an effort to describe the people living in the areas of battle. For example, following the Japanese invasion of Java, Burma, and the Malayan Peninsula, the *New York Times* devoted the entire March 15, 1942, issue of its *Sunday Magazine* to the war in the Pacific and to the politics of China and other Asian countries.[26] This issue presented countries like China and India as struggling for freedom and democracy under threat of Japanese aggression. As such, the stories lent support to fund-raising efforts, especially for China, which had become a fashionable philanthropic cause within the upper echelons of New York society.[27]

Mrs. Lin Yu Tang and Pearl Buck served as guest speakers at the Chinese Women's Relief fund-raising event.[28] At the time, Pearl Buck held enormous stature within American culture as an author, interpreter of the East, and advocate for civil rights. Five years earlier, Buck had received a Nobel Prize for her novel *The Good Earth,* which became an Academy Award–winning film.[29] In her novel, she used a strategy of familiarization to construct her characters as recognizable types.[30] By using a cluster of signs already associ-

ated with American farmers, Buck's characters were understood as "ordinary" farmers who faced droughts and famines. These social types appealed to a broad range of readers, like members of the Book of the Month Club, since *The Good Earth* had much in common with characters of other epic narratives like John Steinbeck's *Grapes of Wrath* (1939).[31] Through her many essays in *Asia* magazine, as well as her activities in the East and West Association, Buck worked hard to promote the "understanding of ordinary people on both sides."[32] Shortly after the Japanese invasion of China, she gave speeches and published a variety of essays to increase awareness of politics in the East. The author was also highly visible in efforts to end racial discrimination in America. With the president of the National Urban League and the editor of *Opportunity* magazine, Buck established the American Civil Liberties Union's Committee Against Racial Discrimination.[33] She wrote extensively on civil rights at home and on European colonialism abroad. For example, her "Warning to the Free Nations" (1941) pointed out the contradiction between the rhetoric of American democracy and the Jim Crow practices of segregation with this four-part analogy: "To fight with England for Europe's freedom while India is governed by tyranny, is a monstrous contradiction, and yet no more monstrous than that while the United States prepares for a mighty defense of her democracy twelve million Americans should be denied equality in a nation founded upon equal opportunity for all."[34]

Buck considered Hoffman's statuettes in terms of cultural, not racial, types. She believed that the figures "brought to the consciousness of the American public the types of everyday people who maintain the culture of the countries of the Far East and the East Indies."[35] In understanding the figures as representations of cultural types, Pearl Buck subscribed to the views of Boasian anthropologist Ruth Benedict, who popularized the notion of cultural personalities in her book *Patterns of Culture* (1934). And Buck also saw advantages to linking her own agenda to the sculptures. In March 1942, she made plans with the artist to exhibit a few Races of Mankind statuettes at the East and West Association's office in New York.[36] The writer saw the sculptures as fitting within the educational policies of the organization, whose aim, she wrote to Hoffman, was to "stress the patterns of life, how people live, work and play and thereby to convey a better understanding of our neighbors."[37]

The National Urban League Guild was also interested in connecting its organization to the *Men of the World* exhibit. For over twenty years, the Urban League and other African American organizations embraced Hoffman's works. For example, in 1928 the Urban League reproduced her charcoal sketch *Nursie* on the cover of its *Opportunity* magazine.[38] The Harlem branch of the

New York Public Library exhibited this drawing along with plaster replicas of "four Negro types" during the following year.[39] And in 1941, Hoffman arranged with Alain Locke to reproduce *Sara Girl, African Slave, Pagan Prayer,* and photographs of her Mongolian dancers in Howard University's *Portfolio.*[40] However, one should not interpret the reproduction and circulation of Hoffman's figures in these venues as evidence that the sculptor advocated the ideological concerns of the New Negro Movement. Unlike Pearl Buck or Anne Morgan, Hoffman did not participate in activities associated with African American organizations like the National Urban League, nor did the sculptor take a public stance against practices of racial discrimination. During the 1940s, the sculptor continued to couch her public statements on racial equality in abstract, spiritual terms. For example, "love and understanding" of humanity, Hoffman argued, could be achieved only through a spiritual connection to a "cosmic whole."[41] It was through such platitudes, rather than direct engagement, that Hoffman addressed racial politics in America.

However, in August 1942, the National Urban League Guild made plans with the Coordinating Council of French Relief Societies to hold a special tribute to the sculptor on the last day of the exhibition. Hoffman declined the guild's offer, stating that she was honored by "the fact that the Negro group feels enthusiasm toward such a project."[42] Instead, Hoffman encouraged the guild to contact prominent African American sculptors to see if they might participate with her in a group show. On short notice, the organization wrote to Mike Bannarn, Richmond Barthé, Selma Burke, Elizabeth Catlett-White, Hilda Prophet, John Sargent, and Augusta Savage and requested them to submit works. Bannarn, Burke, Prophet, and Sargent either were not reached in time or declined to participate. In the end, Barthé, Catlett-White, and Savage served as guests of honor and submitted eight sculptures for the one-day event.[43]

This joint exhibition linked the Races of Mankind statuettes to the newly formed public-relations arm of the National Urban League.[44] The exhibit fit within the guild's social and fund-raising priorities since, according to a review in the October 1942 issue of *Opportunity,* the show promoted "better interracial relations."[45] As an interracial organization, the guild's stance on American racial politics was primarily one of conciliation rather than agitation. On the evening of the event, the sculptor and Lester Granger, then executive secretary of the National Urban League, addressed an audience described as the "ultra cream of colored and white society."[46] The well-known cabaret blues singer Josh White, along with Sam Gary and Little "Cuz" from the Café Society Uptown, performed to an audience numbering well over 250. The guild showed the film *African Tribal Dances* twice to accommodate the large

number of guests. After paying expenses and splitting the proceeds with the Coordinating Council of French Relief Societies, the guild raised only $80.[47] However, because the event furthered alliances with wealthy philanthropists, Lester Granger considered it a "fine job of public relations."[48]

The sculptures, the blues music, and the ethnographic film presented an unstable and even disjunctive cultural experience. Barthé's generalized male figures, Catlett-White and Savage's simplified heads, and Hoffman's highly detailed figures engaged very different aesthetic and ideological concerns. Josh White, known for his Popular Front agitation songs "Uncle Sam Says" and "Defense Factory Blues," performed between the showings of Marcel Griaule's film concerning Dogon funerary practices, which must have formed quite an unusual juxtaposition indeed.[49] Were the guests supposed to understand these various representations through the trope of Africa in terms of a shared cultural history, a racial soul, a biological lineage, or a combination of all three? The guild did not explain how to negotiate these different conceptions of race or how to consider their role in fashioning a New Negro identity. Since the guild endorsed Hoffman's racial taxonomy in its press release, there is evidence suggesting that the organizers of the event also subscribed to a notion of race that was not free of biological determinism.[50] How did this event negotiate the built-in Nordicism of the *Men of the World* show? Without photographs of the exhibit, it is difficult to determine how these cultural juxtapositions engaged elements like the photomural, which constructed a Nordic identity. Presenting these contradictory elements as equivalents, the joint exhibition reworked notions of racial difference into an unstable logic of black and white.

This logic, whether intended or not, maintained existing economic and political formations. Absent from the event was the agitational stance found in contemporaneous activities like the Double Victory Campaign promoted in African American newspapers; Richard Wright and Edwin Rosskam's *12 Million Voices* (1941), which redeployed Farm Security Administration (FSA) photographs to construct a statement on African American oppression; or the March on Washington Movement, which helped to establish the Fair Employment Practices Commission.[51] Instead of employing tactics associated with the left, the guild used a conciliatory strategy to promote better interracial relations.

However, the day before the guild's exhibition, on September 17, 1942, the New York chapter of the American Red Cross sponsored the *Men of the World* exhibition with a fund-raising event. Here, the organization showed the film *They Need Not Die* to explain its blood-donation process.[52] The subject of the film and the scheduling of the event were extremely awkward,

since shortly after the *Men of the World* exhibit opened in June, the National Urban League circulated literature condemning the American Red Cross for its blood-donation policies. At the time, the organization segregated blood donations under the premise that white soldiers should receive blood only from white donors.[53] The league was not alone in its condemnation. Langston Hughes responded to the organization's War Drive policy with this poem entitled *Red Cross:*

The Angel of Mercy's
Got her wings in the mud,
And all because of
Negro blood.[54]

Albert Deutsch argued in *PM* magazine that the Red Cross practices violated "the principles of science and humanity."[55] The American Association of Physical Anthropologists also criticized the organization on scientific grounds.[56] Arguing that the blood banks were Jim Crow, its Committee on Racial Relations claimed that the organization followed practices similar to those based on "the Nazi theory of race."[57] Other than a copy of Deutsch's article, the guild made no other reference to the difficulties between the two organizations in its comprehensive record of the fund-raising event. In fact, there is no indication that the guild expressed concern over the sculptor's Red Cross activities. Since World War I, Hoffman had belonged to the organization, and during World War II, she taught first-aid classes.[58] This omission suggests that the National Urban League Guild chose not to engage the controversy at its benefit show.

That the *Men of the World* exhibit could function as a vehicle for the American Red Cross one day, then serve the National Urban League Guild the next, testifies to the representational power of the sculptures. By linking itself to the exhibition, the American Red Cross may have viewed the show not only as a means to increase blood donations but also as a way to recover from the earlier controversy. Meanwhile, the guild saw the figures as a vehicle for improving relations between black and white America. For the Coordinating Council of French Relief Societies, the figures demonstrated the existence of geographic races throughout the world, while for Pearl Buck they functioned as cultural types. With their variations on the theme of brotherhood, these groups added new meanings to the Races of Mankind sculptures. What enabled the sculptures to serve such diverse groups was their ability to oscillate between notions of individual and type, or of art and science. At the same time, the social network surrounding the figures increased their

value as embodiments of a Brotherhood of Man. Shortly after the *Men of the World* show closed, on October 21, 1942, the exhibit went on display at the International Business Machines (IBM) School in Endicott, New York. This show was followed by another exhibition at the IBM World Headquarters on Madison Avenue. While the *Men of the World* exhibit continued to travel to other venues, these shows mark the beginning of the sculptor's alliance with Thomas J. Watson, the president of the IBM Corporation.

MAPPING RACIAL DIFFERENCE

With Thomas Watson's financial support, the sculptor created a map (figure 6.6) called *Races of the World and Where They Live* (1943), and its later version, *Map of Mankind* (1946) (frontispiece), featuring images of the Races of Mankind figures, and she thereby extended the social life of the sculptures, but in a manner disengaged from the Brotherhood of Man discourse. Through reproduction and mass circulation, Hoffman hoped to increase the educational value of the figures.[59] The sculptor believed that a racial map would have significant military value; soldiers could carry it in their uniform pockets, and large-scale versions could be mounted on military transports as "practical demonstration[s] of who's who and where."[60] Hoffman's idea of creating a small-size racial map for soldiers was probably informed by the publication *A Pocket Guide to China* (1942), featuring Milton Caniff's "How to Spot a Jap" cartoon strip, which provided visual lessons in how to classify individuals in theaters of battle. Hoffman also reasoned that since races like those "in the South Seas and in the heart of Africa" had a greater capacity for judging the "true value of a human being," it was crucial that American soldiers learn how to approach them with sincerity.[61] Confident that reproductions of the sculptures could serve as "a friendly introduction," Hoffman believed that such a chart would prepare soldiers for encountering "unfamiliar races, who are now allies in the war."

On the home front, Hoffman wanted to connect the sculptures with a new visual language associated with the war. During the 1940s, cartographic maps served as a primary way to visualize events of the war. Newspapers and weekly magazines prominently displayed world maps to illustrate movements of U.S. forces and to explain the various theaters of battle. In one of his fireside chats, President Roosevelt encouraged Americans to use maps to follow the progress of the war.[62] Map reading quickly became a widespread cultural activity, and atlas makers like the C. S. Hammond and Hagstrom companies published maps in record numbers to keep up with the demand.

By connecting the Races of Mankind sculptures with a world atlas, Hoffman hoped to profit from this cultural phenomenon; she regarded the map project as a way to "keep afloat."[63] Despite the success of the *Men of the World* show, the sculptor received fewer requests for commissions and public lectures than in the 1930s. Royalties from the sale of the map, she hoped, would supplement her income. Hoffman initially consulted with representatives from the Hagstrom Map Company, but they would not print the map unless she assumed all the costs. If the chart was to be published, Hoffman knew that she would have to recruit individuals and organizations to underwrite the project. Thomas J. Watson was just the kind of sponsor the sculptor was seeking. As president of IBM, Watson had many contacts in international businesses and governments. Previously, Watson had served as the president of the U.S. Chamber of Commerce, president of the New York Merchants' Association, and trustee to the Carnegie Endowment for International Peace, an economic research institute.[64]

In accord with most economists of the time, Watson believed that standardizing local and international markets would be key to a postwar economy. The president of IBM reasoned that if there were a proper flow of goods and services across national borders, there would no longer be a need for war; "World Peace" would be established through "World Trade."[65] IBM key-punch machines, card sorters, tabulators, and other instruments of quantification would help make this global economic system possible; but to unite countries after the war would require "a reconversion in our ways of thinking—a readjustment of our thought processes . . . to a kind of thinking and planning that will best promote understanding and unity of purpose."[66]

Watson viewed Hoffman's racial map as a vehicle for promoting this new way of thinking; he planned to distribute it free to IBM employees as a Christmas present and to give the remainder to public school systems and universities.[67] The chart appealed to Watson, no doubt, because he valued the power of abstractions. At IBM, he practiced a mode of signification that turned abstractions into concrete signs. For example, International Business Machines was made into the word object *IBM*; *THINK* became the title of the corporation's magazine. As if words embodied meaning themselves, Watson had "Think, Observe, Listen, Read" inscribed on the risers of the main staircase of the company school. He regarded such signifying practices as part of a "good form of propaganda," one that would "stimulate and direct our thoughts along constructive lines."[68]

In the present, the map would function as part of IBM's public-service campaign, which was designed to counter the appearance that the company

was profiting from the war. The corporation's earnings from wartime leases to the U.S. government grew from $46 million in 1940 to $140 million in 1945.[69] The campaign also diverted attention away from the company's connections with Nazi Germany. During the late 1930s, Deutsche Hollerith-Maschinen Gesellschaft (Dehomag), IBM Germany, increased the efficiency and speed of collecting data to classify the population of Germany.[70] The Reich Statistical Office that oversaw Nazi race hygiene programs relied upon Dehomag tabulators and sorters and other IBM equipment.[71]

Hoffman knew that to achieve even wider distribution, she would need to build a network of alliances beyond her association with Watson. At her New York studio, Hoffman met with Harry Shapiro, the physical anthropologist at the American Museum of Natural History, and Lieutenant Goodfriend, a representative of the War Production Board, to discuss how to identify races and how to teach this process to others.[72] Hoffman also contacted her old acquaintances at the Field Museum. Since the sculptor did not own the rights to reproduce photographs of Races of Mankind figures, the project hinged on the Field Museum's approval. Hoffman sent a photostat of the chart to Orr Goodson, then director of the Field Museum, with a request that he should submit it to the board of trustees for their review.[73] Hoffman wrote to the president of the museum, Stanley Field, and to Henry Field to see if they would help develop support for the map. Hoffman asked Henry Field, who was working on Roosevelt's Project "M" (Migration) study in Washington, to introduce her to the "tops" of educational organizations who might be interested in the chart.[74]

In November 1942, Hoffman traveled to Washington to meet with Kenneth Holland at the Office of Inter-American Affairs. Although Holland preferred a map concerning the races of the Western Hemisphere, he agreed to buy 300 copies. Holland also decided to help Hoffman garner additional orders by exhibiting a mock-up of the chart at a meeting of the National Congress of School Superintendents.[75] Watson Davis, the director of Science Service, agreed to print and distribute the map through the organization's Science Clubs.[76] His commitment was on the condition that the sculptor obtain an order from the New York Board of Education to supplement Thomas Watson's initial order.[77] It is unclear why Hoffman's arrangements with the Science Service organization fell through, but by early spring, the IBM Company was moving ahead with the production of the chart. Under Hoffman's supervision, IBM photographers and graphic designers revised the chart and assembled a twenty-page racial atlas.[78]

Through this collaborative process, Hoffman's racial chart went through a number of revisions. The "Who Is News Today?" photomural served as the basic design; Hoffman initially replaced photographs of people with reproductions of the Races of Mankind sculptures (figure 6.5). Here, an airbrushed background unified the images and evoked the soft-focus effects of pictorialist photography. However, the range of lights and darks operating in the border clashed with the stark lines of the map. The placement of figures within the rational space of the map further intensified this visual tension. After Hoffman began working with IBM designers, she eliminated the airbrushed border and made other radical changes (figure 6.6). First, the designers did away with the arbitrary arrangement of the figures by placing them in a tabular format and grouping them according to eight colored backgrounds. Unlike the original soft-focus border, this new color system connected different

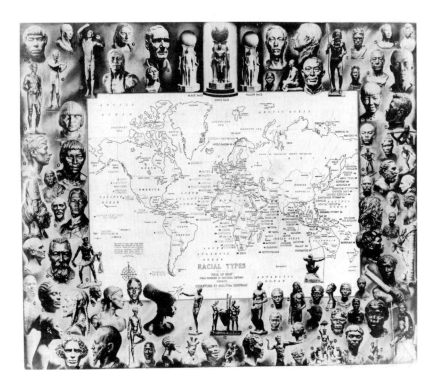

Figure 6.5. Malvina Hoffman, Design for *Races of the World and Where They Live*. Malvina Hoffman papers, Research Library, The Getty Research Institute, Los Angeles (850042).

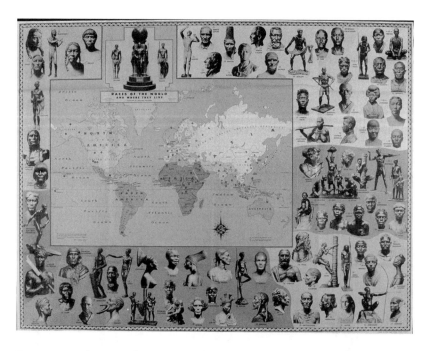

Figure 6.6. Malvina Hoffman, *Races of the World and Where They Live,* printed by C. S. Hammond and Company. Malvina Hoffman papers, Research Library, The Getty Research Institute, Los Angeles (850042).

groups of figures to geographic areas on the atlas. These colors helped to unite the figures with the map, but they lessened the sculptures' three-dimensional appearance. To solve this spatial problem, the designers used duotone printing to generate a stereoscopic effect. Hoffman believed that such an effect was necessary because the chart would be useless without "a good definition of anthropological features."[79] However, the brown and white photographs did not suggest the one anthropological trait governing the map's racial order. Many of the background colors referred to skin tone and thus helped to evoke this absent trait. For example, the figures of Asia now appeared on a yellow area, while the figures of Africa were shown on a dark brown background.[80] Color, then, was a method for grouping and linking, but also served as an associative device.

The tabular arrangement worked with the built-in biases of the Mercator projection that gives Europe and North America visual preference. Following the numerical sequence beginning at the upper-left corner above North America, one scans the figures counterclockwise, ending at number 76, the

Nordic Man. This full-length figure now appears at the center, near the top of the map and above Europe. Almost directly beneath this figure is a circle superimposed upon northern Europe. Like in the "Who Is News Today?" photomural, this circle identifies the location of the Nordic race and separates it from other European groups.

Hoffman and the designers also substituted the phrase "Races of the World and Where They Live" for the original title "Racial Types" and moved it to the top of the map. Enclosed within a rectangle, the title anchored the three reproductions of the figures from the *Unity of Mankind* sculptural group. The designers used a notched border to separate these figures further from those representing racial types and thus affirmed the conceptual boundary between primary "stocks" and secondary types. They also radically changed the *Unity of Mankind* images to solve a problem stemming from photographing figures in different media. On the first chart, Hoffman used a photograph of the bronze sculpture against a light background to represent the white race, while photographs of the clay models with dark background tones served to represent black and yellow races. When juxtaposed, the combined effect of the lights and darks gave the figure representing the white race the appearance of being darker than its counterparts. Since this arrangement contradicted the underlying racial classification, the designers cut and pasted photographs of the three bronze figures and placed them within a uniform pale orange background. A single globe now replaced the three globes that had defied the logic of the new title. Like the repositioning of the *Nordic Man,* these changes gave greater visual presence to the figure representing the white race, since it maintained its relation under the globe and to the sculptural group as a whole.

Hoffman abandoned her pictorialist sensibility in favor of "readability."[81] For Hoffman, "readability" meant incorporating pedagogical tactics developed within the new genre of "journalistic cartography" featured in the *New York Times, Time, Newsweek,* and *PM* magazine.[82] Emerging in the late 1930s, journalistic cartography encompassed a wide range of mapmaking practices but sought to depict an idea or concept dramatically. Unlike in general reference maps, formal elements such as color and typology played a much larger role in linking ideas and orienting the viewer to a theme. To make their maps more efficient, designers significantly reduced the level of information displayed, so much so that in many cases, they represented landmasses as simplified shapes. Called *active* or *suggestive* maps, these atlases, which presented unfamiliar projections, introduced new symbols and icons to the practice of mapmaking and map reading. Like these suggestive maps, the *Races of the*

World and Where They Live chart reduced the level of geographic information to a minimum. Color emphasized formal shapes and played other crucial metonymic operations like grouping and linking, while it also functioned metaphorically to evoke the racial classification based on skin tone.

These new cartographic strategies involve viewers in a complex interpretive process. The chart's color and numbering systems encourage viewers to think relationally and fix the figures to geographic locations or "where they live." One effect of this deciphering process is that it sidetracks viewers into accepting the figures as variables within a larger system of meaning. The representational status of the figures as racial types, therefore, is never in doubt. Ordered and classified, the figures work with the commonly held view of maps as disinterested objective representations of the world. Indeed, these images participate within a regime of representation that border upon tautology, for they engage a logic in which "a map is like a picture of the earth taken from high in the air" and "a doll is a model of a person," to quote a C. S. Hammond primer on cartography. Even those elements referring to the production of the figures, such as the compass rose with the sculptor's initials, modeling tool, and caliper, offer viewers little means of escaping this logic. In fact, the compass rose points to referential systems that testified to the figures' authenticity.

Once they completed the map on April 12, 1943, Hoffman wrote to the president of the Field Museum requesting copyright permission. Hoffman informed Stanley Field that Marshall Field III had already approved the chart, claiming it would be a "splendid channel of publicity for the museum and should interest thousands of new people that have possibly not been to Chicago or even heard about it in the newspapers."[83] Without reservation, Stanley Field gave his permission two days later. On July 15, 1943, Hoffman entered an agreement with C. S. Hammond and Company to publish the map.[84] Their contract specified that Hoffman would receive 10 percent in royalties on all sales beyond IBM's order. The map company also agreed to give full credit to the Field Museum and the sculptor on the chart as well as to include a short statement on Hoffman's books, *Heads and Tales* and *Sculpture Inside and Out*, "phrased in such a manner to avoid the appearance of advertising."[85]

Initially, the Hammond Company published more advertising circulars than actual maps. In October 1943, the map company printed 12,000 "Consent to Examine" forms while publishing only 500 *Races of the World and Where They Live* charts in the month of November.[86] During the following year, the company printed over 95,000 advertising circulars as part of a direct-mail campaign. Through her own contacts, Hoffman used other promotional

venues. The December 1944 issue of IBM's *THINK* magazine reproduced the chart on a two-page spread alongside an essay written by the sculptor. The *East and West Association Monthly Review* and *The New Yorker* magazine published short features on the map. FAO Schwarz mounted a large window display (figure 6.7) in its New York store. Marshall Field and Company placed a small order but failed to comply with Hoffman's request to "push this map idea ahead in Chicago . . . perhaps by some special exhibit in the window."[87] However, officials at the Field Museum agreed to display the racial atlas near a copy of *Heads and Tales* within the Hall of the Races of Mankind and to sell the map at the museum's bookstore.[88]

Trying to secure even wider distribution, Hammond sales representatives solicited prominent educators, cartographers, and anthropologists for written endorsements. This advertising strategy meant that the map would undergo a level of scrutiny that the original sculptures never received. Through a vetting process, the map company found that many individuals refused to endorse the racial chart. At a time when Ruth Benedict and Gene Weltfish's *Races of Mankind* pamphlet (1943) generated a great deal of controversy in the press, most reviewers understood the volatility of the subject of race. Moreover,

Figure 6.7. Window display, FAO Schwarz, New York. Malvina Hoffman papers, Research Library, The Getty Research Institute, Los Angeles (850042).

the tautology of the map seemed to sharpen their criticism; many objected to elements on the chart that generated its appearance of great facticity.

Their chief complaint concerned the title of the map. *Races of the World and Where They Live* placed the figures in the present, as if these types currently inhabited geographic areas on the map. One educator, who subscribed to a typological view of race, claimed that this temporality would confuse high school students because the map did not show European types in North America or in South Africa.[89] Arguing from a similar standpoint, Maynard Owen Williams from the National Geographic Society asked: "It looks as though North America still belongs to the Indians . . . Amid so many 'natives,' where is the white man who rules the whole lot?"[90]

Edward Carter, the director of the Institute of Pacific Relations, declined to recommend the map because he received internal memos from staff members who found the chart unsuitable for schoolchildren.[91] One of these reviewers argued that students needed a chart that stressed similarities, showing the "dignity of the occupations and livelihood of the world's common people." Above all, the anonymous reviewer claimed, an American educator wants to avoid students associating "the great majority of the colored peoples of the world with the small remnants of aboriginal peoples," who were "anthropological extremes" and "repulsive."[92] Such language indicates that the map failed to generate a sense of brotherhood promoted in contemporaneous antiracist pamphlets. Indeed, Carter attributed this failure to the design of the chart. From his recollection, the exhibit at the Field Museum did not give the "place of honor . . . to a representative of the white race."[93] Carter explained further: "Hoffman's sculptures . . . are beautifully modeled and give the beholder a sympathetic feeling. Something seems to have gone wrong with their reproduction which makes the originals appear to be sharp-featured and far from representative of the types intended . . . The layout and the map do not equal the artistic triumph of the sculpture."[94]

These critics took issue with other formal and cartographic elements. For instance, Maynard Owen Williams claimed the map was "off center" and "poorly colored."[95] While the physical anthropologist Harry Shapiro found the chart "handsome," he suggested rephotographing some of the sculptures in order to emphasize racial differences.[96] The *Sicilian Man*, Shapiro believed, "looks quite Negroid by the accident of lighting"; to solve this problem he recommended using "more light" on this figure and less on the "Negro types."[97] In terms of the cartography, Williams pointed out that the map offered too little geographic information. Carter claimed that including "Manchukuo"

as a place name or toponym on the chart was a "trifle unfortunate," since it appeared to legitimate Japan's occupation of Manchuria.[98]

While Shapiro, Carter, and Williams accepted the figures as representatives of racial types, others did not. N. C. Nelson at the American Museum of Natural History doubted the sculptures' status as characteristic types. In this respect, he differed from his colleague at the museum. Unlike Shapiro, Nelson challenged the anthropological value of the figures and questioned Hoffman's sculptural practice. The unfamiliar types "seem well enough," he argued, but the known types "do not always seem well chosen."[99] Nelson's objection did not concern the concept of types within physical anthropology; rather, he disputed the process of selection. Unconvinced that Hoffman's portraits of "Eskimos" served as representative types, he asked, "and who would pick Anatole France as a typical Frenchman? Obviously," he continued, "some of the types were chosen from photographs and I believe I have seen one of the Burma ladies pictured in the National Geographic Magazine."[100] This was exactly the kind of criticism that Hoffman and Field Museum officials had feared from Aleš Hrdlička and other physical anthropologists during the 1930s. As argued in previous chapters, Hoffman used a rhetoric of character and a narrative of "head-hunting" in order to combat such views.

However, the harshest review came from an unexpected source. Officials at the Field Museum refused to endorse the map. As the director of the museum observed, "From a scientific viewpoint, the chart is subject to criticism."[101] Paul Martin, the chief anthropology curator, pointed out that the chart did not "do things it advertises to do."[102] Their unwillingness to endorse the map no doubt took Hoffman by surprise, since before publication she had taken steps to ensure their approval; in July 1943, the Hammond Company had submitted a photostat of the chart to the museum, but no one there offered any significant corrections to it.[103] Stanley Field attempted to appease the sculptor, telling her she was not to blame; the fault, he argued, rested upon previous members of the anthropology department, no doubt referring to Henry Field and Berthold Laufer, who prepared the captions for the original sculptures at the museum.[104]

Unlike Henry Field, Paul Martin was a cultural anthropologist who subscribed to a Boasian position on race and racial prejudice. To help him revise the chart, Martin recruited Wilton Krogman, who was then teaching at the University of Chicago. In retrospect, Krogman was an ideal candidate for the job; not only was he sympathetic to Martin's views on racism, he was also sympathetic to the Races of Mankind sculptures. Recall that while on fellow-

ship at the Royal College of Surgeons, Krogman served as an advisor to the sculptor at her studio in Paris. His studies on human growth and plasticity under the anatomist Wingate Todd set him apart from the views of physical anthropologists like Aleš Hrdlička and Earnest Hooton, who adhered to a typological approach to race.[105] A constant feature in Krogman's writings is a rejection of notions of innate superiority. In his first essay on race, "Is There a Physical Basis for Race Superiority?" (1940), Krogman answered the question with an emphatic "No." Krogman's intellectual flexibility and skepticism meant that he constantly revised his views. For example, he initially maintained the idea of a transmittable germ plasm: "In general, a *race* is a group united by blood and heredity; there is implied continuity of the blood-stream and of the germ-plasm."[106] Three years later, Krogman dropped the idea of a germ plasm in his essay "What We Do Not Know about Race."[107] Published only six months before Martin requested his assistance, Krogman's essay on race indicates his increasing skepticism: "We are not agreed what a race is, we are not sure when and how races arose; we do not know the precise hereditary mechanism in race; we are not sure which physical traits in race are stable, which modifiable; we do not know physiological and immunological features of race-groups; we can not assess race in terms of superiority and inferiority. In very truth we know little about the bio-genetical aspects of race."[108]

Nevertheless, Krogman maintained that certain groups exhibited different trait complexes and that such phenotypes corresponded to combinations of genes or genotypes. Until genetics provided a means for understanding the production of physical differences, Krogman argued, he would continue to "use the system at hand." Krogman's skepticism and his receptiveness to new views on race established him as a reasoned voice on the subject.[109] Krogman and Martin's recommendations are particularly revealing, because through them, one can study how these anthropologists tried to reconcile Hoffman's sculptures to the new discourses on race.

In their report, Krogman and Martin advised changing the title of the map. They believed that the phrase "Races of the World and Where They Live" suggested that all the figures represented different races and thus confused taxonomic distinctions between species and subspecies or populations. They recommended using an alternative title, such as "The Peoples of the World" or "Types of People in the World."[110] Like N. C. Nelson at the American Museum of Natural History, they pointed out that some of Hoffman's figures were not "strictly typical" or representative of a racial group.[111] This was a major departure from the museum's earlier position that the figures represented racial

types. If the figures did not reflect types of races, then what did they represent? The anthropologists' response was that many of the sculptures represented mixtures and devised a system of map symbols—Square = White, Circle = Negro, Triangle = Mongoloid—to indicate mixtures of primary "stocks."[112] This system of symbols reorganized the figures around the three-race schema represented by the *Unity of Mankind* figures at the top of the chart. This system, they believed, would bring the chart more in line with the current views on race, because it would suggest past migrations and interbreeding. Through these symbols, figures like the *Samoan Man* and the *Hawaiian Man* could now be designated as a mixture of all three groups. They also suggested changing the captions so that they, too, would conform to current views on race. Each label, they argued, must be changed to eliminate religious, social, and cultural connotations. But even if the map company incorporated all their recommendations, Martin observed, the chart would still be a "compromise," and he predicted that the museum would "receive adverse criticism from anthropologists from other parts of the world."[113]

In 1946, the C. S. Hammond Company published the revised *Map of Mankind* (frontispiece).[114] Although this renaming was a strategy to avert further criticism, the new title simply placed these figures in an unspecified, universal time. Following Martin and Krogman's recommendations, Hammond incorporated their system of symbols and placed an explanatory key at the bottom of the map. They also removed previous captions referring to social status like "The Untouchable" and activities such as surfboard riding. They intended the other adjustments, like intensifying the background color, to make the atlas more visually stimulating and a more efficient instructional device.

Believing these changes would prevent further criticism, the map company stepped up its advertising efforts and published a new promotional circular. However, A. L. Pattee, Hammond's educational director, did not try to sell the map based upon these revisions. Instead, Pattee returned to the notion of fixed racial types in his promotional letter.[115] In addition, Pattee claimed that the educational value of the chart was as a physiognomic device: "Your eye can be trained to pick out facial traits and bodily habits and quickly make a racial diagnosis."[116] To support this notion, Pattee paraphrased Arthur Keith: "We are all anthropologists; we became so the minute we recognized the features of our own mothers. Now you can add to your gallery of mental portraiture and instantly identify people from distant lands." The ability to perform such a diagnosis, he argued, would be crucial because "in the post-war period of international understanding, there will be increased inter-mingling of

peoples, and knowledge of the different facial characteristics and ancestral backgrounds of different races will be essential. It will be an unforgivable affront to mistake a Chinese for a Jap."[117]

Pattee's certainty of recognizable racial types, as well as his claim that the chart functioned as a diagnostic device, was out of step with antiracist texts circulating at the time. In his book *Man's Most Dangerous Myth* (1942), Ashley Montagu cautioned that since there was a great variability within groups and overlapping of traits between populations, it was risky to circumscribe a group and call it a race. While most anthropologists acknowledged this indeterminacy in their antiracist texts, they did not adopt Montagu's genetically informed viewpoint that "it is not assemblages of characters which undergo change in the formation of the individual and of the group, but single units [genes] which influence the development of those characters."[118] Instead, many anthropologists remained confident that the primary divisions of Caucasoid, Mongoloid, and Negroid existed. Their faith in fixed secondary subgroups somewhat lessened, but many anthropologists who wrote antiracist texts, including Ruth Benedict and Wilton Krogman, continued to uphold previous racial classifications built on the idea of recognizable types. However, all these authors rejected the idea of an innate ability to diagnose race, as advocated by Pattee and Keith, and linked this notion to Nazi claims of Aryan superiority.

THE *MAP OF MANKIND* AND ANTIRACIST PAMPHLETS

Many antiracist materials published in the 1940s, such as *America: A Nation of One People from Many Countries, A Primer on Race, Races of Mankind, In Henry's Backyard, Sense and Nonsense about Race,* and *There Are No Master Races,* featured generalized images such as cartoons or drawings. The absence of photographs or other highly detailed images in these texts suggests that their authors wanted to avoid naturalistic modes of representation associated with physiognomic decipherment. Instead, the novelty of cartoons offered writers like Ruth Benedict a way to circumvent such an interpretive process, while appealing to a wide-ranging audience. However, such images also failed to navigate the unstable racial politics, but for very different reasons.

At the time Hoffman's map received unpublicized criticism, Ruth Benedict and Gene Weltfish's *Races of Mankind* pamphlet created a series of controversies covered in national newspapers and magazines. In January 1944, Chester Irving Barnard, the president of the USO, ordered the YMCA to stop distributing the booklet at USO Clubs.[119] His action generated a series of condem-

nations from labor unions, like the AFL's League for Human Rights and the CIO's War Relief Committee, which previously contributed substantial funds to the organization.[120] African American newspapers also responded, claiming the USO was Jim Crow.[121] A few months later, in May 1944, a North Carolina congressman, Carl Thomas Durham, attacked the pamphlet for being communistic.[122] Durham singled out one of the booklet's pictures as anti-religious because it represented Adam and Eve with navels (figure 6.9).[123] Kentucky congressman Andrew J. May, chair of the House Military Affairs Committee, prohibited its distribution within the U.S. Army.[124] May found the pamphlet offensive because it cited army intelligence tests showing African Americans from Illinois and New York scoring higher than white southerners living in Arkansas, Kentucky, and Mississippi.[125] The news coverage concerning these various controversies led to a greater demand for the booklet. Organizations like the YMCA, the Federal Council of Churches, the American Baptist Home Mission Society, the Junior League, and the National Smelting Company purchased the pamphlet in large quantities for distribution.[126] During the next ten years, over ten million copies were sold, and the booklet was later distributed in France, Germany, and Japan.[127]

Published by the Public Affairs Committee, Benedict and Weltfish's pamphlet marshaled out the "scientific facts on race" to deny Nazi claims of racial superiority and explained racial prejudice as a consequence of cultural training. Although the pamphlet gave historical examples of how social relations govern notions of race, it continued to promote a racial taxonomy.[128] The authors relied upon existing scholarship on race and offered an environmentalist explanation, one that viewed physical differences as specializations or adaptations to different environmental conditions. In this respect, they followed the ideas of Franz Boas and Alfred Haddon. Benedict and Weltfish did not entertain Ashley Montagu's more radical position of questioning the concept of race altogether; rather, they adopted a position founded upon the same epistemology of race that informed Wilton Krogman and Paul Martin's views. In sum, they did not offer a challenge to the biological concept of race, but instead refuted the idea of racial prejudice.

Criticized by Hortense Powdermaker for not including visual images in her earlier publication, *Race: Science and Politics,* Benedict recruited Ad Reinhardt, a former student at Columbia University, to produce twelve illustrations for the pamphlet.[129] Reinhardt employed a visual vocabulary that he developed earlier in the pages of the leftist magazine *New Masses.*[130] As Michael Corris recently argued, Reinhardt's cartoon style helped to shape the "rhetorical tone of the magazine's political line."[131] A similar case can be made for his images in the

Races of Mankind. These cartoons engaged viewers on the terrain of humor, complementing the text's dispassionate plea to renounce racial prejudice. By adhering to Mondrian's aesthetic ideas of balance and counterbalance, Reinhardt created images that engaged the concept of racial equality without resorting to some kind of forced sense of empathy. And by employing different rhetorical strategies, such as repetition and puns, Reinhardt created visual incongruities that destabilized perceptions of similarity and difference.

For example, in his cartoon *People Are Gentle or Warlike Depending on Their Training* (figure 6.8), Reinhardt juxtaposes two pairs of figures to disprove the Nazi idea of an innate instinct for war. This picture also served to combat the views of Sir Arthur Keith, who continued to argue that racial prejudice functioned as an evolutionary mechanism. Theorizing that an "inborn impulse compels" men to "take charge of their evolutionary or racial destiny," Keith maintained, "Hitler is right in his conceptions of race and . . . my British colleagues are wrong, whenever you find a people inhabiting a land in common and prepared to die rather than surrender its integrity of blood and soil, then you are face to face with a real live race of mankind."[132] To undercut such a

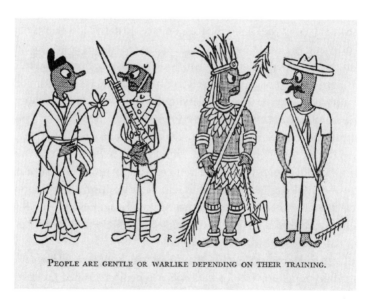

PEOPLE ARE GENTLE OR WARLIKE DEPENDING ON THEIR TRAINING.

Figure 6.8. Ad Reinhardt, "People Are Gentle or Warlike Depending on Their Training," *The Races of Mankind* by Ruth Benedict and Gene Weltfish (1943). © 2010 Estate of Ad Reinhardt/Artists Rights Society (ARS), New York.

view, Reinhardt constructs difference by exaggerating cultural markers like dress and objects. A rhythmic diagonal movement links the four figures and encourages viewers to compare them; the figure representing a frowning Aztec warrior is juxtaposed with an image of a smiling "Mexican peasant," while a "peaceful" Japanese contrasts with a grimacing soldier. In this respect, it closely follows the adjacent text, which argues that depending upon a particular historical moment, a people can hold very different attitudes. To draw the viewer's attention further toward cultural attributes, Reinhardt depicts the male figures with the same body form and facial features. However, each set of figures shares the same skin color, depicted by either parallel lines or Ben-Day dots. Linked together by skin tone, each set implies that while a culture changes over time, biological traits like skin color remain stable.

In Reinhardt's cartoon captioned *The Peoples of the Earth Are One Family* (figure 6.9), four figures share the same body type to visualize the pamphlet's claim that "races of mankind are what the bible says, they are—brothers. In

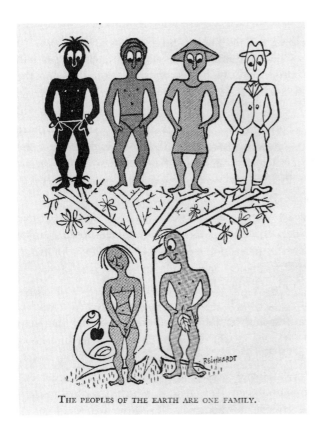

THE PEOPLES OF THE EARTH ARE ONE FAMILY.

Figure 6.9. Ad Reinhardt, "The Peoples of the Earth Are One Family," *The Races of Mankind* by Ruth Benedict and Gene Weltfish (1943). © 2010 Estate of Ad Reinhardt/ Artists Rights Society (ARS), New York.

Deploying the Races of Mankind Figures 171

their bodies is the record of their brotherhood."[133] Unlike Hoffman's *Unity of Mankind* figures on the *Map of Mankind*, which feature different bodily shapes and stature, Reinhardt emphasizes anatomical similarities by repeating the same body type. As such, the image would counter the polygenist arguments of German race theorists, who revived the nineteenth-century idea that various races evolved from multiple origins.[134] While this interpretation closely follows the text, the image of a tree generates additional levels of meaning through spatial and temporal structures. It evokes two systems of thought, science and religion, for the tree image refers simultaneously to the Tree of Knowledge, associated with the biblical story of the Fall from Grace, and an evolutionary tree, a device commonly used to explain phylogenic relationships in natural history. Instead of imitating Henry Field's use of this visual device, in which the Nordic was placed at the uppermost branch, Reinhardt inverts the sense of progress associated with the ascending limbs. Each of the four figures glances downward, directing attention to the biblical story below. Here, Reinhardt includes narrative elements like a smiling serpent with an apple to suggest further aspects of the story of the Fall. The figures' covered bodies relate to the garments shown on the figures above. From left to right, the amount of clothing progressively increases. The lightening of skin tone from left to right also enhances the sense of progression. To denote the different skin tones, Reinhardt uses a system of solid black, cross-hatching, parallel, and contour lines. This tonal range suggests a four-race schema and seems to assert the idea of fixed racial groups. However, these figures differ from the Adam and Eve figures depicted in Ben-Day dots. In this respect, the cartoon relates to the text, which argues that different skin tones are specializations developed for different environments and that a once-uniform skin tone, represented by Ben-Day dots, had diversified over time.[135]

The cartoon that deals with the trait of skin color directly, *Most People in the World Have In-Between-Color Skin* (figure 6.10), incorporates a map, but instead of the Mercator projection employed in the *Map of Mankind*, Reinhardt's map resembles a conical projection that generates a sense of the close proximity of continents. The tilting male figure replicates the map's curvature, humorously suggesting Benedict and Weltfish's One World rhetoric, in which they claimed, "this war, for the first time, has brought home to Americans the fact that the whole world has been made one neighborhood . . . Our neighbors now are peoples of all the races of the earth."[136] The former Republican presidential candidate Wendell Willkie also popularized the idea through his best-selling book *One World* (1943), which described his trip around the globe in an airplane. In August 1943, the Museum of Modern Art,

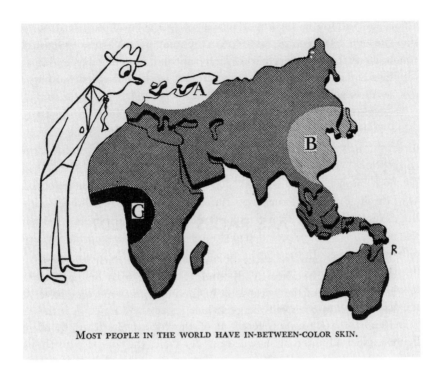

MOST PEOPLE IN THE WORLD HAVE IN-BETWEEN-COLOR SKIN.

Figure 6.10. Ad Reinhardt, "Most People in the World Have In-Between-Color Skin," *The Races of Mankind* by Ruth Benedict and Gene Weltfish (1943). © 2010 Estate of Ad Reinhardt/Artists Rights Society (ARS), New York.

aided by the map designer Richard Edes Harrison, held an exhibition entitled "Airways to Peace," which used passages from Willkie's book as captions to aerial photographs. The exhibition featured an array of unusual cartographic projections that asked visitors to set aside their world picture based on the Mercator projection.

Unlike in the *Map of Mankind*'s coloring system, which fixed racial boundaries between eight geographic zones, Reinhardt creates four distribution zones for this trait. As in the previous cartoon, Reinhardt uses solid black, cross-hatching, and parallel and contour lines to produce a range of tones. This tonal range indicates that the cross-hatched area covers the majority of the continents. Areas marked A, B, and C also correspond to the text, which claims that in these zones the "three primary groups of the world have their strongest developments."[137] Thus the cartoon functions to assert a three-race schema. At the same time, the text encourages viewers to visualize similarities between

groups and diminishes the importance given to a physical trait. The discussion question for this image at the end of the pamphlet reaffirms this sense of commonality. It asks readers to consider the distribution of blood types: "Close your eyes and put your finger on the map of the world. Wherever your finger touches there will be some people with blood types the same as your own."

The tilting male figure in a business suit and tie recalls one of the types shown at the top of the previous cartoon. Here, it functions as a diegetic agent, directing the viewer's attention toward the map. The figure's outline form corresponds with the "A" area, denoting the distribution of white skin across northern Europe. It also furnishes the viewer with a subject position coded as white and European to negotiate the argument against racial superiority. In this respect, Reinhardt's map requests the viewer to take a subject position that is similar to the one provided in Hoffman's *Map of Mankind,* but for very different purposes. In the *Map of Mankind,* this subject position suggests a fixed position within a racial hierarchy, while in Reinhardt's cartoon, it was intended to ease the viewer's transition from views of racial superiority to the discourse of racial equality.

In Reinhardt's *Our Food Comes from Many Peoples* (figure 6.11), the male figure reappears but is now shown seated at a table. The table also functions as a world map, which resembles a sinusoidal projection with its bulge at the center. Unlike Mercator maps, this form of projection maintains the relative size of continents, and for this reason landmasses appear closer together. The table/map device allows for linking the figure with seven other figures, which are shown in various costumes and skin tones. These standing figures are doing the giving, while the seated white figure holds a fork and knife as if ready to eat. Here, the implied "us" in the "our food" caption refers to Americans of European descent. The lines and dots connect the figures and foods to geographic locations in a manner reminiscent of the linking system operating in the *Map of Mankind.* However, following this system to its conclusion, white Americans' sense of superiority is deflated as the European contributions to the American diet, hazelnuts and crabapples, are represented as insignificant in relation to those of other peoples.

The white male figure appears in seven out of the twelve cartoons and thus provides continuity between images, but the subject position is not consistent. For example, in Reinhardt's cartoon featured on the pamphlet's cover (figure 6.12), the male figure is shown twice, functioning both as a diegetic agent and as a member of a diverse group. This repetition within the same picture offers viewers a dual subjective position of identifying with the male scratching his head on the right, and with the group of figures represented

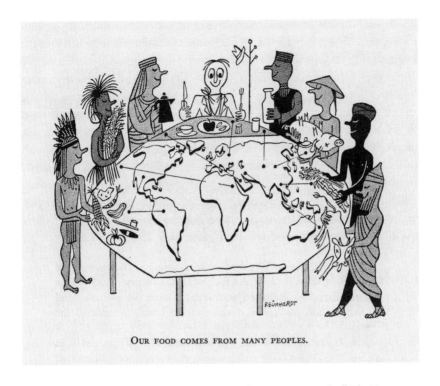

Figure 6.11. Ad Reinhardt, "Our Food Comes from Many Peoples," *The Races of Mankind* by Ruth Benedict and Gene Weltfish (1943). © 2010 Estate of Ad Reinhardt/Artists Rights Society (ARS), New York.

Figure 6.12. Ad Reinhardt, cover image, *The Races of Mankind* by Ruth Benedict and Gene Weltfish (1943). © 2010 Estate of Ad Reinhardt/Artists Rights Society (ARS), New York.

on the left. This cartoon is featured once more inside the pamphlet, but with the caption "There Is No Jewish Race," which asks readers to reinterpret the image and to understand that religion should not be associated with race.[138] The reuse of this image demonstrates how the various doubling devices in Reinhardt's cartoons hinge on perceiving similarities and differences. The shifting functions of the white figure, the repetition of the same body type, the table/map device, and the biblical/evolutionary tree present irresolvable incongruities and thus challenge entrenched visual habits associated with race. Both the *Map of Mankind* and the *Races of Mankind* pamphlet explicitly attempted to reshape white American attitudes toward race, albeit in very different ways. Hoffman's map asserted racial differences fixed to geographic regions, while Reinhardt's visual puns generated a sense of cognitive failure to deflate notions of superiority.

HAMMOND WORLD ATLASES AND PLATES IN THE ENCYCLOPEDIA

At the same time C. S. Hammond revised the *Map of Mankind,* the company began negotiating directly with Field Museum officials on a new project, involving the Races of Mankind photographic reproductions, that largely excluded Malvina Hoffman. In 1945, George Davis, the sales manager at C. S. Hammond, obtained permission from the director of the Field Museum to reproduce sections from the museum's guidebook and photographs of the sculptures in a new leaflet entitled *The Races of Mankind* (figure 6.13). The company planned to sell this twenty-four-page booklet as a supplement to the *Map of Mankind* and as an insert within Hammond's various world atlases. The map company practiced a form of production in which they compiled such leaflets to form atlases targeted to different social classes and educational audiences. Publication records for the booklet show that the map company published about 50,000 to 75,000 *Races of Mankind* leaflets each year from 1945 through 1954. The company steadily increased the number of leaflets, publishing 210,000 in 1960. Thereafter, the figure dropped down to around 75,000 a year until 1965, when the company's records end. Over this twenty-year period, the *Races of Mankind* leaflet appeared in various Hammond atlases sold within the United States, as well as those published for distribution in Canada, Mexico, and Central and South America.

The *Races of Mankind* leaflet tied the figures to the earlier explanation of race written by Henry Field and updated in 1942 by the curator of African ethnology at the Field Museum, Wilfred Hambly. The map company decided

Figure 6.13. "The Races of Mankind," *Hammond's Superior Atlas and Gazetteer of the World* (1946). C. S. Hammond and Company, by permission of the American Map Corporation.

not to include the essays on race by Berthold Laufer and Arthur Keith. However, they did solicit Malvina Hoffman to provide a short statement, which she entitled "While Head Hunting for Sculpture." Hoffman framed the sculptures in terms of the One World rhetoric; she claimed that the recent war brought unknown places and peoples closer into perspective.[139] Instead of valorizing the innate spiritualness of primitive people, Hoffman now argued that they possessed great moral values, such as bravery, trustworthiness, and honor.[140]

As the sculptor claimed, "There is a sort of sixth sense in many tribes that enables them to size up to their own scale of values the integrity of the stranger who comes into their territory."[141] Field Museum anthropology curator Paul Martin agreed to the company's request to include Hoffman's statement, but on certain conditions. Martin stipulated that the company must clearly separate Hoffman's statement from the materials written by Field Museum anthropologists and that he approve her essay before publication. The map company complied with Martin's requests and sent Hoffman's text for his review. Martin deleted some value-laden phrases from her essay, like "primitive families," but did not remove others. Under the subtitle "Description of Races," a short disclaimer was added stating that *race* did not imply inferiority or superiority of a group and that the term must not be confused with "social status or psychological attributes."[142] However, the text that followed failed to correspond to these ideas. Although Hambly revised Henry Field's guidebook essay, he did not correct the problems within the text discussed in chapter 4. Adjectives like "aristocratic," "well shaped," and "refined" still appeared. For example, the essay continued to claim that the busts *Jakun Woman* and *Jakun* represented a primitive type that contrasted with a "pure type of Malay, whose features express a high grade of intelligence compared with the Jakun."[143] The revised text also attributed the appearance of "fine, delicate features" of African peoples to Hamitic mixture.[144]

The Hammond Company was not alone in using photographic images to represent race in its publications. Other educational publishers who produced standard reference books like the *World Book Encyclopedia,* the *American Educator Encyclopedia,* and the *Wonderland of Knowledge* featured reproductions of the sculptures in their entries on race. Of these publications, the *World Book Encyclopedia* included the largest number of images of the sculptures, reproducing thirty-nine photographs (figure 6.14). As if to replicate the practice of using cartoons and simplified drawings to represent race, the publisher reproduced the sculptures through a photolithographic method that created a sketched appearance. This printing process also served as a way to unify the images with anthropometric photographs of actual people and with a chart on racial differences (figure 6.15).

Introduced in the 1947 edition of the *World Book Encyclopedia,* which Field Enterprises, headed by Marshall Field III, had recently purchased, the images accompanied an entry on race written by Wilton Krogman. While Marshall Field's reappearance in this narrative may seem unexpected, perhaps Wilton Krogman's does not. Given his numerous publications on race, his recent recommendations for revising the *Map of Mankind,* and his previous

Figure 6.14. "Races of Man: Basic Types," excerpted from
The World Book Encyclopedia. © 1948 The Quarrie Corporation, by
permission of World Book, Inc., www.worldbookonline.com.

advice to Hoffman during the production of the figures, it is not surprising
that Krogman would now write an essay for the *World Book Encyclopedia* on
race that featured the sculptures. In his essay, Krogman attempted to use the
sculptures as a way to show how members of the "human family" differ from
one another like brothers and sisters who are "basically alike but they still
appear to be different."[145] However, the layout of the images of the sculptures

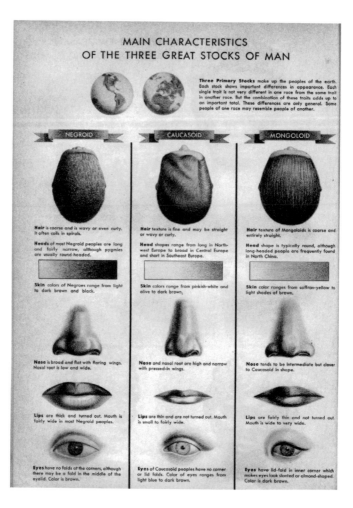

Figure 6.15. "Main Characteristics of the Three Great Stocks of Man," excerpted from *The World Book Encyclopedia.* © 1948 The Quarrie Corporation, by permission of World Book, Inc., www.worldbookonline.com.

(figure 6.14) contradicts Krogman's analogy of a family. The photographs are presented in a three-tiered format with the Caucasoid, the head of the *Nordic Type,* placed at the top, three images representing Mongoloid in the center, and figures representing two types of Negroids at the bottom.[146] Thus it recalls the traditional ranking of races. Krogman explains that anthropologists divide groups into stocks and races with the understanding that they classify on

physical characteristics alone, and that some even argue that because all blood types are found in every population there is "only one race of people—the human race."[147] At the same time Krogman lays out characteristics to classify phenotypes, he includes statements on notions of racial superiority and race prejudice that reflect the views of Ruth Benedict and others: "The leaders of Nazi Germany talked a great deal about the purity of their 'race,' but they were talking nonsense."[148] He also adds that there are "uninformed persons" who argue for an innate racial prejudice and that members of different races possess a "natural" dislike for one another. Krogman takes apart his former mentor Arthur Keith's key evolutionary concept, stating that "race prejudice is *learned* and *cultivated,* rather than inherited."[149] While Krogman uses the term *genes,* his essay does not introduce the notion of genotypes, nor does he present how the "new systematics" challenged taxonomic classifications and undermined typological approaches to human diversity. Instead, his essay and the Races of Mankind images would acquaint schoolchildren and general audiences with a view of race couched in terms of human sympathy.

During the postwar period, many public schools in the United States purchased educational texts like the *World Book Encyclopedia,* the *Wonderland of Knowledge,* and C. S. Hammond world atlases to supplement classroom instruction. From 1945 through 1965, C. S. Hammond alone published between 50,000 and 75,000 atlases each year for consumption in the United States, Canada, and Mexico. Such extensive circulation enabled the Races of Mankind figures to achieve the status of normative representations of race within many different cultural sites and communities. How did teachers use materials featuring images of the Races of Mankind sculptures? Anecdotal evidence suggests that they were used in educational campaigns to present students with the scientific facts on race. An article entitled "Vitalizing Intercultural Relations" published in *Chicago Schools Journal* shortly after the war indicates that they were used in relation to other antiracialist publications. The author of the essay, Henrietta Hafemann, a Chicago high school teacher, recommended using *Races of the World and Where They Live* in international relations classes along with Benedict and Weltfish's *Races of Mankind* pamphlet, Ethel Alpenfels's *Sense and Nonsense about Race,* and the revised edition of the Field Museum's guidebook to the Hall of the Races of Mankind when visiting the exhibit.[150] In a speech at a race-relations conference held at Fisk University, Ethel Alpenfels recalled an incident involving a map that featured photographic images of the Races of Mankind sculptures. Alpenfels gave her class a quiz based on a test Eugene Hartley developed to identify common prejudices. Her quiz asked students to rate known national groups as well

as fictitious ethnic groups such as "Pierians" and "Tieriens": "as soon as the first boy hit the word Pierian he raised his hand and said 'Can I look on the map?' On the front of the wall we had the regular old fashioned map but on the back we had Melvina [*sic*] Hoffman's map based upon her bronzes in the Chicago museum. And he was back there looking for the Pierians. And within five minutes every student was looking for the Pierians and that was the end of my test. They said it wasn't fair to put in people who didn't exist. Here were students who had begun to think of people as persons and not as green and yellow spots on a map."[151] While this latter incident suggests that educators could potentially use the map in ways that undermined its logic, Hafemann's essay, which was intended to assist teachers in developing antiracist courses, indicates that Chicago teachers considered the Hoffman sculptures in ways that were similar to Wilton Krogman's views; they served as valuable resources for introducing students to a taxonomy of races that was framed in terms of human understanding.

CONCLUSION: RETRACTION AND REDEPLOYMENT OF THE SCULPTURES IN CHICAGO

AT THE BEGINNING OF THIS STUDY, I proposed that in reconstructing the career of the Races of Mankind figures, one could track, in a concrete way, representational and social dimensions of race formation at specific historical moments. In focusing on processes of production, exhibition, and circulation, we have examined the productivity of the Races of Mankind figures within diverse cultural arenas. We have seen how the Races of Mankind figures gained the status of normative representations of race through their reproduction and circulation within reference materials like the *World Book Encyclopedia*. However, this study would not be complete without considering efforts to circumscribe the meanings and functions of the Races of Mankind figures following the shift in science to population genetics, which invalidated notions of race, and during the emergence of Black Power movements, which rejected the integrationist goals of civil-rights organizations.[1] Such powerful reformulations of race effected enormous change within a broad array of social fields, including the realms of art, science, education, and everyday life. This chapter examines the processes of refashioning the Races of Mankind figures during this transitional moment by tracing two contradictory movements of retraction and redeployment. The sculptures were removed from display at the Field Museum as an anthropological exhibit on race, and some of the sculptures were later displayed at the museum and at another Chicago institution, Malcolm X College. This study ends with a discussion of *OpEd: Fred Wilson* (1994) at the Museum of Contemporary Art, Chicago, which featured sixteen of the Races of Mankind sculptures in an installation

that invited visitors to consider how whiteness permeates the modern museum setting and defines notions of the artist, while engaging racial politics operating within public spaces of Chicago.

By the summer of 1966, the Hall of the Races of Mankind needed renovation. The gloomy forty-watt lighting, the dirty buff walls, and the outdated Art Deco architectural format gave some visitors the impression that the museum had long neglected the exhibit. Distressed by the appearance of the exhibit hall, one Chicagoan wrote to the museum offering to help refurbish it. The visitor, Walter Jones, commented not only upon the dismal state of the display, he also questioned its pedagogical effectiveness: "As it now stands [the exhibit] does not make clear exactly what 'race' means and what it is based on."[2] Noting that Hoffman's "handsome bronze sculptures" illustrated "enormous variation in face and body conformation within each racial group," Jones claimed that he could not reconcile this apparent variability with the three-race schema presented on the museum labels. From observing the sculptures, he found that "flat noses, high cheekbones, narrow eyes and full lips were not the exclusive property of any one racial group," which specifically defied the museum's racial classification. This contradiction led him to wonder "how the scientist determines which is which, especially if the [subject's ancestry] or birthplace are unknown." Jones further pointed out that the charts, photographs, plaster casts, and skulls displayed in the special exhibit area failed to answer this question. While he surmised that the museum intended these didactic displays to demonstrate traits used in constructing a racial classification, he nevertheless argued that these exhibits did "nothing to show how the scientists use these factors or how important any one characteristic . . . is in the classifying process." He urged the director of the museum to renovate the display on the grounds that if the Hoffman figures were used much more "creatively," then they had the potential of being "a very timely and significant contribution to greater understanding of race in these days of racial problems."

The Field Museum officials knew that to continue to exhibit the sculptures as an anthropological display ran the risk of receiving much harsher criticism than Jones's amiable letter. In 1962, they understood that as a demonstration of a taxonomy of races, the exhibit contradicted the findings of population genetics. The anthropology curator Philip Lewis, for example, had found it "naïve" to present the Races of Mankind figures in terms of a three-race classification in C. S. Hammond educational materials, given "genetically oriented physical anthropology."[3] Beyond withdrawing the *Races of Mankind* anthropology leaflet from publication, the museum had done little to change

the exhibit hall.[4] The museum had earlier ceased publication of the guidebook to the hall because the essays by Berthold Laufer, Arthur Keith, and Henry Field required substantial revision. Even if they revised the text, the museum administrators feared that it would still offend some groups. In 1963, Director Clifford Gregg claimed that the museum could not "predict the reaction of the Negro either in Africa or in America at the present time," and therefore it was best to pull the guidebook from publication.[5]

The museum administrators had well-grounded fears. At the time that the president of the museum wrote his comments, efforts were under way in Chicago to combat racial segregation within public housing and schools. Numerous local and national organizations pursued a strategy of nonviolent action to protest the Chicago Board of Education's neighborhood school policy, which reflected the de facto racial segregation in Chicago. On July 4, 1963, the NAACP held its *Free by Sixty-Three* conference in Chicago, and over four hundred conference delegates participated in a demonstration at the Board of Education building in order to protest "the most segregated school system in the North."[6] Six days later, CORE began a sit-in at the Board of Education building.[7] In October, the Coordinating Council of Community Organizations (CCCO) organized a boycott of public schools, and in another demonstration, over eight thousand people marched from City Hall to the Board of Education.[8] Rallies and demonstrations continued over the next several years, and some, like the Chicago Freedom Movement's event that called for an "Open Chicago" and featured Martin Luther King and Floyd McKissick as speakers, were held at Soldier Field, in close proximity to the Field Museum.[9] The "Open Chicago" event, held on July 10, 1966, and the organizational responses to a riot that occurred the following day, revealed the tensions over goals and strategies among the various activist groups, and a Black Power movement began to emerge in Chicago.[10]

The local efforts to desegregate Chicago public schools coincided with a national reappraisal of educational materials used in public school systems. Many African American organizations called attention to how textbooks presented racial stereotypes and promoted a white pedagogy. They demanded changes within the publishing industry. As Charles Hurst Jr., the president of Malcolm X College, Chicago, observed in 1972:

> Most American publishers apparently did not begin to understand their failures in the areas of fiction, reference books, and textbooks until a few years ago. A number of things happened in 1966 to throw the spotlight on the publishing industry's failures. The Michigan legislature passed a

law requiring that the state's schools use only history texts which "include accurate recording of any and all ethnic groups who have made contributions to world, American or the State of Michigan societies." California had enacted a similar law a year earlier. Congressman Adam Clayton Powell, while still Chairman of the House Education and Labor Committee, held hearings on the treatment of minority groups in text and library books used in the nation's schools. The hearings produced an 800-page record of testimony. Although no new laws were passed, new pressure on the publishers resulted.[11]

Hurst, as well as other educators, relied upon the earlier research of Kenneth and Mamie Clark to support their claim that existing educational materials hindered the psychological development of African American children, especially their ability to formulate positive "self-awareness." The Clarks had investigated the issue of self-identification through presenting different-colored dolls to a group of African American children. They found that the majority of the children participating in their study preferred white-toned dolls over brown-toned dolls. Thurgood Marshall used their findings as evidence of the effects of racial segregation in the 1954 U.S. Supreme Court case *Brown v. Board of Education.* Kenneth Clark later testified before the National Advisory Commission on Civil Disorders, which investigated riots in American cities such as Newark and Detroit during the summer of 1967. The resulting Kerner Report concluded that the racial riots were due primarily to long-standing segregation and poverty in cities that had created a "racial ghetto," in which "white society is deeply implicated . . . White institutions created it, white institutions maintain it, and white society condones it."[12]Despite its critique of white racism, the committee feared Black Nationalism and its call for building black unity and self-esteem.[13]

The widespread condemnation of white racial attitudes and the call for positive images of African Americans were addressed in the work of the Chicago artist Jeff Donaldson. A member of the Organization for Black American Culture (OBAC), Donaldson engaged racial stereotypes circulating within mass advertising. In his *Aunt Jemima and the Pillsbury Doughboy* (figure C.1), the artist referenced two well-known advertisement icons but altered them in significant ways. Donaldson turned the saccharine-sweet Pillsbury doughboy into a menacing figure of a white policeman, transformed the docile "mammy" figure of Aunt Jemima into a muscular woman, and placed these figures in front of another familiar icon, the American flag.[14] Donaldson used the flag as a formal means to compress the foreground space, but also to

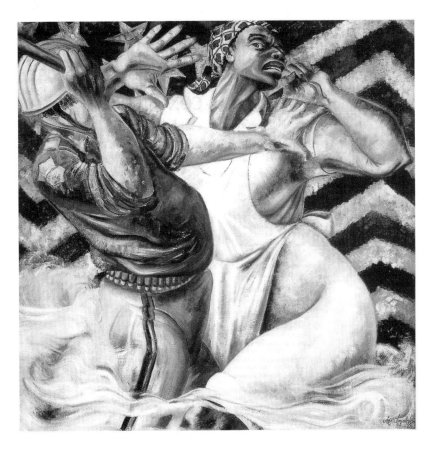

Figure C.1. Jeff Donaldson, *Aunt Jemima and the Pillsbury Doughboy* (1963), courtesy of the Jeff Donaldson Estate.

provide a symbolic backdrop. Notions of liberty, equality, and freedom associated with the American flag were called into question by the flag's placement behind the figure of the white policeman and its assault of the black female. The resulting image powerfully challenged American ideals of freedom by pointing out how corporate white America relied upon racial stereotypes to sell products and how police departments functioned as repressive instruments in American cities like Chicago.

In 1967, Donaldson engaged the issue of providing "positive role models" within Chicago's South Side community. Donaldson and other members of the Visual Art Workshop of the OBAC created the famous *Wall of Respect* (figure C.2). This twenty-by-sixty-foot mural featured narrative scenes and portraits

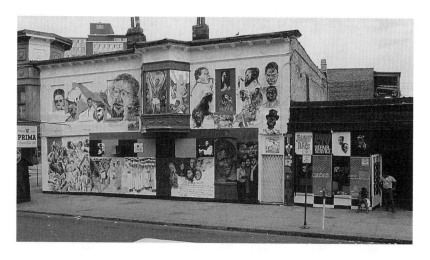

Figure C.2. *Wall of Respect,* mural, corner of Forty-third Street and Langley Avenue, Chicago (1967). Photography by Robert Abbott Sengstacke/Archive Photos/Getty Images.

of Muhammad Ali, Amiri Baraka (LeRoi Jones), Gwendolyn Brooks, H. Rap Brown, Stokely Carmichael, Marcus Garvey, Dick Gregory, Elijah Muhammad, Adam Clayton Powell Jr., and Malcolm X, as well as other well-known athletes, entertainers, and local black leaders on a building at Forty-third Street and Langley Avenue.[15] Donaldson was recently quoted as saying that the "very act of making public portraits of black heroes was a radical undertaking during an era when advertisements and school textbooks rarely featured African Americans and the mainstream media rarely reported positive stories about the black community."[16] For members of the Visual Art Workshop and for educators like Charles Hurst, the genre of portraiture served as one way to build a sense of black unity and self-esteem within Chicago communities.

Working as a collective, the OBAC artists had circulated a list of prominent African Americans throughout the South Side community to select who would be portrayed on the mural. At the time, OBAC defined a black hero as any African American who:

1. Honestly reflects the beauty of Black life and genius in his or her style
2. Does not forget his Black brothers and sisters who are less fortunate
3. Does what he does in such an outstanding manner that he or she cannot be imitated or replaced.[17]

From the list, the community chose well-known activists, religious leaders, musicians, and entertainers, many of whom were associated with Black Power organizations. A placard placed at the corner window of the building read, "This wall was created to honor our Black heroes and to beautify our community."[18]

Despite the emergence of a Black Power politics in Chicago and rioting within black and white communities, events that must have increased the Field Museum administrators' concern of possible criticism from African American communities, the Hall of the Races of Mankind remained on display until February of 1969, when it was dismantled, allegedly to make room for a new exhibit commemorating the seventh-fifth anniversary of the museum.[19] However, the museum administrators' earlier fears materialized shortly thereafter when one of the heroes portrayed on the *Wall of Respect,* LeRoi Jones (Amiri Baraka), wrote to the director of the museum to object to the circulation of the *Map of Mankind* and other C. S. Hammond publications featuring reproductions of the sculptures within American school systems, since they were a "kind of white racist pseudo anthropology."[20] On stationery bearing the Black Power salute, the poet and activist condemned the Hammond educational materials, stating that they were filled with "consistent and glaring inaccuracies throughout which can only be the result of ignorant white nationalism and white racism."[21] In response to Amiri Baraka's criticism, the president of the museum, Donald Collier, wrote to the editor of C. S. Hammond Company, demanding the removal of the *Map of Mankind* (frontispiece) and the *Races of Mankind* leaflet (figure 6.13) from circulation. Collier faulted the map company for not following up on the museum's earlier request to revise the "outdated historical, linguistic and racial data." The Hamiticization theory of the racial and cultural development of Africa, Collier argued, was especially out of date.[22] He concluded by stating, "I cannot emphasize too strongly that the *Races of Mankind* as it now stands is scientifically indefensible and socially objectionable," and he sent a blind copy of his letter to Baraka.[23] C. S. Hammond Company immediately withdrew the *Map of Mankind* and the *Races of Mankind* leaflet from its atlases. The following year, Field Enterprises also removed photographic reproductions of the sculptures from the *World Book Encyclopedia*'s entry on race.

One would think that, after these events and the dismantling of the exhibit hall, the Races of Mankind sculptures had reached the end of their career. Yet they remained in storage for only two years. In May 1971, the Field Museum decided to exhibit thirty-five sculptures in the corridors overlooking Stanley Field Hall and in the north and south lounges. Displayed as decorative elements within the public areas of the museum, the Races of Mankind sculptures

now functioned outside an explicit biological theory of race. The curator of prehistory, Glen Cole, hoped that the Races of Mankind sculptures would now be understood as "examples of people from around the world" rather than illustrations of racial types. Cole claimed that the figures represented "cultural diversity" and emphasized the ethnographic elements of the sculptures, such as the "hairdos, jewelry and costumes."[24] In an attempt to distance the sculptures from ideas of race, the museum exhibited them with new labels. The phrase "Bushman Family . . . circa 1930" replaced an earlier label that read "Bushman Family Negroid Mongoloid Mixture."[25] Philip Lewis, who had earlier advocated dismantling the exhibit hall, found the new presentation of the Races of Mankind sculptures "inoffensive" and "unobtrusive."

Ceremonies marking the return of the Races of Mankind sculptures to public display coincided with a special exhibition of textiles from the Design Works of Bedford-Stuyvesant. These artworks, which the museum claimed successfully blended "classical African motifs and contemporary design," were exhibited in relation to Benin art from the museum's permanent collection. Entitled "Afro-American Style," this show endorsed the project of artists associated with the Black Arts Movement, who turned to art and cultures of Africa to formulate a new cultural identity.[26] Mounting this special exhibition was one way for the Field Museum to appeal to local African American communities, while another was to establish professional relationships with new educational institutions like Malcolm X College. Following student sit-ins at City Colleges of Chicago, the city changed the names of several of its campuses, and in 1969 Crane Junior College became Malcolm X College with Charles G. Hurst Jr. serving as its new president. Hurst quickly instituted radical changes in the faculty and curriculum and oversaw the move of the college to its new Mies van der Rohe style building, designed by Chicago architects Gene Summers and Thomas Beeby, which opened officially on May 19, 1971.

Shortly after the inauguration of the new campus building, Malcolm X College administrators contacted the Field Museum to see if it would agree to loan African artworks for display.[27] Reluctant to part with objects from its permanent collection, the museum officials instead offered to loan plaster replicas of the Races of Mankind sculptures.[28] However, the anthropology curator Philip Lewis failed to understand how an exhibition of the Races of Mankind figures would serve educational purposes as the president of the college had claimed.[29] Since an interior decorator accompanied Malcolm X College representatives to meetings with Field Museum officials, Lewis speculated that the figures might be used simply to decorate the austere interior of the building.[30] The school officials did not provide Lewis with a clear rationale

for how the Hoffman sculptures fit into the college's educational program. Given Baraka's severe criticism of the *Map of Mankind* and Lewis's own concerns about the "militancy" of Malcolm X College students, the anthropology curator was wary about loaning the figures.[31] Nevertheless, the Field Museum administrators agreed to a six-month renewable loan of eleven full-size plaster replicas, but with some restrictions. The college could not permit the Races of Mankind figures to be photographed commercially without the museum's permission, thus precluding any use of reproductions. The museum also stipulated that the figures must be clearly identified as being on loan from the Field Museum. On December 7, 1971, students from Malcolm X College came to the museum to pick up the replicas. Someone prominently signed the name "LeRoy Jones" on the acknowledgement receipt, no doubt intending to reference Amiri Baraka as an act of defiance to white authority.[32]

If the president of Malcolm X College knew of this incident, he probably would have understood it within the logic of resistance underlying various Black Power movements, which he defined largely in generational terms. Charles Hurst Jr. recognized that a "new Black youth" had emerged, one who demanded "freedom, justice, and equality of opportunity—not one who stands hat in hand begging or praying for the basic rights of human existence."[33] In his *Passport to Freedom: Education, Humanism, and Malcolm X* (1972), Hurst explained that Black Power was one of the "healthiest and most legitimate developments in the history of America," which was currently shaping the field of education.[34] Hurst situated his views within recent international discussions on education and quoted the following remarks by Paulo Freire, then the educational director of the World Council of Churches: "It is important to emphasize the impossibility of neutral education. It is either for liberation or domestication. Education either functions as an instrument to integrate the younger generation into the logic of the present system and bring about conformity to it, or education becomes the means by which men and women deal critically and creatively with reality and discover how to participate in the transformation of their world. Most often we think we are working for the liberation and humanization of men but by the methods we use we prevent men from becoming free."[35] As outlined in *Passport to Freedom*, the student-centered approach at Malcolm X College served as a model for how an educational institution could function as a means for black liberation. Flowing from black experience, the curriculum at the college, Hurst believed, fulfilled Malcolm X's view that "power grows out of a knowledge and appreciation of one's own culture and an understanding of the essentials that historically have been the psychological and spiritual supports of a free

people."[36] According to Hurst, the college's Afrocentric curriculum would assist students in the process of forming a new black consciousness through identification with the history and culture of Africa.[37] He claimed that the moral code of "traditional African society" offered America a much-needed form of humanism, which emphasized the "dignity of the human spirit" and the sense of collective responsibility.[38]

For Charles Hurst, the Races of Mankind figures would support his educational program. Unlike Amiri Baraka, Hurst did not perceive the Races of Mankind figures as instruments of white racism, but as a visual means to promote the humanism of traditional Africa (figure C.3). From the entire Races of Mankind sculptural series, the Malcolm X College officials chose six full-length figures: *Daboa, Shilluk Warrior, Solomon Islander, Kalahari Bushman, Semang Warrior,* and the black figure from the *Unity of Mankind.* They also included one figural group, the *Ituri Pygmy Family,* and four female busts, *Mangbetu Woman, Zulu Woman, Sudanese Woman,* and *Ubangi Woman.* The inclusion of the *Semang Warrior* and the *Solomon Islander* on the list expanded the notion of a black identity beyond the continent of Africa. Both of these works previously had been displayed within the Oceanic

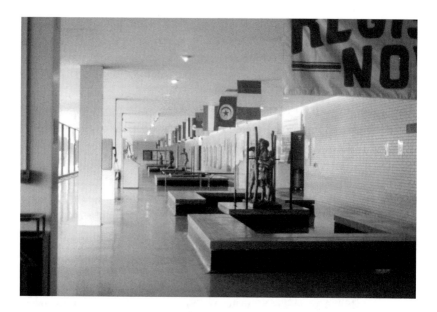

Figure C.3. Interior, Main Building, Malcolm X College, Chicago (1996). Photography by Lisa Schrenk.

section of the Hall of the Races of Mankind. This definition of blackness suggests that their selection process was guided by reading phenotypical features rather than by geographical considerations. Indeed, the college officials did not choose works such as the *Berber, Somali,* or *Ethiopian,* which the Field Museum anthropologists had previously defined as Hamites and other members of the "white stock" of Africa.

Charles Hurst perceived how Anglo-American ideals of beauty, informed by Western aesthetics, had an extremely corrosive effect on African American self-identity: "We were taught also to be ashamed of our own physical characteristics. Our concept of beauty was based on a white model of western European origin."[39] He also pointed out that images circulating pervasively in mass culture, such as the emasculated "Stepin Fetchit" male and the "good old mammy" female, worked with the Anglo-European canon of beauty to promote a sense of psychological inferiority.[40] For Hurst, the selected group of Races of Mankind figures functioned outside both the white canon of beauty and mass cultural stereotypes. Indeed, the representational power of Hoffman's figures lay not only as an alternative to these two ideological constructs, but as a way to redefine the values and meanings of blackness in terms of "Black is beautiful."[41] Since the replicas were white plaster, the Field museum preparators painted the figures in a variety of brown and black tones to signify a range of skin colors. Aspects of the figures that Henry Field had used to explain racial difference in the exhibit hall, such as hair form, could also articulate symbolic meanings associated with the discourses of Black Power and Black Pride. For example, the "Peppercorn hair" of the *Kalahari Bushman* male figure (figure 4.8) could be read in relation to "natural" hairstyles, such as the Afro. The head shape of *Mangbetu Woman* (figure 3.7), which Field had earlier described as an example of artificial deformation, could be understood as a formal exaggeration to emphasize the elaborate coiffure. The hairstyle and the pose and shape of the head worked together to promote the idea of African dignity and assurance. The woven hairstyle of the *Zulu Woman* and the spiked hair of the *Sudanese Woman* could suggest "authentic" African cultural practices functioning outside Western ideals.

Although the Field Museum agreed to a six-month renewable loan, the installation format was clearly designed for permanent display. The college mounted a majority of the painted plaster figures on square pedestals enclosed in Plexiglas and surrounded them with wooden benches on the first floor of the long, three story rectangular building. In the interior corridor running parallel to Van Buren Street, they installed the full-length male figures and the *Ituri Pygmy Family* group. In the hall running parallel to Jackson Street,

they mounted four female busts on pedestals. They exhibited the *Shilluk Warrior, Daboa,* and the black figure from the *Unity of Mankind* sculptural group in the African American Cultural Center near exhibition cases filled with West African sculptures and textiles from Northeast Africa.

In June 1997, when I visited Malcolm X College, the display of the Races of Mankind figures included additional elements that situated them further within the discourse of Black Nationalism. Flags from various African countries such as Ethiopia, Tunisia, Sierra Leone, and Cameroon were suspended above the full-length figures and busts displayed in the corridors. Plaques bearing quotations by Malcolm X, such as "By Any Means Possible . . . as long as it is intelligently directed and designed to get results," appeared above doorways. A portrait of Malcolm X and other objects relating to the life of the African American leader, such as his 1965 black Oldsmobile, were also exhibited nearby. Outside the building, the red, black, and green Black Nationalism flag hung next to the state flag of Illinois, and portions of the *Wall of Respect,* which had been salvaged after a fire at its original site, were also displayed near the east entrance. Such a context significantly detached the Races of Mankind figures from their earlier career as normative representations of race within educational materials. Perhaps to ensure that the figures and busts were sufficiently removed from their former "lives," no labels appeared on the sculptures to identify them as works by Malvina Hoffman nor that they were property of the Field Museum. By not acknowledging the artist and the museum, the college firmly established the sculptures' role in promoting an Afrocentric discourse.[42]

Before my visit, Malcolm X College officials had begun to question the value of the display. In 1995, college administrators wrote to the Field Museum about "refreshing" the exhibit so that it would be more inclusive and responsive to the diversification of the student population. The administrators believed that the increased enrollment of "Asian American and Latino" students necessitated changing the display, since it did not "represent their cultures." Their reevaluation suggests that the college not only recognized that its promotion of Black Nationalism might be irrelevant to an increasing number of students, but that members of the college were aware of the current critique of Afrocentric approaches in public education. Cultural theorists like Kwame Anthony Appiah argued that multicultural strategies in education were preferable to Afrocentrism, which he viewed as an inversion of Eurocentrism.[43] In 2003, the college appeared to adopt this stance when it dismantled the display and returned the sculptures to the Field Museum.

Shortly before my first visit to the Field Museum archives in March 1994, the artist Fred Wilson had been researching the Races of Mankind sculptures for his forthcoming *OpEd* exhibition at the Museum of Contemporary Art, Chicago. Known for installations, such as *Mining the Museum* (1992), that investigate social and racial politics of museological practices of collection and display, Wilson received an invitation from the curators to undertake a project concerning the art institution's mission and policies. This invitation occurred at a self-reflective moment when the museum was planning to move to its new building, located in the Near North Side neighborhood, and designing *Under Development: Dreaming the MCA's Collection,* an exhibition that considered the future role of the permanent collection in its new location.[44] Like other American cultural institutions, the museum wanted to engage the discourse of multiculturalism that had emerged in the 1980s and to sponsor current artistic activities that examined issues of identity as well as institutional policies and practices.

The *OpEd: Fred Wilson* installation was interspersed within the *Under Development: Dreaming the MCA's Collection* exhibition, which took up three floors of the museum.[45] The artist selected sixteen of the Races of Mankind bronze portraits to set up a complex system of relations among paintings and sculptures from the museum's permanent collection, as well as historical artifacts and academic portrait busts loaned by the Chicago Historical Society. Fred Wilson placed wall texts and labels with these objects and included auditory elements throughout the exhibition space to create what he called "a postmodernist dialogue about race, culture and difference in the art museum setting."[46] He structured this dialogue simultaneously on local and national levels by using these objects to make connections among collecting activities at the Chicago museum, the racialized space in which it was situated, the notion of aesthetic autonomy of the modern art museum, and the dominant image of the artist as white and male. Wilson's wall labels and audio components of the installation prompted visitors to think about their activities of seeing and to consider how exhibition techniques shape their interpretation of art.[47]

Upon entering the foyer of the museum, spectators encountered an architectural model of the museum's new building on a white pedestal, which "emitted religious music" to suggest the sacrosanct notion of the museum.[48] Within most areas of the installation, Wilson used an asymmetrical plan in

which a series of freestanding partitions punctuated the gallery space. This layout encouraged an embodied form of experience, where visitors moved through the installation space to discover unusual display techniques, such as exhibiting academic marble portrait busts on the floor or on floating platforms, beneath Abstract Expressionist paintings.[49] Spectators encountering unusual juxtapositions of objects were encouraged to perceive new relationships among the artworks as they came into and went out of view.

However, in one section of the installation (figure C.4), Wilson created a much more static environment. In the cubical space, he displayed five Races of Mankind bronze portraits, *Jakun Woman, Maya Male, South Chinese Man, Ainu Male,* and *Arab Male,* on white shelves staggered against one wall. On the adjacent wall he hung framed architectural plans for the new Museum of Contemporary Art building with those of the Cabrini Extension and Winthrop Tower. Fred Wilson asked visitors to engage the racial politics of space in Chicago in his selection of architectural plans, which point out the museum's location within the affluent section of the Near North Side neighborhood and its close proximity to public housing.[50] Known as one of the worst public-housing projects in America, Cabrini-Green was part of the urban renewal program of the 1950s and 1960s that segregated impoverished residents, primarily African Americans, into stripped-down International

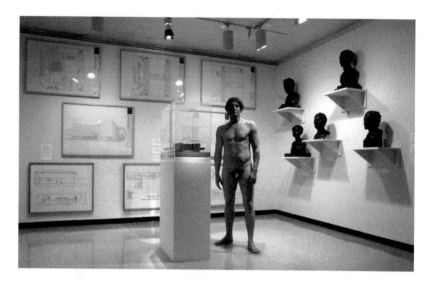

Figure C.4. Installation view of *OpEd: Fred Wilson,* Museum of Contemporary Art, Chicago (1994). Photography © Museum of Contemporary Art, Chicago.

style high-rise buildings. Two months before *OpEd: Fred Wilson* opened, the chairman of the Chicago Housing Authority, Vincent Lane, advocated demolishing some of the buildings in the Cabrini-Green complex, which generated intense debates concerning the displacement of residents and the prospect of gentrification in which the city might sell the much-coveted land to private developers.[51] During the previous summer, the *Chicago Tribune* sponsored a revitalization competition for Cabrini-Green, with Vincent Lane serving on the selection jury, and over one hundred proposed plans and architectural models were exhibited at the Chicago Atheneum.[52] Also in the summer of 1993, the U.S. Department of Housing and Urban Development sold Winthrop Tower, a dilapidated nineteen-story public-housing high-rise located in the Uptown neighborhood, for one dollar to a local nonprofit group, who planned to renovate the building and turn it into affordable residential units.[53] The architectural plans on display engaged these issues in the future tense; it appears that Wilson did not select architectural plans of the existing buildings but chose plans that showed how public housing could be transformed, much as the museum was about to be transformed.

In the center of the square room, Wilson installed *Standing Man* (1970) by John De Andrea next to Josef Paul Kleihues's architectural model of the new art museum, which rested upon a white pedestal within a Plexiglas vitrine. He arranged the ceiling light fixtures to cast an intense light directly upon the full-length figure and upon the Races of Mankind portraits. The intense brightness of the light created reflections of the rectangular-framed architectural plans and the De Andrea sculpture on the linoleum floor. His use of space and light, physically and metaphorically, situated the white nude male at the center of the display. His exaggeration of display techniques, such as lighting, underscored the whiteness of the modernist space. The alcove's austere rectangular space, the stance of *Standing Man* in its center, and Wilson's repeated references to architectural drawings also recall Leonardo's *Vitruvian Man*, which underwrote anthropometric studies and the ideal system of proportions within classical architectural spaces.[54] In so doing, the installation made visible how race and gender function within Western architectural thought.

The five Races of Mankind sculptures played a crucial role as humanizing elements within the austere environment. By placing these bronze portraits on shelf-like pedestals against the white wall, Wilson situated them as marginalized subjects in relationship to the dominant white male. Wilson's choice of the Races of Mankind sculptures suggested racially marginalized subjects that are neither white nor black and asked spectators to think about the politics

of race beyond a binary construct. His exhibition format created an intersubjective dialogue between the sculptures, in which the Races of Mankind portraits, placed on the wall as if they were in a theater balcony, appear to gaze across, glance sideward, or peer down toward the centrally positioned *Standing Man*, which does not respond to their look but gazes outward. This pattern of gazes creates a dramatic encounter in which the Races of Mankind sculptures seem to recognize the invisible whiteness represented by *Standing Man*.[55] Wilson also capitalized on how Malvina Hoffman had positioned the heads of the portraits to effect this system of gazes. (Recall how Royal Cortissoz complimented the sculptor on her ability to make the "turn of the head significant" [page 141] and how Stanley Field remarked that in the *Sioux Indian Male* portrait Hoffman had "[posed] the head so that it has life and is not dead" [page 50]). The staggered arrangement of the pedestals calls attention to Fred Wilson's staging of the objects to create this system of gazes. His method of display offers a kind of viewing experience that the architect Carlo Scarpa applied earlier in the sculpture galleries at Castelvecchio in Verona. There, Scarpa situated sculptures in relation to one another through a system of gazes; viewers who noticed the sculptures looking at one another would experience shifts between perceiving them as subjects and as inanimate objects.[56] Such experimental forms for displaying sculpture make each viewer aware of his or her own look and thus relate to Walter Benjamin's association of aura with the projection of subjectivity: "Experience of the aura thus rests on the transposition of a response common in human relationships to the relationship between the inanimate or natural object and man. The person we look at, or who feels he is being looked at, looks at us in turn. To perceive the aura of an object we look at means to invest it with the ability to look at us in return."[57] By exploiting the long-held tradition that portraits can serve as substitutes for individuals, Wilson enhanced this psychic investment of the viewer and the possibilities of an imagined returned gaze by constructing fictional artistic personas for each of the Races of Mankind sculptures on wall labels.[58] These personas reverse the sculptures' role as normative representations of racial types subjected to a physiognomic gaze and indicate the potential range of forms of identification that viewers can have with them. In fashioning artistic identities for these sculptures, Wilson concealed his own identity as an artist, but also that of Malvina Hoffman. The sculptor, who had worked so hard to present herself as a creative artist through her rhetoric of character, is absent from the setting.

Fred Wilson's dialogue among these sculptures functions in the gaps between likeness, imagined referent, and literal object, issues that have struc-

tured discussions of the genre of sculptural portraiture since the nineteenth century. It also suggests the instability of values associated with material processes that we have tracked throughout this study. What makes *Standing Man,* a painted polyresin figure with artificial hair, a work of art is how notions of realism and the process of direct casting have been reformulated since the late 1960s and early 1970s. Sympathetic critics of verism or superrealism consider De Andrea's work in terms of simulacra and consider direct casting as a mode of representation that challenges both traditional sculpture and the taste for pure form in modernist sculpture. Such an understanding of direct casting increases its status as an artistic practice but does not address the anthropological tradition of casting and the production of ethnographic lay figures in natural history museums. In contrast, Malvina Hoffman relied upon the latter tradition to assert the value of bronze and the sculptural process of modeling to situate the Races of Mankind sculptures within the realm of fine art. There is an irony here. Without question, John De Andrea's cast figure is considered an example of late-twentieth-century sculpture, an object appropriate for display within the Museum of Contemporary Art, while Malvina Hoffman's Races of Mankind sculptures, with their uneasy toehold within the history of American art, are uncomfortable presences in the modern museum setting.

ABBREVIATIONS

The following abbreviations are used in the notes.

AAFM Department of Anthropology Archives, Field Museum, Chicago.

AHP Aleš Hrdlička Papers, National Anthropological Archives, Smithsonian Institution, Washington, D.C.

AKP Arthur Keith Papers, Royal College of Surgeons of England, London.

CPMET Coupures de presse sur les expositions temporaires et inaugurations de salle 1933–1934, M.E.T. Archives, Musée de l'Homme.

DAFM Directors' Archives. Field Museum, Chicago.

FBP Franz Boas Papers, American Philosophical Society Library, Philadelphia.

HFFM Henry Field Papers, Special Collections, Field Museum, Chicago.

HFMH Henry Field Correspondence, Musée de l'Homme archives.

LSP Louis Slobodkin Papers, Tamara and Lawrence Slobodkin Collection, Setauket, New York.

MHMH Malvina Hoffman file, M.E.T. Archives, Musée de l'Homme.

MHMR Malvina Hoffman File and Correspondence, Musée Rodin, Paris.

MHPG Malvina Hoffman Papers, Special Collections, Accession Number 850042, Getty Research Institute for the History of Art and the Humanities, Los Angeles.

NUL National Urban League Papers, Series X, Related Organizations, Container 18, "Hoffman, Malvina, Sculpture Exhibit 1942—Correspondence, finances, invites, publicity and misc." Manuscript Division, Library of Congress, Washington, D.C.

PRP Paul Rivet Papers, Musée de l'Homme.

NOTES

Introduction

1. Stookie Allen, "Women of Daring: A Woman 'Head Hunter,'" *New York Daily Mirror* (August 27, 1934), Oversized Scrapbook, Box 154, MHPG.

2. Alice Cecilia Cooper and Charles A. Palmer, *Twenty Modern Americans* (New York: Harcourt, Brace, 1942), 232–33.

3. Malvina Hoffman, *Heads and Tales* (New York: Charles Scribner's Sons, 1936), 12.

4. For more on this subject, see Elspeth H. Brown, *The Corporate Eye: Photography and the Rationalization of American Commercial Culture, 1884–1929* (Baltimore: Johns Hopkins University Press, 2005).

5. Although Warren Susman argues that a paradigmatic shift, from the rhetoric of *character* to *personality*, occurred during the early twentieth century, I have found that these terms were consistently confused in the genre of portraiture. Warren Susman, *Culture as History: The Transformation of American Society in the Twentieth Century* (New York: Pantheon Books, 1984). Andrew Heinze has questioned Susman's view; he finds that *character* and *personality* functioned in many publications as synonyms. Andrew R. Heinze, "Schizophrenia Americana: Aliens, Alienists and the 'Personality Shift' of Twentieth-Century Culture," *American Quarterly* 55, no. 2 (2003): 227–56.

6. Robin R. Salmon with Ilene Susan Fort and Lauretta Dimmick, "Malvina Cornell Hoffman," in *American Masters: Sculptures from Brookgreen Gardens* (Murrells Inlet, S.C.: Brookgreen Gardens, 1996), 35.

7. The Races of Mankind sculptures have been discussed in the following essays: Pamela Hibbs Decoteau, "Malvina Hoffman and the Races of Mankind," *Woman's Art Journal* 10, no. 2 (1990): 7–12; Linda Nochlin, "Malvina Hoffmann: A Life in Sculpture," *Arts Magazine* 59 (1984): 106–10; and Tracy Lang Teslow, "Reifying Race: Science and Art in *Races of Mankind* at the Field Museum of Natural History," in *The Politics of Display*, ed. Sharon Macdonald (London: Routledge, 1998), 53–76.

8. Susan Leigh Star and James R. Griesemer, "Institutional Ecology, 'Translations' and Boundary Objects: Amateurs and Professionals in Berkeley's Museum of Vertebrate Zoology, 1907–39," *Social Studies of Science* 19 (1989): 393. Their methodological approach builds upon the ideas of Bruno Latour, whose concepts of translation, immutable mobiles, and centers of calculation inform my study. See especially Bruno Latour, *Science in Action* (Cambridge, Mass.: Harvard University Press, 1987), and "Drawing Things Together," in *Representation in Scientific Practice*, ed. Michael Lynch and Steven Woolgar (Cambridge, Mass.: MIT Press, 1990), 19–68.

9. Allan Sekula, "The Traffic in Photographs," in *Only Skin Deep: Changing Visions of the American Self,* ed. Coco Fusco and Brian Wallis (New York: Harry N. Abrams, 2003), 81.

10. Benjamin H. D. Buchloh, "Residual Resemblance: Three Notes on the Ends of Portraiture," in Melissa E. Feldman, *Face Off: The Portrait in Recent Art* (Philadelphia: Institute of Contemporary Art, University of Pennsylvania, 2004), 53–69.

11. Okwui Enwezor, "Repetition and Differentiation—Lorna Simpson's Iconography of the Racial Sublime," in *Lorna Simpson* (New York: Harry N. Abrams and American Federation of Arts, 2006), 117.

12. Nicholas Mirzoeff, "The Shadow and the Substance," in Fusco and Wallis, eds., *Only Skin Deep,* 126.

13. Armand Marie Leroi, "A Family Tree in Every Gene," *New York Times* (March 14, 2005): A21. For rebuttals, see Social Science Research Council, "Is Race 'Real'?," Social Science Research Council, http://raceandgenomics.ssrc.org (accessed January 26, 2010).

14. See Barbara A. Koenig, Sandra Soo-Jin Lee, and Sarah S. Richardson, eds., *Revisiting Race in a Genomic Age* (New Brunswick, N.J.: Rutgers University Press, 2008), for a variety of viewpoints on race and genetics.

15. Michael Omi and Howard Winant, *Racial Formation in the United States: From the 1960s to the 1990s* (New York: Routledge, 1994).

16. American Anthropological Association, "Statement on 'Race' (May 17, 1998)," American Anthropological Association, http://www.aaanet.org/stmts/racepp.htm (accessed January 16, 2010).

17. Antoinette Le Normand-Romain, "Sculpture et ethnographie," in *La sculpture ethnographique de la Vénus Hottentote à la Tehura de Gauguin,* ed. Antoinette Le Normand-Romain, Anne Roquebert, Jeanine Durand-Revillon, and Dominique Serena (Paris: Réunion des Musées Nationaux, 1994), 42.

18. Royal Cortissoz, "Malvina Hoffman's Bronzes in Chicago," *New York Herald Tribune* (November 26, 1933), Oversized Scrapbook 1933–38, Box 151, MHPG.

19. Georges Didi-Huberman, *L'empreinte* (Paris: Centre Georges Pompidou, 1997), 76.

20. Ernst Benkard, *Undying Faces: A Collection of Death Masks with a Note by Georg Kolbe,* trans. Margaret M. Green (London: Hogarth Press, 1929), 17.

21. Lorraine Daston and Peter Galison, "The Images of Objectivity," *Representations* 40 (1992): 81–128.

22. See Édouard Papet, "Le moulage sur nature au service de la science," in *À fleur de peau: Le moulage sur nature au XIXe siècle* (Paris: Réunion des Musées Nationaux, 2001), 88–95.

23. Charles Schuchert, "What Is a Type in Natural History?" *Science,* n.s., 5, no. 1 (1897): 637; and Donald Leslie Frizzell, "Terminology of Types," *American Midland Naturalist* 14, no. 6 (1933): 651.

24. Jules Dalou quoted in Édouard Papet, "Historical Life Casting," in Stephen Feeke, *Second Skin: Historical Life Casting and Contemporary Sculpture* (Leeds: Henry Moore Institute, 2002), n.p.

25. Auguste Rodin quoted in Edouard Papet, "Historical Life Casting," n.p.

26. Charles Cordier, "Rapport de Charles Cordier: Types ethniques représentés par la sculpture," *Bulletins de la Société d'Anthropologie de Paris* 3 (1862): 66. For more on Charles Cordier, see Barbara Larson, "Exhibition Review, The Artist as Ethnographer: Charles Cordier and Race in Mid-Nineteenth Century France," *Art Bulletin* 87, no. 4 (2005): 714–22; and Laure de Margerie and Edouard Papet, eds., *Charles Cordier (1827–1905), sculpteur: L'autre et l'ailleurs* (Paris: Éditions de la Martinière, 2004).

27. Cordier, "Rapport de Charles Cordier," 65–66. All translations are by the author unless otherwise noted.

28. For more on Ward's sculptures, see Mary Jo Arnoldi, "A Distorted Mirror: The Exhibition of the Herbert Ward Collection of Africana," in *Museums and Communities: The Politics of Public Culture,* ed. Ivan Karp, Christine Mullen Kreamer, and Stephen D. Lavine (Washington, D.C.: Smithsonian Institution Press, 1992); Mary Jo Arnoldi, "Herbert Ward's 'Ethnographic Sculptures' of Africans," in *Exhibiting Dilemmas: Issues of Representation at the Smithsonian,* ed. Amy Henderson and Adrienne L. Kaeppler (Washington, D.C.: Smithsonian Institution Press, 1997), 70–91; and Hugh Marles, "Arrested Development: Race and Evolution in the Sculpture of Herbert Ward," *Oxford Art Journal* 19, no. 1 (1996): 16–28.

29. Arnoldi, "A Distorted Mirror," 438, and Marles, "Arrested Development," 18.

30. Herbert Ward quoted by William Henry Holmes, "Herbert Ward's Achievements in the Field of Art," *Art and Archeology* 18, no. 3 (1914): 118.

31. Herbert Ward quoted by Holmes, "Herbert Ward's Achievements," 118.

32. Arnoldi, "Herbert Ward's 'Ethnographic Sculptures' of Africans," 85–86.

33. Arlo Bates, "Literary Affairs in Boston," *The Book Buyer* 10 (1893): 61. For a discussion of the later Normman and Norma statues and the statistically derived type, see Christina Cogdell, *Eugenic Design: Streamlining America in the 1930s* (Philadelphia: University of Pennsylvania Press, 2004).

34. Charles Norton quoted by Charles E. L. Wingate, "Boston Letter," *The Critic,* n.s., 19 (1893): 420.

35. Franz Boas, "Remarks on the Theory of Anthropometry," *Publications of the American Statistical Association* 3 (1893): 573.

36. Department of Anthropology, Notebook on Special Exhibits 1951–1952, NAA.

37. *Index* is a semiotic term for a sign that bears a direct physical relationship to its referent (e.g., smoke is an index of fire). Indexical forms of representation, such as photography and casting, involve a causal relationship between an object and its image.

38. Aleš Hrdlička, *Physical Anthropology: Its Scope and Aims, Its History and Present Status in the United States* (Philadelphia: Wistar Institute of Anatomy and Science, 1919), 13–14.

39. Adolph H. Schultz, "Biographical Memoir of Aleš Hrdlička, 1869–1943," *National Academy of Sciences of the United States of America Biographical Memoirs* 23 (1944): 312; and Stephen Loring and Miroslav Prokopec, "A Most Peculiar Man: The Life and Times of Aleš Hrdlička," in *Reckoning with the Dead: The Larsen Bay*

Repatriation and the Smithsonian Institution, ed. Tamara L. Bray and Thomas W. Killon (Washington, D.C.: Smithsonian Institution Press, 1994), 27.

40. Hrdlička, *Physical Anthropology,* 139. See the scholarship of Nélia Dias, and especially her essay "The Visibility of Difference: Nineteenth-Century French Anthropological Collections," in *The Politics of Display: Museums, Science Culture,* ed. Sharon Macdonald (New York: Routledge, 1998), 36–52. I wish to thank Dan Sherman, who brought her scholarship to my attention.

41. Michael Blakey, "Skull Doctors Revisited," in *Race and Other Misadventures: Essays in Honor of Ashley Montagu in his Ninetieth Year,* ed. Larry T. Reynolds and Leonard Lieberman (New York: General Hall, 1996), 74.

42. Aleš Hrdlička to Aimé Rutot, July 28, 1913, Correspondence with A. Rutot, Box 57, Aleš Hrdlička Papers, NAA.

43. Robert Rydell, *All the World's a Fair* (Chicago: University of Chicago Press, 1984), 220–23, 227–31.

44. Raf De Bont, "The Creation of Prehistoric Man: Aimé Rutot and the Eolith Controversy, 1900–1920," *Isis* 94 (2003): 624.

45. Aleš Hrdlička to William Henry Holmes, March 21, 1912, San Diego Exposition File, Box 58, Aleš Hrdlička Papers, NAA.

46. Aleš Hrdlička, *A Descriptive Catalogue of the Section of Physical Anthropology, Panama–California Exposition 1915* (San Diego: National View Company, 1914), 9.

47. Aleš Hrdlička, "Physical Differences between White and Colored Children," *American Anthropologist* 11, no. 11 (1898): 347.

48. Aleš Hrdlička, "Evolution of Man in the Light of Recent Discoveries and Its Relation to Medicine," *Washington Medical Annals* 14, no. 6 (1915): 305.

49. Hrdlička, *Physical Anthropology,* 24.

50. Hrdlička, *A Descriptive Catalogue,* 11.

51. Ibid.

52. Berthold Laufer to Frederick Skiff, April 18, 1916, "Hall of the Races of Mankind" Papers, AAFM.

53. Berthold Laufer to Frederick J. V. Skiff, April 18, 1916, File Correspondence Henry Field 1916–1933, original from Volume II of Henry Field's Notebooks, HFFM.

54. Ibid.

55. Frederick Skiff to Berthold Laufer, April 21, 1916, File Correspondence Henry Field 1916–1933, original from Volume II of Henry Field's Notebooks, HFFM.

56. Berthold Laufer to Stanley Field, November 17, 1921, AAFM. Berthold Laufer to Aleš Hrdlička, February 15, 1922, Aleš Hrdlička Correspondence, AAFM.

Chapter 1. Initial Plans for a Physical Anthropology Display

1. Henry Field, *The Track of Man: Adventures of an Anthropologist* (New York: Greenwood Press, 1953), 131. The proposed physical anthropology exhibits later became the Hall of the Stone Age of the Old World and the Chauncey Keep Memorial Hall of Physical Anthropology (renamed the Hall of the Races of Mankind).

2. Berthold Laufer to Aleš Hrdlička, April 3, 1928, Aleš Hrdlička Correspondence, AAFM.

3. Stanley Field, "Fifty Years of Progress," *Field Museum News* 14, nos. 9–10 (1943): 7.

4. Stanley Field to S. C. Simms, April 15, 1930, File 1, Box 1, DAFM, and also Stanley Field to Malvina Hoffman, May 5, 1930, Box 3, MHPG.

5. Ibid.

6. Henry L. Ward, "Exhibition of Fossils and Skeletons in Popular Museums," *Proceedings of the American Association of Museums* 4 (1910): 100. See also Charles F. Millspaugh, "Botanical Installation," *Proceedings of the American Association of Museums* 4 (1910): 53.

7. S. C. Simms, "University of Chicago Honors Stanley Field," *Field Museum News* 2, no. 1 (1931): 2. His father, Joseph Field, a partner in Marshall Field and Company, headed the purchasing office in Manchester, England. Stanley Field initially clerked in the State Street department store and remained on the store's board of directors until his death. Lloyd Wendt and Herman Kogan, *Give the Lady What She Wants!* (South Bend, Ind.: And Books, 1952), 239, 294.

8. William Leach, *Land of Desire: Merchants, Power, and the Rise of a New American Culture* (New York: Pantheon Books, 1993), 60. See also Tony Bennett, *The Birth of the Museum: History, Theory, Politics* (London: Routledge, 1995).

9. Stephen Simms quoted in L. M. Belfield, "The Visual Idea Functioning through Museums," *Visual Education* 2, no. 8 (1921): 10–11. I would like to thank Peter Reichardt for bringing this journal to my attention.

10. Arthur Parker, "Habitat Groups in Wax and Plaster," *Museum Work* 1 (1918): 78, 83.

11. Wilfred Osgood, *Taxidermy and Sculpture: The Work of Carl E. Akeley in Field Museum of Natural History* (Chicago: Field Museum of Natural History, 1927). In 1896, the museum appointed Carl Akeley chief taxidermist, and during his tenure there he refined his techniques. Donna Haraway, "Teddy Bear Patriarchy: Taxidermy in the Garden of Eden, New York City, 1908–1936," *Social Text* 11 (1984–85): 20–64.

12. Michael Leja, "Modernism's Subjects in the United States," *Art Journal* 55, no. 2 (1996): 66.

13. Ibid., 69.

14. Walter Hough, "Installation of Ethnological Material," *Proceedings of the American Association of Museums* 10 (1917): 118.

15. William Henry Holmes, "Classification and Arrangement of the Exhibits of an Anthropological Museum," *Annual Report of the National Museum for the Year Ending June 30, 1901* (Washington, D.C.: Smithsonian Institution, 1902), 258.

16. William Henry Holmes, "The Exhibit of the Department of Anthropology," *Report of the National Museum, 1901* (Washington, D.C.: Smithsonian Institution, 1902), 201.

17. Ibid., 202. See also Walter Hough, "Racial Groups and Figures in the Natural History Building of the United States National Museum," *Annual Report Smithsonian Institution for the Year Ending June 30, 1920* (Washington, D.C.: Smithsonian Institution, 1921), 615–16. Berthold Laufer held an ambiguous position on ethno-

graphic life groups. Like Boas, he believed that their purpose was to demonstrate cultural objects. However, Laufer retained the idea of cultural stages, which was more in tune with Holmes's position. Berthold Laufer, "The Department of Anthropology—Its Aims and Objects," *Field Museum News* 2, no. 8 (1931): 2.

18. Henry Field, "Man—Past and Present—in the Field Museum," *Scientific Monthly* 38 (1934): 293.

19. The Hall of Prehistoric Man was the first attempt by a museum to present the subject of physical anthropology in a habitat format. Henry Field, "Stone Age Hall, Soon to Open, Will Show Ancestors of Human Race," *Field Museum News* 4, no. 7 (1933): 1.

20. During its first fifty years, the museum was closely associated with the Field family and Marshall Field's department store. Marshall Field provided an initial sum of $1 million to found the museum in 1893 and left an additional $8 million in his will. Oliver Farrington, "A Brief History of Field Museum," *Field Museum News* 1, no. 2 (1930): 3–4. His nephew Stanley Field gave large sums to the institution, donating more than $1.5 million over the course of his life. Orr Goodson, "Men and Women Whose Contributions Have Made the Museum Possible," *Field Museum News* 14, nos. 9–10 (1943): 10. Marshall Field III continued the family tradition and annually gave $100,000 to the museum. In 1932 he gave $96,000 for general operating expenses and contributed $32,000 for the Hall of the Races of Mankind but did not take an active role in the daily running of the museum. During the 1940s, he established the *Chicago Sun* newspaper and *PM* magazine. He also headed Field Enterprises, Inc., which published *World Book Encyclopedia*.

21. Gabrielle Lyon, "The Forgotten Files of a Marginal Man: Henry Field, Anthropology and Franklin D. Roosevelt's 'M' Project for Migration and Settlement" (master's thesis, University of Chicago, 1994).

22. Berthold Laufer to Henry Field, October 20, 1925, General Correspondence, Vol. 25, HFFM.

23. Shortly after the Hall of the Races of Mankind opened, Field took measures to correct the situation. In 1936, Field went to Harvard University to take Earnest Hooton's physical anthropology classes but found the courses confusing. Henry Field to Pat [Harper] Kelley, October 2, 1936, Vol. 16, HFFM.

24. Bennet Bronson, "Berthold Laufer," *Fieldiana*, n.s., 36 (2003): 117.

25. Stanley A. Freed, Ruth Freed, and Laila Williamson, "Tough Fieldworkers: History and Personalities of the Jesup Expedition," in *Drawing Shadows to Stone: The Photography of the Jesup North Pacific Expedition, 1871–1902*, by Laurel Kendall et al. (New York: American Museum of Natural History in association with Douglas & McIntyre, 1997), 12.

26. "The Death of Dr. Laufer," 2.

27. Berthold Laufer, preface to *The Races of Mankind: An Introduction to Chauncey Keep Memorial Hall*, by Henry Field (Chicago: Field Museum of Natural History, 1933), 4–6.

28. Henry Field, *The Track of Man*, 134.

29. For a sustained study on different conceptions of race during the 1930s, see Elazar Barkan, *The Retreat of Scientific Racism: Changing Concepts of Race in Britain and the United States between the World Wars* (Cambridge: Cambridge University Press, 1992).

30. Franz Boas to Henry Field, August 30, 1929, photocopy, AAFM.

31. George Stocking Jr., *Race, Culture, and Evolution: Essays in the History of Anthropology* (New York: The Free Press, 1968), 182. Boas was understood as subscribing to a two-race classification system, the Mongoloid and Negroid, based on skin color, hair, nose shape, form of the face, and bodily proportions. He considered populations outside these two divisions as divergences or local specializations. George Dorsey, "Race and Civilization," in *Whither Mankind*, ed. Charles A. Beard (New York: Longmans, Green, 1928), reprinted in *Frontiers of Anthropology*, ed. Ashley Montagu (New York: G. P. Putnam's Sons, 1974), 456.

32. Franz Boas, *Anthropology and Modern Life* (1928; New York: Norton, 1962), 26.

33. Stocking, *Race, Culture, and Evolution*, 190.

34. Boas, *Anthropology and Modern Life*, 12.

35. Stocking, *Race, Culture, and Evolution*, 180.

36. Boas, *Anthropology and Modern Life*, 22.

37. Ibid., 22–23.

38. George Stocking, ed., *The Shaping of American Anthropology, 1883–1911: A Franz Boas Reader* (New York: Basic Books, 1974), 190.

39. "Hall of Physical Anthropology Suggestions by Dr. Hrdlička," n.d., n.a., Vol. 2, HFFM.

40. Ibid.

41. "Hall of Physical Anthropology 1930 Material to Be Acquired," n.d., n.a., Vol. 2, HFFM. Berthold Laufer had previously visited the museum and sent a letter to Hrdlička requesting his permission to copy charts and descriptive labels. Berthold Laufer to Aleš Hrdlička, April 3, 1928, Aleš Hrdlička Correspondence, AAFM.

42. However, both anthropologists received letters from Laufer asking them to advise Hoffman in selecting "good racial types." Berthold Laufer to Franz Boas, February 25, 1930, microfilm reel 31, FBP. Boas responded that he did not have the kind of information that Hoffman needed and suggested she consult the Bureau of American Ethnology, where "good photographs, at least of Indian heads, are available." Franz Boas to Berthold Laufer, March 19, 1930, microfilm reel 31, FBP. Hrdlička advised Hoffman to work from live models rather than photographs. Aleš Hrdlička to Berthold Laufer, April 2, 1930, Berthold Laufer Correspondence, Aleš Hrdlička Papers, NAA. When Hoffman met with Hrdlička in October 1930, she received a cool reception from the physical anthropologist. Hoffman perceived Hrdlička as a "killjoy," who would "find something to tear to pieces when done by a mere woman and not a grey bearded scientist or museum man." Malvina Hoffman to Stanley Field, December 22, 1943, File 7, Box 3, DAFM.

43. Arthur Keith was conservator to the Royal College of Surgeons of Great

Britain and rector of the University of Aberdeen. He served on the Government University Grants Committee and was a member of the board of managers for the Royal Institute. He had enormous influence over colleagues by serving on the selection-of-professor committees at Cambridge, London, and Oxford universities. Besides these powerful professional positions, he was recognized as an authority on race and evolution. Elazar Barkan argues that British racialists like Keith remained respected figures in the profession and dominated the Royal Anthropological Institute well into the 1930s. Barkan, *The Retreat of Scientific Racism,* 286.

44. Dudley Buxton, *The Peoples of Asia* (New York: Knopf, 1925), 18.

45. Ibid., 21.

46. Arthur Keith, "An Introduction to the Anthropology of the Near East in Ancient and Recent Times," *Nature* 135, no. 3413 (1935): 487.

47. Arthur Keith and Wilton Krogman, "Appendix A: The Racial Characteristics of the Southern Arabs," in *Arabia Felix: Across the "Empty Quarter,"* by Bertram Thomas (New York: Charles Scribner's Sons, 1932), 318.

48. Barkan, *The Retreat of Scientific Racism,* 292.

49. Berthold Laufer to Franz Boas, December 7, 1931, Berthold Laufer Correspondence, AAFM.

50. "War and Prejudices Called Ill for Man: Boas, at American Science Session, Challenges Views of Sir Arthur Keith," *New York Times* (June 16, 1931): 5.

51. Arthur Keith to Henry Field, August 12, 1929, Vol. 2, HFFM.

52. Ibid.

53. Wilton Krogman, "What We Do Not Know about Race," *Scientific Monthly* 57 (1943): 100. Keith also linked these mechanisms to sexual differentiation. Keith claimed that since white races possessed a more active pituitary gland, they are therefore more masculine than the other two races. Arthur Keith, "The Differentiation of Mankind into Racial Types," *Nature* 104 (1919): 446.

54. Henry Field, *The Track of Man,* 230.

55. Invoice, December 12, 1930, William Finerly, Royal College of Surgeons, Races of Mankind Correspondence, Vol. 12, HFFM.

56. Dudley Buxton to Henry Field, August 29 [1930?], "Malvina Hoffman History of Hall of Races of Mankind 1930–1934" file, Vol. 2, HFFM.

57. Ibid.

58. Dudley Buxton to Henry Field, March 10, 1930, Vol. 12, HFFM.

59. Buxton, *Peoples of Asia,* 14.

60. Alfred Cort Haddon, *The Races of Man and Their Distribution,* 2nd ed. (New York: Milner, 1925), 151.

61. Barkan, *The Retreat of Scientific Racism,* 301.

62. Buxton, *Peoples of Asia,* 14.

63. Haddon, *Races of Man,* 155.

64. Alfred Cort Haddon, *History of Anthropology* (London: Watts, 1934), 42.

65. Haddon, *Races of Man,* 159.

66. There were exceptions to this conceptual format, such as including the Veddah and Andaman types in the right side of the hall.

67. Henry Field also envisioned the exhibit hall as working in relation to the Hall of Prehistoric Man. As in Hrdlička's exhibit at the Panama–California Exposition, humans' phylogenic past would be placed next to displays concerning present racial divisions.

Chapter 2. Malvina Hoffman as Professional Artist

1. Malvina Hoffman, *Yesterday Is Tomorrow* (New York: Crown, 1965), 213.

2. Stanley Field to S. C. Simms, April 27, 1934. Box 2, File 8, DAFM.

3. Arthur Keith, *An Autobiography* (London: Watts, 1950), 556.

4. Hoffman, *Yesterday Is Tomorrow*, 12–13.

5. Joshua Taylor, "Malvina Hoffman," *American Art and Antiques* 2, no. 4 (1979): 96.

6. Richard Hoffman, *Some Musical Recollections of Fifty Years* (New York: Charles Scribner's Sons, 1910); Hoffman, *Yesterday Is Tomorrow*, 18.

7. Hoffman, *Yesterday Is Tomorrow*, 70.

8. Ibid.

9. Ibid., 95.

10. Malvina Hoffman, "Naples, 1910," Summaries of Diaries, Box 40, MHPG.

11. Malvina Hoffman, "Paris, 1910," Summaries of Diaries, Box 40, MHPG.

12. Malvina Hoffman, "Paris, July 29, 1912," Diaries from Various Trips, Box 134, MHPG.

13. Malvina Hoffman, "Paris, June 25, 1910," Diaries from Various Trips, Box 134, MHPG.

14. Malvina Hoffman, "Paris, February 15, 1911," Diaries from Various Trips, Box 134, MHPG.

15. Mariea Caudill Dennison, "The American Girls' Club in Paris: The Propriety and Imprudence of Art Students, 1890–1914," *Woman's Art Journal* 26, no. 1 (2005): 33.

16. Ibid., 32.

17. Malvina Hoffman, "May 18, 1910," Summaries of Diaries, Box 40, MHPG.

18. Ibid.

19. Malvina Hoffman, "June 2, 1910," Summaries of Diaries, Box 40, MHPG.

20. Hoffman, *Yesterday Is Tomorrow*, 133.

21. Malvina Hoffman, "Paris, February 13, 1911," Diaries from Various Trips, Box 134, MHPG.

22. Malvina Hoffman, "Feb. 1911," Summaries of Diaries, Box 40, MHPG.

23. Kathleen McCarthy uses the term *assimilationists* to describe women artists who chose to work within established institutions, studied under male artists, and deferred to their male mentors' aesthetic sensibilities. Kathleen McCarthy, *Women's Culture: American Philanthropy and Art, 1830–1930* (Chicago: University of Chicago Press, 1991), 109.

24. Janet Scudder, "Janet Scudder Tells Why So Few Women Are Sculptors," *New York Times Sunday Magazine* (February 18, 1912): 13.

25. Ibid.

26. Malvina Hoffman, *Heads and Tales* (New York: Charles Scribner's Sons, 1936), 34.

27. Malvina Hoffman to Auguste Rodin on Carol Averill Harriman calling card, n.d.; Malvina Hoffman to Auguste Rodin, February 11, 191[3?]; and Malvina Hoffman to Auguste Rodin, March 25, 191[4?], MHMR.

28. Malvina Hoffman to Auguste Rodin, undated letter [1915?], MHMR.

29. Malvina Hoffman, *Sculpture Inside and Out* (New York: Norton, 1939), 316. Hoffman relied upon her patrons not only for commissions, but also for additional favors. Mrs. Harriman purchased the stables in Sniffen Court so that Hoffman could rent a studio at a nominal amount. For many years, Paul Warburg, brother of the art historian Aby Warburg, provided the sculptor with a summer cottage in Hartsdale, New York.

30. Mrs. Harriman supported the eugenics movement. Her large financial contributions to the Eugenics Record Office in Long Island helped to cover the organization's annual operating expenses from 1910 to 1918. Garland E. Allen, "The Eugenics Record Office at Cold Spring Harbor, 1910–1940: An Essay in Institutional History," *Osiris*, 2nd ser., 2 (1986): 235. In 1921, Mrs. Harriman underwrote the Second International Exhibition of Eugenics, held in conjunction with the Second International Congress of Eugenics at the American Museum of Natural History. Harry H. Laughlin, *The Second International Exhibition of Eugenics* (Baltimore: Williams and Wilkins, 1923), 15. An exhibit mounted by the Eugenics Record Office, the "Eugenical Classification of the Human Stock," listed Auguste Rodin among the most eugenically fit. Laughlin, *Second International Exhibition*, 67.

31. Taylor, "Malvina Hoffman," 100.

32. Hoffman, *Heads and Tales*, 52.

33. The value of creating such a persona was not lost on Louis Slobodkin, who understood it as a way to fashion a professional identity: "One must strike some eccentricity in clothes and stick to it. Ignatz with his little fedora perched on the top of his head (very Pollock), M., her black velvet tam—Jimmy Walker, his kippy hat and wasp waisted suits, G. K. Chesterton, his caped coat and hat pinned up on one side, our pal Rossi, his silver headed walking stick, Al Smith's brown derby—ad infinitum." Louis Slobodkin to Florence Slobodkin, June 26 and 27, 1931, LSP.

34. Linda Nochlin, "Malvina Hoffman: A Life in Sculpture," *Arts Magazine* 59 (1984): 110.

35. "Suffragist Painter and Sculptor Strike Out for Themselves as Exhibitors of Their Work," *New York Sun* (December 26, 1912).

36. Lorado Taft, "Women Sculptors of America," *The Mentor* 6, no. 24 (1919): 1–2.

37. Gardner Teall, "Women Sculptors of America: How Many Readers Knew There Were So Many of Them? And So Talented," *Good Housekeeping* 53 (1911): 176.

38. Ibid., 176, 177, and 185.

39. Edward McCartan to Malvina Hoffman, September 12, 1920, Box 7, MHPG.

40. Hoffman, *Yesterday Is Tomorrow*, 183–84.

41. Michele Bogart, *Public Sculpture and the Civic Ideal in New York City, 1890–1930* (Chicago: University of Chicago Press, 1989), 55, 84, and 86.

42. Marlene Park, "Sculpture Has Never Been Thought a Medium Particularly Feminine," in *The Figure in American Sculpture: A Question of Modernity*, ed. Ilene Susan Fort (Los Angeles: Los Angeles County Museum of Art and University of Washington Press, 1995), 55–56; and Michele Bogart, "American Garden Sculpture," in *Fauns and Fountains: American Garden Statuary, 1890–1930* by Maureen C. O'Brien et al. (Southampton, N.Y.: The Parrish Art Museum, 1985), n.p.

43. Bogart, *Public Sculpture*, 52.

44. Ibid., 54.

45. Malvina Hoffman, "1913," Summaries of Diaries, Box 40, MHPG.

46. Bogart, *Public Sculpture*, 51.

47. Ibid., 78–80; and George Gurney, *Sculpture and the Federal Triangle* (Washington, D.C.: Smithsonian Institution Press, 1985), 69–84.

48. Bogart, *Public Sculpture*, 84.

49. Louis Slobodkin to Florence Slobodkin, July 14, [1932?], LSP.

50. Gurney, *Sculpture and the Federal Triangle*, 304.

51. Louis Slobodkin, *Sculpture: Principles and Practice* (New York: World Publishing, 1949), 178.

52. Ibid., 179.

53. It was not until the late 1930s that this hierarchical structure collapsed; the system slowly deteriorated because of changing taste in sculptural styles and techniques and because of new forms of professional alliances. Slobodkin, along with a group of artists associated with modernism and direct carving, established the Sculptors' Guild in 1938 to challenge this system of influence and the power of the National Sculpture Society.

54. Nochlin, "Malvina Hoffman: A Life in Sculpture," 109.

55. To assert the notion of a shared racial identity, Hoffman used a classical vocabulary of forms to represent the figures of America and England.

56. Louis Slobodkin to Florence Slobodkin, July 10, [1931 or 1932], LSP.

57. Janis Conner, *A Dancer in Relief: Works by Malvina Hoffman* (Yonkers, N.Y.: Hudson River Museum, 1984), n.p.

58. Hoffman, *Yesterday Is Tomorrow*, 141.

59. Ibid., 166.

60. Ibid.

61. Auguste Rodin, *Rodin on Art and Artists: Conversations with Paul Gsell*, trans. Mrs. Romilly Fedden (1912; repr., New York: Dover, 1983), 20.

62. Ibid., 54.

63. Ibid., 57–58.

64. Hoffman, *Heads and Tales*, 56.

65. Hoffman served as a medium during an "evening of automatic writing" held at Scudder's studio and called up a ghost whom Scudder once encountered in Italy. Hoffman, *Yesterday Is Tomorrow*, 102 and 133.

66. Hoffman, *Yesterday Is Tomorrow,* 97.

67. Ibid., 98.

68. In his autobiography, Henry Field claimed that during the Field Museum commission, Hoffman had one such premonition and recounted an incident involving the death of Malcolm Whitman. The sculptor was supposed to have had a "queer sensation" ten minutes before Whitman committed suicide. Henry Field, *The Track of Man: Adventures of an Anthropologist* (New York: Doubleday, 1953), 199.

69. See chapter eight in Linda Henderson, *Duchamp in Context* (Princeton, N.J.: Princeton University Press, 1998).

70. Hoffman, *Heads and Tales,* 56 and 398.

71. Ibid., 13.

72. Henderson, *Duchamp in Context,* 101.

73. Ibid., 117.

74. Katherine Park, "Impressed Images: Reproducing Wonders," in *Picturing Science, Producing Art,* ed. Caroline A. Jones and Peter Galison (New York: Routledge, 1998), 256–57, 262.

75. Hoffman, *Heads and Tales,* 12.

76. Walter Agard, "The Sculptural Portrait," *International Studio* 81 (1925): 24.

77. Jacob Epstein, *The Sculptor Speaks* (Garden City, N.Y.: Doubleday, Doran, 1932), 67.

78. Herbert Lambert, "Imaginative Portraiture," *The Photographic Journal* 62 (1922): 297.

79. H. W. Honess Lee, "Portraits, Personalities and Character Studies," *American Photography* 32, no. 4 (1938): 229.

80. W. H. Best, "Art-Sense and Nonsense," *American Photography* 25 (1931): 420.

Chapter 3. Producing the Sculptures and Building Consensus

1. Henry Field, "Private and Confidential: The Story of the Hall of Physical Anthropology," March 12, 1930, Hall of the Races of Mankind Papers, AAFM.

2. Ibid.

3. Henry Field, *The Track of Man: Adventures of an Anthropologist* (Garden City, N.Y.: Doubleday, 1953), 138.

4. Ibid., 197.

5. Field also considered hiring sculptors from the School of the Art Institute, Chicago. Ibid., 190–91.

6. Malvina Hoffman to Henry Field, January 3, 1930, Races of Mankind Correspondence, Vol. 12, HFFM.

7. Malvina Hoffman to Henry Field, March 9, 1930, Races of Mankind Correspondence, Vol. 12, HFFM.

8. Stanley Field decided on the amount of $125,000 because Hoffman was unsure of her figure of $109,000. Stanley Field to Marshall Field III, February 18, 1930, page 2, Box 2, File 16, DAFM.

9. Malvina Hoffman to S. C. Simms, March 13, 1930, Box 1, DAFM.

10. Dudley Buxton to Henry Field, August 29 [no year], AAFM.

11. Because of Hoffman's price for plaster casting, the museum decided to supplement her facial masks by purchasing fifty additional casts from other museums. Stanley Field to Marshall Field, February 18, 1930, Box 2, File 16, DAFM. The Field Museum already owned the Otto Finsch collection and facial casts made by Caspar Mayer at the 1904 St. Louis world's fair.

12. Press release, April 1, 1930, AAFM.

13. Malvina Hoffman, March 11, 1930, entry, 1930 Daybook, Box 48, MHPG. For her comments on Gruppe, see her March 13, 1930, entry, 1930 Daybook.

14. Malvina Hoffman, March 11, 1930, entry, 1930 Daybook, Box 48, MHPG.

15. Harry Shapiro advised the sculptor in fashioning eyes for the bust. Malvina Hoffman, April 28, 1930, entry, 1930 Daybook, Box 48, MHPG.

16. Stanley Field to S. C. Simms, April 15, 1930, Box 1, File 1, DAFM.

17. Ibid.

18. Ibid.

19. Ibid.

20. The globe would appear with a "colored map of the world painted on its outer surface." Provision Number Five, February 18, 1930, Contract, Box 2, File 16, DAFM.

21. Henry Field to Malvina Hoffman, April 26, 1930, Races of Mankind Correspondence, Vol. 12, HFFM.

22. Berthold Laufer to Director Simms, March 17, 1930, Box 1, File 2, DAFM.

23. Malvina Hoffman to Henry Field, April 6, 1930, Races of Mankind Correspondence, Vol. 12, HFFM.

24. Stanley Field to S. C. Simms, April 15, 1930.

25. Ibid.

26. Berthold Laufer to S. C. Simms, April 21, 1930, Box 1, File 1, DAFM.

27. Ibid.

28. Malvina Hoffman, 1930 Daybook, Box 48, MHPG.

29. Malvina Hoffman, "Consultations with Anthropologists June 1931," Box 16, MHPG.

30. Stanley Field to Malvina Hoffman, May 5, 1930, Box 3, MHPG.

31. Stanley Field to Malvina Hoffman, no date, Box 3, MHPG.

32. Betty Field and Henry Field to Malvina Hoffman, May 19, 1930, Box 3, Races of Mankind Correspondence, Vol. 12, HFFM.

33. Malvina Hoffman, November 28, 1930, entry, 1930 Daybook, Box 48, MHPG.

34. In Hoffman's 1930 Daybook, she notes that she assembled the facial mold on December 8, 1930, and on December 19, 1930, she took the mold to Capelli's. Ibid.

35. Louis Slobodkin to Florence Slobodkin, January 27, 1931, and January 6, 1931, LSP.

36. Wilton Krogman to Malvina Hoffman, January 28, 1931, Box 16, MHPG. Krogman spent several weeks during February and March of 1931 at Hoffman's studio

organizing her large collection of photographs, explaining anatomical details to the sculptor, and approving various figures. Along with Hoffman and Slobodkin, Krogman went to several ethnographic museums in Paris to study various cast collections and to help the sculptor learn how to identify race. Malvina Hoffman to Henry Field, March 23, 1931, Box 3, MHPG; and Louis Slobodkin to Florence Slobodkin, March 15, 1931, LSP.

37. Malvina Hoffman to Stanley Field, January 12, 1931, Box 1, File 4, DAFM.

38. Georges Didi-Huberman, *L'empreinte* (Paris: Centre Georges Pompidou, 1997), 76.

39. Malvina Hoffman, *Heads and Tales* (New York: Charles Scribner's Sons, 1936), 43.

40. Stanley Field to Malvina Hoffman, April 24, 1931, Box 1, File 5, DAFM.

41. Berthold Laufer to S. C. Simms, Interoffice Correspondence, May 16, 1934, Box 2, File 9, DAFM. Laufer later accused Hoffman of "passing off" Keith's portrait as an Anglo-Saxon type "as Henry was anxious to have this type." Ibid.

42. [Berthold Laufer] to Arthur Keith, May 4, 1934, General Correspondence Files, Field Museum.

43. Ibid.

44. Ibid.

45. Arthur Keith to Berthold Laufer, May 20, 1934, General Correspondence Files, Field Museum.

46. Malvina Hoffman, quoted by Stanley Field to Henry Field, February 11, 1931, Races of Mankind Correspondence, Vol. 12, HFFM.

47. Photographs appeared in Felix von Luschan, "The Racial Affinities of the Hottentots," *Report of the British and South African Associations 1905* (London: Spottiswoode, 1907) and in Felix von Luschan, *Voelker Rassen Sprachen* (Berlin: Welt Verlag, 1922).

48. Morris Steggerda, *Anthropometry of Adult Maya Indians: A Study of Their Physical and Physiological Characteristics* (Washington, D.C.: Carnegie Institute of Washington, 1922).

49. Charlotte Benton, Tim Benton, and Ghislaine Wood, eds. *Art Deco: 1910–1939* (London: Bulfinche Press and the Victoria and Albert Museum, 2003), 131.

50. Dominique Taffin, conservator of the Historical Collection, Musée National des Arts d'Afrique et d'Oceanie, personal communication with author, November 2, 1998.

51. Ibid.

52. Richard Powell, "Re/Birth of a Nation," in *Rhapsodies in Black: Art of the Harlem Renaissance,* ed. Richard Powell et al. (London: Hayward Gallery, 1997), 29.

53. For a reproduction of this work, see negative number J0035199, Peter A. Juley and Son Collection, National Museum of American Art, Smithsonian Institution. The photograph resurfaced in Carrie Mae Weems's exhibition *From Here I Saw What Happened and I Cried* (1995), in which two copies bracketed a series of photographs.

54. Haardt also removed the figures from the context of a tennis court when it was reproduced on the inside cover of *The Black Journey* (New York: Cosmopolitan,

1927). Since Haardt gave Hoffman permission to reprint many of his photographs, Hoffman gave him a replica of *Daboa* as a present "with compliments from Field Museum." Malvina Hoffman to Mr. Field, February 5, 1931, Box 1, File 4, DAFM.

55. Malvina Hoffman tape-recorded interview, 1961, Box 16, MHPG.

56. Malvina Hoffman, "To Oblivion," unpublished manuscript ca. 1938–40, Box 55, MHPG.

57. Malvina Hoffman to Henry Field, March 23, 1931, Races of Mankind Correspondence, Vol. 12, HFFM; and Malvina Hoffman to Stanley Field, February 25, 1931, Box 1, DAFM. As Stephen J. Gould notes, the association of asymmetry in facial features to criminal tendencies was asserted earlier by Cesare Lombroso in *Crime and Its Causes* (1911). Stephen J. Gould, *Ontogeny and Phylogeny* (Cambridge, Mass.: Harvard University Press, 1977), 123.

58. Stanley Field to Malvina Hoffman, February 10, 1931, Box 1, File 4, DAFM.

59. Wilton Krogman to Stanley Field, March 25, 1931, Box 1, File 5, DAFM.

60. Ibid.

61. Berthold Laufer to Stanley Field, August 12, 1930, File 2, "Malvina Hoffman May 1930–October 1930," DAFM.

62. Malvina Hoffman, November 26, 1930, entry, 1930 Daybook, and idem, February 18, 1931, entry, 1931 Daybook, Box 48, MHPG.

63. Malvina Hoffman, "Consultations with Anthropologists June 1931."

64. Ibid.

65. Stanley Field to Malvina Hoffman, May 26, 1932, Box 16, MHPG.

66. Malvina Hoffman to Henry Field, May 28, [1932?], AAFM.

67. C. C. Day to Editor, *Scientific American* (February 20, 1934), Box 2, File 8, DAFM.

68. Malvina Hoffman, September 30, 1930, entry, 1930 Daybook, Box 48, MHPG.

69. Director's Copy, Supplemental Contract, October 27, 1930, Box 1, File 15, DAFM.

70. Malvina Hoffman, October 27, 1930, entry, 1930 Daybook, Box 48, MHPG. Stanley Field also signed a separate contract for a set of twenty-two small-scale reductions for his art collection. Agreement between Stanley Field and Malvina Hoffman, October 27, 1930, Box 16, MHPG.

71. Stanley Field to Henry Field, November 12, 1930, Races of Mankind Correspondence, Vol. 12, HFFM. However, Malvina Hoffman had already wired him on November 5, 1930.

72. Stanley Field to Malvina Hoffman, June 22, 1931. Box 2, File 15, DAFM.

73. Stanley Field to Malvina Hoffman, June 30, 1931, Box 3, MHPG.

74. Stanley Field to Malvina Hoffman, February 23, 1931, Box 1, File 4, DAFM.

75. Unknown author to Malvina Hoffman, April 6, 1931, Box 1, File 5, DAFM. Hoffman then began using subjects from the exposition as her models.

76. Henry Field, "Rough Estimate for Photography for Around the World Trip with Hoffman," February 23, 1931, Box 1, File 4, DAFM.

77. Arthur Keith to Mr. Field, July 13, 1931, Box 1, File 4, DAFM.

78. Ibid.

79. Stanley Field to Malvina Hoffman, September 9, 1931, Box 1, File 7, DAFM.

80. E. A. Hooton to Henry Field, September 4, 1931, Vol. 13, HFFM.

81. Ibid.

82. Ibid.

83. Roland Dixon to E. A. Hooton, January 19, 1932, Vol. 13, HFFM.

84. Malvina Hoffman, *Heads and Tales,* 250.

85. Unidentified individual associated with the Office of the Governor General of the Philippine Islands to Stanley Field, April 11, 1932, File 11, "Malvina Hoffman April 1932," DAFM.

86. Davidson Black to George E. Vincent, December 5, 1931, Box 1, MHPG.

87. Malvina Hoffman, "Beyond the Sunset and the Seven Seas," unpublished manuscript ca. 1934, Box 59, MHPG.

88. Louis Slobodkin to Florence Slobodkin, undated letter, page 7, LSP.

89. Malvina Hoffman to Mr. Field, October 17, 1931, Malvina Hoffman Papers, Box 1, File 8, DAFM.

90. The Hall of the Races of Mankind included portraits of some of Hoffman's assistants and foundry workers: Rossi's portrait served as the *Italian Male,* Gozo Kawamura's portrait served as the *Japanese Male,* and the portrait of Eugène Rudier, in whose Paris foundry many of the figures were cast into bronze, served as the *Frenchman.*

91. Champlain served as an assistant to A. A. Weinman, Isidore Konti, A. Sterling Calder, and Hermon MacNeil. National Sculpture Society, *Contemporary American Sculpture: The California Place of the Legion of Honor* (New York: Kalkhoff, 1929), 50.

92. Louis Slobodkin to Florence Slobodkin, July 27, [1931], and February 20, 1931, LSP.

93. Édouard-Joseph's *Dictionnaire biographique des artistes contemporains 1910– 1930* (Paris: Art & Edition, 1930–34) lists a Lucien-Georges Guérin as a "sculpteur" who studied with Faguière, Céret, and Bouerie, but he may not be the individual Hoffman identified as Guerin. There is little information on Rosso Rossi. Slobodkin states that he was an Italian who lived in Paris. Hoffman identifies a small-scale gazelle figure as a bronze by Rossi in her book *Heads and Tales.*

94. Maurice Saulo is listed in Edouard-Joseph's *Dictionnnaire biographique des artistes contemporains 1910–1930* as a "statuaire" born in Paris. Saulo studied under his father, Georges-Ernest Saulo, as well as Coutan at the École des Beaux-Arts. Hoffman reproduced a photograph of Saulo working on his bas-relief in her book *Sculpture Inside and Out* (New York: Norton, 1939).

95. Malvina Hoffman, April 24, 1930, entry, 1930 Daybook, Box 48, MHPG.

96. On March 25, 1930, Hoffman notes that she worked on the "Eskimo busts in the morning" and that during the same month, Gruppe worked on an "Indian mask." Malvina Hoffman, 1930 Daybook, Box 48, MHPG.

97. Louis Slobodkin to Florence Slobodkin, July 7, 1931, LSP. Slobodkin also stated that he had managed to model "a life-size seven year old boy without a model direct from the armature in four hours." Louis Slobodkin to Florence Slobodkin, August 8, 1931, LSP.

98. Louis Slobodkin to Florence Slobodkin, June 16, 1931, and Louis Slobodkin to Florence Slobodkin, June 17, 1931, LSP. Hoffman's own daybook confirms his involvement in the work. Malvina Hoffman, May 10, 1930 entry, 1930 Daybook, Box 48, MHPG. Hoffman wrote a letter to the museum stating that she had completed the Ainu male "as a bust with a full beard" prior to her trip. Malvina Hoffman to Mr. Field, July 28, 1930, Box 1, File 2, DAFM.

99. Louis Slobodkin to Florence Slobodkin, July 17, [1932], LSP.

100. Berthold Laufer, quoted in Stanley Field to Malvina Hoffman, December 24, 1931, Box 3, MHPG.

101. Berthold Laufer to Director Simms, memo, May 16, 1934, Box 2, File 9, DAFM.

102. Ibid.

103. Berthold Laufer, undated memo, Box 2, File 5, DAFM.

104. Ibid.

105. Berthold Laufer quoted in Stanley Field to Malvina Hoffman, May 18, 1933, Box 2, DAFM.

106. Berthold Laufer to Director, November 18, 1933, Box 2, File 5, DAFM.

107. Extract from Malvina Hoffman, January 6, 1934, letter, "Correspondence from Vol. II," HFFM.

108. Wu Lien-Teh to Director of Field Museum, June 21, 1933, Box 16, MHPG.

109. Ibid.

110. Owen Lattimore, "Mongolia Enters World Affairs," *Pacific Affairs* 7, no. 1 (1934): 5–28.

111. Malvina Hoffman, "Facts concerning Mrs. Wu," n.d., Box 16, MHPG.

112. Wu Lien-Teh to Director of Field Museum.

113. Samuel Grimson to Stanley Field, August 8, 1933, Box 16, MHPG.

114. Wu Shu-ch'iung to Malvina Hoffman, March 27, 1933, Box 3, MHPG.

115. Samuel Grimson to Stanley Field, August 8, 1933.

116. Copy of Berthold Laufer to Wu Lien-Teh, n.d., Box 16, MHPG.

117. Ibid.

118. Ibid.

119. Ibid.

120. Arthur Keith, "Race and Art" manuscript, AKP.

121. Copy of Berthold Laufer to Wu Lien-Teh.

122. Stanley Field to Malvina Hoffman, November 10, 1936, Box 16, MHPG.

123. Clifford Gregg to Malvina Hoffman, July 10, 1946, Box 16, MHPG.

124. Stanley Field to Malvina Hoffman, May 16, 1933, Box 2, DAFM.

125. For example, the curators agreed to substitute a head representing a Lapp for a Scandinavian. Henry Field to Stanley Field, September 11, 1933, and Henry Field to Stanley Field, September 27, 1933, "Correspondence from Vol. II," HFFM.

Chapter 4. The Hall of the Races of Mankind

1. The overhead lighting used 100-watt lamps with mirror reflectors set at a 35-degree angle, while the reflectors for illuminating the *Unity of Mankind* were set at a 45-degree angle. The secondary system of light within the alcoves used 40-watt lamps and mirror reflectors. The Curtis Lighting Company engineered these novel indirect lighting systems. "Brief description of lighting in connection with Races of Mankind Sculptures, Exhibited Chauncey Keep Memorial Hall, Chicago Natural History Museum," Anonymous, undated memo, Box 3, File 5, DAFM.

2. At the time, most curators avoided placing artworks in this area. Isadore Rosenfield, "Light in Museum Planning," *Architectural Forum* 56 (1932): 623.

3. Ibid., 620.

4. Franz Boas, "Some Principles of Museum Administration," *Science* 25, no. 650 (1907): 921–33.

5. Lewis Mumford, "The Marriage of Museums," *Scientific Monthly* 7, no. 3 (1918): 259.

6. Ibid., 256–58.

7. Adolf Hildebrand, *The Problem of Form in Painting and Sculpture,* trans. Max Meyer and Robert Morris Ogden (1907; repr., New York: G. E. Stechert, 1945), 58 and 113.

8. Franz Boas quoted in Ira Jacknis, "Franz Boas and Exhibits," in *Objects and Others: Essays on Museums and Material Culture,* ed. George W. Stocking Jr. (Madison: University of Wisconsin Press, 1985), 102.

9. Mumford, "The Marriage of Museums," 255.

10. Lee Simonson, "Museum Showmanship," *Architectural Forum* 56, no. 6 (1932): 533.

11. W. Brooke Graves, "Topics for Further Investigation and Discussion," *Readings in Public Opinion: Its Formation and Control* (New York: D. Appleton, 1928), 501.

12. Hildebrand, *The Problem of Form,* 28–29.

13. Simonson, "Museum Showmanship," 537.

14. Ibid., 535.

15. Lee Simonson, *The Stage Is Set* (New York: Theatre Arts Books, 1932), 356 and 376.

16. Ibid., 58.

17. Ibid., 60.

18. Ibid.

19. Mary Anne Staniszewski, *The Power of Display: A History of Exhibition Installations at the Museum of Modern Art* (Cambridge, Mass.: MIT Press, 1998), 99.

20. Ibid., 64.

21. Hoffman claimed that a modern setting was very reasonable, "for the hall of living man is certainly a modern idea and Greek rosettes are quite out of place also Greek pilasters as a frame to the bronzes." Malvina Hoffman to Stanley Field, no date, Box 3, DAFM. In a letter to S. C. Simms she explained further why this

installation strategy should be used: "You and Mr. Field will agree flat treatment of the background is the simplest and safest way to avoid unnecessary expense and complication of constructions . . . I suggest continue our plain surfaces and modern treatment . . . keep entire hall of living man in a consistent style not only to the subjects shown but to the age in which they are actually living." Malvina Hoffman to S. C. Simms, February 18, 1933, Box 1, File 16, DAFM.

22. In a letter to S. C. Simms, Hoffman stated, "To photograph a work of art the background plays a very important part in giving an artistic impression of the subject." Malvina Hoffman to S. C. Simms, April 21, 1933, Box 1, File 18, DAFM.

23. At the time Hoffman signed the original contract, in February 1930, both she and the museum officials envisioned a long, rectangular hall with the figures exhibited within wall cases. In such an arrangement, the figures would be displayed in a series of dioramas. While initially accepting this form of display, Hoffman worried about the context. She suggested painted landscapes for the backgrounds and considered lighting effects and spatial requirements for each figure. However, they abandoned the diorama format after the museum officials agreed to use bronze materials for the full-length figures. Clause Seven of the Supplementary Agreement, dated October 27, 1930, indicates that the museum officials reconsidered exhibition techniques and gave Hoffman control over the installation. Director's Copy, Supplemental Contract, Box 1, File 15, DAFM.

24. At the Volkerkunde Museum, the race biologist (and later Nazi) Eugen Fischer took Hoffman through the Africa and Oceania exhibits. Malvina Hoffman, April 29, 1931, 1931 Daybook, Box 48, MHPG.

25. For a history on the installation practices at the Volkerkunde Museum, see Markus Schindlbeck, "Die Südsee-Ausstellungen in Berlin," *Baessler-Archiv: Beitrage zur Volkerkunde,* n.s., 45 (1997): 565–88. For images of the reinstalled exhibits, see the website of the museum at http://www.smb.spk-berlin.de/mv/g.html.

26. See photographs of interiors of both the first and second Netherlands Pavilion in Patricia Morton, *Hybrid Modernities: Architecture and Representation at the 1931 Colonial Exposition, Paris* (Cambridge, Mass.: MIT Press, 2000) as well as the library website at California State University Fresno, http://www.lib.csufresno.edu/images/specialcollections/worldsfairs/paris1931.

27. Malvina Hoffman, "Consultations with Anthropologists June 1931," Box 16, MHPG.

28. However, Stanley Field returned to his previous position on glass cases in January 1933. He claimed that the bronzes needed some kind of protection from visitors. Stanley Field to Malvina Hoffman, January 17, 1933, Box 1, File 15, DAFM. Hoffman responded that Marshall Field agreed with her that the bronzes should not be placed under glass. She also mentioned that "there are many bronzes at the Metropolitan Museum and they are watched by the guards and are not in any way damaged by vandals." Malvina Hoffman to Stanley Field, January 24, 1933, Box 2, File 6, DAFM.

29. Henry Watson Kent wrote to Hoffman, claiming that her sculptures would

require a special form of display: "I have been thinking a great deal about the problem of exhibition of your statues in the Field Museum . . . [It] has an opportunity in showing your work which is unusual, and which should be considered only after examining the methods of exhibition which have been defined in the last few years." Kent recommended Lee Simonson, who he claimed was "the best exponent of the kind of exhibition that I mean, and I hope very much that you may think it wise to call him and his art in display to the attention of the authorities of the Field Museum." Henry Watson Kent to Malvina Hoffman, October 23, 1930, Box 16, MHPG. Hoffman's daybooks and correspondence indicate that she met them on November 10, 1930, and on September 9, 1931. Stanley Field to Malvina Hoffman, Western Union cable, September 9, 1931, Box 1, DAFM.

30. Haeffelin made up a scale model of the hall, which Hoffman showed to Marshall Field and Stanley Field, and both agreed to her idea of "dividing the entire space into two halls." Malvina Hoffman, October 19, 1932, Diary Summaries, Box 58, MHPG.

31. Unfortunately, there are few statements concerning the exhibition format. An earlier art review published in the *American Magazine of Art* quoted F. A. Gutheim as stating: "The installation of the whole exhibit is unfortunate. One sees the dilemma created in the quarrel between art and ethnology. Field Museum is interested in the latter aspect, but the demands of the sculpture as art are so insistent they cannot be ignored. The result is the exhibition lacks clarity." "Malvina Hoffman's 'Races of Mankind,'" *American Magazine of Art* 27, no. 2 (1934): 91. However, Edward Carter, at the Institute of Pacific Relations, later recalled that the display did not set up a hierarchy of races; instead, he believed that the display produced a "sympathetic feeling." Edward Carter to George Davis, January 5, 1944, Box 19, MHPG.

32. Elizabeth Eiselen, "The Technique of Exhibits," *The Journal of Geography* 39 (1940): 321.

33. While both Malvina Hoffman and Henry Field articulate this ordering, it did not conform to the classification Field worked out with Haddon and Buxton. The 1937 edition of the Races of Mankind guidebook claimed that the works represented the "basic divisions and subgroups of the races of mankind." Henry Field, *The Races of Mankind: An Introduction to Chauncey Keep Memorial Hall*, 3rd ed. (Chicago: Field Museum of Natural History, 1937), 44.

34. Since *character* was the primary operative term in Hoffman's rhetoric, physical anthropological constructions of race, and moral notions of identity, my analysis concerns how this term served to link these various discourses. At the time, varied typological approaches to identity or race were articulated: Benedict's Apollonian and Dionysian types, Sapir's Jungian types, Ernst Kretschmer's constitutional types, L. H. Clauss's idea types, Ottmar Rutz's spiritual archetypes, and Wilhelm Bohle's "psycho-bodily" types. For a discussion of the latter German typologies in racialist studies, see David Efron, *Gesture and Environment* (New York: King's Crown Press, 1941).

35. Three other sculptural groups in the Africa and Oceania sections of the hall exhibit this strategy. *Bushman Family, Kalahari Desert* achieves compositional

balance largely through a pyramidal composition. The *Pygmy Group, Ituri Forest* group creates a sense of equilibrium through vertical and horizontal elements. The *Australian Mother and Child* group shows a strong vertical thrust that is countered with a diagonal. Many of the busts also exhibit a triangular arrangement.

36. Henry Field, *The Races of Mankind: An Introduction to Chauncey Keep Memorial Hall* (Chicago: Field Museum of Natural History, 1933), 27. The sense of a particular moment troubled Laufer because these various groups would not be found living in one geographic location. He approved the work on the basis that the work would not be understood as an ethnographic group but as a composite image of Malayan racial types. Berthold Laufer, May 11, 1931, Memo, Box 1, File 5, DAFM.

37. Jane Belo, "The Balinese Temper," *Character and Personality* 4 (1935): 144.

38. Ruth Benedict, *Patterns of Culture* (1934; repr., Boston: Houghton Mifflin, 1959), 15.

39. Margaret Mead, preface to *Patterns of Culture,* by Ruth Benedict, ix. Edward Sapir, *The Psychology of Culture: A Course of Lectures,* ed. Judith T. Irvine (New York: Mouton de Gruyter, 1994), 177.

40. Sapir, *The Psychology of Culture,* 184. Sapir recognized the underlying similarity between the two typological projects when he explained, "We can say that the member of a society belongs to a certain race, and the biological elements tend to express themselves in that way, we can also say that certain cultures have an ideal program that the participants tend to realize." Ibid., 177.

41. Sapir, *The Psychology of Culture,* 51. Despite Franz Boas's earlier studies on differences between groups in different environments, the confusion between biological and cultural traits continued. David Efron's *Gesture and Environment* (1941) served as one of the first sustained studies concerning this problem. The confusion between cultural and biological traits in physical anthropology was usually expressed in terms of adaptive and nonadaptive traits.

42. Sapir, *The Psychology of Culture,* 44–45.

43. See Donna Haraway, *Primate Visions* (New York: Routledge, 1989) for a discussion of the emergence of hunter-gatherer paradigm and how the Kalahari Bushman figured into discussions of "universal man" in postwar anthropology.

44. "African Bushman Family Depicted in Bronze Sculptures," *Field Museum News* 7, no. 5 (1936): 4.

45. Linda Nochlin, "Malvina Hoffman: A Life in Sculpture" *Arts Magazine* 59, no. 3 (1984): 110.

46. Ibid.

47. S. C. Simms to Malvina Hoffman, November 5, 1930, File 3, Box 1, DAFM.

48. Malvina Hoffman, *Heads and Tales* (New York: Charles Scribner's Sons, 1936), 155. However, Henry Field did not consider this group to be representative of Hottentots, which he speculated were a racial mixture of the "Bushman with Negroes and possibly with early invading Hamites." He claimed that steatopygia was an anatomical feature shared by the Kalahari Bushman and Ituri Forest Pygmies. Henry Field, *The Races of Mankind,* 18–19.

49. The bamboo pole placed across the shoulders of the *Cantonese Woman* bust

also ends abruptly. The sculpture *Tamil in the Act of Climbing a Tree* shows a male figure with a fragment of a tree. The *Solomon Islander Climbing a Tree* exhibited in the west end of the hall also relies on this strategy.

50. Walter Lippmann, *Public Opinion* (New York: Macmillan, 1922), 8.

51. Ibid., 89.

52. Hildebrand, *The Problem of Form*, 105.

53. Berthold Laufer, "The Projected Hall of the Races of Mankind," *Field Museum News* 2, no. 12 (1931): 2.

54. See Richard Dyer, *White* (New York: Routledge, 1997), for a discussion concerning the aspirational aspects operating in whiteness.

55. Paul Gsell, *Rodin on Art and Artists: Conversations with Paul Gsell,* trans. Mrs. Romilly Fedden (1912; repr., New York: Dover, 1983), 33.

56. While the overall pose recalls the *Age of Bronze,* the figure's elongated limbs, narrow hips, and large torso formed the ideal proportions of the Nordic race envisioned later by Nazi sculptors such as Arno Breker.

57. Fritz Lenz, quoted in David Efron, *Gesture and Environment,* 3 and 5.

58. L. Hamilton McCormick, *Characterology* (New York: Rand McNally, 1920), 486.

59. Maria Montessori, *Pedagogical Anthropology,* trans. Frederic Taber Cooper (New York: Frederick A. Stokes, 1913), 265.

60. Ibid., 270.

61. Henry Field, *The Races of Mankind,* 15.

62. Arthur Keith, *Man: A History of the Human Body* (New York: Holt, 1912), 189. Keith later explained that growth-regulating hormones controlled the development of muscles as well as other racial characteristics, such as bones, jaw size, nose shape, skin texture, and hair shape. Arthur Keith, "The Evolution of the Human Races," (1928), reprinted in *This Is Race,* ed. Earl Count (New York: Schuman, 1950), 430.

63. Carney Landis, "Studies of Emotional Reaction I: A Preliminary Study of Facial Expression," *Journal of Experimental Psychology* 7, no. 5 (1924): 336.

64. Rex Knight, "Character and the Face," *The Human Factor* 6 (1932): 417.

65. This technique had been utilized by Houdon, Carpeaux, and Rodin.

66. Malvina Hoffman, *Sculpture Inside and Out* (New York: Norton, 1939), 135.

67. Malvina Hoffman, caption under photograph of work, Artist's scrapbook, Box 107, MHPG.

68. An anonymous essay in *Field Museum News* used the term *Indo-Afgan* to describe this sculpture. The essay claimed that the Kashmiri language was classed in the Indo-Aryan group and that Brahmins practiced the Hindu religion. "Kashmiri in Meditation," *Field Museum News* 8, no. 5 (1937): 4. The terms *Brahmin, Indo-Afgan,* and *Indo-Aryan* were ways to describe a group formerly considered Aryan. The figure has also functioned as a portrait of Prakash Haksar. Family members have visited the Field Museum to see the work: Mrs. Kiran Dar in 1971 and Mr. A. N. D. Haksar in 1983. "A Reunion of Sorts," *Field Museum Bulletin* 54, no. 2 (1983): 7.

69. Malvina Hoffman, no date, Scrapbook, Box 107, MHPG.

70. Such ideas would have been readily understood by the growing number

of Americans interested in Eastern religions, especially Hinduism. See Wendell Thomas, *Hinduism Invades America* (New York: Beacon Press, 1930), for a survey of various organizations and publications devoted to promoting Hinduism in the 1920s and 1930s.

71. Malvina Hoffman, Radio Talk Manuscript, June 7, 1933, Box 61, MHPG.

72. Robert P. Welsh, "Sacred Geometry: French Symbolism and Early Abstraction," in *The Spiritual in Art: Abstract Painting, 1890–1985*, ed. Maurice Tuchman (Los Angeles: Los Angeles County Museum of Art, 1986), 68–69. In her autobiography, Hoffman states that she read Schuré's *Les grands initiés* as well as other spiritualist texts like Fabre d'Olivet's *Hermeneutic Interpretation of the Origin of the Social State of Man* with Joseph Fraenkel, whom she believed possessed great psychic powers. Malvina Hoffman, *Yesterday Is Tomorrow* (New York: Crown, 1965), 189.

73. Romy Golan, *Modernity and Nostalgia: Art and Politics in France between the Wars* (New Haven, Conn.: Yale University Press, 1995), 76.

74. Ibid., 85–86. Golan argues that French avant-garde and regionalist artists advanced this discourse during the 1920s and 1930s. But as Roger Griffin notes, this myth of spiritual rebirth was also at work in Nazi rhetoric. Roger Griffin, "Nazi Art: Romantic Twilight or (Post)modernist Dawn?" *Oxford Art Journal* 18, no. 2 (1995): 103–7. See also James Clifford, "On Ethnographic Surrealism," *The Predicament of Culture* (Cambridge, Mass.: Harvard University Press, 1988), and Patricia Morton, *Hybrid Modernities,* on how these discourses operated in France and at the Exposition Coloniale.

75. Arthur Keith, introduction to *The Races of Mankind,* by Henry Field, 9–10.

76. Some later saw the group as representing the cooperation of the three races and their common purpose in supporting and protecting the world. Clifford Gregg, quoted in the *Chicago American* (February 16, 1958), clipping, Box 3, DAFM.

77. Hoffman, *Heads and Tales,* 335.

78. Keith, "The Evolution of Human Races," 434.

79. "Sir Arthur Keith Holds War Helpful," *New York Times* (June 7, 1931): 12.

80. Arthur Keith, *Ethnos, or the Problem of Race Considered from a New Point of View* (London: Kegan Paul, Trench, Trubner, 1931), 20.

81. Arthur Keith, "America: The Greatest Race Experiment," *New York Times* (January 24, 1932): SM7.

82. "Sir Arthur Keith Holds War Helpful," 12; H. H. Horne, quoted in "Disputes Keith View as to Race Prejudice," *New York Times* (June 8, 1931): 13; and Bailey Millard, "Biological Bunk," *Los Angeles Times* (July 5, 1931): A4.

83. "War and Prejudices Called Ill for Man," *New York Times* (June 16, 1931): 5.

84. Wingate Todd, review of *The Anthropometry of the American Negro Columbia University Contributions to Anthropology No. XI,* by Melville Herskovits, *American Anthropologist,* n.s., 34, no. 3 (1932): 527–28.

85. Melville J. Herskovits, "Social Selection and the Formation of Human Types," *Human Biology* 1, no. 1 (1929): 256.

86. Melville J. Herskovits, "Some Effects of Social Selection on the American Negro," *Publications of the American Sociological Society* 20 (1926): 77.

87. W. O. Brown, "The Nature of Race Consciousness," *Social Forces* 10, no. 1 (1931): 92.

88. W. O. Brown, "Rationalization of Race Prejudice," *International Journal of Ethics* 43, no. 3 (1933): 295.

89. Henry B. Ward, "The Fourth Chicago Meeting of the American Association for the Advancement of Science and Associated Societies," *Science,* n.s., 78, no. 2013 (1933): 65.

90. Other than the guidebook to the hall, the only sources of information available to visitors in June 1933 were labels consisting of the title of each work and a small map that assigned it to a geographic location.

91. A 1936 essay claimed that this group shows the "most primitive people," who possessed "extremely small heads," "broader and flatter noses than any other race," a "peculiar development of buttocks," and the "simplest social organization, elementary religious beliefs, crude magical practices." "African Bushman Family Depicted in Bronze Sculpture," *Field Museum News* 7, no. 5 (1936): 4.

92. "Pygmies of Ituri Forest," *Field Museum News* 8, no. 1 (1937): 3.

93. Stanley Field to Malvina Hoffman, January 17, 1933, Box 1, File 15, DAFM.

94. Ibid.

95. Berthold Laufer, preface to *The Races of Mankind*, by Henry Field, 6. Instead of discussing the exhibit as a display of "primitive avenues of man" as he did in 1931, Laufer now explained the hall as a way to promote human sympathy.

96. Laufer, preface to *The Races of Mankind*, 6.

97. Ibid., 5.

98. Ibid., 6.

99. Ibid., 4.

100. Ibid.

101. Ibid., 5–6.

102. Laufer stated that "our Negroes in America" belong to the "African or black race" and would "always remain within this division; even intermarriage with whites will not modify their racial characteristics to any marked degree." Ibid., 4. Thus Laufer differed from Franz Boas, who believed that through intermarriage, physical differences would lessen and "therefore the color question would disappear." Boas, quoted in Roger Sanjek, "Intermarriage and the Future of Races in the United States," in *Race,* ed. Steven Gregory and Roger Sanjek (New Brunswick, N.J.: Rutgers University Press, 1996), 104.

103. Arthur Keith, introduction to *The Races of Mankind,* by Henry Field, 7.

104. Ibid., 8.

105. Ibid., 8–9.

106. Ibid., 8.

107. Ibid.

108. Arthur Keith, "John Bull Is Dissected by a Scientist," *New York Times* (January 30, 1927): SM3.

109. Arthur Keith, *Nationality and Race from an Anthropologist's Point of View* (London: Humphrey Milford and Oxford University Press, 1919), 12 and 36.

110. Arthur Keith, introduction to *The Races of Mankind*, 9.

111. Arthur Keith, "Races of the World: A Gallery in Bronze," *New York Times Magazine* (May 21, 1933): 10.

112. Arthur Keith to Berthold Laufer, April 23, 1933, Box 16, MHPG.

113. Arthur Keith, "Art Wedded to Anthropology," *Illustrated London News* (May 20, 1933): 730.

114. Ibid.

115. Henry Field, *The Races of Mankind*, 14.

116. Ibid., 14–16.

117. Wilton Krogman to Henry Field, June 14, 1933, HFFM.

118. Lucien Levy-Bruhl to Henry Field, February 10, 1934, HFFM.

119. Melville Herskovits to Henry Field, June 15, 1933, HFFM.

120. "Malvina Hoffman's Human-Racial-Type Bronzes," *Eugenical News* 18, no. 4 (1933): 71; and Theodore McCown, review of *The Races of Mankind: An Introduction to Chauncey Keep Memorial Hall*, by Henry Field, *American Anthropologist*, n.s., 35, no. 4 (1933): 784. The editor of the latter journal, Robert Lowie, also recognized the educational value of the sculptures; he included photographic reproductions of some of the figures in his college textbook *An Introduction to Cultural Anthropology* (New York: Farrar and Rinehart 1934).

121. "Hall 3," January 2, 1934, Vol. 2, HFFM.

122. Henry Field, "Notes on the Third International Eugenics Congress Exhibition Held in American Museum of Natural History, New York, September 1932," n.d., Vol. 2, HFFM.

123. Henry Field, "Plan for Technical Division of Hall 3," January 8, 1933, HFFM.

124. "Eugenics as a Museum Subject," *Eugenical News* 18, no. 4 (1933): 66.

125. Harry H. Laughlin to Henry Field, December 2, 1933, Vol. 2, HFFM.

126. Henry Field to Harry H. Laughlin, December 5, 1933, Vol. 2, HFFM.

127. Wingate Todd to Henry Field, September 9, 1931, File "Hall 3 Division Demographic, eugenics," Vol. 2, HFFM.

128. Berthold Laufer, "The Department of Anthropology—Its Aims and Objects," *Field Museum News* 2, no. 8 (1931): 2.

129. Walter F. Jones, June 1, 1966, Box 3, File 4, "Malvina Hoffman, misc.," DAFM.

130. Henry Field, *The Races of Mankind*, 3rd ed., 37. For another interpretation of these charts, see Jeff Rosen, "Of Monsters and Fossils: The Making of Racial Difference in Malvina Hoffman's *Hall of the Races of Mankind*," *History and Anthropology* 12, no. 2 (2001): 124.

131. Oliver Cummings Farrington, "Notes on European Museums," *The American Naturalist* 33, no. 394 (1899): 763–81.

132. Henry Field, *The Races of Mankind: An Introduction to Chauncey Keep Memorial Hall*, 2nd ed. (Chicago: Field Museum of Natural History, 1934), 37.

133. Alfred Kroeber, *Anthropology: Biology and Race*, rev. ed. (1948; repr., New York: Harcourt, Brace and World, 1963), 82.

134. These terms had been applied in earlier anthropological studies concerning Japan. Alfred Haddon borrowed them from Dr. Erwin Balz to assign physical

markers by social class. A. C. Haddon, *The Study of Man* (New York: G. P. Putnam's Sons, 1898), 100–101.

135. Henry Field, *The Races of Mankind,* 29.

136. Ibid.

137. Ibid., 27.

138. Ibid., 20. Alfred Haddon also relied on Seligman's theory. A. C. Haddon, *The Races of Man and Their Distribution,* 2nd ed. (New York: Milner, 1925), 44.

139. The museum later published statements that continued to use Seligman's Hamiticization theory. "Ethiopian Types Included among Sculpture of Races," *Field Museum News* 6, no. 12 (1935): 3.

140. C. G. Seligman, *Races of Africa* (New York: Holt, 1930), 19, quoted in Elazar Barkan, *The Retreat from Scientific Racism: Changing Concepts of Race in Britain and the United States between the World Wars* (Cambridge: Cambridge University Press, 1992), 33.

141. Ibid., 19.

142. Ibid., 20.

143. For more on the use of evolutionary trees in science, see Constance Areson Clark, "Evolution for John Doe: Pictures, the Public, and the Scopes Trial Debate," *Journal of American History* 87, no. 4 (2001): 1275–1303.

144. A. C. Haddon, *The Races of Man,* 165.

145. This arrangement also differed from Grafton Elliot Smith's tree illustrated in *The Evolution of Man* (Oxford: Oxford University Press, 1924). Elliot Smith argued that humans originated in Africa and not in Asia, as Haddon believed. Ibid., 40.

146. Henry Field, *The Races of Mankind,* 3rd ed., 40.

147. Emil D. W. Hauser, *Diseases of the Foot* (Philadelphia: W. B. Saunders, 1940), 7–10.

148. Henry Field, *The Races of Mankind,* 3rd ed., 39.

149. Stephen Jay Gould, *The Mismeasure of Man* (New York: Norton, 1981), 125.

150. Stanley Field to Malvina Hoffman, May 16, 1933, Box 16, MHPG.

151. Henry Field, *The Races of Mankind,* 3rd ed., 39.

152. Paul Broca, quoted in Gould, *The Mismeasure of Man,* 82.

153. Henry Field, *The Races of Mankind,* 3rd ed., 40.

154. Misia Landau, *Narratives of Human Evolution* (New Haven, Conn.: Yale University Press, 1991), 65.

155. Smith, *The Evolution of Man,* 145.

156. Ibid, 63.

157. Alfred L. Kroeber, "Reviewed Works: An Introduction to Physical Anthropology by E. P. Stibbe," *American Anthropologist,* n.s., 33, no. 2 (1931): 231.

158. E. P. Stibbe, *An Introduction to Physical Anthropology* (London: Edward Arnold, 1930), 28–29 and 39.

159. Hoffman, *Heads and Tales,* 165.

160. Label to photograph 88753, AAFM.

161. Henry Field, "A 'Family Tree' of Man and the Apes," *Field Museum News* 5, no. 2 (1934): 4.

162. Ibid.

Chapter 5. Life beyond the Field Museum

1. "Great Art Gallery will open March 21," *New York Times* (March 6, 1923): 8.

2. 18 February 1930 Contract, 5, File 6, Box 2, DAFM.

3. To fulfill anticipated orders, the contract specified that Hoffman would maintain original molds for the statuettes at her studio but that the molds for the life-size figures would be sent to the Field Museum. Director's Copy, "Supplemental Agreement between Field Museum of Natural History and Malvina Hoffman, Made on October 27, 1930," Box 1, File 15, January 1933, DAFM.

4. Ibid.

5. "Malvina Hoffman's Triumph," *Art Digest* 8, no. 11 (1934): 23.

6. S. C. Simms to Stanley Field, February 19, 1934, Box 2, File 7, DAFM.

7. Memo, May 23, 1932, Box 1, File 15, DAFM.

8. Malvina Hoffman, *Heads and Tales* (New York: Charles Scribner's Sons, 1936), 354.

9. James Clifford, "On Ethnographic Surrealism," *The Predicament of Culture: Twentieth-Century Ethnography, Literature, and Art* (Cambridge, Mass.: Harvard University Press, 1988), 135.

10. Daniel Sherman, "'Peoples Ethnographic': Objects, Museums, and the Colonial Inheritance of French Ethnology," *French Historical Studies* 27, no. 3 (2004): 670; Carole Reynaud-Paligot, "Paul Rivet: Contradictions et ambiguitiés," *Transmettre les passés: Nazisme, Vichy et conflits coloniaux: Les responsabilités de l'université*, ed. Marie-Claire Hoock-Demarle and Claude Liauzu (Paris: Éditions Syllepse, 2001), 163; and Benoît de l'Estoile, "From the Colonial Exhibition to the Museum of Man: An Alternative Genealogy of French Anthropology," *Social Anthropology* 11 (2003): 351, 357.

11. De l'Estoile, "From the Colonial Exhibition," 357, and Jean Jamin, "Le savant et le politique: Paul Rivet (1876–1958)," *Bulletins et Mémoires de la Société d'Anthropologie de Paris* 1, nos. 3–4 (1989): 286. Rivet was a founding member of the Committee of Antifascist Intellectuals.

12. Reynaud-Paligot, "Paul Rivet: Contradictions et ambiguitiés," 162.

13. Ibid.

14. Paul Rivet, "Les données de l'anthropologie," *Nouveau traité de psychologie*, ed. Georges Dumas (Paris: Alcan, 1930), 62.

15. "Anthropologie physique docteur P. Rivet," MS 23, PRP, 1930–1931 and 1934–1935.

16. Paul Rivet, "Les données de l'anthropologie," 89.

17. "Anthropologie physique docteur P. Rivet," MS 23, PRP, 1930–1931, 6.

18. "Anthropologie physique docteur P. Rivet," MS 23, PRP, 1934–1935, 8.

19. "Anthropologie physique docteur P. Rivet," MS 23, PRP, 1930–1931, 6.

20. "Anthropologie physique docteur P. Rivet," MS 23, PRP, 1934–1935, 8.

21. "Anthropologie physique docteur P. Rivet," MS 23, PRP, 1930–1931, 4.

22. Paul Rivet to Malvina Hoffman, November 17, 1932, MHMH.

23. R. D. [René Daumal], "Au Musée d'Ethnographie du Trocadéro," *La Nouvelle Revue Française* 94, no. 2 (1933), CPMET.

24. René Daumal, "Des nouveautés au musée ethnographique," *Le Rempart* (November 25, 1933), CPMET.

25. Jean Jamin, "Le Musée d'Ethnographie en 1930: L'ethnologie comme science et comme politique," in *La muséologie selon Georges-Henri Rivière: Cours de muséologie, textes et témoignages* (Paris: Dunod, 1989), 117.

26. Jean Jamin, "Objets trouvés des paradis perdus: À propos de la Mission Dakar-Djibouti," in *Collections Passion,* ed. J. Hainard and R. Kaehr (Neuchâtel: Musée d'Ethnographie, 1982), 81, 90.

27. Ibid., 90.

28. Georges-Henri Rivière, "L'objet d'un musée d'ethnographie comparé à celui d'un musée de Beaux-Arts," *Cahiers de Belgique* 9 (1930), repr. in *Gradhiva* 33 (2003): 68.

29. Georges-Henri Rivière, "Le Musée d'Ethnographie du Trocadéro," *Documents* 1 (1929): 56; and Christine Laurière, "Georges-Henri Rivière au Trocadéro," *Gradhiva* 33 (2003): 63.

30. Jamin, "Le Musée d'Ethnographie en 1930," 119.

31. Paul Rivet, "Ce qu'est l'ethnologie," *L'encylopédie française* (1936), quoted in de l'Estoile, "From the Colonial Exhibition," 357.

32. Paul Rivet, Eric Lester, and Georges-Henri Rivière, "Le laboratoire d'anthropologie du muséum," *Archives du Muséum National d'Histoire Naturelle,* 6th ser., 12, no. 2 (1935): 520, and "Trocadéro and Guimet Museums Reorganized," *Museum News* 9, no. 17 (1932): 1.

33. J. Peron, "Trois expositions et une salle nouvelle seront inaugurées Samedi prochain au Musée d'Ethnographie du Trocadéro," *Le Journal* (November 7, 1933), CPMET.

34. Clifford, "On Ethnographic Surrealism," 132. Clifford reads the use of collage in *Documents* as a kind of "playful museum" that collects and reclassifies specimens, and he contrasts this defamiliarizing attitude toward culture to their later practices of ethnographic humanism at the Musée de l'Homme. Clifford, 132 and 139.

35. Paul Rivet to Malvina Hoffman, November 17, 1932, Malvina Hoffman file, PRP.

36. Malvina Hoffman, June 1930 daybook, Box 51, MHPG.

37. Other than references to helping Hoffman find models, few documents state how they advised Hoffman. Henry Field wrote to Paul Rivet in November 1932 thanking Rivet for "all your generous assistance to Miss Hoffman in her work." Henry Field to Paul Rivet, November 7, 1932, MS 1/5832, HFMH.

38. Georges-Henri Rivière to Malvina Hoffman, November 24, 1933, Box 16, MHPG.

39. Malvina Hoffman to Georges-Henri Rivière, February 23, 1934, MHMH.

40. May Birkhead, "Today in Society," *Chicago Tribune* (November 11, 1933), oversized scrapbook, Box 113, MHPG.

41. Malvina Hoffman to Stephen C. Simms, November 28, 1933, File 5, "Malvina Hoffman October 1933 to December 1933," DAFM.

42. Birkhead, "Today in Society."

43. Hoffman, *Heads and Tales,* 357.

44. Birkhead, "Today in Society."

45. Hoffman, *Heads and Tales,* 357, and *Yesterday Is Tomorrow,* 273.

46. Georges-Henri Rivière to Malvina Hoffman, November 24, 1933, and Marcel Griaule to Malvina Hoffman, December 8, 1933, Box 3, MHPG.

47. Daumal, "Des nouveautés au musée ethnographique."

48. Daumal, "Au Musée d'Ethnographie du Trocadéro."

49. Marcel Cougny, "L'éducation physique et le perfectionnement de l'artiste," *Education Physique* (April 1934): 141, CPMET.

50. Raymond Lécuyer, "Un répertoire anthropologique en bronze," *Le Figaro* (November 16, 1933), CPMET.

51. Romy Golan, *Modernity and Nostalgia: Art and Politics in France between the Wars* (New Haven, Conn.: Yale University Press, 1995), 139–40.

52. Louis Vauxcelles, "Une aventureuse expedition d'art et science: Les cent vingt statues de Mme. Hoffman," *Excelsior* (November 29, 1932), MHMR.

53. Ibid.

54. Louis Vauxcelles, "La vie artistique: Mme. Malvina Hoffmann [*sic*] au musée d'ethnographie," *Excelsior* (November 13, 1933), CPMET.

55. Ibid.

56. Ibid.

57. Huguette Godin, "Mouvement féministe: Malvina Hoffman sculpteur ethnographe," *Le Quotidien* (November 6, 1933), MHMR.

58. Malvina Hoffman to Stephen C. Simms, December 7, 1933, File 5, "Malvina Hoffman Oct 1933 to Dec 1933," DAFM.

59. Jean Gallotti, "Une exposition de sculpture au Trocadéro," *L'Illustration,* no. 4734 (November 25, 1933): 398–99.

60. Ibid.

61. Ibid.

62. Malvina Hoffman to Georges-Henri Rivière, December 14, 1933, MHMH.

63. Erwin S. Barrie to Malvina Hoffman, October 20, 1933, Box 23, MHPG.

64. Erwin S. Barrie to Malvina Hoffman, December 22, 1933, Box 23, MHPG.

65. "Great Art Gallery Will Open March 21," *New York Times* (March 6, 1923): 8.

66. Grand Central Galleries also received a small commission on sales of artworks that went toward paying operating expenses.

67. "New Home for Art to Cost $100,000," *New York Times* (March 11, 1923): E7.

68. "Social Notes—To Draw Paintings," *New York Times* (June 20, 1923): 19.

69. Katherine Eggleston Roberts, "Chicago Letter," *The Arts* 2, no. 4 (1922): 218.

70. "Great Art Gallery Will Open March 21," and "100 Pictures at $250 Each," *New York Times* (May 8, 1923): 33.

71. H. I. Brock, "Business Ideas Applied to Art," *New York Times* (November 1, 1925): X10.

72. "Great Art Gallery Will Open March 21."

73. Howard Devree, "Grand Central Art on the Avenue," *New York Times* (July 30, 1930): 118.

74. "Home Talent in Art Gaining in Favor," *New York Times* (March 22, 1925): 31.

75. Anthony Raynsford, "Swarm of the Metropolis: Passenger Circulation at Grand Central Terminal and the Ideology of the Crowd Aesthetic," *Journal of Architectural Education* 50, no. 1 (1996): 7.

76. Ibid., 9.

77. Ibid.

78. "The Grand Central Art Galleries," *New York Times* (May 21, 1923): 16.

79. "For Commuters," *Time* 1, no. 4 (1923): 18; Edward Alden Jewell, "Founder's Exhibition Opens with Forty-seven Paintings at the Grand Central Galleries," *New York Times* (June 2, 1932): 19.

80. Henry McBride, "Modern Art," *The Dial* 77, no. 6 (1924): 530.

81. Ibid.

82. Ibid.

83. "Citadel Taken," *Time* 15, no. 6 (1930): 44.

84. Elisabeth Luther Cary, "Welcoming Every Test," *New York Times* (December 16, 1928): XX13.

85. Edward Alden Jewell, "Downtown Moves Up," *New York Times* (February 2, 1930): 116.

86. See Molly H. Mullin, "The Patronage of Difference: Making Indian Art 'Art, Not Ethnology,'" in *The Traffic of Culture: Refiguring Art and Anthropology,* ed. George E. Marcus and Fred R. Myers (Berkeley: University of California Press, 1995), 166–98.

87. Henry McBride, "The Races of Mankind, Malvina Hoffman's Monumental Work on View Here," *New York City Sun* (January 31, 1934), clipping, Box 114 over-size, MHPG.

88. *Art Digest* (February 1934), *Art News* (February 3, 1934), and *Parnassus* (January 1934).

89. Mr. Maltisky, Brentano's Book Stores, Inc. to Malvina Hoffman, December 28, 1933, Box 23, MHPG.

90. Alexander Woollcott to Malvina Hoffman, January 15, 1934, MHPG.

91. "Hoffman Show a Great Success," *Art News* (March 17, 1934): 20.

92. Malvina Hoffman to Stanley Field, March 5, 1934, File 6, Box 2, DAFM.

93. Elizabeth N. Todhunter to Malvina Hoffman, February 13, 1934, Box 23, MHPG.

94. Reports by Rhoda Limburg, Edna Goetz, and Marion Rous, Box 113, MHPG.

95. Ibid.

96. Lewis Mumford, "The Marriage of Museums," *Scientific Monthly* 7, no. 3 (1918): 258.

97. Ibid., 259.

98. Ibid.

99. Royal Cortissoz, "Malvina Hoffman's Bronzes in Chicago," *New York Herald Tribune* (November 26, 1933), Oversized Scrapbook 1933–1938, Box 151, MHPG.

100. Ibid.

101. Ibid.

102. Ibid.

103. Ibid.

104. Royal Cortissoz, "The Distinctive Traits in Malvina Hoffman's Sculpture," *New York Herald Tribune* (February 4, 1934), Oversized Scrapbook 1933–1938, Box 151, MHPG.

105. Edward Alden Jewell, "Sculpture Renaissance—Season Has Brought Forth an Abundance of Plastic Work—Malvina Hoffman," *New York Times* (February 4, 1934): X12.

106. Ibid.

107. Ibid.

108. Edward Alden Jewell, "The Masterpiece and the Modeled Chart," *New York Times* (September 18, 1932): XX9. See Mary K. Coffey, "The American Adonis: A Natural History of the 'Average American' (Man), 1931–1932," in *Popular Eugenics: National Efficiency and American Mass Culture in the 1930s,* ed. Susan Currell and Christina Cogdell (Athens: Ohio University Press, 2006).

109. Jewell, "The Masterpiece and the Modeled Chart."

110. Ibid.

111. Ibid.

112. John Ruskin, "The Unity of Art," *The Complete Works of John Ruskin, LL.D in Twenty Six Volumes,* vol. 13 (Philadelphia: Reuwee, Wattley and Walsh, 1891), 61.

113. Ibid.

114. Lewis Mumford, "New York Art Galleries," *New Yorker* 10 (1934): 48.

Chapter 6. Deploying the Races of Mankind Figures during the 1940s

1. Ruth Benedict and Gene Weltfish, *The Races of Mankind* (New York: Public Affairs Committee, 1943), 5.

2. Matthew Frye Jacobson, *Whiteness of a Different Color* (Cambridge, Mass.: Harvard University Press, 1998), 107.

3. Gunnar Myrdal, *An American Dilemma: The Negro Problem and Modern Democracy* (New York: Harper, 1944), lxxi.

4. Jacobson, *Whiteness of a Different Color,* 112.

5. Joseph C. Hough Jr., *Black Power and White Protestants* (London: Oxford University Press, 1968), 77; and Peter Conn, *Pearl Buck: A Cultural Biography* (Cambridge: Cambridge University Press, 1996), 259.

6. In February of 1942, Ruth Benedict wrote in the *New York Herald Tribune* that ending racial prejudice was crucial to the victory program. Margaret M. Caffrey, *Ruth Benedict: Stranger in This Land* (Austin: University of Texas Press, 1989), 312–13.

7. Florence Gilliam, Press Release, Publicity Bureau, Coordinating Council of French Relief Societies, Inc., June 9, 1942, NUL.

8. The home of Whitelaw Reid, editor and part owner of the *New York Herald Tribune,* served as the headquarters of the Coordinating Council of French Relief Societies during the war. Following Hoffman's exhibit, the council scheduled the "First Papers of Surrealism" exhibition, organized by André Breton and Marcel Duchamp. "Art Notes," *New York Times* (September 24, 1942): 30.

9. "Malvina Hoffman's Men Serve Man," *Art Digest* 16, no. 18 (1942): 14.

10. Ibid.

11. Catholic University of America, *New Catholic Encyclopedia* 6 (New York: McGraw-Hill, 1967), 29.

12. John T. McGreevy, *Parish Boundaries: The Catholic Encounter with Race in the Twentieth-Century Urban North* (Chicago: University of Chicago Press, 1996), 43–44. The Catholic Interracial Council worked toward reshaping policies and practices in the American Catholic Church, specifically the segregation of parishes by racial categories. Widespread anti-Semitism within the church frustrated their efforts. Father Coughlin's radio broadcasts during the 1940s are perhaps the most extreme example.

13. Hoffman's "Victory" panel resembles photomurals made under the auspices of the Office of War Information. Its Defense Bond photomural (1941), located at Grand Central Station, combined enlarged FSA photographs of individuals with quotations like "That Government . . . By the People shall not perish from the Earth." See Terry Smith, *Making the Modern* (Chicago: University of Chicago Press, 1993), 443–48.

14. Emma Bugbee, "Men of the World," *New York Herald Tribune* (August 3, 1942), Box 23, MHPG.

15. Gilliam, Press Release.

16. "Men of the World in Art," *New York Times* (June 20, 1942): 12.

17. The article on the exhibition appeared in the June 27, 1942, edition of *L'Victoire.* The July 4, 1942, issue of *Forward* presented a full-page spread featuring Hoffman's sculptures and a photograph of Malvina Hoffman with the actor Madeleine Carroll. Box 23, MHPG.

18. This image had already circulated on the cover of Hoffman's *Heads and Tales.* It was designed by the sculptor and the Peruvian artist Elena Izcue.

19. Gilliam, Press Release. However, it was up to the viewer to interpret the ambiguous term "character." Did "character" refer to cultural, mental, or physical differences, or perhaps a conflation of all three, as the sculptor believed in 1942? As late as December 1942, Hoffman still maintained that she could diagnose race by observing differences in hair growth, watching the use of hands or "instinctive gestures," hearing differences in language and pronunciation, and smelling odors that she believed were specific to each race. Malvina Hoffman to Watson Davis, December 1, 1942, Box 19, MHPG.

20. Malvina Hoffman to Beatrice Winser, Director of the Newark Museum, November 24, 1942, Box 23, MHPG.

21. The captions on the map refer to the Races of Mankind statuettes, located outside the mural. Nevertheless, most of the captions linked the surrounding photographs to geographic regions. For example, the captions like "Apache," "Navaho," and "Pueblo" are reproduced on the map and fix the images to the North American continent. The photographs labeled "American" are also linked to the label "America" on the map.

22. On such conceptual leaps see Ann Reynolds, "Visual Stories," in *Visual Display: Culture beyond Appearances,* ed. Lynne Cooke and Peter Wollen (Seattle: Bay Press, 1995).

23. Some of the sponsors were Dean Virginia C. Gildersleeve, Barnard College; Professor James T. Shotwell; the author Henrik Willem van Loon; sculptor Jo Davidson; the Baron Robert de Rothschild; Rabbi Stephen S. Wise; and the Archbishop of North America and Aleut, Reverend Nicholas. "Men of the World" invitation, June 15, 1942, NUL.

24. Ibid.

25. Florence Gilliam, Press Release, Publicity Bureau, Coordinating Council of French Relief Societies, Inc., August 20, 1942, NUL.

26. The March 15, 1942, issue of the *New York Times Magazine* featured photographs of some of the Races of Mankind sculptures.

27. Conn, *Pearl Buck,* 243.

28. Pearl Buck was a close friend of the sculptor. During the 1930s, she rented Hoffman's New York studio. In 1935, Buck read an early draft of *Heads and Tales* and gave Hoffman criticism. Buck later based a novel on Hoffman's life; *This Proud Heart* (1938) told the story of how a young American woman became a sculptor.

29. Buck was the first American woman to receive the prize. The actor Luise Rainer won an Oscar for her role as O-Lan. Conn, *Pearl Buck,* 192. Hoffman worked with Jack Dawn, the makeup artist at Metro–Goldwyn–Mayer Studios, to turn Rainer and her co-star Paul Muni into "Mongolian" types. Malvina Hoffman to Watson Davis, December 1, 1942.

30. Her technique was similar to Hoffman's rhetoric of character. Both the writer and the sculptor were known for their sympathetic interpretations of humanity. Many associated Hoffman's *Mud Carrier* with O-Lan, the female character in Buck's *The Good Earth.*

31. Conn, *Pearl Buck,* 131. For an analysis of the cultural relevance of Steinbeck's novel and its participation in a racialized discourse, see Michael Denning, "Grapes of Wrath: The Art and Science of 'Migratin,'" in *The Cultural Front* (New York: Verso, 1997), chap. 7.

32. Conn, *Pearl Buck,* 245. Buck and her husband, Richard Walsh, founded the organization and published the magazine. Ibid., xv. An article on Hoffman and her Races of Mankind sculptures appeared in the January 1934 issue of *Asia.*

33. Conn, *Pearl Buck,* 259.

34. Pearl Buck, quoted by Conn, *Pearl Buck,* 248–49.

35. Pearl Buck to Malvina Hoffman, March 24, 1943, Pearl Buck Correspondence File, Box 1, MHPG.

36. Pearl Buck to Malvina Hoffman, May 28, 1943, Pearl Buck Correspondence File, Box 1, MHPG. Although the display did not materialize, Pearl Buck mounted Hoffman's racial map in the lobby of its headquarters. George Davis to Malvina Hoffman, March 1, 1944, Box 19, MHPG.

37. Pearl Buck to Malvina Hoffman, March 24, 1943.

38. Malvina Hoffman, May 29, 1928, summary of works in scrapbook, Box 51, MHPG.

39. "List of Gallery Exhibitions," Box 23, MHPG.

40. Alain Locke to Malvina Hoffman, January 29, 1941, Box 60, MHPG.

41. Malvina Hoffman, manuscript, November 12, 1941, speech given to the American Women's Association, Box 61, MHPG.

42. Despite the honor the guild bestowed upon her, Hoffman penciled in the event on her calendar as "Negro Day," a term referring to set-aside days at world's fairs.

43. Richmond Barthé exhibited *Stevedore, Julius, Boxer,* and *Rugcutters;* Augusta Savage exhibited *Creations* and *Baby;* and Elizabeth Catlett-White exhibited *Singing Head* and *Mother and Child*. Exhibition Brochure, NUL.

44. An interracial organization formed in 1942, the guild was intended to "encourage and assist and engage in activities of cultural civic and social nature which will publicize and further the general well being of the Urban League." Lester B. Granger, May 10, 1948, Memorandum to Executive Secretaries of affiliated organizations and Presidents of local Urban League Guilds, Guild Constitution Committee File, Container 18, National Urban League Papers, Series X, Related Organizations, Manuscript Division, Library of Congress.

45. "Urban League Guild Sponsors Sculpture Exhibit," *Opportunity* 20 (1942): 310.

46. Unknown author to Bernice Kandel, September 19, 1942, NUL.

47. Mollie Moon to Lester B. Granger, Memo, October 2, 1942, NUL.

48. Lester Granger to Mollie Moon, September 21, 1942, NUL.

49. Denning, *The Cultural Front,* 358. The invitation claimed that Hoffman filmed the short movie, but since she did not go to Africa during the Field Museum commission, it was more than likely a copy of Marcel Griaule's film of a Dogon funerary dance. In Hoffman's 1939 inventory of her film collection, two copies of Griaule's film are listed. No other film relating to Africa is included. Box 31, MHPG.

50. In its publicity materials, the league included excerpts from the council's press release, like "dramatic distinctions between contrasting types" and "an extraordinary feature of the show is a world map in color bordered by examples of the four main races." Press Release #1, undated, NUL. There were other possible positions on race that the organization could have articulated. For example, the guild could have chosen to discuss the sculptures in terms of cultural types like Pearl Buck did, or it could have taken the more radical position that racial types did not exist. As early as 1923, Alain Locke questioned the scientific validity of the race

concept and suggested abandoning racial categories in science. Alain Locke, "The Problem of Race Classification," *Opportunity* 1 (1923): 261–64. On the complexity of and shifting positions on race within African American organizations and how these positions relate to Boasian anthropology, see Lee D. Baker, *From Savage to Negro: Anthropology and the Construction of Race, 1896–1954* (Berkeley: University of California Press, 1998).

51. Jacobson, *Whiteness of a Different Color*, 112.

52. Press Release, Alice Hill Chittenden, no date, Oversized Scrapbook, Box 116, MHPG.

53. Conn, *Pearl Buck*, 259.

54. Ibid.

55. Albert Deutsch, "Blood Policy of the American Red Cross Condemned by Anthropologists," *PM* (June 23, 1942), reprint issued by the National Urban League, NUL.

56. Ibid.

57. Elazar Barkan, *The Retreat from Scientific Racism: Changing Concepts of Race in Britain and the United States between the World Wars* (Cambridge: Cambridge University Press, 1992), 334.

58. Malvina Hoffman, *Yesterday Is Tomorrow* (New York: Crown, 1965), 297.

59. Malvina Hoffman to Watson Davis, December 21, 1942, Box 19, MHPG.

60. Malvina Hoffman to Watson Davis, December 5, 1942, Box 19, MHPG.

61. Malvina Hoffman to George Davis, C. S. Hammond Company, December 16, 1943, Box 19, MHPG.

62. Gilbert Grosvenor, "Maps for Victory," *National Geographic* 81, no. 5 (1942): 667.

63. Malvina Hoffman to Stanley Field, March 19, 1943, Box 3, File 7, DAFM.

64. William Rodgers, *Think: A Biography of the Watsons and IBM* (New York: Stein and Day, 1969), 109.

65. Thomas J. Watson Jr. and Peter Petre, *Father, Son and Company* (New York: Bantam Books, 1990), 162.

66. Thomas J. Watson, "Reconversion," *Think* 10 (1944): 3.

67. Watson increased his order from 2,000 to 25,000 so he could give them to schools and educational institutions. Malvina Hoffman to Stanley Field, April 12, 1943, Box 19, MHPG.

68. Rodgers, *Think*, 194.

69. Watson and Petre, *Father, Son and Company*, 113.

70. Edwin Black, *IBM and the Holocaust* (New York: Crown, 2001), 55.

71. Ibid., 91.

72. Malvina Hoffman to Watson Davis, December 5, 1942.

73. Malvina Hoffman to Orr Goodson, December 11, 1942, Box 3, File 7, DAFM.

74. Malvina Hoffman to Henry Field, September 30, 1942, Vol. 13, HFFM.

75. Watson Davis to Malvina Hoffman, November 13, 1942, Box 19, MHPG.

76. Watson Davis to Malvina Hoffman, December 2, 1942, Box 19, MHPG; and Malvina Hoffman to Orr Goodson, December 11, 1942, Box 3, File 7, DAFM.

77. Watson Davis to Malvina Hoffman, December 2, 1942.

78. They mounted photographs and prepared captions under Hoffman's supervision. Thomas J. Watson also provided suggestions, which they incorporated. Malvina Hoffman to Stanley Field, April 12, 1943, Box 3, File 7, DAFM. Although the twenty-page atlas was never published, it served as the initial idea for Hammond's *Races of Mankind* leaflet. IBM paid Hoffman $1,000 to cover expenses she incurred before their involvement. A. Davis to Malvina Hoffman, July 4, 1943, Box 19, MHPG.

79. Malvina Hoffman to George Davis, July 15, 1943, Box 19, MHPG.

80. This coloring system was not consistent for South East Asian countries and Australia are shown in green. However, labels under each *Unity of Mankind* figure read "yellow," "white," and "black" and thus confirmed that skin color was the basis for determining race.

81. Malvina Hoffman to George Davis, July 15, 1943.

82. Cartographers coined the term *journalistic cartography* to differentiate their mapmaking practices from those of illustrators and artists. Walter W. Ristow, "Journalistic Cartography," *Surveying and Mapping* 17 (1957): 369–90.

83. Malvina Hoffman to Stanley Field, April 12, 1943, Box 3, File 7, DAFM.

84. Malvina Hoffman to C. S. Hammond Company, July 15, 1943, Box 19, MHPG.

85. Ibid.

86. Photocopy, *Races of the World and Where They Live* job description forms, Hammond Incorporated. While the company's archives are closed to researchers, Joseph F. Kalina Jr., the company's information research manager, kindly sent me photocopies of their incomplete printing records.

87. Malvina Hoffman to Stanley Field, November 20, 1943, Box 16, MHPG.

88. Stanley Field to Malvina Hoffman, December 27, 1943, Box 3, File 7, DAFM.

89. J. H. Beck, Vice-President, The George F. Cram Company, no date, no addressee, Box 19, MHPG.

90. Maynard Owen Williams to Malvina Hoffman, February 15, 1944, Box 19, MHPG.

91. Edward Carter, Institute of Pacific Relations, to Watson Davis, January 5, 1944, Box 19, MHPG.

92. J. H. Beck, Vice-President, The George F. Cram Company, no date, no addressee.

93. Edward Carter to Watson Davis, January 5, 1944.

94. Ibid.

95. Maynard Owen Williams to Malvina Hoffman, February 15, 1944.

96. Harry L. Shapiro to Malvina Hoffman, April 7, 1944, Box 19, MHPG.

97. Ibid.

98. Edward Carter to Watson Davis, January 5, 1944.

99. N. C. Nelson to E. J. Schmidt, c/o C. S. Hammond Company, February 19, 1944, Box 19, MHPG.

100. Ibid.

101. Orr Goodson to Guy Turner, December 20, 1943, Box 19, MHPG.

102. Orr Goodson to Stanley Field, December 16, 1943, Box 3, File 7, DAFM.

103. Malvina Hoffman to Henry Field, February 17, 1944, Volume 13, HFFM.

104. Stanley Field to Malvina Hoffman, January 4, 1944, Box 3, File 7, DAFM.

105. Edward E. Hunt, Jr., "The Old and New Physical Anthropology in the Careers of E. A. Hooton and W. M. Krogman," *American Journal of Human Biology* 3 (1991): 566.

106. Wilton Krogman, "Is There a Physical Basis of Race Superiority?" *Scientific Monthly* 51, no. 5 (1940): 430.

107. Wilton Krogman, "What We Do Not Know about Race," *Scientific Monthly* 57, no. 2 (1943): 97–104. See also Krogman, "The Concept of Race," in *The Science of Man in the World Crisis,* ed. Ralph Linton (New York: Columbia University Press, 1945), 38–62.

108. Krogman, "What We Do Not Know about Race," 104.

109. For example, Ethel Alpenfels reprinted his "A Decalogue of Race" in her *Sense and Nonsense about Race* (New York: Friendship Press, 1946), 6.

110. Paul Martin to Malvina Hoffman, February 5, 1944, Box 19, MHPG.

111. Ibid.

112. Ibid.

113. Paul Martin quoted in Malvina Hoffman to C. S. Hammond & Company, no date, Box 19, MHPG.

114. Unfortunately, Hammond's publishing records for the period between 1945 through 1952 are incomplete. The job cards skip from 1944 to 1952. However, since the map company published over 95,000 advertising circulars in 1944, the company must have planned wide-scale distribution of the chart.

115. A. L. Pattee, Educational Director, C. S. Hammond & Company, publicity material for the *Map of Mankind,* page 3, no date, Box 19, MHPG. Although this is undated, Pattee refers to the chart as the *Map of Mankind,* which included Martin and Krogman's revisions.

116. Ibid.

117. Ibid.

118. Ashley Montagu, "The Meaninglessness of the Anthropological Conception of Race," paper presented at the American Association of Physical Anthropologists, Chicago, April 1941, published in *The Journal of Heredity* 23 (1941): 243–47, repr. in *The Concept of Race,* ed. Ashley Montagu (Toronto: Collier–Macmillan Canada, 1969), 7.

119. "Race Question," *Time* 43, no. 5 (1944): 56.

120. Ibid.

121. Ibid.

122. "Umbilicose," *Time* 43, no. 20 (1944): 38.

123. Ibid.

124. Caffrey, *Ruth Benedict,* 298.

125. Ibid.

126. Ibid.

127. Ibid.

128. In his analysis of the pamphlet, Matthew Frye Jacobson claims that the authors subscribed to conflicting racial paradigms. He argues that beginning in the late 1920s, a three-race paradigm started replacing a schema that emphasized differences between secondary races. Since many other antiracist texts present similar contradictory views, it may be best to view the instability of the concept as a shift in which cultural differences outweighed physical differences. Jacobson convincingly demonstrates this position. See especially his discussion in *Whiteness of a Different Color,* 103–6.

129. Caffrey, *Ruth Benedict,* 296.

130. Reinhardt had already developed a repertoire of social types like the obese capitalist, the worker wearing overalls, and gestures like scratching the head in his earlier cartoons for the *New Masses.* In this respect, the artist recycled previous images.

131. Michael Corris, "The Difficult Freedom of Ad Reinhardt," in *Art Has No History! The Making and Unmaking of Modern Art,* ed. John Roberts (New York: Verso, 1994), 80.

132. Arthur Keith "Race and Propaganda," manuscript, July 15, 1941, AKP.

133. Benedict and Weltfish, *The Races of Mankind,* 5.

134. Ashley Montagu, *Man's Most Dangerous Myth,* 2nd ed. (New York: Columbia University Press, 1945), 6–7.

135. Benedict and Weltfish, *The Races of Mankind,* 10.

136. Ibid., 2. Reinhardt produced map illustrations for the *New Masses* magazine in the early 1940s. Corris, "Difficult Freedom," 85.

137. Benedict and Weltfish, *The Races of Mankind,* 10.

138. Ibid., 11.

139. Malvina Hoffman, "While Head Hunting for Sculpture," in *Hammond's Superior Atlas and Gazetteer of the World* (Maplewood, N.J.: C. S. Hammond, 1946), 274.

140. Ibid.

141. Ibid.

142. "The Races of Mankind," *Hammond's Superior Atlas and Gazetteer of the World,* 275.

143. Ibid., 286.

144. Ibid., 278.

145. Wilton Krogman, "Races of Man," *World Book Encyclopedia* (Chicago: Quarrie, 1948), 6732–34.

146. The photograph labeled "Northern Chinese" is an image of an individual and not a Races of Mankind sculpture.

147. Krogman, "Races of Man," 6732.

148. Ibid., 6734.

149. Ibid.

150. Henrietta Hafemann, "Vitalizing Intercultural Relations," *Chicago Schools Journal* 28 (1947): 57.

151. Transcript of the Address of Miss Ethel Alpenfels, July 4, 1946, on the subject

"Can Presentation of Facts Change Attitudes," Institute of Race Relations, 15, Roll 16, Box 36, Folder 11, Archives of the Race Relations Department of the United Church Board for Homeland Ministries.

Conclusion

1. Michael Omi and Howard Winant, *Racial Formation in the United States: From the 1960s to the 1990s,* 2nd ed. (New York: Routledge, 1994), 101. The Brotherhood of Man discourse continued to operate within the early civil rights movement of the late 1950s and early 1960s. Ibid., 69.

2. Walter Jones, June 1, 1966, Box 3, File 4, "Malvina Hoffman, Misc.," DAFM.

3. Philip Lewis, October 29, 1962, Referral #28404, "Races of Mankind Map" File, AAFM.

4. Draft letter, Donald Collier to Ashley P. Talbot, January 29, 1970, Hall of Man File, AAFM. At the urging of Paul Martin, the museum stopped publishing the guidebook to the hall and selling it in the museum's bookstore. In 1962, the anthropologists had given approval to use the figures in Hammond publications, but they did so with reservations, and they requested that captions be changed to reflect new political designations.

5. Clifford Gregg to Malvina Hoffman, 1963, Box 3, File 5, DAFM.

6. Alan B. Anderson and George W. Pickering, *Confronting the Color Line: The Broken Promise of the Civil Rights Movement in Chicago* (Athens: University of Georgia Press, 1986), 111.

7. Ibid., 112.

8. Ibid., 119.

9. Ibid., 202, 208.

10. Ibid. 210, 213. Held a few days after James Meredith had been shot in Mississippi and Stokely Carmichael's use of the term "Black Power," this rally marks the emergence of a Black Power position in Chicago. The local debates concerning the Chicago Freedom Movement mirrored the growing dissension within national organizations. Ibid., 196.

11. Charles Hurst Jr., *Passport to Freedom: Education, Humanism, and Malcolm X* (Hamden, Conn.: Linnet Books, 1972), 144.

12. Report of the National Advisory Commission on Civil Disorders (Washington, D.C.: U.S. Government Printing Office, March 1, 1968), 1. It is reproduced by the Eisenhower Foundation, http://www.eisenhowerfoundation.org/docs/kerner .pdf, accessed May 25, 2008.

13. Lisa Gail Collins and Margo Natalie Crawford, "Introduction: Power to the People! The Art of Black Power," in *New Thoughts on the Black Arts Movement,* ed. Lisa Gail Collins and Margo Natalie Crawford (Brunswick, N.J.: Rutgers University Press, 2006), 6.

14. Michael D. Harris, *Colored Pictures: Race and Visual Representations* (Chapel Hill: University of North Carolina Press, 2003), 109.

15. The mural involved over twenty-one artists, including Sylvia Abernathy, Jeff

Donaldson, Elliot Hunter, Wadsworth Jarrell, Barbara Jones, Carolyn Lawrence, Norman Parish, William Walker, and Myrna Weaver, and photographers Billy Abernathy, Darrell Cowherd, Roy Lewis, Robert Sengstacke, Onikwa Bill Wallace, and Edward Christmas. For more on the *Wall of Respect,* see Margo Natalie Crawford, "Black Light on the Wall of Respect: The Chicago Black Arts Movement," in *New Thoughts on the Black Arts Movement,* ed. Collins and Crawford, 23–40.

16. Gregory Foster-Rice, "The Artistic Evolution of the *Wall of Respect,*" http://www.blockmuseum.northwestern.edu/wallofrespect/main.htm, accessed March 20, 2003.

17. "Faces on the Wall," the *Wall of Respect,* http://www.blockmuseum.northwestern.edu/wallofrespect/main.htm, accessed March 20, 2003.

18. Alan W. Barnett, *Community Murals: The People's Art* (Cranbury, N.J.: Cornwall Books, 1984), 50. Don L. Lee and Gwendolyn Brooks recited poems about the *Wall of Respect,* and the dancer Darlene Blackburn performed during the dedication ceremonies on August 27, 1967.

19. Marshall Rosenthal, "Malvina's Mankind," *Panorama–Chicago Daily News,* May 1–2, 1971, clipping, Malvina Hoffman File, AAFM.

20. LeRoi Jones, Committee for a Unified Newark, to Leland Webber and Leon Siroto, August 7, 1969, Hall of Man File, AAFM.

21. Baraka received national attention after being beaten and arrested by police during the 1968 Newark riots. He represented the Committee for a Unified Newark (CFUN), an agitational organization aimed to empower the local community through electing African Americans to government positions and through reforming the educational system of the Newark School Board.

22. Collier recommended again that the company consult physical anthropologists such as Sherwood Washburn, Stanley Garn, Ashley Montagu, Harry Shapiro, and Edward Hunt. Donald Collier to Ashley P. Talbot, C. S. Hammond & Co., Draft, January 29, 1970, Hall of Man File, AAFM.

23. Ibid.

24. Rosenthal, "Malvina's Mankind."

25. Ibid.

26. The temporary display also formed part of a national trend of museums featuring exhibitions of African American art. A succession of shows—*Harlem on My Mind* at the Metropolitan Museum of Art, *New Black Arts* at the Brooklyn Museum, *Afri-Cobra I* at the Studio Museum of Harlem, and *Contemporary Black Artists in America* at the Whitney Museum—were held with varying degrees of success.

27. James Van Stone to Robert Inger, August 19, 1971, Malcolm X Loan File, AAFM.

28. Memo regarding meeting with Mrs. Moore and Mr. Robinson of Malcolm X College, August 25, 1971, Malcolm X Loan File, AAFM.

29. Charles Hurst, August 25, 1971, Malcolm X Loan File, AAFM.

30. Philip Lewis, "Notes on Malcolm X II," August 18, 1971, Malcolm X Loan File, AAFM.

31. Philip Lewis, interview with the author, June 27, 1997.

32. Invoice of Specimens, #A-2340, December 8, 1971, Malcolm X Loan File, AAFM.

33. Hurst, *Passport to Freedom*, 135.

34. Ibid., 41.

35. Ibid., 26.

36. Ibid., 136 and 187.

37. Ibid., 123.

38. Ibid., 17–18.

39. Ibid., 27.

40. Ibid.

41. For a discussion of the politics of hair during the 1970s, see Kobena Mercer, "Black Hair/Style Politics," in *Out There: Marginalization and Contemporary Cultures*, ed. Russell Ferguson, Martha Gever, Trinh T. Minh-ha, and Cornel West (New York: The New Museum of Contemporary Art, 1990), 24764; and Robin D. G. Kelley, "Nap Time: Historicizing the Afro," *Fashion Theory* 1, no. 4 (1994): 339–51.

42. For a discussion of this binary logic within Black Power movements, see Mercer, "Black Hair/Style Politics," 254–55.

43. See Kwame Anthony Appiah, "Fallacies of Eurocentrism and Afrocentrism" (Washington, D.C.: American Enterprise Institute Bradley Lecture Series, May 10, 1993); Kwame Anthony Appiah, *Identity against Culture: Understandings of Multiculturalism*, Doreen B. Townsend Center Occasional Papers 1 (Berkeley: Doreen B. Townsend Center for the Humanities, 1994); and K. Anthony Appiah, "Race, Pluralism and Afrocentricity," *The Journal of Blacks in Higher Education* 19 (1998): 116–18.

44. "Conceptual Artist Has His Way with MCA's 'Dreaming' Show," *Chicago Sun-Times* (June 26, 1994): 2, and Garrett Holg, "Dreams of a Permanent Collection," *Chicago Sun-Times* (June 12, 1994): 5.

45. Holg, "Dreams of a Permanent Collection," 5.

46. Fred Wilson, "Artist Statement," *OpEd: Fred Wilson* (Chicago: Museum of Contemporary Art, Chicago, 1994), 7.

47. Fred Wilson, "Art in Context: An Annotated Catalog of Projects and Artworks between Fred Wilson and Cultural Institutions," in *Fred Wilson: Objects and Installations 1979–2000* by Maurice Berger, Jennifer Gonzalez, and Fred Wilson (Baltimore: Center for Art and Visual Culture and the University of Maryland, 2000), 159. Jennifer Gonzalez notes that Wilson used an interrogative strategy within his earlier installations. Jennifer Gonzalez, "Against the Grain: The Artist as Conceptual Materialist," in *Fred Wilson*, by Berger, Gonzalez, and Wilson, 27.

48. Wilson, "Art in Context," 159.

49. Wilson's strategy of exhibition brings to mind Carlo Scarpa's designs for the painting galleries in the Castelvecchio art museum in Verona. For analysis on Carlo Scarpa's renovations and techniques of display, see Gianna Stavoulaki and John Peponis, "The Spatial Construction of Seeing at Castelvecchio," *Proceedings of the 4th International Space Syntax Symposium London 2003*, www.spacesyntax.net/symposia/sss4/fullpapers/66Stavroulaki-Peponis.pdf, accessed May 25, 2008.

50. Nadine Wasserman notes that in other areas of the installation, Fred Wilson included photographs of the 1893 World's Columbian Exposition and its status as the White City. "Dismantling the Mausoleum: Multiple Truths and Museum Experiences," in *OpEd: Fred Wilson,* an exhibition catalogue (Chicago: Museum of Contemporary Art, Chicago, 1994) 15.

51. Don Terry, "Housing Chief Wields a Wrecking-Ball Plan," *New York Times* (February 15, 1994): A14.

52. Witold Rybczynski, "Bauhaus Blunders: Architecture and Public Housing— 1950s Public Housing Estates Cabrini-Green Chicago Illinois, US," *Public Interest,* no. 113 (1993): 87. The winning project visualized a return to low-rise row houses, with a mixture of housing and commercial buildings, small parks, and squares, which informed the approach that was ultimately adopted in 2000. Ibid. In 2000, the city of Chicago created the Plan for Transformation, but demolition exceeded the pace of the construction of new buildings, and in 2004, residents sued the city over relocation plans. Susan Saulny, "At Housing Project, Both Fear and Renewal," *New York Times* (March 18, 2007): 1.20.

53. J. Linn Allen, "HUD Swallows Hard, Sells Troubled Tower for $1," *Chicago Tribune* (June 22, 1993): 2. Peter Landon's architectural plan for renovating Winthrop Tower was realized in 1995 when it opened as a cooperative residence.

54. Lance Hosey, "Hidden Lines: Gender, Races and the Body in *Graphic Standards,*" *Journal of Architectural Education* 55, no. 2 (2001): 102.

55. In her essay in the exhibition catalog, Nadine Wasserman suggests this kind of relationship. Wasserman, "Dismantling the Mausoleum," 14.

56. I wish to thank Calum Storrie, who brought the work of Carlo Scarpa to my attention.

57. Walter Benjamin, "On Some Motifs by Baudelaire," in *Illuminations,* ed. Hannah Arendt and trans. Harry Zohn (New York: Schocken Books, 1969), 188.

58. Wasserman, "Dismantling the Mausoleum," 14.

SELECT BIBLIOGRAPHY

Archival and Unpublished Materials

Archives du Musée de l'Ethnographie. Musée de l'Homme, Paris, now housed at the Musée du quai Branly.

Archives of the Race Relations Department of the United Church Board for Homeland Ministries, Institute of Race Relations, 15, Microfilm Roll 16, Box 36, Folder 11.

Boas, Franz, Papers. American Philosophical Society Library, Philadelphia, Microfilm Reels 30 and 31.

Directors' Archives. Field Museum, Chicago.

Field, Henry, Papers. Field Museum, Chicago.

Field, Henry, Correspondence. Musée de l'Homme archives, now housed at the Musée du quai Branly.

"Hall of the Races of Mankind" Papers. Department of Anthropology, Field Museum, Chicago.

Hoffman, Malvina, File. Musée d'Ethnographie du Trocadéro (M.E.T.) Archives, Musée de l'Homme, now housed at the Musée du quai Branly.

Hoffman, Malvina, File. National Gallery of Art, Washington, D.C.

Hoffman, Malvina, File and Correspondence. Musée Rodin, Paris.

Hoffman, Malvina, Papers. Special Collections, Accession Number 850042, Getty Research Institute for the History of Art and the Humanities, Los Angeles. Box numbers used throughout this book are in accordance with the finding aid used in 1997.

Hrdlička, Aleš, Papers. National Anthropological Archives, Smithsonian Institution, Washington, D.C.

Keith, Arthur, Papers. Royal College of Surgeons of England, London.

Laufer, Berthold, Papers. Department of Anthropology, Field Museum, Chicago.

Lyon, Gabrielle H. "The Forgotten Files of a Marginal Man: Henry Field, Anthropology and Franklin D. Roosevelt's 'M' Project for Migration and Settlement." Master's thesis, University of Chicago, 1994.

Malcolm X College Loan Files. Department of Anthropology, Field Museum.

National Urban League Papers. Series X, Related Organizations, Container 18, "Hoffman, Malvina, Sculpture Exhibit 1942." Manuscript Division, Library of Congress, Washington, D.C.

Slobodkin, Louis, Papers. Tamara and Lawrence Slobodkin Collection, Setauket, New York.

Articles

"African Bushman Family Depicted in Bronze Sculpture." *Field Museum News* 7, no. 5 (1936): 4.

Agard, Walter. "The Sculptural Portrait." *International Studio* 81 (1925): 22–28.

Allen, Garland E. "The Eugenics Records Office at Cold Spring Harbor, 1910–1940: An Essay in Institutional History." *Osiris,* 2nd ser., 2 (1986): 225–64.

Allen, J. Linn. "HUD Swallows Hard, Sells Troubled Tower for $1." *Chicago Tribune,* June 22, 1993, 2.

Appiah, Kwame Anthony. "Fallacies of Eurocentrism and Afrocentrism." Washington, D.C.: American Enterprise Institute Bradley Lecture Series, May 10, 1993.

———. "Race, Pluralism and Afrocentricity." *The Journal of Blacks in Higher Education* 19 (1998): 116–18.

Arnoldi, Mary Jo. "A Distorted Mirror: The Exhibition of the Herbert Ward Collection of Africana." In *Museums and Communities: The Politics of Public Culture,* edited by Ivan Karp, Christine Mullen Kreamer, and Stephen D. Lavine, 428–57. Washington, D.C.: Smithsonian Institution Press, 1992.

———. "Herbert Ward's 'Ethnographic Sculptures' of Africans." In *Exhibiting Dilemmas: Issues of Representation at the Smithsonian,* edited by Amy Henderson and Adrienne L. Kaeppler, 70–91. Washington, D.C.: Smithsonian Institution Press, 1997.

"Art Notes." *New York Times,* September 24, 1942, 30.

Bates, Arlo. "Literary Affairs in Boston." *The Book Buyer* 10 (1893): 61–62.

Belfield, L. M. "The Visual Idea Functioning through Museums." *Visual Education* 2, no. 8 (1921): 9–17.

Belo, Jane. "The Balinese Temper." *Character and Personality* 4 (1935): 120–46.

Benjamin, Walter "On Some Motifs by Baudelaire." In *Illuminations,* edited by Hannah Arendt and translated by Harry Zohn, 155–200. New York: Schocken Books, 1969.

Best, W. H. "Art-Sense and Nonsense." *American Photography* 25 (1931): 416–22.

Blakey, Michael. "Skull Doctors Revisited." In *Race and Other Misadventures: Essays in Honor of Ashley Montagu in his Ninetieth Year,* edited by Larry T. Reynolds and Leonard Lieberman, 64–95. New York: General Hall, 1996.

Boas, Franz. "Remarks on the Theory of Anthropometry." *Publications of the American Statistical Association* 3 (1893): 569–75.

———. "Some Principles of Museum Administration." *Science* 25, no. 650 (1907): 921–33.

Bogart, Michele. "American Garden Sculpture." In *Fauns and Fountains: American Garden Statuary, 1890–1930,* by Maureen C. O'Brien et al., n.p. Southampton, N.Y.: The Parrish Art Museum, 1985. An exhibition catalogue.

Brian, Doris, "Hoffman's Men of the World." *Art News* 41 (1942): 32.

Brock, H. I. "Business Ideas Applied to Art." *New York Times,* November 1, 1925, X10.

Bronson, Bennet. "Berthold Laufer." *Fieldiana,* n.s., 36 (2003): 117.

"Brotherhood from Bronzes." *Christian Science Monitor,* June 12, 1933, 14.

Brown, W. O. "The Nature of Race Consciousness." *Social Forces* 10, no. 1 (1931): 90–97.

———. "Rationalization of Race Prejudice." *International Journal of Ethics* 43, no. 3 (1933): 294–306.

Buchloh, Benjamin H. D. "Residual Resemblance: Three Notes on the Ends of Portraiture." In *Face Off: The Portrait in Recent Art,* by Melissa E. Feldman, 53–69. Philadelphia: Institute of Contemporary Art, University of Pennsylvania, 2004.

Cary, Elisabeth Luther. "Welcoming Every Test." *New York Times,* December 16, 1928, XX13.

"Citadel Taken." *Time* 15, no. 6 (1930): 44.

Clark, Constance Areson. "Evolution for John Doe: Pictures, the Public and the Scopes Trial Debate." *Journal of American History* 87 (2001): 1275–1303.

Coffey, Mary K. "The American Adonis: A Natural History of the 'Average American' (Man), 1931–1932." In *Popular Eugenics: National Efficiency and American Mass Culture in the 1930s,* edited by Susan Currell and Christina Cogdell, 185–216. Athens: Ohio University Press, 2006.

Collins, Lisa Gail, and Margo Natalie Crawford. "Introduction: Power to the People! The Art of Black Power." In *New Thoughts on the Black Arts Movement,* edited by Lisa Gail Collins and Margo Natalie Crawford, 1–22. Brunswick, N.J.: Rutgers University Press, 2006.

Cordier, Charles. "Rapport de Charles Cordier: Types ethniques représentés par la sculpture." *Bulletins de la Société d'Anthropologie de Paris* 3 (1862): 64–68.

Corris, Michael. "The Difficult Freedom of Ad Reinhardt." In *Art Has No History! The Making and Unmaking of Modern Art,* edited by John Roberts, 63–110. New York: Verso, 1994.

Crawford, Margo Natalie. "Black Light on the Wall of Respect: The Chicago Black Arts Movement." In *New Thoughts on the Black Arts Movement,* edited by Lisa Gail Collins and Margo Natalie Crawford, 23–40. Brunswick, N.J.: Rutgers University Press, 2006.

Daston, Lorraine, and Peter Galison. "The Images of Objectivity." *Representations* 40 (1992): 81–128.

"The Death of Dr. Laufer, Curator of Anthropology." *Field Museum News* 5, no. 10 (1934): 2.

De Bont, Raf. "The Creation of Prehistoric Man: Aimé Rutot and the Eolith Controversy, 1900–1920." *Isis* 94, no. 4 (2003): 604–30.

Decoteau, Pamela Hibbs. "Malvina Hoffman and the Races of Mankind." *Woman's Art Journal* 10, no. 2 (1990): 7–12.

Dennison, Mariea Caudill. "The American Girls' Club in Paris: The Propriety and Imprudence of Art Students, 1890–1914." *Woman's Art Journal* 26, no. 1 (2005): 32–37.

Devree, Howard. "Grand Central Art on the Avenue." *New York Times,* July 30, 1930, 118.

Dias, Nélia. "The Visibility of Difference: Nineteenth-Century French Anthropo-

logical Collections." In *The Politics of Display: Museums, Science, Culture,* edited by Sharon Macdonald, 36–52. New York: Routledge, 1998.

Dorsey, George. "Race and Civilization." In *Whither Mankind,* by Charles A. Beard. New York: Longmans, Green, 1928. Reprint, in *Frontiers of Anthropology,* edited by Ashley Montagu, 437–62. New York: G. P. Putnam's Sons, 1974.

Eiselen, Elizabeth. "The Technique of Exhibits." *The Journal of Geography* 39 (1940): 321.

Enwezor, Okwui. "Repetition and Differentiation—Lorna Simpson's Iconography of the Racial Sublime." In *Lorna Simpson,* 103–31. New York: Harry N. Abrams and American Federation of Arts, 2006.

l'Estoile, Benoît de. "From the Colonial Exhibition to the Museum of Man: An Alternative Genealogy of French Anthropology." *Social Anthropology* 11 (2003): 341–61.

"Ethiopian Types Included among Sculpture of Races." *Field Museum News* 6, no. 12 (1935): 3.

"Eugenics as a Museum Subject." *Eugenical News* 18, no. 4 (1933): 65–66.

Farrington, Oliver Cummings. "A Brief History of the Field Museum." *Field Museum News* 1, no. 2 (1930): 3.

———. "Notes on European Museums." *American Naturalist* 33, no. 394 (1899): 763–81.

Field, Henry. "A 'Family Tree' of Man and the Apes." *Field Museum News* 5, no. 2 (1934): 4.

———. "Man—Past and Present—in the Field Museum." *Scientific Monthly* 38 (1934): 293–96.

Field, Stanley. "Fifty Years of Progress." *Field Museum News* 14, no. 9–10 (1943): 7.

———. "Stone Age Hall, Soon to Open, Will Show Ancestors of Human Race." *Field Museum News* 4, no. 7 (1933): 1, 3.

"For Commuters." *Time* 1, no. 4 (1923): 18.

Freed, Stanley A., Ruth Freed, and Laila Williamson. "Tough Fieldworkers: History and Personalities of the Jesup Expedition." In *Drawing Shadows to Stone: The Photography of the Jesup North Pacific Expedition, 1871–1902,* by Laurel Kendall, Ruth S. Freed, Stanley A. Freed, Thomas Rose Miller, Barbara Mathe, and Laila Williamson, 9–19. New York: American Museum of Natural History in association with Douglas & McIntyre, 1997.

Frizzell, Donald Leslie. "Terminology of Types." *American Midland Naturalist* 14, no. 6 (1933): 637–68.

Gallotti, Jean. "Une exposition de sculpture au Trocadéro." *L'Illustration,* no. 4734 (November 25, 1933): 398–99.

Gonzalez, Jennifer. "Against the Grain: The Artist as Conceptual Materialist." In *Fred Wilson: Objects and Installations, 1979–2000,* by Maurice Berger, Jennifer Gonzalez, and Fred Wilson, 22–31. Baltimore: Center for Art and Visual Culture and the University of Maryland, 2000.

Goodson, Orr. "Men and Women Whose Contributions Have Made the Museum Possible." *Field Museum News* 14, nos. 9–10 (1943): 10.

Graves, W. Brooke. "Topics for Further Investigation and Discussion." In *Readings in Public Opinion: Its Formation and Control.* New York: D. Appleton, 1928.

Griffin, Roger. "Nazi Art: Romantic Twilight or (Post)modernist Dawn?" *Oxford Art Journal* 18, no. 2 (1995): 103–7.

Grosvenor, Gilbert. "Maps for Victory." *National Geographic* 81, no. 5 (1942): 667–90.

Hafemann, Henrietta. "Vitalizing Intercultural Relations." *Chicago Schools Journal* 28 (1947): 54–61.

Haraway, Donna. "Teddy Bear Patriarchy: Taxidermy in the Garden of Eden, New York City, 1908–1936." *Social Text* 11 (1984–85): 20–64.

Heinze, Andrew R. "Schizophrenia Americana: Aliens, Alienists, and the 'Personality Shift' of Twentieth-Century Culture." *American Quarterly* 55, no. 2 (2003): 227–56.

Herskovits, Melville J. "Social Selection and the Formation of Human Types." *Human Biology* 1, no. 1 (1929): 250–62.

———. "Some Effects of Social Selection on the American Negro." *Publications of the American Sociological Society* 20 (1926): 77–82.

Hoffman, Malvina. "While Head Hunting for Sculpture." In *Hammond's Superior Atlas and Gazetteer of the World,* 317. Maplewood, N.J.: C. S. Hammond, 1946.

"Hoffman Show a Great Success." *Art News,* March 17, 1934, 20.

Holg, Garrett. "Dreams of a Permanent Collection." *Chicago Sun-Times,* June 12, 1994, 5.

Holmes, William Henry. "Classification and Arrangement of the Exhibits of an Anthropological Museum." *Report of the U.S. National Museum, 1901* (1902): 255–78.

———. "The Exhibit of the Department of Anthropology." *Report of the U.S. National Museum, 1901* (1902): 200–218.

Hosey, Lance. "Hidden Lines: Gender, Races and the Body in *Graphic Standards.*" *Journal of Architectural Education* 55, no. 2 (2001): 102–12.

Hough, Walter. "Installation of Ethnological Material." *Proceedings of the American Association of Museums* 11 (1917): 117–19.

———. "Racial Groups and Figures in the Natural History Building of the United States National Museum." In *Annual Report Smithsonian Institution for Year Ending June 30, 1920,* 611–56. Washington, D.C.: Smithsonian Institution, 1921.

Hrdlička, Aleš. "Evolution of Man in the Light of Recent Discoveries and its Relation to Medicine." *Washington Medical Annals* 14, no. 6 (1915): 304–7.

———. "An Exhibit in Physical Anthropology." *Proceedings of the National Academy of Science* 1 (1915): 407–10.

———. "Physical Differences between White and Colored Children." *American Anthropologist* 11, no. 11 (1898): 347–50.

Hunt, Edward E., Jr. "The Old and New Physical Anthropology in the Careers of E. A. Hooton and W. M. Krogman." *American Journal of Human Biology* 3 (1991): 563–69.

Jacknis, Ira. "Franz Boas and Exhibits." In *Objects and Others: Essays on Museums and Material Culture,* edited by George W. Stocking Jr., 75–111. Madison: The University of Wisconsin Press, 1985.

Jamin, Jean. "Objets trouvés des paradis perdus: À propos de la Mission Dakar-Djibouti." In *Collections Passion,* edited by J. Hainard and R. Kaehr, 69–100. Neuchâtel: Musée d'ethnographie, 1982.

———. "Le musée d'ethnographie en 1930: L'ethnologie comme science et comme politique." In *La muséologie selon Georges-Henri Rivière: Cours de muséologie, textes et témoignages,* 110–21. Paris: Dunod, 1989.

———. "Le savant et le politique: Paul Rivet (1876–1958)." *Bulletins et Mémoires de la Société d'Anthropologie de Paris* 1, nos. 3–4 (1989): 277–94.

Jewell, Edward Alden. "Downtown Moves Up." *New York Times,* February 2, 1930, 116.

———. "Founder's Exhibition Opens with Forty-seven Paintings at the Grand Central Galleries." *New York Times,* June 2, 1932, 19.

———. "The Masterpiece and the Modeled Chart." *New York Times,* September 14, 1932, XX9.

———. "Men of the World in Art." *New York Times,* June 20, 1942, C12.

———. "Sculpture Renaissance—Season Has Brought Forth an Abundance of Plastic Work—Malvina Hoffman." *New York Times,* February 4, 1934, X12.

"Kashmiri in Meditation." *Field Museum News* 8, no. 5 (1937): 4.

Keith, Arthur. "America: The Greatest Race Experiment." *New York Times,* January 24, 1932, SM7.

———. "Art Wedded to Anthropology." *Illustrated London News,* May 20, 1933, 730.

———. "The Differentiation of Mankind into Racial Types." *Nature* 104 (1919): 443–53.

———. "An Introduction to the Anthropology of the Near East in Ancient and Recent Times." *Nature* 135, no. 3413 (1935): 487–88.

———. Introduction to *The Races of Mankind,* by Henry Field, 7–12. Chicago: Field Museum of Natural History, 1933.

———. "John Bull Is Dissected by a Scientist." *New York Times,* January 30, 1927, SM3.

———. "Races of the World: A Gallery in Bronze." *New York Times Magazine,* May 21, 1933, 10.

Keith, Arthur, and Wilton Krogman. "Appendix: The Racial Characteristics of the Southern Arabs." In *Arabia Felix: Across the "Empty Quarter,"* by Bertram Thomas, 301–33. New York: Charles Scribner's Sons, 1932.

Kelley, Robin D. G. "Nap Time: Historicizing the Afro." *Fashion Theory* 1, no. 4 (1994): 339–51.

Knight, Rex. "Character and the Face." *The Human Factor* 6 (1932): 413–22.

Kroeber, Alfred L. "Reviewed Works: *An Introduction to Physical Anthropology* by E. P. Stibbe." *American Anthropologist,* n.s., 33, no. 2 (1931): 231.

Krogman, Wilton. "The Concept of Race." In *The Science of Man in the World Crisis,* edited by Ralph Linton, 38–62. New York: Columbia University Press, 1945.

———. "Is There a Physical Basis of Racial Superiority?" *Scientific Monthly* 51, no. 5 (1940): 428–34.

———. "Races of Man." *World Book Encyclopedia.* Chicago: Quarrie, 1947, 6732–34.

———. "What We Do Not Know about Race." *Scientific Monthly* 57, no. 2 (1943): 97–104.

Lambert, Herbert. "Imaginative Portraiture." *The Photographic Journal* 62 (1922): 297–303.

Landis, Carney. "Studies in Emotional Reaction, I: A Preliminary Study of Facial Expression." *Journal of Experimental Psychology* 7, no. 5 (1924): 325–44.

Larson, Barbara. "Exhibition Review, the Artist as Ethnographer: Charles Cordier and Race in Mid-Nineteenth-Century France." *Art Bulletin* 87, no. 4 (2005): 714–22.

Latour, Bruno. "Drawing Things Together." In *Representation in Scientific Practice*, edited by Michael Lynch and Steven Woolgar, 19–68. Cambridge, Mass.: MIT Press, 1990.

Lattimore, Owen. "Mongolia Enters World Affairs." *Pacific Affairs* 7, no. 1 (1934): 5–28.

Laufer, Berthold. "The Department of Anthropology—Its Aims and Objects." *Field Museum News* 2, no. 8 (1931): 2.

———. Preface to *The Races of Mankind*, by Henry Field, 3–6. Chicago: Field Museum of Natural History, 1933.

———. "The Projected Hall of the Races of Mankind." *Field Museum News* 2, no. 12 (1931): 2.

Laurière, Christine. "Georges Henri Rivière au Trocadéro." *Gradhiva* 33 (2003): 57–66.

Lee, H. W. Honess. "Portraits, Personalities and Character Studies." *American Photography* 32, no 4 (1938): 229–36.

Leja, Michael. "Modernism's Subjects in the United States." *Art Journal* 55, no. 2 (1996): 65–72.

Le Normand-Romain, Antoinette. "Sculpture et ethnographie." In *La sculpture ethnographique de la Vénus Hottentote à la Tehura de Gauguin*, edited by Antoinette Le Normand-Romain, Anne Roquebert, Jeanine Durand-Revillon, and Dominique Serena, 33–50. Paris: Réunion des Musées Nationaux, 1994.

Leroi, Armand Marie. "A Family Tree in Every Gene." *New York Times,* March 14, 2005, A21.

Locke, Alain. "The Problem of Race Classification." *Opportunity* 1 (1923): 261–64.

Loring, Stephen, and Miroslav Prokopec. "A Most Peculiar Man: The Life and Times of Aleš Hrdlička." *Reckoning with the Dead: The Larsen Bay Repatriation and the Smithsonian Institution,* edited by Tamara L. Bray and Thomas W. Killon, 26–40. Washington, D.C.: Smithsonian Institution Press, 1994.

Luschan, Felix von. "The Racial Affinities of the Hottentots." In *Report of the British and South African Associations, 1905.* Reprint, London: Spottiswoode, 1907.

"Malvina Hoffman Uses Art to Present Characteristics of the Races." *Art Digest* 8, no. 9 (1934): 10.

"Malvina Hoffman's Human—Racial-Type Bronzes." *Eugenical News* 18, no. 4 (1933): 71.

"Malvina Hoffman's Men Serve Man." *Art Digest* 16, no. 18 (1942): 14.

"Malvina Hoffman's 'Races of Mankind.'" *American Magazine of Art* 27, no. 2 (1934): 91.

"Malvina Hoffman's Triumph." *Art Digest* 8, no. 11 (1934): 23.

Marles, Hugh. "Arrested Development: Race and Evolution in the Sculpture of Herbert Ward." *Oxford Art Journal* 19, no. 1 (1996): 16–28.

McBride, Henry. "Modern Art." *The Dial* 77, no. 6 (1924): 530.

———. "The Races of Mankind: Malvina Hoffman's Monumental Work on View Here." *New York Sun,* January 1, 1934.

McCown, Theodore D. "Book Reviews: The Races of Mankind: An Introduction to Chauncey Keep Memorial Hall." *American Anthropologist,* n. s., 35 (1933): 783–84.

Mead, Margaret. Preface to *Patterns of Culture,* by Ruth Benedict. 1934. Reprint, Boston: Houghton Mifflin, 1959.

Mercer, Kobena. "Black Hair/Style Politics." In *Out There: Marginalization and Contemporary Cultures,* edited by Russell Ferguson, Martha Gever, Trinh T. Minh-ha, and Cornel West, 247–64. New York: The New Museum of Contemporary Art, 1990.

Millard, Bailey. "Biological Bunk." *Los Angeles Times,* July 5, 1931, A4.

Millspaugh, Charles F. "Botanical Installation." *Proceedings of the American Association of Museums* 4 (1910): 52–56.

Mirzoeff, Nicholas. "The Shadow and the Substance." In *Only Skin Deep: Changing Visions of the American Self,* edited by Coco Fusco and Brian Wallis, 111–26. New York: Harry N. Abrams, 2003.

Montagu, Ashley. "The Meaninglessness of the Anthropological Conception of Race." *The Journal of Heredity* 23 (1944): 243–47. Reprint, *The Concept of Race,* edited by Ashley Montagu, 1–11. Toronto: Collier-Macmillan Canada, 1969.

Mullin, Molly H. "The Patronage of Difference: Making Indian Art 'Art, Not Ethnology.'" In *The Traffic of Culture: Refiguring Art and Anthropology,* edited by George E. Marcus and Fred R. Myers, 166–98. Berkeley: University of California Press, 1995.

Mumford, Lewis. "The Marriage of Museums." *Scientific Monthly* 7 (1918): 252–60.

———. "New York Art Galleries." *New Yorker* 10 (1934): 48.

Nochlin, Linda. "Malvina Hoffman: A Life in Sculpture." *Arts Magazine* 59, no. 3 (1984): 106–10.

Papet, Édouard. "Historical Life Casting." In Stephen Feeke, *Second Skin: Historical Life Casting and Contemporary Sculpture,* n.p. Leeds: Henry Moore Institute, 2002.

———. "Le moulage sur nature au service de la science." In *À fleur de peau: Le moulage sur nature au XIXe siècle,* 88–95. Paris: Réunion des Musées Nationaux, 2001.

Park, Katherine. "Impressed Images: Reproducing Wonders." In *Picturing Science Producing Art,* edited by Caroline A. Jones and Peter Galison, 256–57, 262. New York: Routledge, 1998.

Park, Marlene. "Sculpture Has Never Been Thought a Medium Particularly Feminine." In *The Figure in American Sculpture: A Question of Modernity,* edited by Ilene Susan Fort, 55–56. Los Angeles: Los Angeles County Museum of Art and University of Washington Press, 1995.

Parker, Arthur. "Habitat Groups in Wax and Plaster." *Museum Work* 1, no. 3 (1918): 78–85.

Phillips, J. G. "Racial Types in Sculpture by Malvina Hoffman." *London Studio* 5, no. 38 (1934): 251–54.

"Pygmies of Ituri Forest." *Field Museum News* 8, no. 1 (1937): 3.

"Race Question." *Time* 43, no. 5 (1944): 56.

"Racial Portraiture: A Sculptor's View." *Nature* 139 (1937): 487–88.

Raynsford, Anthony. "Swarm of the Metropolis: Passenger Circulation at Grand Central Terminal and the Ideology of the Crowd Aesthetic." *Journal of Architectural Education* 50, no. 1 (1996): 2–14.

"A Reunion of Sorts." *Field Museum Bulletin* 54 (1983): 7.

Reynaud-Paligot, Carole. "Paul Rivet: Contradictions et ambiguitiés d'un intellectuel antifasciste." In *Transmettre les passés: Nazisme, Vichy et conflits coloniaux: Les responsabilités de l'université,* edited by Marie-Claire Hoock-Demarle and Claude Liauzu, 161–74. Paris: Éditions Syllepse, 2001.

Reynolds, Ann. "Visual Stories." In *Visual Display: Culture beyond Appearances,* edited by Lynne Cooke and Peter Wollen, 82–109. Seattle: Bay Press, 1995.

Ristow, Walter W. "Journalistic Cartography." *Surveying and Mapping* 17 (1957): 369–90.

Rivet, Paul. "Les données de l'anthropologie." In *Nouveau traité de psychologie,* edited by Georges Dumas, 55–101. Paris: Alcan, 1930.

Rivet, Paul, Eric Lester, and Georges-Henri Rivière, "Le laboratoire d'anthropologie du museum." *Archives du Muséum National d'Histoire Naturelle,* 6th ser., 12, no. 2 (1935): 520.

Rivière, Georges-Henri. "Le musée d'ethnographie du Trocadéro." *Documents* 1 (1929): 56.

———. "L'objet d'un musée d'ethnographie comparé a celui d'un musée de Beaux-Arts." *Cahiers de Belgique* (1930). Reprint, *Gradhiva* 33 (2003): 67–68.

Roberts, Katherine Eggleston. "Chicago Letter." *The Arts* 2, no. 4 (1922): 218.

Rosen, Jeff. "Of Monsters and Fossils: The Making of Racial Difference in Malvina Hoffman's *Hall of the Races of Mankind.*" *History and Anthropology* 12, no. 2 (2001): 101–58.

Rosenfield, Isadore. "Light in Museum Planning." *Architectural Forum* 56, no. 6 (1932): 619–26.

Ruskin, John. "The Unity of Art." In *The Complete Works of John Ruskin, LL.D in Twenty Six Volumes,* vol. 13. Philadelphia: Reuwee, Wattley and Walsh, 1891.

Rybczynski, Witold. "Bauhaus Blunders: Architecture and Public Housing—1950s Public Housing Estates Cabrini-Green, Chicago, Illinois, US." *Public Interest,* no. 113 (1993): 87.

Salmon, Robin R., with Ilene Susan Fort and Lauretta Dimmick. "Malvina Cornell Hoffman." In *American Masters: Sculptures from Brookgreen Gardens,* 35. Murrells Inlet, S.C.: Brookgreen Gardens, 1996.

Sanjek, Roger. "Intermarriage and the Future of Races in the United States." In *Race,* edited by Steven Gregory and Roger Sanjek, 103–30. New Brunswick, N.J.: Rutgers University Press, 1994.

Saulny, Susan. "At Housing Project, Both Fear and Renewal." *New York Times,* March 18, 2007, 1.20.

Schindlbeck, Markus. "Die Südsee-Ausstellungen in Berlin." *Baessler-Archiv: Beiträge zur Völkerkunde,* n.s., 45 (1997): 565–88.

Schuchert, Charles. "What Is a Type in Natural History." *Science,* n.s., 5, no. 1 (1897): 636–40.

Schultz, Adolph H. "Biographical Memoir of Aleš Hrdlička, 1869–1943." *National Academy of Sciences of the United States of America Biographical Memoirs* 23 (1944): 305–38.

"The Science of Man." *Fortune Magazine* 8, no. 4 (1933): 66–70, 98, 103.

Scudder, Janet. "Janet Scudder Tells Why So Few Women Are Sculptors." *New York Times,* February 18, 1912, SM13.

Sekula, Allan. "The Traffic in Photographs." In *Only Skin Deep: Changing Visions of the American Self,* edited by Coco Fusco and Brian Wallis, 79–109. New York: Harry N. Abrams, 2003.

Sherman, Daniel. "'Peoples Ethnographic': Objects, Museums, and the Colonial Inheritance of French Ethnology." *French Historical Studies* 27, no. 3 (2004): 669–703.

Simms, S. C. "University of Chicago Honors Stanley Field." *Field Museum News* 2, no. 1 (1931): 2.

Simonson, Lee. "Museum Showmanship." *Architectural Forum* 56, no. 6 (1932): 533–40.

Star, Susan Leigh, and James R. Griesemer. "Institutional Ecology, 'Translation' and Boundary Objects: Amateurs and Professionals in Berkeley's Museum of Vertebrate Zoology, 1907–1939." *Social Studies of Science* 19 (1989): 387–420.

Stein, Clarence. "Making Museums Function." *Architectural Forum* 56, no. 6 (1932): 609–16.

Taft, Lorado. "Women Sculptors of America." *The Mentor* 6, no. 24 (1919): 1–11.

"Tales of Hoffman." *Time* 28, no. 14 (1936): 45–46.

Taylor, Joshua. "Malvina Hoffman." *American Art and Antiques* 2 (1979): 96–103.

Teall, Gardner. "Women Sculptors of America: How Many Readers Knew There Were So Many of Them? And So Talented." *Good Housekeeping* 53 (1911): 175–87.

Temperley, Harold. "Malvina Hoffman in the East." *American Magazine of Art* 20 (1929): 132–36.

Terry, Don. "Housing Chief Wields a Wrecking-Ball Plan." *New York Times,* February 15, 1994, A14.

Teslow, Tracy. "Reifying Race: Science and Art in *Races of Mankind* at the Field Museum of Natural History." In *The Politics of Display,* edited by Sharon Macdonald, 53–76. London: Routledge, 1998.

Todd, Wingate. Review of *The Anthropometry of the American Negro Columbia University Contributions to Anthropology No. XI,* by Melville Herskovits. *American Anthropologist,* n.s., 34, no. 3 (1932): 527–28.

"Trocadéro and Guimet Museums Reorganized." *Museum News* 9, no. 17 (1932): 1.

"Umbilicose." *Time* 43, no. 20 (1944): 38.

"Urban League Guild Sponsors Sculpture Exhibit." *Opportunity* 20 (1942): 310.

Ward, Henry B. "The Fourth Chicago Meeting of the American Association for the Advancement of Science and Associated Societies." *Science*, n.s., 78, no. 2013 (1933): 65.

Ward, Henry L. "Exhibition of Fossils and Skeletons in Popular Museums." *Proceedings of the American Association of Museums* 4 (1910): 100–103.

Wasserman, Nadine. "Dismantling the Mausoleum: Multiple Truths and Museum Experiences." In *OpEd: Fred Wilson*, 9–16. Chicago: Museum of Contemporary Art, Chicago, 1994. An exhibition catalog.

Watson, Thomas. "Reconversion." *Think* 10 (1944): 3.

Welsh, Robert P. "Sacred Geometry: French Symbolism and Early Abstraction." In *The Spiritual in Art: Abstract Painting, 1890–1985*, edited by Maurice Tuchman, 68–69. Los Angeles: Los Angeles County Museum of Art, 1986.

Wilson, Fred. "Art in Context: An Annotated Catalog of Projects and Artworks between Fred Wilson and Cultural Institutions." In *Fred Wilson: Objects and Installations, 1979–2000*, by Maurice Berger, Jennifer Gonzalez, and Fred Wilson, 152–65. Baltimore: Center for Art and Visual Culture and the University of Maryland, 2000.

Wingate, Charles E. L. "Boston Letter." *The Critic*, n.s., 19 (1893): 420–21.

Anthologies, Catalogues, and Books

Alexandre, Arsène. *Malvina Hoffman*. Paris: J. E. Pouterman, 1930.

Alpenfels, Ethel. *Sense and Nonsense about Race*. New York: Friendship Press, 1946.

Anderson, Alan, and George W. Pickering. *Confronting the Color Line: The Broken Promises of the Civil Rights Movement in Chicago*. Athens: University of Georgia Press, 1986.

Appiah, Kwame Anthony. *Identity against Culture: Understandings of Multiculturalism*. Doreen B. Townsend Occasional Papers 1. Berkeley: Doreen B. Townsend Center for the Humanities, 1994.

Baker, Lee D. *From Savage to Negro: Anthropology and the Construction of Race, 1896–1954*. Berkeley: University of California Press, 1998.

Barkan, Elazar. *The Retreat of Scientific Racism: Changing Concepts of Race in Britain and the United States between the World Wars*. Cambridge: Cambridge University Press, 1992.

Barnett, Alan W. *Community Murals: The People's Art*. Cranbury, N.J.: Cornwall Books, 1984.

Bay, Christian. *History [of the Field Museum]*. Chicago: John Crerar Library, 1929.

Benedict, Ruth. *Patterns of Culture*. 1934. Reprint, Boston: Houghton Mifflin, 1959.

———. *Race: Science and Politics*, 2nd ed. New York: Viking Press, 1943.

Benedict, Ruth, and Gene Weltfish. *The Races of Mankind*. New York: Public Affairs Committee, 1943.

Benkard, Ernst. *Undying Faces: A Collection of Death Masks*. London: Hogarth Press, 1929.

Bennett, Tony. *The Birth of the Museum: History, Theory, Politics.* London: Routledge, 1995.

Benton, Charlotte, Tim Benton, and Ghislaine Wood, eds. *Art Deco, 1910–1939.* London: Bulfinche Press and the Victoria and Albert Museum, 2003.

Berger, Maurice, Jennifer Gonzalez, and Fred Wilson. *Fred Wilson: Objects and Installations 1979–2000.* Baltimore: Center for Art and Visual Culture and the University of Maryland, 2000.

Black, Edwin. *IBM and the Holocaust.* New York: Crown, 2001.

Boas, Franz. *Anthropology and Modern Life.* 1928. Reprint, New York: Norton, 1962.

Bogart, Michele. *Public Sculpture and the Civic Ideal in New York City, 1890–1930.* Chicago: University of Chicago Press, 1989.

Bray, Tamara L., and Thomas W. Killon, eds. *Reckoning with the Dead: The Larsen Bay Repatriation and the Smithsonian Institution.* Washington, D.C.: Smithsonian Institution Press, 1994.

Brown, Elspeth H. *The Corporate Eye: Photography and the Rationalization of American Culture, 1884–1929.* Baltimore: The Johns Hopkins University Press, 2005.

Buxton, Dudley. *The Peoples of Asia.* New York: Knopf, 1925.

Caffrey, Margaret M. *Ruth Benedict: Stranger in This Land.* Austin: University of Texas Press, 1989.

Catholic University of America. *New Catholic Encyclopedia,* vol. 6. New York: McGraw-Hill, 1967.

Clifford, James. *The Predicament of Culture.* Cambridge, Mass.: Harvard University Press, 1988.

Cogdell, Christina. *Eugenic Design: Streamlining America in the 1930s.* Philadelphia: University of Pennsylvania Press, 2004.

Conn, Peter. *Pearl Buck: A Cultural Biography.* Cambridge: Cambridge University Press, 1996.

Conner, Janis. *A Dancer in Relief: Works by Malvina Hoffman.* New York: The Hudson River Museum, 1984.

Cooke, Lynne, and Peter Wollen. *Visual Display: Culture beyond Appearances.* Seattle: Bay Press, 1995.

Coombes, Annie. *Reinventing Africa.* New Haven, Conn.: Yale University Press, 1994.

Cooper, Alice Cecilia, and Charles Palmer. *Twenty Modern Americans.* New York: Harcourt Brace, 1942.

Count, Earl W., ed. *This Is Race: An Anthology Selected from the International Literature on Races of Man.* New York: Schuman, 1950.

Currell, Susan, and Christina Cogdell, eds. *Popular Eugenics: National Efficiency and American Mass Culture in the 1930s.* Athens: Ohio University Press, 2006.

Curtis, Penelope, Peter Funnell, and Nicola Kalinsky. *Return to Life: A New Look at the Portrait Bust.* Leeds: Henry Moore Institute, 2001.

Denning, Michael. *The Cultural Front.* New York: Verso, 1997.

Didi-Huberman, Georges. *L'empreinte.* Paris: Centre Georges Pompidou, 1997.

Dumas, Georges, ed. *Nouveau traité de psychologie.* Paris: Alcan, 1930.

Dyer, Richard. *White*. London: Routledge, 1997.

Édouard-Joseph, René. *Dictionnaire biographique des artistes contemporaines, 1910–1930*. Paris: Art & Edition, 1930–34.

Efron, David. *Gesture and Environment*. New York: King's Crown Press, 1941.

Enwezor, Okwui. *Lorna Simpson*. New York: Harry N. Abrams and American Federation of Arts, 2006.

Epstein, Jacob. *The Sculptor Speaks*. Garden City, N.Y.: Doubleday, Doran, 1932.

Feeke, Stephen. *Second Skin: Historical Life Casting and Contemporary Sculpture*. Leeds: Henry Moore Institute, 2002.

Feldman, Melissa E. *Face Off: The Portrait in Recent Art*. Philadelphia: Institute of Contemporary Art, University of Pennsylvania, 2004.

Field, Henry. *The Races of Mankind: An Introduction to the Chauncey Keep Memorial Hall*. Chicago: Field Museum of Natural History, 1933.

———. *The Races of Mankind: An Introduction to the Chauncey Keep Memorial Hall*, 2nd ed. Chicago: Field Museum of Natural History, 1934.

———. *The Races of Mankind: An Introduction to the Chauncey Keep Memorial Hall*, 3rd ed. Chicago: Field Museum of Natural History, 1937.

———. *The Track of Man: Adventures of an Anthropologist*. New York: Greenwood Press, 1953.

Fort, Ilene Susan, ed. *The Figure in American Sculpture: A Question of Modernity*. Los Angeles: Los Angeles County Museum of Art, 1995.

Fusco, Coco, and Brian Wallis, eds. *Only Skin Deep: Changing Visions of the American Self*. New York: Harry N. Abrams, 2003.

Golan, Romy. *Modernity and Nostalgia: Art and Politics in France between the Wars*. New Haven, Conn.: Yale University Press, 1995.

Gould, Stephen Jay. *The Mismeasure of Man*. New York: Norton, 1981.

———. *Ontogeny and Phylogeny*. Cambridge, Mass.: Harvard University Press, 1977.

Graves, W. Brooke, ed. *Readings in Public Opinion: Its Formation and Control*. New York: D. Appleton, 1928.

Gregory, Steven, and Roger Sanjek, eds. *Race*. New Brunswick, N.J.: Rutgers University Press, 1996.

Gurney, George. *Sculpture and the Federal Triangle*. Washington, D.C.: Smithsonian Institution Press, 1985.

Haardt, Georges Marie. *The Black Journey*. New York: Cosmopolitan, 1927.

Haddon, Alfred C. *History of Anthropology*. London: Watts, 1934.

———. *The Races of Man and Their Distribution*, 2nd ed. New York: Milner, 1925.

———. *The Study of Man*. New York: G. P. Putman's Sons, 1898.

Hainard, J., and R. Kaehr, eds., *Collections Passion*. Neuchâtel: Musée d'ethnographie, 1982.

Haraway, Donna. *Primate Visions*. New York: Routledge, 1989.

Harris, Michael D. *Colored Pictures: Race and Visual Representations*. Chapel Hill: University of North Carolina Press, 2003.

Hauser, Emil D. W. *Diseases of the Foot*. Philadelphia: W. B. Saunders, 1940.

Henderson, Linda. *Duchamp in Context*. Princeton, N.J.: Princeton University Press, 1998.

Hildebrand, Adolf. *The Problem of Form in Painting and Sculpture*. Translated by Max Meyer and Robert Morris Ogden. 1907. Reprint, New York: G. E. Stechert, 1945.

Hill, May Brawley. *The Woman Sculptor: Malvina Hoffman and Her Contemporaries*. New York: Berry-Hill Galleries, 1984.

Hoffman, Malvina. *Heads and Tales*. New York: Charles Scribner's Sons, 1936.

———. *The Map of Mankind*. Maplewood, N.J.: C. S. Hammond, 1946.

———. *Sculpture Inside and Out*. New York: Norton, 1939.

———. *Yesterday Is Tomorrow*. New York: Crown, 1965.

Hoffman, Richard. *Some Musical Recollections of Fifty Years*. New York: Charles Scribner's Sons, 1910.

Hoock-Demarle, Marie-Claire, and Claude Lianzu, eds. *Transmettre les passés: Nazisme, Vichy et conflits coloniaux: Les responsibilités de l'université*. Paris: Éditions Syllepse, 2001.

Hough, Joseph C., Jr. *Black Power and White Protestants*. London: Oxford University Press, 1968.

Hrdlička, Aleš. *A Descriptive Catalogue of the Section of Physical Anthropology, Panama–California Exposition 1915*. San Diego, Calif.: National View Company, 1914.

———. *Physical Anthropology: Its Scope and Aims, Its History and Present Status in the United States*. Philadelphia: Wistar Institute of Anatomy and Science, 1919.

Hurst, Charles, Jr. *Passport to Freedom: Education, Humanism and Malcolm X*. Hamden, Conn.: Linnet Books, 1972.

Jacobson, Matthew Frye. *Whiteness of a Different Color*. Cambridge, Mass.: Harvard University Press, 1998.

Jones, Catherine A., and Peter Galison, eds. *Picturing Science, Producing Art*. London: Routledge, 1998.

Karp, Ivan, Christine Mullen Kreamer, and Steven D. Lavine. *Museums and Communities: The Politics of Public Culture*. Washington, D.C.: Smithsonian Institution Press, 1992.

Karp, Ivan, and Steven D. Lavine. *Exhibiting Cultures: The Politics of Museum Display*. Washington, D.C.: Smithsonian Institute Press, 1991.

Keith, Arthur. *An Autobiography*. London: Watts, 1950.

———. *Ethnos, or the Problem of Race Considered from a New Point of View*. London: Kegan Paul, Trench, Trubner, 1931.

———. *Man: A History of the Human Body*. New York: Holt, 1912.

———. *Nationality and Race from an Anthropologist's Point of View*. London: Humphrey Milford and Oxford University Press, 1919.

Kendall, Laurel, Ruth S. Freed, Stanley A. Freed, Thomas Rose Miller, Barbara Mathe, and Laila Williamson. *Drawing Shadows to Stone: The Photography of the Jesup North Pacific Expedition, 1871–1902*. New York: American Museum of Natural History in association with Douglas and McIntyre, 1997.

Koenig, Barbara A., Sandra Soo-Jin Lee, and Sarah S. Richardson, eds. *Revisiting Race in a Genomic Age*. New Brunswick, N.J.: Rutgers University Press, 2008.

Kroeber, Alfred. *Anthropology: Biology and Race*, revised edition. New York: Harcourt, Brace and World, 1948.

Landau, Misia. *Narratives of Human Evolution*. New Haven, Conn.: Yale University Press, 1991.

Latour, Bruno. *Science in Action*. Cambridge, Mass.: Harvard University Press, 1987.

Laughlin, Harry H. *The Second International Exhibition of Eugenics*. Baltimore: Williams and Wilkins, 1923.

Leach, William. *Land of Desire: Merchants, Power, and the Rise of a New American Culture*. New York: Vintage Books, 1994.

Le Normand-Romain, Antoinette, Anne Roquebert, et al. *La sculpture ethnographique de la Vénus Hottentote à la Tehura de Gauguin*. Paris: Éditions de la Réunion des Musées Nationaux, 1994.

Linton, Ralph, ed. *The Science of Man in the World Crisis*. New York: Columbia University Press, 1945.

Lippmann, Walter. *Public Opinion*. New York: Macmillan, 1922.

Lowie, Robert. *An Introduction to Cultural Anthropology*. New York: Farrar and Rinehart, 1934.

Luschan, Felix von. *Voelker Rassen Sprachen*. Berlin: Welt Verlag, 1922.

Lynch, Michael, and Steven Woolgar, eds. *Representation in Scientific Practice*. Cambridge, Mass.: MIT Press, 1990.

Macdonald, Sharon, ed. *The Politics of Display: Museums, Science, Culture*. London: Routledge, 1998.

Marcus, George E., and Fred R. Myers, eds. *The Traffic of Culture: Refiguring Art and Anthropology*. Berkeley: University of California Press, 1995.

Margerie, Laure de, and Édouard Papet, eds. *Charles Cordier (1827–1905), sculpteur: L'autre et l'ailleurs*. Paris: Éditions de la Martinière, 2004.

Martin, Rudolf. *Lehrbuch der Anthropologie in systematischer Darstellung*, 2nd ed. Jena: G. Fischer, 1928.

McCarthy, Kathleen. *Women's Culture: American Philanthropy and Art, 1830–1930*. Chicago: University of Chicago Press, 1991.

McCormick, L. Hamilton. *Characterology*. New York: Rand McNally, 1920.

McGreevy, John T. *Parish Boundaries: The Catholic Encounter with Race in the Twentieth-Century Urban North*. Chicago: University of Chicago Press, 1996.

Montagu, Ashley. *Man's Most Dangerous Myth*, 2nd ed. New York: Columbia University Press, 1945.

Montagu, Ashley, ed. *The Concept of Race*. Toronto: Collier-Macmillan Canada, 1969.

———. *Frontiers of Anthropology*. New York: George P. Putnam's Sons, 1974.

Montessori, Maria. *Pedagogical Anthropology*. Translated by Frederic Taber Cooper. New York: Frederick A. Stokes, 1913.

Morton, Patricia. *Hybrid Modernities: Architecture and Representation at the 1931 Colonial Exposition, Paris*. Cambridge, Mass.: MIT Press, 2000.

Musée d'Orsay. *À fleur de peau: Le moulage sur nature au XIXe siècle.* Paris: Réunion des Musées Nationaux, 2001.

Myrdal, Gunnar. *An American Dilemma: The Negro Problem and Modern Democracy.* New York: Harper, 1944.

National Sculpture Society. *Contemporary American Sculpture: The California Palace of the Legion of Honor.* New York: Kalkhoff, 1929.

O'Brien, Maureen C., et al. *Fauns and Fountains: American Garden Statuary, 1890–1930.* Southampton, N.Y.: The Parrish Art Museum, 1985.

Omi, Michael, and Howard Winant. *Racial Formation in the United States: From the 1960s to the 1990s.* London: Routledge, 1994.

Osgood, Wilfred. *Taxidermy and Sculpture: The Work of Carl E. Akeley in the Field Museum of Natural History.* Chicago: Field Museum of Natural History, 1927.

Powell, Richard J., et al., eds. *Rhapsodies in Black: Art of the Harlem Renaissance.* London: Hayward Gallery, 1997.

Reynolds, Larry T., and Leonard Lieberman, eds. *Race and Other Misadventures: Essays in Honor of Ashley Montagu in his Ninetieth Year.* New York: General Hall, 1996.

Roberts, John, ed. *Art Has No History! The Making and Unmaking of Modern Art.* New York: Verso, 1994.

Rodgers, William. *Think: A Biography of the Watsons and IBM.* New York: Stein and Day, 1969.

Rodin, Auguste. *Rodin on Art and Artists: Conversations with Paul Gsell.* Translated by Mrs. Romilly Fedden. 1912. Reprint, New York: Dover, 1983.

Rydell, Robert W. *All the World's a Fair.* Chicago: University of Chicago Press, 1984.

Sapir, Edward. *The Psychology of Culture: A Course of Lectures.* Edited by Judith T. Irvine. New York: Mouton de Gruyter, 1994.

Seligman, C. G. *Races of Africa.* New York: Holt, 1930.

Shapiro, H. L. *Migration and Environment.* London: Oxford University Press, 1939.

Simonson, Lee. *The Stage Is Set.* New York: Theatre Arts Books, 1932.

Slobodkin, Louis. *Sculpture: Principles and Practice.* New York: World Publishing, 1949.

Smith, Grafton Elliot. *The Evolution of Man.* Oxford: Oxford University Press, 1924.

Smith, Terry. *Making the Modern.* Chicago: University of Chicago Press, 1993.

Staniszewski, Mary Anne. *The Power of Display: A History of Exhibition Installations at the Museum of Modern Art.* Cambridge, Mass.: MIT Press, 1998.

Steggerda, Morris. *Anthropometry of Adult Maya Indians: A Study of Their Physical and Physiological Characteristics.* Washington, D.C.: Carnegie Institute of Washington, 1922.

Stibbe, E. P. *An Introduction to Physical Anthropology.* London: Edward Arnold, 1930.

Stocking, George W., Jr. *Race, Culture, and Evolution: Essays in the History of Anthropology.* New York: The Free Press, 1968.

Stocking, George W. Jr., ed. *Objects and Others: Essays on Museums and Material Culture.* Madison: University of Wisconsin Press, 1985.

Susman, Warren. *Culture as History: The Transformation of American Society in the Twentieth Century.* New York: Pantheon Books, 1984.

Thomas, Bertram. *Arabia Felix: Across the "Empty Quarter."* New York: Charles Scribner's Sons, 1932.

Thomas, Wendell. *Hinduism Invades America.* New York: Beacon Press, 1930.

Tuchman, Maurice, et al. *The Spiritual in Art: Abstract Painting, 1890–1985.* Los Angeles: Los Angeles County Museum of Art, 1986.

Ward, Logan. *An Explorer's Guide to the Field Museum.* Chicago: Field Museum, 1998.

Watson, Thomas Jr., and Peter Petre. *Father, Son and Company.* New York: Bantam Books, 1990.

Wendt, Lloyd, and Herman Kogan. *Give the Lady What She Wants!* South Bend, Ind.: And Books, 1952.

Willkie, Wendell. *One World.* New York: Simon and Schuster, 1943.

Wilson, Fred. *Op-Ed: Fred Wilson.* Chicago: Museum of Contemporary Art, Chicago, 1994. An exhibition catalogue.

INDEX

Note: Page numbers in italics represent illustrations.

Académie Colarossi, 37
Agard, Walter, 46–47
Age of Bronze (Rodin), 8, 96, 98, 143, 224n56
Ainu (Hoffman), 75, 141
"Airways to Peace" (Museum of Modern Art), 173
Akeley, Carl E., 22–23, 24, 207n11
Aldrich, Mildred, 37
Alexandre, Arsène, 138, 141
Allen, Stookie, 1
Alpenfels, Ethel, 181–82
L'âme humaine, ses mouvements, ses lumières et l'iconographie de l'invisible fluidique (Baraduc), 45
American Anthropologist, 110
American Civil Liberties Union Committee Against Racial Discrimination, 145, 152
American Educator Encyclopedia, 178
American Girls Club (Paris), 37
American Masters: Sculptures from Brookgreen Gardens, 3
American Museum of Natural History, 17, 26, 50–51, 64–65, 70, 111, 117, 124, 142, 158, 165–66
American Red Cross, 40–41, 145, 151, 154–55
Anthropology and Modern Life (Boas), 27
anthropometric statues 9–10, 142. *See also* ethnographic sculpture

anthropometry, 3, 9–10, 28, 30, 68–70, 71, 76, 106, 118, 127–28, 197
antiracist pamphlets, 144, 164, 168, 181
Appia, Adolphe, 87
Appiah, Kwame Anthony, 194
Armenian Jew (Hoffman), 77–78, *77*
Arnoldi, Mary Jo, 9
Art Digest, 125, 138, 145–46, 148
artistic persona, 1, 42–43, 198, 212n33
Art News, 138, 139, 148
Art Préhistorique de l'Afrique du Nord (Musée d'Ethnographie du Trocadéro), 129
"Art Wedded to Anthropology" (Keith), 78–80, 109–10, *109*
Asian expedition, 1, 68–71
assimilationism, 38, 211n23
atlases, 3–4, 156, 158, 176–78, 238n80. *See also* cartography
Aunt Jemima and the Pillsbury Doughboy (Donaldson), 186–87, *187*
Australian (Hoffman), 65–68, *65*, 105
Australian painted plaster model (Hoffman), 66, *67*
The Average American (Harris), 142. *See also* anthropometric statues
Aztec Male (Hoffman), 64

Bacchanale Russe (Hoffman), 43
Bacon, Mrs. Roger, 37
Baraduc, Hippolyte, 45
Baraka, Amiri (LeRoi Jones), 188, 189, 191, 192, 242n21
Barnard, Chester Irving, 168–69
Barr, Alfred, 88. *See also* museum displays; Museum of Modern Art

Barrie, Erwin S., 136–39. *See also*
Grand Central Galleries
Benedict, Ruth, 19, 92–93, 144–45, 152,
163, 168–69, 172, 181
Bengali, India (Hoffman), 102
Bengali Woman (Hoffman), 100–101,
101
Benjamin, Walter, 198
Berenson, Bernard, 87
Best, Walter, 47
Black, Davidson, 69
Black Arts Movement, 190, 242n26
"Black is beautiful," 193
Black Nationalism, 186, 194
Black Power movement, 19, 183,
185–94, 241n10
Blandat, Max, 38
Blaschke, Frederick, 25, 48, 49. *See also*
prehistoric reconstructions
Boas, Franz, 26: on anthropologists'
and anatomists' concepts of racial
types 27; Boasian anthropology,
152, 165; on cephalic index, 27–28;
criticism of anthropometric statues,
10; criticism of Arthur Keith's racial
theory, 29, 104, 210; exhibit plan-
ning advisory role, 26; Laufer cor-
respondence, 209n42; on museum
architecture and methods of display,
86–87; on panoramas, 86–87; racial
classification, 209n31; recommenda-
tions for a museum display on race,
27–28
Bogart, Michele, 42
booklets, 168–76. *See also* specific
booklet titles
Borglum, Gutzon, 14, 36, 38
boundary objects, 4, 143, 203n8
Bourdelle, Antoine, 47
Bourke-White, Margaret, 149. *See also*
"Who Is News Today" photomural
Brahmin Benares (Hoffman), 101
Breuil, Abbé Henri, 25, 77
British Museum, 17, 59, 64

Brotherhood of Man concept, 4, 33,
102, 144–48, 150, 151, 155–56
Brown, William O., 104. *See also*
stereotype
Brown v. Board of Education (1954),
186
Buck, Pearl, 145, 151–52, 155, 235n28–30
Bushman Family, Kalahari Desert
(Hoffman), 75, 92, 93–94, *94*, 105,
193
Buxton, Dudley, 26, 28, 30–32, 49, 105

Camper, Petrus, 99. *See also* facial
angle
Carpeaux, Jean-Baptiste, 6, 37, 38, 43,
52, 140
cartographic projections, 173; conical
projection, 172; Mercator projec-
tion, 160, 172, 173, 174; sinusoidal
projection, 174
cartography, 3–4, 156, 161–62. *See also*
specific map titles
Carrel, Alexis, 64
Carter, Edward, 164–65
casting. *See* plaster casting
Century of Progress Exposition (Chi-
cago world's fair, 1933), 29, 105, 111,
117, 136
cephalic index, 5, 27, 28, 110, 113, 114,
127. *See also* anthropometry
Champlain, Duane, 74, 218n91
"Change in Bodily Form of Descen-
dants of Immigrants" (Boas), 27. *See
also* cephalic index
character: divination of, 45–47; rheto-
ric of, 3, 8, 12, 18, 36, 47, 145, 165, 198,
203n5; Rodin's views on, 43–45
"Character and the Face" (Knight), 100
Chatterji, Kamala, 81. *See also Bengali
Woman*
Chauvel, Georges, 74
Chicago Daily News, 105
Chicago Freedom Movement, 185
Chicago Schools Journal, 181

Chicago Tribune, 131, 197
Chinese Jinriksha Coolie (Hoffman), 95–96, *95*
Chinese Woman, Type of Scholar, Southern China (Hoffman), 78–81, *79*, 110
Chinese Women's Relief Association, 150–51
Citroën expedition, 60, 63
Clark, Kenneth and Mamie, 186
Clark, Walter L., 136, 137. *See also* Grand Central Galleries
clay modeling, 2, 6–7, 11–12, 18, 24, 41–42, 58, 75, 140
Clifford, James, 127
Cole, Glen, 190
composite figures, 10, 11, 92, 142–43
composite photography, 10, 63–64. *See also* photography
Congo Chief (Ward), 9
Congress of Racial Equality (CORE), 145, 185
Coordinating Council of Community Organizations (CCCO), 185
Cordier, Charles, 6, 8
Corris, Michael, 169
Cortissoz, Royal, 140–41, 198
Cranial Deformation and Evolution (H. Field), 120–22, *121*
craniology, 110, 113–15, 121. *See also* anthropometry
Criminal Man (Lombroso), 120
La croisière noire (Haardt), 60
C. S. Hammond and Company, 156, 162–64. *See also* specific map titles
Curtis Lighting Company, 90, 220n1

Dalou, Jules, 7
Daston, Lorraine, 7. *See also* objectivity
Daumal, René, 128, 132, 135
Davenport, Charles, 29, 142. *See also* eugenics
Davidson, Jo, 47, 235n23
Davies, David C. (Director, Field Museum, 1921–28), 21

De Andrea, John, 197, 199
Defiance (Ward), 9
Deniker, Joseph, 127
Denning, Michael, 144
Design Works of Bedford-Stuyvesant, 190
Deutsch, Albert, 155
Didi-Huberman, Georges, 7. *See also* life casting
dioramas, 18, 22, 23, *24*, *25*, 32, 60–61, 86, 87, 88, 112, 129, 212n23. *See also* ethnographic lay-figures; habitat groups; Hall of Prehistoric Man; Salle de préhistoire exotique
direct casting. *See* life casting
Distress (Ward), 9
divination of character, 12, 44–47, 234n19. *See also* character
Dixon, Roland, 69
Dodge, Mabel, 37
Donaldson, Jeff, 186–88
Donne, John, 147–48
Double Victory Campaign, 145, 154
Douglas, Aaron, 61–62
Durham, Carl Thomas, 169

Eberle, Abastenia St. Leger, 39
Eiselen, Elizabeth, 90
Elephant Hunter (Hoffman), 76–77, 138
Emergency Fund for Needy American Artists, 139
encyclopedias, 178. *See also* atlases; cartography; specific encyclopedias
endocranial casts, 120–22
Enwezor, Okwui, 5
Epstein, Jacob, 47
Ethiopian Male (Hoffman), 59, 193
ethnographic humanism, 127
ethnographic lay-figures, 23–26, 60–61, 140, 199
ethnographic sculpture, 5–16, 103, 132, 134
ethnologie, 126–27
Eugenical News, 110, 112

eugenicists, 29, 99, 117

eugenics, 18, 29, 39, 59, 99, 110, 111–12, 117, 118, 142, 212n30

Eugenics Record Office, 59, 111, 212n30

evolution, theories of: Gregory, 111; Haddon, 31; in Hall of Prehistoric Man, 25; in Hall of the Races of Mankind, 111–22, 123; Herskovits, 104; Hrdlička, 12, 13, 14, 16; Keith, 29, 100, 103–4, 107–10, 122, 170, 181; Laughlin, 112; Rivet, 127, 134; Smith, 122. *See also* phylogenic tree; racial classifications

exhibition techniques. *See* museum displays

Expédition Citroën, 60, 63

Exposition Coloniale (Paris, 1931), 61, 68, 89, 134, 225n74

facial angle, 99, 114, 127, 149

facial features: and physiognomic decipherment, 6, 44–45, 64, 99–100, 127–28, 217n57; and racial classifications, 16, 28, 30, 110, 115–16, 167–68, 184, 209n31; and representational techniques, 11–12, 14, 50, 98, 101–2, 141, 171

Farrington, Oliver, 114

Fassbender, Adolf, 149. *See also* "Who Is News Today" photomural

fauvism, 36, 132

Field, Evelyn I. Marshall, 48

Field, Henry (Assistant Curator, Physical Anthropology, Field Museum, 1926–35): consultations with expert anthropologists, 18, 26–28, 30, 68–69; consultations with Hoffman, 48, 56; eugenics inclusion in Hall of the Races of Mankind, 111–12; Field family expectations, 25–26; Hall of Physical Anthropology plan, 31–32; Hall of Prehistoric Man, 24–25, 122, 123, 211n67; Hall of the Races of Mankind guidebook

essay, 99, 106, 110, 115–16, 178, 185; Hall of the Races of Mankind tour arrangements, 105; Hoffman Asian expedition, 68; Hoffman premonition, 214n68; hyperpituitarism study, 30; limited knowledge of physical anthropology, 25–26, 32; natural history museum visits, 28, 30; Oxford education, 25–26; praise received for guidebook, 110; Project "M" (migration) study, 158; racial classification conflicts, 77, 92, 216n61, 223n48 ; sculpture production disagreements, 49, 54, 56; special scientific exhibit development, 19, 28, 30, 50, 105, 111–23

Field, Marshall, 25, 208n20

Field, Marshall III, 25, 48–49, 56, 67, 89, 162, 178, 208n20, 221n28, 222n30

Field, Stanley (President, Field Museum, 1908–61): appraisal of Hoffman, 34; exhibition preferences, 18, 21–22, 32–33, 89, 113, 221n28, 222n30; first meeting with Hoffman, 48; on Hall of Prehistoric Man, 106; at Marshall Field and Company, 21, 207n7; museum endowments, 208n20; personal contract with Hoffman, 217n70; racial classification conflicts, 64, 73–74, 76–81; and *Races of the World and Where They Live* map, 158, 162, 165; sculpture production preferences, 50, 52, 54–56, 66; on sculpture reproduction rights, 125–26

Field Enterprises, 178, 189, 208n20

Field family museum endowments, 208n20

Field Museum, 16–20, 21–22, 22–25, 88, 208n20

Field Museum commission: contractual arrangements, 49–50, 56, 59, 66, 125–26; cost estimates, 49; planning processes, 48–50; representational techniques, 50–68; substitutions, 76–77, 81

Field Museum News, 93, 224n68
Le Figaro, 132
Four Seasons dioramas (Field Museum), 22–23
Fraser, Arthur, 21
Freire, Paulo, 191
Friendship of the English Speaking Peoples (Hoffman), 35, 43
Frobenius, Leo, 129

Galison, Peter, 7. *See also* objectivity
Gallotti, Jean, 134
Galton, Francis, 63. *See also* composite photography
Gelert, Johannes, 23
gender: and artistic training, 37–39; in definitions of creativity, 46, 133; division in National Sculpture Society, 41; and notion of successful woman sculptor, 40; and nuclear family structure in dioramas, 22–25; in Races of Mankind sculptures, 93–94; stereotype of woman sculptor (nineteenth-century), 38, 75
genetics, 5, 166, 168, 181, 183, 184
Getty Research Institute, 4
Godin, Huguette, 133
The Good Earth (Buck), 151–52
Good Housekeeping, 40
Grand Central Galleries (New York), 136–38
Grand Central Galleries exhibition *(Races of Man)*, 19, *135*, 136–43
Les grands initiés (Schuré), 52, 102
Green, Gretchen, 69, 80
The Green Line (Matisse), 36
Gregg, Clifford (Director, Field Museum, 1937–62), 185
Gregory, William K., 111, 117
Griaule, Marcel, 126, 130, 131, 154, 236n49
Griesemer, James, 4. *See also* science studies

Grimson, Samuel B., 34, 69, 70, 79–80, 118, 149
Group of Cockfighters (Hoffman), 70–71, 91–92, *91*, 106
Gruppe, Karl, 50, 74, 218n96
Gsell, Paul, 98
Guérin, Lucien-Georges, 74, 218n93
Günther, Hans, 99
Gurney, George, 41–42

Haardt, Georges-Marie, 60, 216–17n54
habitat groups, 22–24, 32. *See also* dioramas
Haddon, Alfred, 26, 30–32, 105, 110, 117, 128, 149, 169, 222n33, 228n145
Haeckel, Ernst, 116. *See also* phylogenic tree
Hafemann, Henrietta, 181–82
Hall of Physical Anthropology (proposed), 16–17, 21, 26–29, 31, 56, 206n1. *See also* Hall of the Races of Mankind
Hall of Prehistoric Man (Field Museum), 21, 24–25, 28, 48, 50, 105–6, 112, 122–23, 208n19, 211n67
Hall of the Races of Mankind, 2, *53, 83, 84*: alcove design, 82, 90, 99–100; closure of, 189; collaborators, 88–90; deviation from racial logic of 1930 plan, 105–6; diorama format and plans for wall cases, 49, 89, *89*, 221n23, 221n28; exhibition format, 82–86, 89–90; facilitating multiple frameworks and generating ambiguity, 90–91, 99–103; geographic arrangement of sculptures, 106; Hoffman development of installation design, 88–90, 221n23; lighting, 82–83, 90, 220n1; location in Field Museum, 106; octagonal room, 82, 84, 96, 103, 105; opening and first reactions to, 90, 104–6, 138; plan diagrams, *31, 83*; publicity campaigns, 104–10; reasons for name change,

56; renovation need, 183–85; scale and palatial architectural spaces, 82, 85–90; shadow boxes, 82–83, 102; sources for format, materials, and critical influences, 86–90; special scientific exhibit, 111–23; taxonomic order, 90, 222n33; wood pedestals, benches, and simulated wood flooring, 82, 89, 103

Hambly, Wilfred, 176, 178

Hamiticization theory, 115–16, 189

Hammond atlases, 3–4, 156, 176, 181. *See also* atlases; C. S. Hammond and Company

Harriman, Mrs. E. H., 39, 40–41, 43–44, *44*, 136, 212n29–30. *See also* eugenics

Harris, Jane Davenport, 142

Harrison, Richard Edes, 173

Harvard University, 10, 50, 69, 208n23

Hauser, Emil, 119–20

Hawaiian Surf-Rider, Polynesia (Hoffman), 70, *72*, 133, 138

Hawaiian Surf-Rider, Polynesia sketch (Hoffman), *73*

"head hunting," 1, 59, 165, 177

Heads and Tales (Hoffman), 45, 162, *163*

Henderson, Linda, 45

Heng, Auguste, 61

Herskovits, Melville, 104, 110

Hildebrand, Adolf, 86, 87, 96. *See also* stereotype

Hoffman, Fidelia M. Lamson (mother), 36

Hoffman, Malvina, *35*, *71*, *146*; artistic studies, 37–40; Asian expedition, 68–71; background and family connections, 36; character divination, 45–47, 213n65, 234n19; collaboration with IBM designers, 156, 158, 159–60, *160*, 161–62; collaborative studio process 18, 47, 71–74; contractual

arrangements, 49–50, 59, 66, 125, 217n70, 221n23, 229n3; exhibition design involvement, 88–90, *89*, 221n23; Grand Central Galleries exhibition role, 138; Hall of the Races of Mankind publicity, 105; as "head hunter," 1, 165, 177; influences, 37–40, 43–45; Keith relationship, 34–35; *Men of the World* benefit exhibition and photomurals, 145–56; *Men of the World* brochure design, 148; on modern art, 37; on modern setting for exhibits, 220–21n21; objections to cultural practices displays, 120; patrons, 39–41, 130, 136, 139, 212n29; philanthropic activities and associations, 40–41, 155; and photography, 59–64, 221n22; on pricing, 125; primitivism, 102, 176–77; as promoter, 34–35; psychic abilities and phenomena, 45–46, 213n65, 214n68; Races of Mankind involvement overview, 18–19; racial classification conflicts, 76–81; reverence for artists, 36, 39; rhetoric of character, 3, 8–9, 45–46; and Rodin, 36, 38–39, 43, 96, 98, 133, 134, 140, 141, 224n65; sculpture production hierarchy, 41–42; Slobodkin on, 74, 75–76; social connections, 37–38, 42, 43, 69–70, 139, 212n29; social status, 34, 36, 40; on Trocadéro exhibition, 126, 135; Trocadéro exhibition role, 130–31

Hoffman, Richard (father), 36

Holmes, William Henry, 23–24

Hooton, Earnest, 26, 50, 52, 68–69, 166, 208n23

Houdon, Jean Antoine, 37, 43, 46–47

House Military Affairs Committee, 169

Hovenden, Thomas, 23

Hrdlička, Aleš, 12–16, 18, 21, 26, 28, 30, 52, 88, 109, 111, 114, 165, 166, 209n42

Hughes, Langston, 155

Hunterian Museum (London), 29–30
Hurst, Charles Jr., 185–86, 188, 190, 191, 192, 193
Hyatt, Anna, 40

Illustrated London News, 78, 80, 109
L'Illustration, 133–34
Institute of Pacific Relations, 164
International Business Machines Corporation (IBM), 148, 150, 156, 157, 158, 159, 162, 163, 238n78
International Studio, 46–47
An Introduction to Physical Anthropology (Stibbe), 122
"Is There a Physical Basis for Race Superiority?" (Krogman), 166

Jacobson, Matthew Frye, 144
Jaipur Woman (Hoffman), 102, 110
Jakun (Hoffman), 106, 115, 178
Jakun Woman (Hoffman), 106, 115, 178, 196
Jamin, Jean, 129
"Janet Scudder Tells Why So Few Women Are Sculptors" (Scudder), 38
Jewell, Edward Alden, 140, 141–43
Jones, LeRoi (Amiri Baraka), 188, 189, 191, 192, 242n21
Jones, Walter, 184

Kahanamoku, Sargent, 70
Kashmiri in Attitude of Meditation (Hoffman), 101–2
Kawamura, Gozo, 72, 218n90
Keith, Arthur, 57: advisor to Hall of Prehistoric Man, 24–25, 28; anthropometry devaluation, 28–29, 108, 128; on cephalic index, 28; on craniology, 114; credentials, 28, 209–10n43; on diagnosing race as an instinctive process, 28, 42, 106, 108; exhibit planning advisory role, 26, on Hall of the Races of Mankind and his theories, 78–80, 108–9; Hall of the Races of Mankind guidebook essay, 107–8; Hall of the Races of Mankind publicity, 105; Hoffman relationship, 34–35, 56–57; on Hoffman as sculptor, 68–69, 108; on museum exhibition techniques, 107–8; on nationalism and war instinct, 103–4, 170; portrait, 57; racial classification, 108; on racial prejudice as an evolutionary mechanism, 103–4, 170; racial theory of endocrine action, 29–30, 210n53, 224n62; on reading facial muscles, 100; recommendations for a museum display on race, 29–30; sculpture production approval, recommendations, and disagreements, 58–59, 64–67, 103
Kelley, Harper, 130
Kent, Henry W., 89–90, 221–22n29
Kerner Report, 186
Kitson, Henry Hudson, 9–10
Kitson, Theodora Alice, 9–10, 40
Knight, Rex, 100
Kroeber, Alfred, 114, 122
Krogman, Wilton, 110, 111, 168, 169, 182: credentials, 58, 104, 165; criticism of race prejudice as evolutionary mechanism, 181; as Hoffman advisor, 68, 215–16n36; racial studies and evolving ideas on race, 166; revisions to *Races of the World and Where They Live* map, 165–67; sculpture production approval and disagreements, 64; *World Book Encyclopedia*, 178–81, 179, 180; writings in anti-racist pamphlets, 239n109

Lamarckian concept of acquired characteristics, 18, 119
Lamarckian law of Transformism, 31
Landis, Carney, 100
Latour, Bruno, 203n8. *See also* science studies

Laufer, Berthold (Anthropology Curator, Field Museum, 1915–34), 26: on anthropology displays as university courses, 112; Boas correspondence, 209n42; on ethnographic accessories, 55–56; on ethnographic life groups, 207–8n17; Hall of Physical Anthropology proposals, 16–17, 21; Hall of the Races of Mankind guidebook essay, 106–7; limited knowledge of physical anthropology, 32; as mentor to Henry Field, 26; on physical functions v. measurements, 96; racial classification conflicts, 58–59, 76–81, 120, 216n41, 223n36; on racial intermarriage, 226n102; sculpture production disagreements, 54–56, 65, 78–81

Laughlin, Harry H., 111, 112. *See also* eugenics

Lebzelter, Viktor, 117

Lécuyer, Raymond, 132

Lehrbuch der Anthropologie (Martin), 114

Leja, Michael, 23

Lenz, Fritz, 99

Leroi, Armand Marie, 5

Levy-Bruhl, Lucien, 110

Lewis, Philip, 184, 190–91

life casting, 2–3, 6–8, 14, 50–52, 205n37

Ligon, Glenn, 5

Lin Yu Tang, Mrs., 151

Lippmann, Walter, 95–96. *See also* stereotype

Locke, Alain, 150, 153, 236–37n50

Lombroso, Cesare, 45–46, 120, 217n57

Luschan, Felix von, 59

Lutten, Eric, 130

Lyon, Gabrielle, 25

MacMonnies, Frederick, 37, 38, 43, 136

Maillol, Aristide, 47

"Main Characteristics of the Three Great Stocks of Man" (*World Book Encyclopedia*), 178, *180*

Malcolm, L. W. G., 66, 68

Malcolm X College, 19, 183, 185–86, 188, 190

Malcolm X College exhibit, 190–94, *192*

Malvina Hoffman (Alexandre), 138, 141

Mangbetu Woman (Hoffman), 60, *61*, 62, 116, 192, 193

Man's Most Dangerous Myth (Montagu), 168

"Man's Variation" physical anthropology exhibit, 14–16, *15*

Map of Mankind (Hoffman, C. S. Hammond), 19, 156–68, 176, 189, 239n114; frontispiece, 189. See also *Races of the World and Where They Live*; "Who Is News Today" photomural

maps. *See* cartography

Marco, Jean de, 69, 72, *73*, 118

"The Marriage of Museums" (Mumford), 86, 87, 139–40

Marshall Field and Company (department store), 207n7, 208n20; window displays, 21

Martin, Paul (Anthropology Curator, Field Museum, 1934–64), 165–67, 169, 178, 241n4

Martin, Rudolf, 114

Martinique Woman (Hoffman) 131, 134, 138

Mascré, Louis, 14, 25

"The Masterpiece and the Modeled Chart" (Jewell), 142–43

Matisse, Henri, 36

Mauss, Marcel, 66, 129

May, Andrew J., 169

Maya Male (Hoffman), 59, 196

McBride, Henry, 137, 138

McCartan, Edward, 40, 136

Men of the World benefit exhibition, *146*: brochure, 148–49, *148*; Brotherhood of Man concept, 145–48;

joint exhibition honoring Hoffman, 153–54; and Nordicism, 150, 154; organizations and individuals supporting, 150–56, 234n8, 234n12, 235n23; and racial equality, 150–51, 154; statuettes, 145–46; "Victory" photomural, *147*, 234n13; "Who Is News Today" photomural, 149–50, *149*, 159, 161

Meštrović, Ivan, 47

Mička, Frank, 14

Monier, Emile Adolphe, 61

Montagu, Ashley, 148, 168, 169

Montessori, Maria, 99

Morgan, Anne, 153

morphology: Boas on head shape, 27; body proportions in Hall of Prehistoric Man, 21; in *Cranial Deformation and Evolution* display, 121; Haddon on hair form and nose shape, 30; muscle forms in *Unity of Mankind*, 54–55; in racial classifications, 6, 26; Rivet on visual assessments, 127–28

Most People in the World Have In-Between-Color Skin (Reinhardt), 172–74, *173*

Mumford, Lewis, 86, 87, 139–40, 143

Murdocci, Eve, 37

Musée d'Ethnographie du Trocadéro de Paris, 19, 64–65, 76, 124, 126–35, *126*, 138

Musée d'Orsay, 6

museum architecture: German cabinet 86, 89; palatial model, 85–87, 138

museum displays: comparative exhibits, 16, 29, 32, 122, 123, 129; dioramas, ethnographic life groups, and habitat groups, 18, 22–25, 32, 86–88, 112, 129; dual arrangement at Field Museum, 25, 50; equivalence to university courses, 17, 112; phylogenic tree diagrams, 116–17; and public education, 21–24, 86; systematic or taxonomic exhibits, 12, 14, 16, 18, 21, 28, 87, 90. *See also* Hall of the Races of Mankind

museum fatigue, 87, 129

museum objects: exhibition objects v. study collections, 6, 17, 52, 129; as material witness, 130; as representative or characteristic types, 16, 60, 129; in representative series, 16, 28

Museum of Contemporary Art (Chicago), 20, 183, 195–96, *196*, 199

Museum of Modern Art, 88, 172

museum preparators, 6, 12, 14, 22, 30, 50, 57, 132, 140, 193

"Museum Showmanship" (Simonson), 87

Myrdal, Gunnar, 144

National Advisory Commission on Civil Disorders, 186

National Association for the Advancement of Colored People (NAACP), 185

National Geographic Society, 164

National Sculpture Society, 18, 41, 74, 213n53

National Urban League, 152–53, 154–55, 236n44

National Urban League Guild, 150, 152–53, 155, 236n44

Negro Dancing Girl, Sara Tribe [Daboa] (Hoffman), 62–63, *62*, 66, 119, 134, 135, 138, 153, 192, 194, 216–17n54

Nelson, N. C., 165–66

New Masses, 169, 240n130

Newsweek, 161

The New Yorker, 143, 163

New York Herald Tribune, 140–41, 148

New York studio, 34, 56, 72, 74–75, 158, 235n28

New York Times, 5, 29, 38, 105, 108–9, 141–42, 147–48, 151, 161

Ni Polog, 70, *71*. See also *Group of Cockfighters; Woman, Bali*

"Nobosodrou, Femme Mangbetou" (Specht), 60–62, *60*

Nochlin, Linda, 39, 42–43, 93

Nordicism, 59, 96, 99, 108, 117, 120, 150, 154, 161, 172, 180, 224n56

Nordic Man (Hoffman), 160–61

Nordic Type (Hoffman), 67, 96–99, *97*, 120, 131, 180

Nordic Type, Great Britain (Hoffman), 35, *57*, 59

Nordic Type plaster sketch (Hoffman), 97–98, *98*

Norton, Charles Eliot, 10

La Nouvelle Revue Française, 132

Number 151: Sioux (Mayer), 50, *51*

N. W. Harris Public School Extension Program, 22

objectivity: and anthropology, 12–13, 111; and documents, 131–33, 140; and maps, 162; and mechanical forms of representation or direct casting, 7, 18, 42, 46, 58; and science, 7

Omi, Michael, 5

One World (Willkie), 172–73

"Ontogeny" physical anthropology exhibit, 14–16, *15*

OpEd (Wilson), 20, 183, 195–99, *196*

Opportunity magazine, 62, 152, *153*

Organization for Black American Culture (OBAC), 186–88

Osborn, Henry Fairfield, 99

osteological exhibits, 21, 32, 122–23

Our Food Comes from Many Peoples (Reinhardt), 174–76, *175*

pamphlets, 168–76. See also specific pamphlet titles

Panama-California Exposition (San Diego world's fair, 1915–16), 12–16, *13*, *15*, *17*, 114, 211n67

Paris studio, 1, 41, 58, 66–67, 70–71, *73*, 74–75

Parnassus (journal), 138

Passport to Freedom: Education, Humanism, and Malcolm X (Hurst), 191

pathognomy, 3, 100. See also physiognomy and physiognomic decipherment

Pattee, A. L., 167–68

Patterns of Culture (Benedict), 152

Peabody Museum, 10, 52

Pedagogical Anthropology (Montessori), 99

People Are Gentle or Warlike Depending on Their Training (Reinhardt), 170–71, *170*

The Peoples of the Earth Are One Family (Reinhardt), 171–72, *171*

Photographic Journal, 47

photography, 7, 10, 12, 45, 46, 47, 58–68, 63–64, 118, 159, 205n37, 221n22

phylogenic tree, 116–17, *116*, 123, 172, 228n145. See also evolution

"Phylogeny" physical anthropology exhibit, 13–14, *13*

The Physical Character of the Indians of Southern Mexico (Starr), 64

Physical Characteristics of Mankind (H. Field), 113–15, *113*, 128

physiognomy and physiognomic decipherment, 3, 5, 6, 8, 44, 45, 90, 99, 100, 108, 109, 115, 167, 198; avoidance of 168; destabilization of, 5, 170

Pitt-Rivers, George, 29

Plan for the Hall of the Races of Mankind (Buxton, H. Field, Haddon), 31–33, *31*, 83, 105

plaster casters, 72. See also sculptors, assistant

plaster casting, 7, 11–16, 45, 46, 52, 56, 58, 66, 205n37. See also life casting

Pöch, Rudolf, 119

Poisson, Pierre-Marie, 38

portraiture, 2, 3, 4–5, 8, 11–12, 43; anti-

portraits, 5, 36; honorific portraits, 4, 188, 193; resemblance, 36; three categories of, 46, 47, 141. *See also* character

Powdermaker, Hortense, 169

prehistoric reconstructions, 13–14, 21, 25, 48, 49

production. *See* sculpture production

prognathism, 99, 100, 127, 149. *See also* facial angle

Proper, Ida, 37, 39–40

Public Affairs Committee, 169

Public Opinion (Lippmann), 95–96

Quatre parties du monde (Carpeaux), 52, 140

quest narrative, 1–2, 8, 69, 106, 133

race: ambiguity of concept, 59, 104, 123; conflicting theories of, 18, 26–33, 103–4, 112–23; cultural construction of, 5, 168, 239n118; and population genetics, 5, 183, 184; portrait and likeness relationship, 4–5; separation from language and culture, 92–93, 107, 144, 152. *See also* anthropometry; craniology; facial features; Hall of the Races of Mankind; morphology; physiognomy and physiognomic decipherment; Races of Mankind sculptures; racial classifications; racial equality; racial identification; racial representation, concepts of

Race: Science and Politics (Benedict), 169

Les races humaines (Musée d'Ethnographie du Trocadéro exhibition), 19, 126–35, *126*

Races of Africa (Seligman), 115–16

The Races of Man and Their Distribution (Haddon), 31

"Races of Man: Basic Types" (*World Book Encyclopedia*), 178, *179*

Races of Man (Grand Central Galleries exhibition), 19, *135*, 136–43

Races of Mankind (Benedict, Weltfish), 144, 163, 168–69, 181

Races of Mankind after Viktor Lebzelter (H. Field), 116–18, *116*

Races of Mankind guidebook (H. Field): acceptance in various anthropological communities, 110; conflicting presentations of race, 106–8, 110

Races of Mankind leaflet (C. S. Hammond, Field Museum, Hoffman), 176–77, *177*, 189, 238n78

Races of Mankind sculptures: advisor approval of, 56, 58–59, 64–66, 70–71, 77, 126, 130; ambiguity of, 92–93, 95–96, 99; anthropological accuracy considerations and practices, 52, 57–60, 68–69; as boundary objects, 7, 90–91, 143; character as mediating term, 90; collaborative studio process, 18, 72–74; compositional formats of, 91–94, 99; in culture and personality studies, 92–93; display at Malcolm X College, 190–94; ethnographic figures and anatomical models, 3, 54–56, 90, 92–96; as fine art portraits of people 3, 190; narrative structures, 90–93; in OpEd: Fred Wilson, 195–99; overviews, 3–6, 18–20; photography role in production, 58–68; production disagreements, 64–68, 76–81; publicity campaigns, 104–10; racial classification conflicts, 73–81; reanimation, 195–99, *196*; reinstallation at Field Museum (1971), 189–90; sculpture effects and expressions, 96–103; shift from direct casting to mixed sculptural procedures, 50–52; shift from plaster to bronze and stone, 66–68; stereotype perception, 95–96; symbolic representations of

race, 49, 52, 55, 103, 131. *See also* Hall
of the Races of Mankind; individual
titles of sculptures
"Races of the World: A Gallery in
Bronze" (Keith), 108–9
*Races of the World and Where They
Live* (Hoffman, C. S. Hammond),
156–68, *159*, *160*, *163*, 181
racial classifications: two-race system
of Boas, 209n223; three-race system,
240n128: [of Benedict and Weltfish,
173; of H. Field, 110, 116; of Haddon,
30–32; in Hall of the Races of Man-
kind, 52, 55, 90, 103, 167, 184, 225n76;
of Hrdlička, 14, 16, 17; of Keith, 30;
of Rivet, 127]; four-race system: [in
Hall of Prehistoric Man, 123; of
Hrdlička, 28; of Keith, 108; in spe-
cial scientific exhibit, 123]; six-race
system of Stibbe, 122
"Racial Differences" chart (Hrdlička),
17
racial equality, 144–74
racial identification: visual devices
for learning, 99–100, 109–10, 128,
156, 167–68. *See also* morphology;
physiognomy and physiognomic
decipherment
racial representation, concepts
of: characteristic type, 3, 8, 16, 27,
60, 165; composite, 10–11, *10*, 63,
142–43; and representational se-
ries, 16, 28; symbolic type, 8–9, 49,
52, 55, 103. *See also* representational
techniques
Radcliffe-Brown, Arthur, 66
Raynsford, Anthony, 137
Reinhardt, Ad, 19, 169–76
Le Rempart, 132
representational techniques, 50–68
reproductions. *See* statuettes
Rivet, Paul, 126–30, 134
Rivière, Georges-Henri, 126, 128–31, 135
Rodin, Auguste, 36, 38–39, 43–45, 133,
140, 141; *Age of Bronze*, 8, 96, 98,
143, 224n56
Rodin Museum, Philadelphia, 85–86,
85
Roosevelt, Franklin Delano, 144–45
Rosales, Emanuel, 37, 38
Rossi, Rosso, *73*, *74*, 212n33, 218n90,
218n93
Ruskin, John, 142
Russian Dancers (Hoffman), 43
Rutot, Aimé, 14

Salle de préhistoire exotique (Musée
d'Ethnograpie du Trocadéro),
129–30
San Diego Museum of Man, 17, 111
San Diego world's fair (Panama-Cali-
fornia Exposition, 1915–16), 12–16,
13, *15*, *17*, 114, 211n67
Sapir, Edward, 55, 93, 223n40
Sargent, Dudley, 9–10
Saulo, Maurice, 74–75, 218n94
Scarpa, Carlo, 198
Schreckengost, Victor, 61
Schultz, Adolph, 66
Schuré, Édouard, 52, 102
Schweppe, Mrs. Charles, 49, 54
science studies, 4, 203n8
Scudder, Janet, 37, 38, 39, 40, 45, 46, 136
sculptors, assistant, 18, 38, 41–42,
71–76, 118, 131, 218n90
Sculptors' Guild, 213n53
*La sculpture ethnographique de la
Vénus Hottentote à la Tehura de
Gauguin*, 6
Sculpture Inside and Out (Hoffman),
162
Sculpture: Principles and Practice (Slo-
bodkin), 42
sculpture production, 41–42, 64–68,
71–81, 213n53
Sekula, Allan, 4
self-awareness, 186
Self-Portrait Exaggerating My Black

Features/Self-Portrait Exaggerating My White Features (Ligon), 5

Seligman, Charles, 115–16

Senegalese Warrior (Hoffman), 131, 134, 138

Sense and Nonsense about Race (Alpenfels), 181–82Sergi, Giuseppe, 115

Setzler, Frank, 11

Shapiro, Harry, 50, 69, 70, 158, 164–65

Shapley, John, 55

Simms, Stephen (Director, Field Museum, 1928–37), 22, 55, 78, 105

Simonson, Lee, 87–88, 89–90, 221–22n29

Simpson, Lorna, 5

Sioux Indian Male (Hoffman), 50, *51*, 198

skin color: bronze v. painted plaster figures, 49, 66–67; denotation in hand-colored photographic transparencies, 67, 118; denotation through patina, 67; denotation through stone materials, 67; in Hall of the Races of Mankind guidebook, 107, 110, 116; and painted plaster figures exhibited at Malcolm X College, 193; in *Physical Characteristics of Mankind* wall case, 113–15; and *Races of Mankind* leaflet, 171, 172–74; and *Races of the World and Where They Live* map, 160, 162; in racial classifications, 5, 16, 30, 120, 127, 160, 162, 171, 172–74

Slobodkin, Louis, *73*: contract and involvement in project, 74–75, 130, 216n36, 218n97, 219n98; on fashioning an artistic persona, 212n33; on Hoffman Asian expedition, 70; on Hoffman as sculptor, 75–76; Keith portrait collaboration, 58; as sculptor, 74; and Sculptors' Guild, 213n53; on social dynamics for sculptors, 42

Smith, Grafton Elliot, 24, 122, 228n145

Smith Sound Eskimo (U.S. National Museum, Smithsonian Institution), *24*

Society of Women Geographers, 139

the Sorbonne, 66

Sorcerer (Ward), *9*

Specht, George, 60

The Stage Is Set (Simonson), 87–88

Staniszewski, Mary Anne, 88

Star, Susan Leigh, 4. *See also* boundary objects

Starr, Frederick, 64

Statues of Typical Americans, Male and Female (Kitsons), *10*

statuettes: art v. science, 141–43; commodity status of, 124–25; contractual arrangements, 125, 229n3; critical response, 131–35, 139–43; as cultural types, 152; dance figures, 43; Grand Central Galleries exhibition, 136, 138–39; *Men of the World* exhibition, 145, 146, 153; National Sculpture Society female members' production of, 41; publicity value, 125–26, 130, 135–36, 138–39, 143; social life of, 124–25; Trocadéro exhibition, 126–35; and "Who Is News Today" photomural, 235n21

Stein, Gertrude, 37

stereotype, 75, 91, 95, 96, 104, 120, 185, 186, 187, 193

Stewart, T. Dale, 11–12, 14

Stibbe, Edward P., 122

Summer diorama (Field Museum), 22–23, *23*

system of gazes, 22, 198

Taft, Lorado, 40, 136

Taylor, Joshua, 36

Teall, Gardner, 40

Theosophy, 53, 102

THINK magazine, 157, 163

Time, 137–38, 161

Todd, Wingate, 68, 104, 111, 112, 166

Toklas, Alice B., 37

Topinard, Paul, 128
Tozzer, Alfred, 69
travel narrative, 1–2, 8, 69, 106, 133
tree diagram, 116–17, 123, 172, 228n145, 116. *See also* evolution
Trocadéro exhibition *(Les races humaines)*, 19, 124, 126–35, *126*
Twenty Modern Americans (Cooper, Palmer), 1–2

United Services Organization (USO), 168–69
"The Unity of Art" (Ruskin), 142–43
Unity of Mankind (Hoffman), 53, *84*, 104, 123, *177*, 192, 194, 238n80; anatomical models v. ethnographic figures, 54–56; as artworks, 52, 55; exhibited in hall, 82, 90, 220n1; funding donor, 49; and morphological comparison, 54; preliminary sketches, 49, 52, 54; reproduction in maps, 161, 167, 172; as symbolic representations, 49, 52, 55, 103, 131; and theosophical ideas, 52–53
Unity of Mankind clay sketch (Hoffman), 52, *54*
U.S. National Museum, *9, 11, 24*
Use of Hands and Feet (H. Field), 118–20, *118*

Van Nest, Mrs. (grandmother), 36
Vauxcelles, Louis, 132–33, 134, 138, 141
"Victory" photomural, *147*, 234n13. See also *Men of the World* benefit exhibition
Visual Art Workshop, 187–89, 241–42n15

Wall of Respect (Visual Art Workshop), 187–89, *188*, 194, 241–42n15, 242n18

Ward, Herbert, 8–9, 37–38
Watson, Thomas J., 150, 156, 157, 158, 237n67, 238n78. *See also* International Business Machines Corporation
Weems, Carrie Mae, 5, 216n53
Wellcome Museum, 66
Weltfish, Gene, 19, 144, 163, 168, 169, 172, 181
Weston, Edward, 47
"What We Do Not Know about Race" (Krogman), 166
"While Head Hunting for Sculpture" (Hoffman), 177–78
Whitney, Gertrude, 40
"Who Is News Today" photomural, 149–50, *149*, 159, 161. See also *Men of the World* benefit exhibition
Williams, Owen, 164, 165
Willkie, Wendell, 145, 172–73
Wilson, Fred, 5, 20, 183, 195–99, 243–44n47–50
Winant, Howard, 5
Wissler, Clark, 50
Wistar Institute, 17
Woman, Bali (Hoffman), 70–71
Women of Daring: A Woman Headhunter (Allen), *xiv*, 1
Wonderland of Knowledge, 178, 181
Woollcott, Alexander, 139
World Book Encyclopedia, 3–4, 19, 178–82, 189
World War II period, 144–45. See also *Men of the World* benefit exhibition
Wright, Alice Morgan, 39
Wu Lien-Teh, 78–81
Wu Shu-ch'iung, 78–81, 110. See also *Chinese Woman, Type of Scholar, Southern China*

Yesterday Is Tomorrow (Hoffman), 45

MARIANNE KINKEL is an
associate professor of fine arts at
Washington State University.

The University of Illinois Press
is a founding member of the
Association of American University Presses.

Designed by Matthew Smith
Composed in 10.25/13.25 Adobe Minion Pro
with Romeo display
by Jim Proefrock
at the University of Illinois Press
Manufactured by Thomson-Shore, Inc.

University of Illinois Press
1325 South Oak Street
Champaign, IL 61820-6903
www.press.uillinois.edu